A KIND OF MAGIC

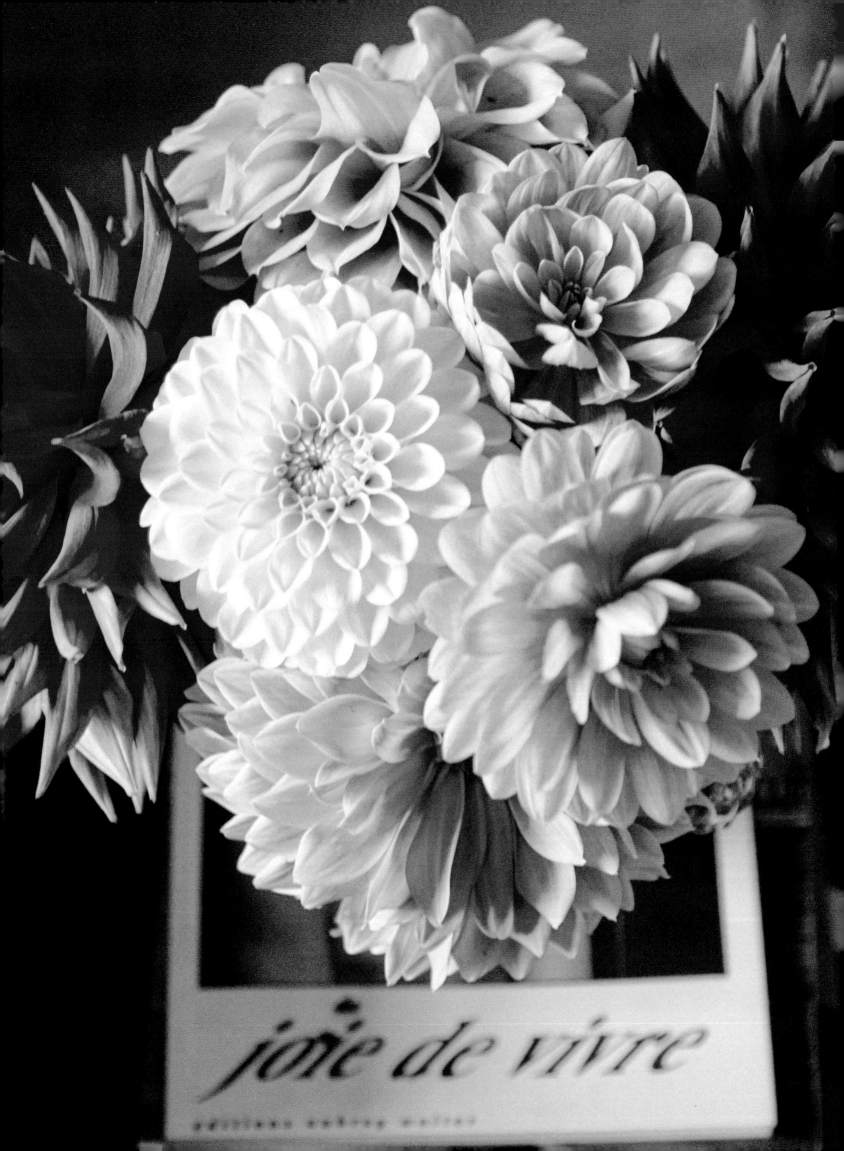

A KIND OF MAGIC

The Kaleidoscopic World of Luke Edward Hall

VENDOME

NEW YORK · LONDON

FOREWORD

... dear hand, deft hand,
limner of fable and fantasy ...
faithful friend to my art ...

These words, half-remembered from a song from *Kismet*, always come to me when reflecting on the multi-faceted, infinite variety of Luke Edward Hall's oeuvre; 'deftness' is indeed the *mot juste*.

He has that enviable talent for spontaneity, for translating visual ideas, immediately, from his fertile mind to his eager fingers. From them flow images both tender and tough, of gaiety blended with a touch of melancholy, which spring from a mind that is filled with a thousand images from the past – via artists and writers, designers and photographers – from the sheer *atmosphere* of the periods he venerates (principally the early 21st century, with a bit of Gothic thrown in), and which he transforms with contemporary and experimental verve, colours and wit. He has assimilated the best, considered it, refined and reformed it with his own, unique, dexterity.

But those fingers are not merely paint- and – now, with this book – ink-stained. They are also, by nature, green. Luke plants a garden where flowers seem to grow faster, more abundantly, some subtly shaded, some positively noisy, and often of an astonishing size, that will soon vividly enhance the charm and thrall of his own rooms – rooms that themselves are fearlessly kitted out with light-hearted panache, from junk to the urbane and the precious. His favourite books, his dog, his latest sketch, odd china, delectable appetisers, pot-pourri and prints lie about in comfortable confusion; Luke's inborn fastidiousness likes a bit of disarray.

This is evident in the distinctive clothes he designs, in the myriad idiosyncratic interiors he creates for clients, in the graceful murals he conjures for friends – myself included. That deftness, albeit carefully considered, is never uniform. Like other artists of his genre he admires, Luke recognises the point where such skills can slip into parody. That said, there is no stopping him, his vision and his flow.

This book being titled *A Kind of Magic* is therefore totally appropriate, but sleight of hand is not what makes it so. Rather, it is the very real and beguiling variety of shapes and silhouettes, colour and craftsmanship, knowledge and style. And the surprise that dazzles with every shake of the kaleidoscope Luke Edward Hall holds in his deft hands.

Nicky Haslam
Gloucestershire, 2022

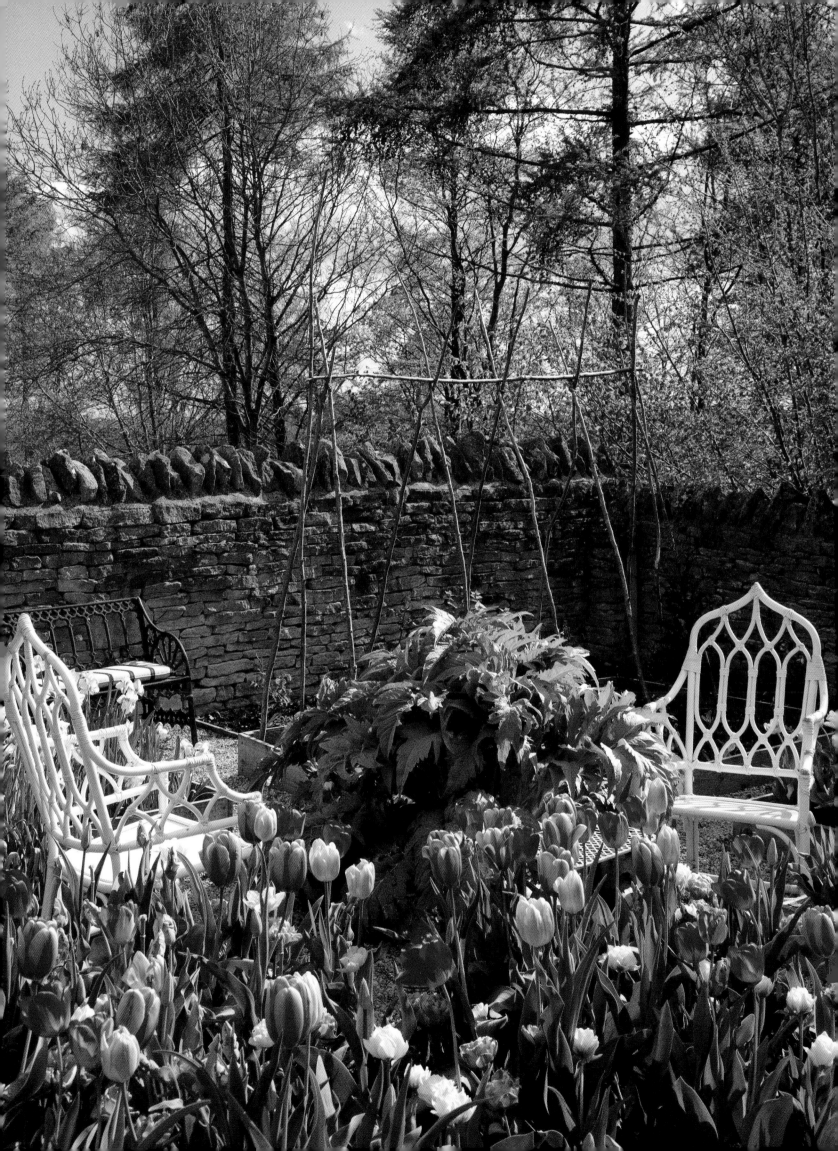

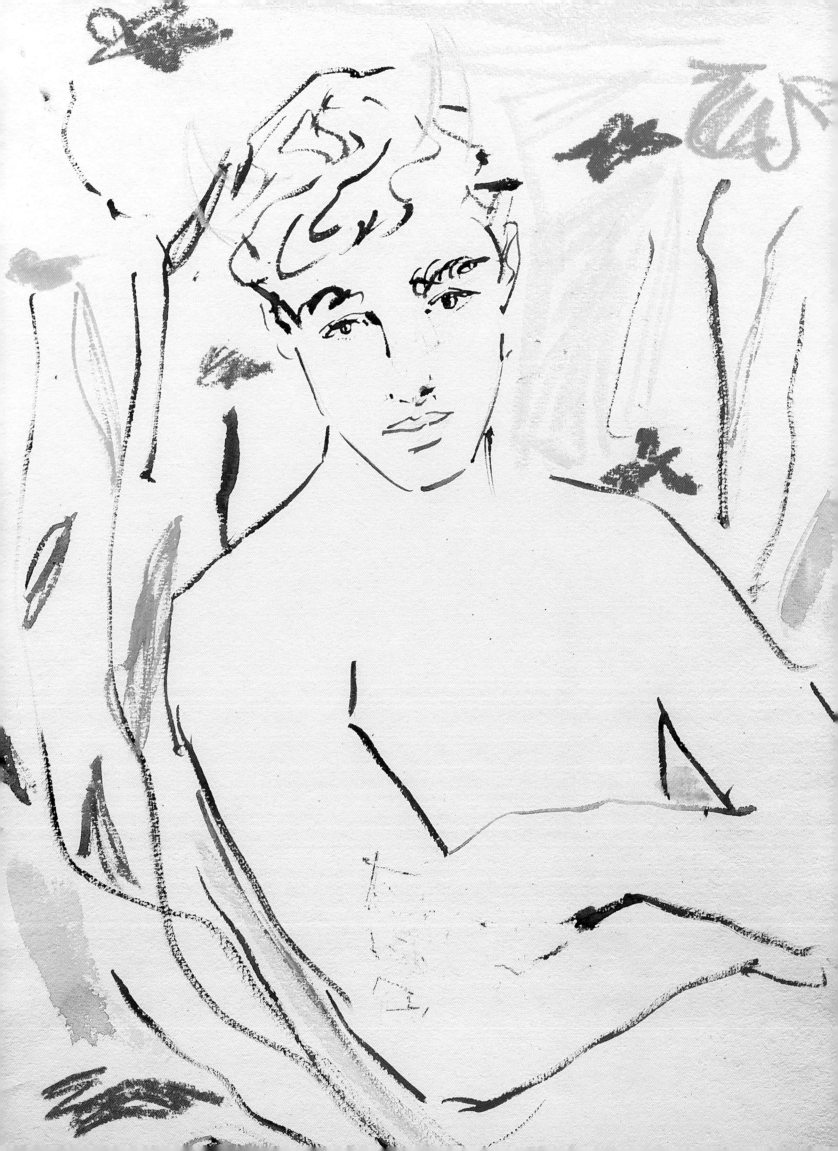

INTRODUCTION

I spent many months pondering the title of this book. I love giving things names and inventing stories, but, as I usually find, it was hard to sum up a lot of thoughts and feelings in a few short words. After much to-ing and fro-ing with the Vendome team, I settled on 'A Kind of Magic', because often, when I'm describing my work, I end up shoehorning the word 'magic' in somehow.

Magic is about using powers to make things happen that would normally be impossible. Magic is a special quality that makes something seem different from the ordinary. Magic is elusive, curious, not an everyday thing. Whenever I'm putting a room together, or painting a picture, or designing an object, I'm hoping and praying I create something with that fleeting quality, that sense of enchantment, that sprinkling of wonder. It's about taking oneself out of the everyday and instead inserting head and body and heart into someplace more fantastical. It's about atmosphere. Magic is what I'm always aiming for.

Aside from all this, 'A Kind of Magic' was one of my favourite songs when I was a kid. Every August I'd mosey on down to the North Devon coast from Hampshire with (almost) my entire family: Mum and siblings, Grandad, aunts and cousins. (These days I take the train and meet everyone there, because I have our whippet Merlin to consider; he loves the beach.) I have distinct memories of asking my aunt to play this song on repeat in the car on the journey down. I can't say that I was, or am, the biggest Queen fan, but back then this particular song – for me, at least – fizzed with magic and energy. So, on we listened, over and over (and also to Squeeze's 'Cool for Cats', if I recall correctly, which I was perhaps even more obsessed with). My aunt clearly had a lot of patience ... Anyway, these songs bring back happy memories of sandcastles and ice-cream cones and home, even though we were on holiday.

Home: it's what this book is all about. Home, mostly, plus a bit of work – though, for me, the boundaries between home and work are very blurry, which is just how I like them. It's a book about my spaces – the three spaces I spend most of my time in: our flat in London, our country cottage and my studio, which is also in the countryside. I say 'our' because the first two I share with my husband Duncan. These are spaces that we have made together: they're the sum of us, our interests and our passions.

The studio, on the other hand, is my own domain. I like to think of it as a kind of fabulous creative cave. I work at home sometimes, but the studio is the place where I can spread out all my books, get paint up the walls and leave teacups and paintbrushes in the sink, if I want to.

I see this book also as a collaboration between me and my great friend Billal Taright, who took the photographs. Billal has shot my projects for several years now, and I trust his eye implicitly. We've had a lot of fun over the past year photographing the flat and the studio; the cottage we shot at least four or five times. We met up throughout the year and captured various moments in the garden: February's delicate narcissi, pale and ghostly; the bursting open of candy-coloured tulips in April; high summer and the borders, a blur of green and blue and pink and buzzing with life; September and October's dinner-plate-sized dahlias.

Along with the photographs, I have included short essays on things that I love and relate to our homes and my work: past artists and designers who inspire; local folklore; old clothes; recipes for a pudding and a cocktail we often make. My drawings feature throughout, and snippets of projects I've worked on pop up in the studio section: the hotel in Paris I designed the interiors for; my new clothing company; sketches for murals ... In essence, it's a window on some of the things I actually make and do in these spaces.

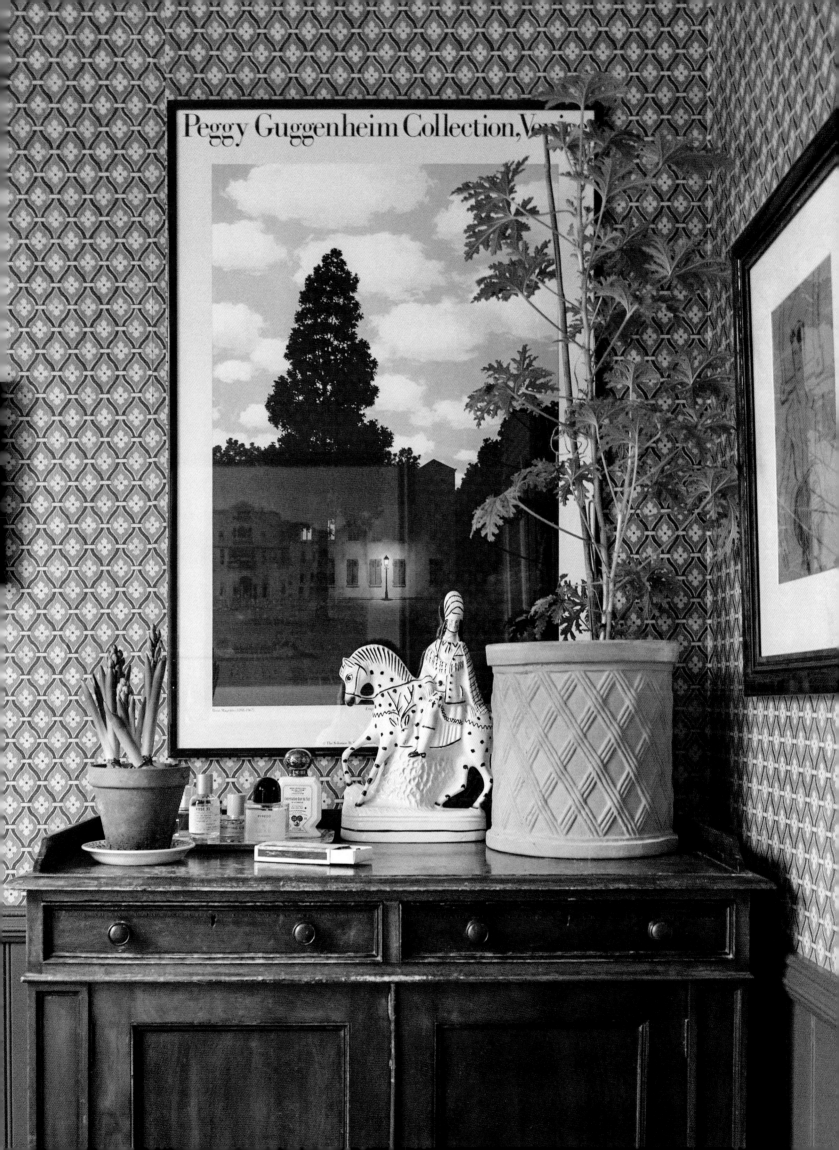

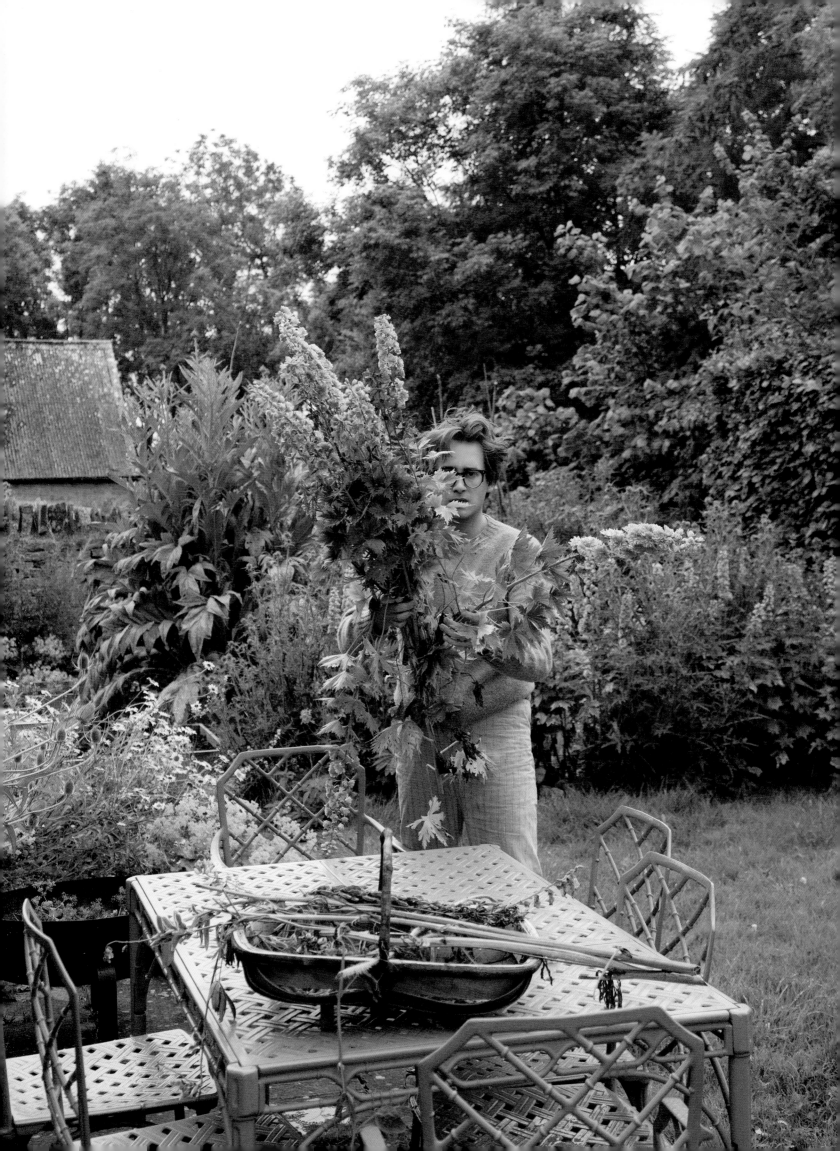

I admit that I may have tidied up here and there, mostly because I can never help myself from tweaking, but I did try my best not to 'style' Billal's photographs too much. There is a box of wine, a coffee machine and an open bag of crisps on the kitchen worktop; a shirt and a pair of trousers drying on a radiator. Everyday things. I know I mentioned earlier that magic is not about the everyday, but really magic can be discovered in the most unlikely places. And that's worth remembering. Magic is not always about grand overarching ideas and fantasy, or about removing oneself from an ordinary day at home (the place in which all of our belongings build a picture that explains who we are) and floating off into the clouds. And so, a shirt and a pair of trousers on a radiator feels magical because the trousers are mine and the shirt is Duncan's, and this vignette tells its own story – not one of great significance to the whole world, but still a special one to me.

Luke Edward Hall
Gloucestershire, 2022

COUNTRY

SNIPPING ROSES
the colour of
freshly churned
West country
butter. Dahlias
in September, all
complex geometry
and Blooms in
acid yellow
and shocking
Schiaparelli pink.

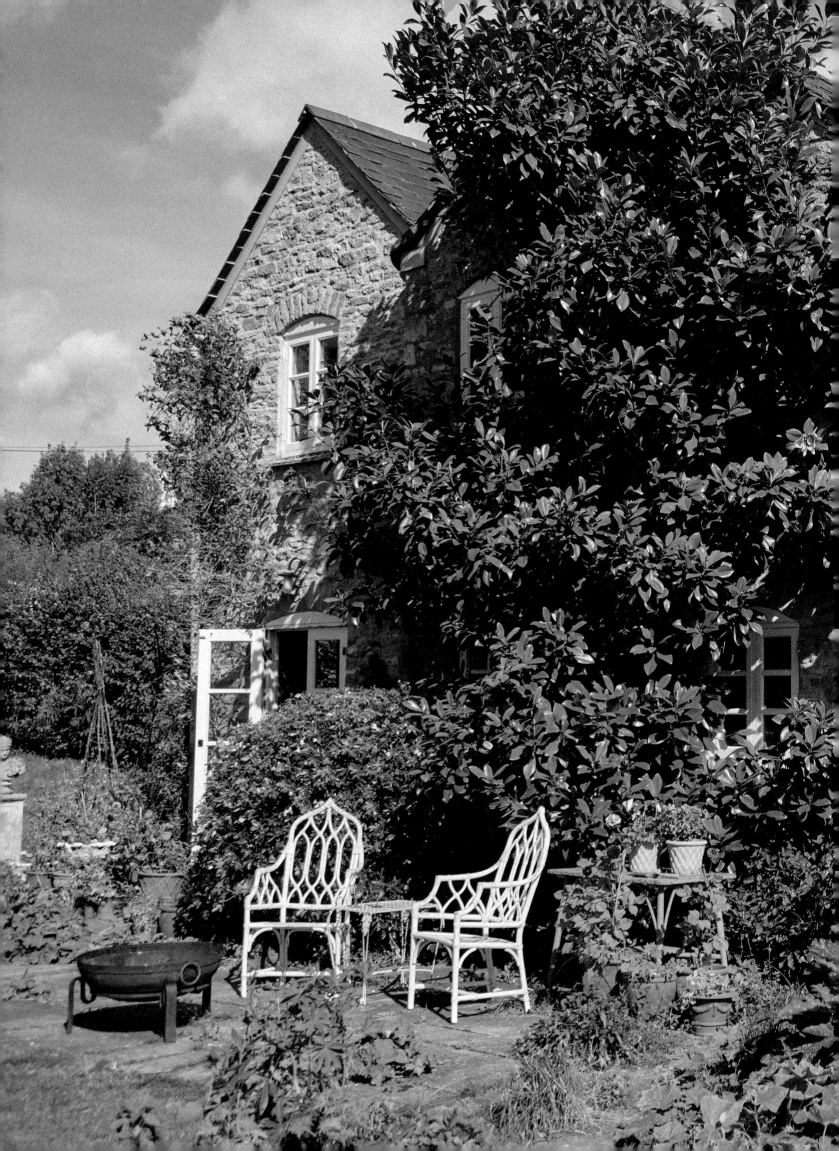

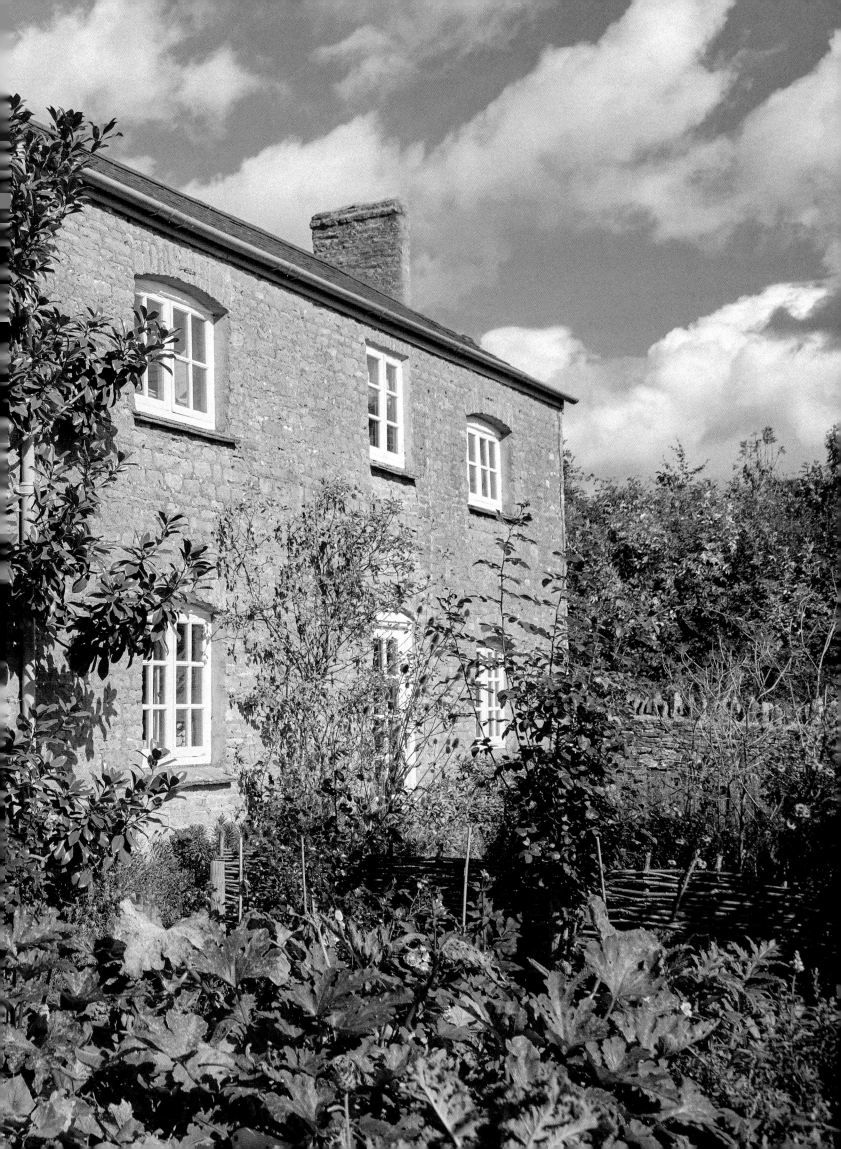

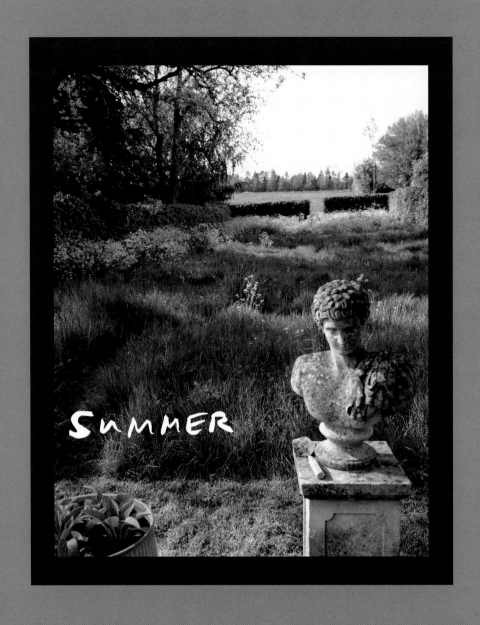

SUMMER

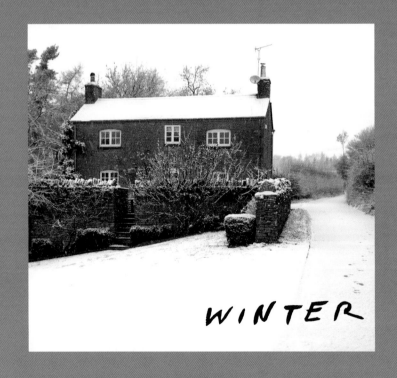

WINTER

A SANCTUARY
found

It was a drab day in January 2019 when Duncan and I began hunting for a house in the country. As we trawled the web for cottages, our new lives flashed in my head as a gleeful, Arcadian slide show: garden weeding and village dog shows (we didn't even own a dog at this point); long walks and longer lunches with friends and brilliant new neighbours. Plus, crucially, we would have an entirely new set of rooms to fill with wonderful things. But most of all, and in a very simple way, I looked forward to spending more time with hills and trees and sky around me. It would be an adventure.

We scoured the map and focused our search on rural pockets we'd visited in the past – towns and villages we liked the idea of. From Somerset to Sussex, Wilton to Winchester, we spent months viewing potential new homes. We pined for a folly – I am a romantic, and I dreamt of bedrooms in towers, Gothic windows and glistening grottoes – and, indeed, we visited several gatehouses and unusual buildings, but every time we drove away unsatisfied and disappointed. Then, one March morning, a house in the Cotswolds popped up on my screen. A child's drawing of a cottage, really. I could see from the photographs that it looked out over unblemished, rolling fields, and in no time at all we were there, poking around and rather quickly falling in love. It didn't have turrets or crenellations,

but that view won us over in a heartbeat. We loved many other things, too: I spotted a barn full of cows a bit further down the lane along from the house, but no other buildings as far as the eye could see; the house was situated on the edge of a beautiful, hidden estate; the garden was big and had lots of potential; and, inside, the bathrooms were good and the stone flags to die for. We signed the lease a few days later and began renting in June.

From the off, we laughed a lot. We slept on an air bed for weeks and used a cardboard box for a bedside table. Our oven (a Stanley, much like an Aga) gave up the ghost on our first night, so we decamped to the pub for fish and chips. Friends turned up for a house-warming weekend, piling into the two guest bedrooms and sleeping on more air beds. We went for a walk and ended up clambering over fences to get back to the house, a baby, pushchair and friend with an injured leg and walking stick all in tow.

We both loved London and, at first, continued working in the city on weekdays. The cottage quickly became our sanctuary – a place not only to rest and recharge but to enjoy with friends and family. Long weekends here are spent visiting local beauty spots, talking, snoozing and feasting. We began spending more and more time in the country, and, when the pandemic struck in 2020, we made the big move. These days, the cottage is our base. My studio is on a farm ten minutes up the lane, and we pop to London when we need to. We won't be here forever, but for now this humble little house more than fits the bill.

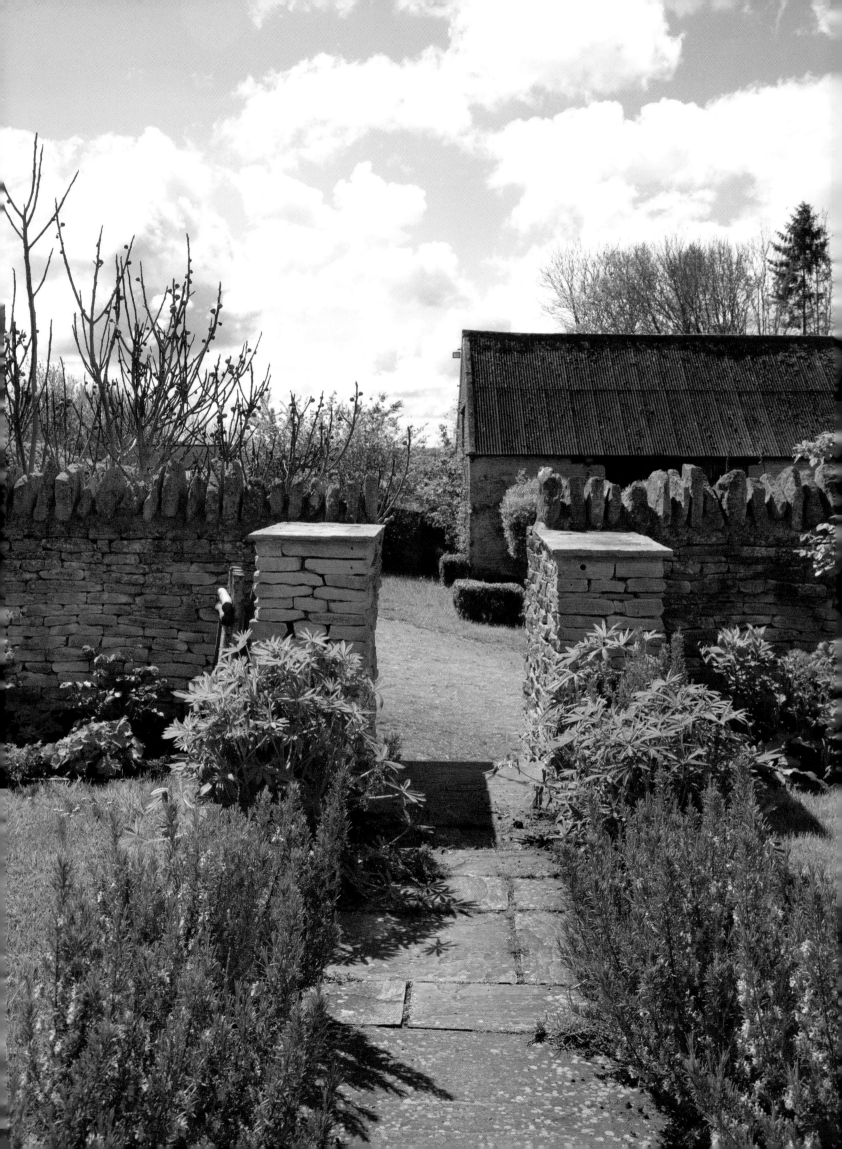

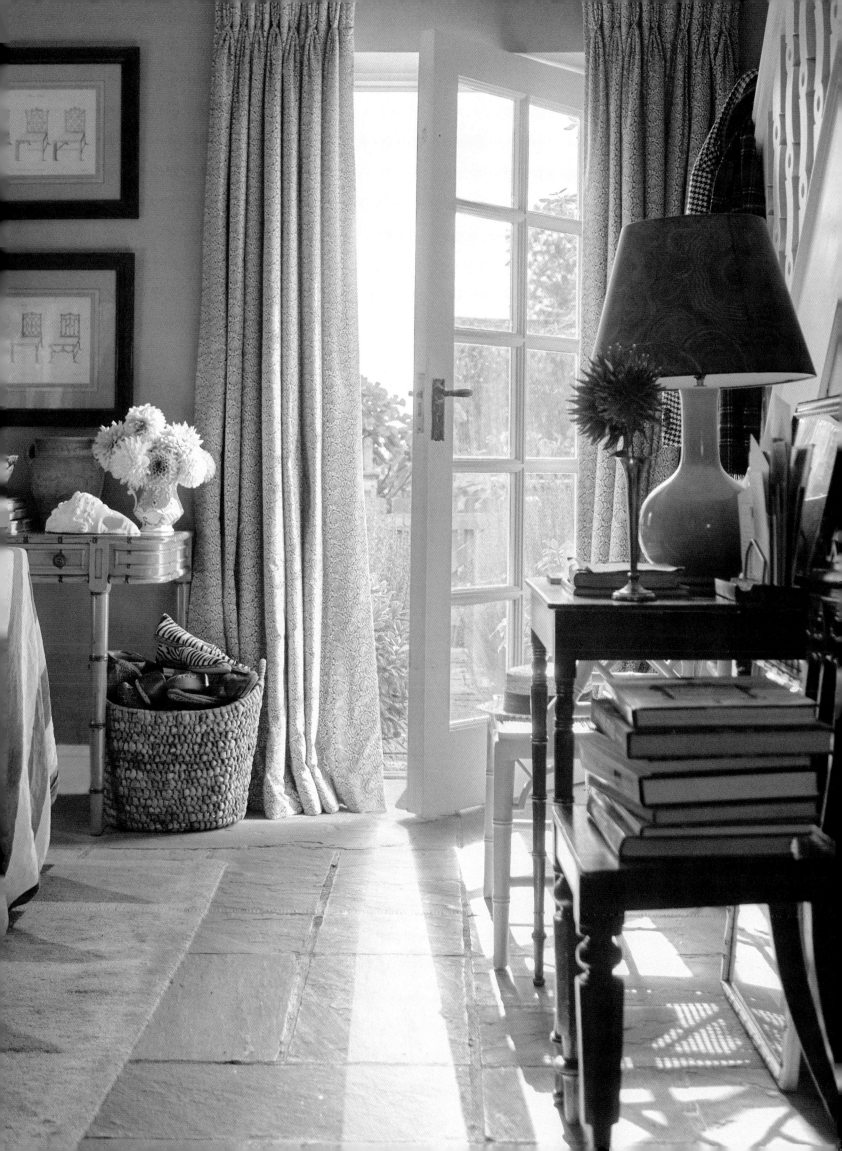

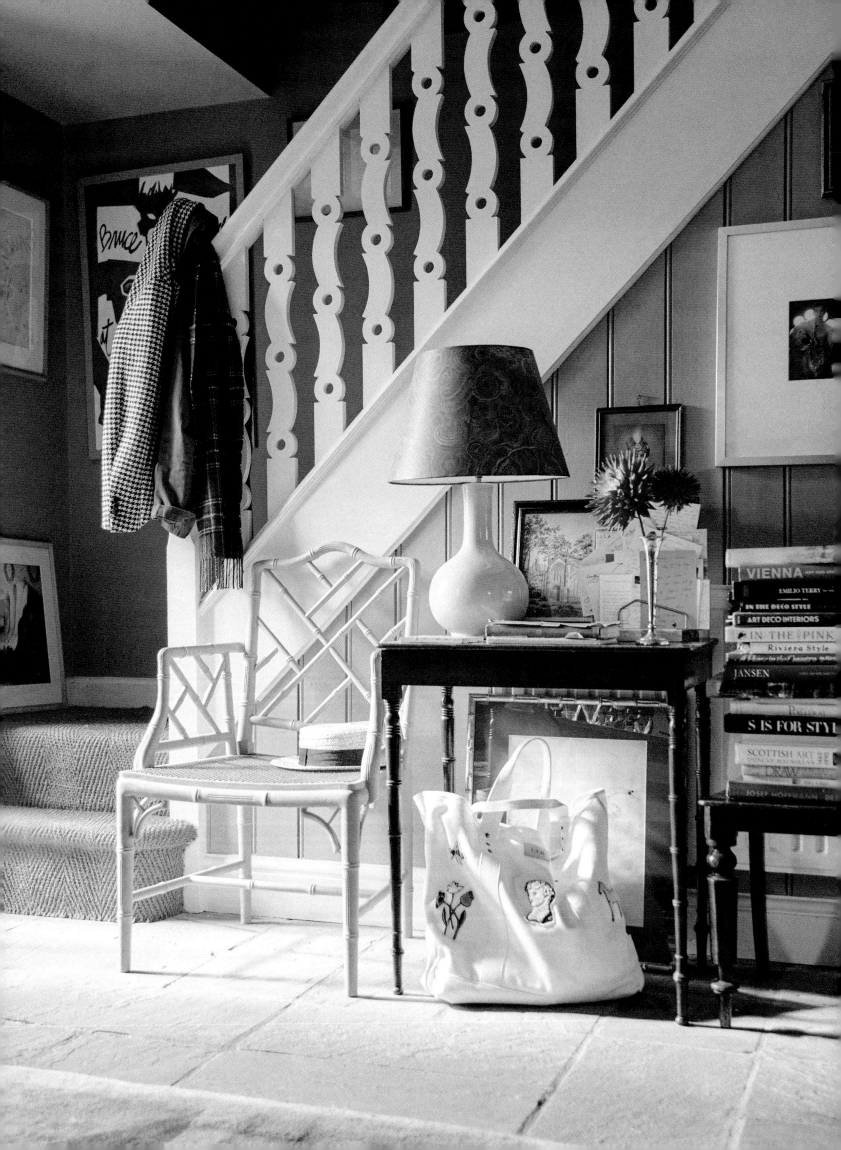

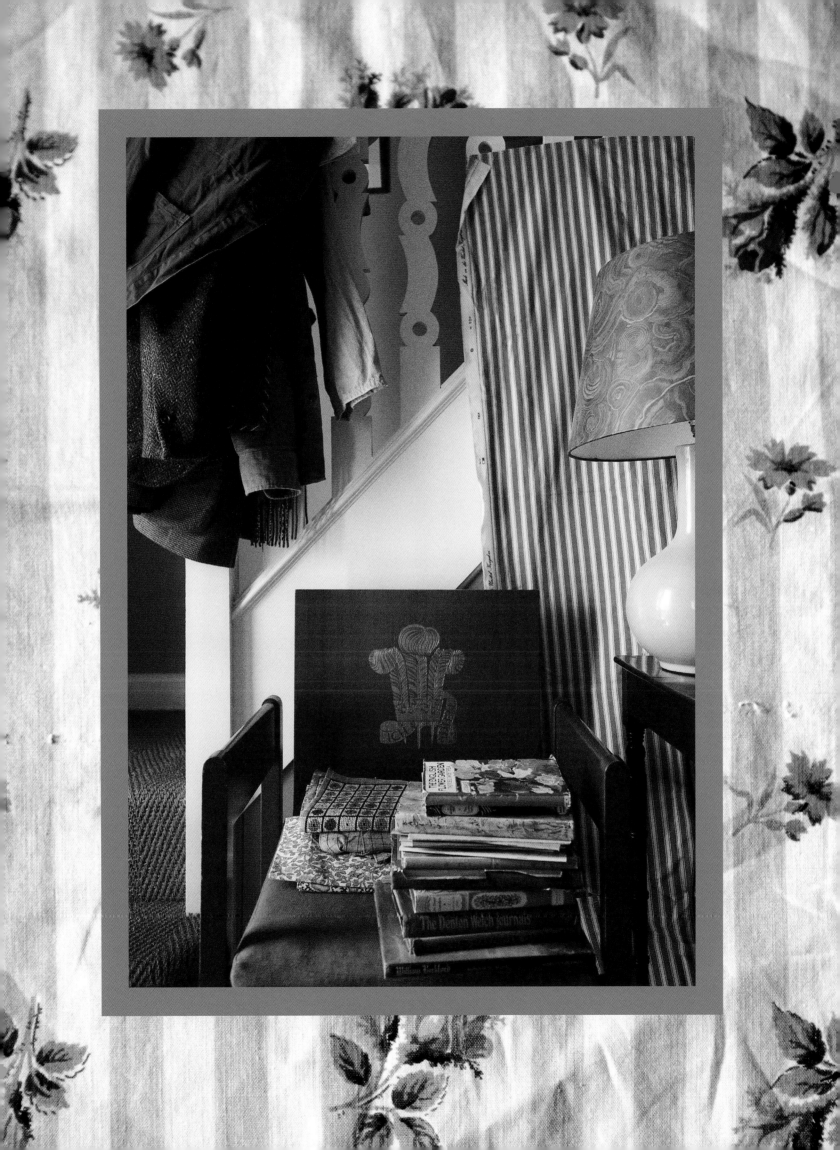

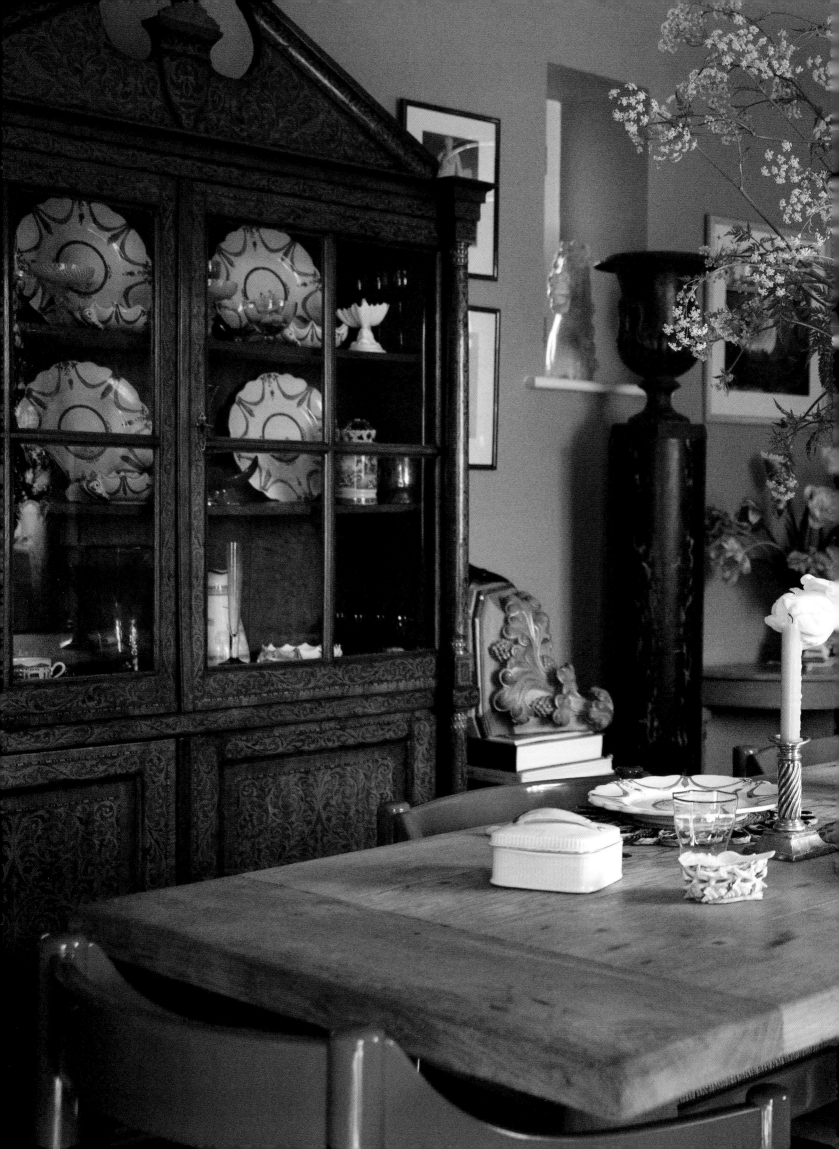

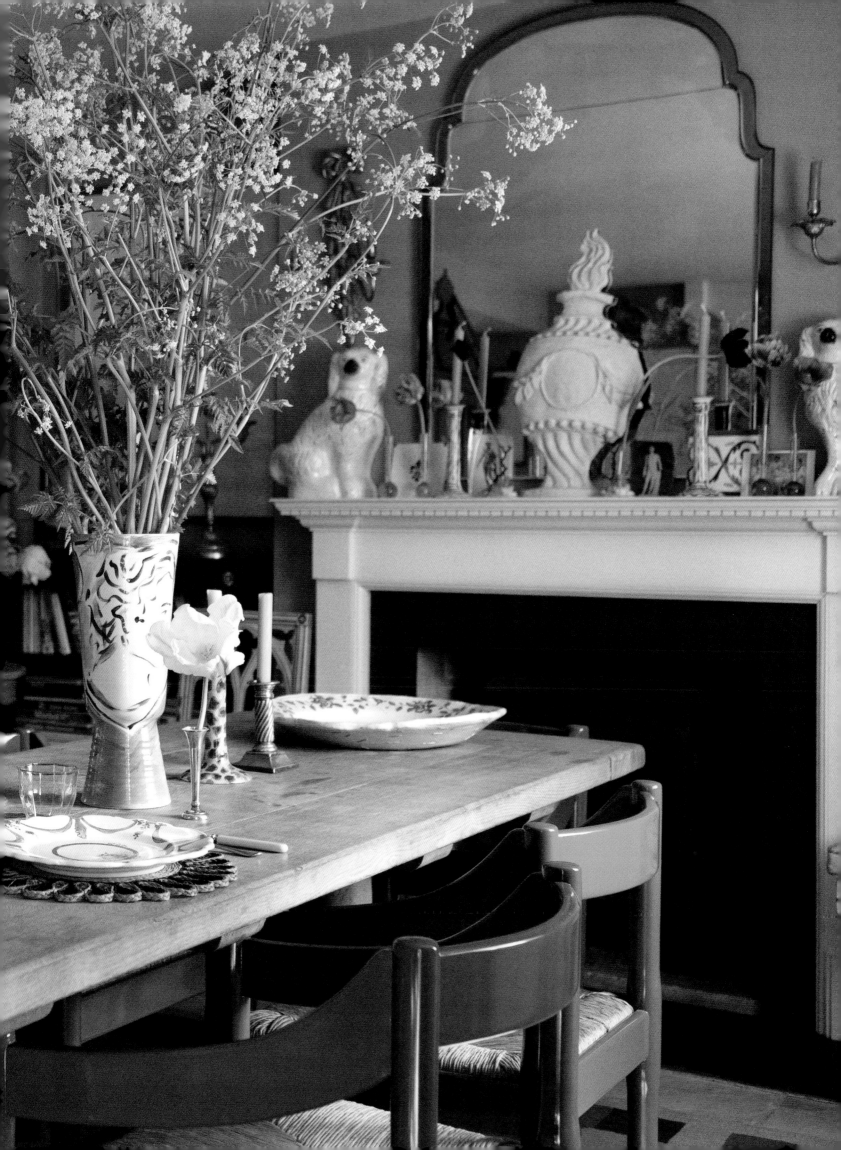

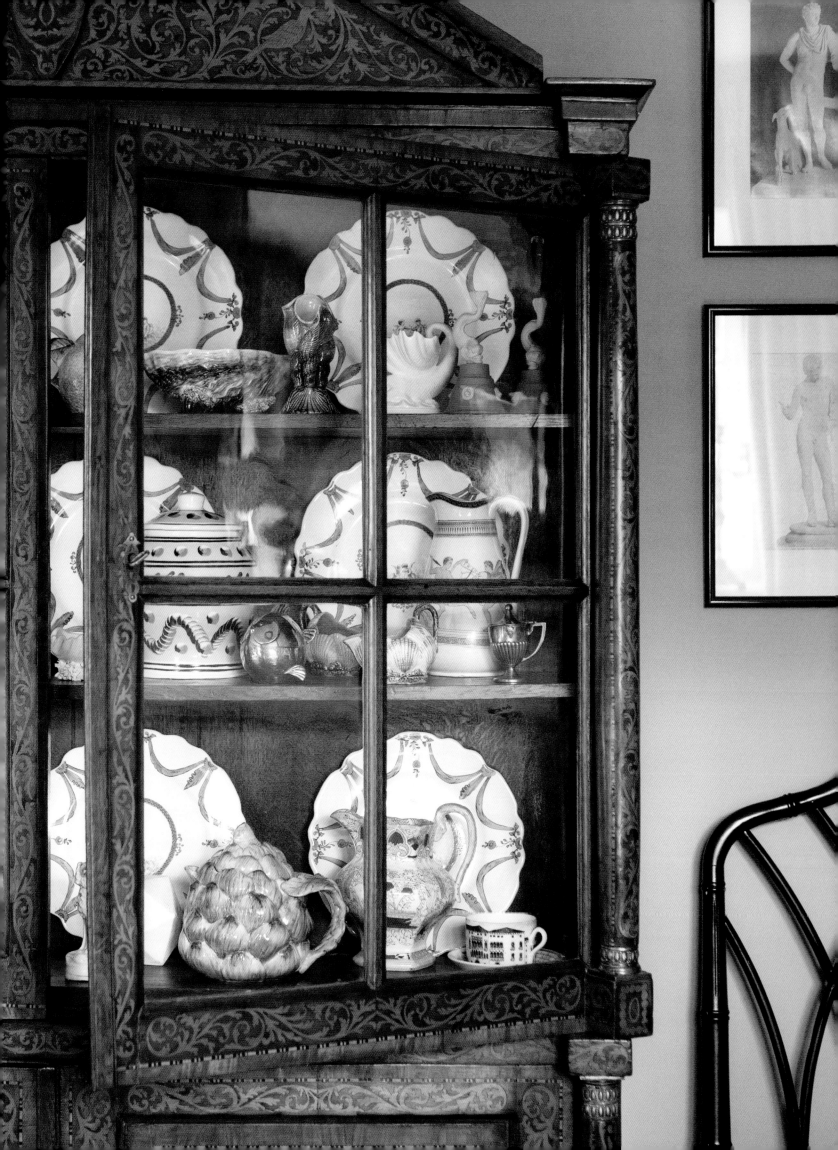

Other HOUSES

The Cotswolds – a rural area of England covering parts of six counties including Gloucestershire and Oxfordshire (we live on the border of the two) – is littered with crumbling country houses made from the region's distinctive golden-yellow local stone. Since my teenage days of working in the café of a National Trust property close to my home in Hampshire, I have loved the atmosphere of old houses with a passion. These days, I can't think of a nicer way to spend a country afternoon than in the engagement of a slow snoop through a historical building; we get on our hands and knees to inspect furniture and fabrics, and gossip with friends about which pictures we would like to strap to our cars and drive off with. A bit of lunch, brought with us in a basket or provided by a pub, followed by a languid garden stroll. We are amazed by the flowers, forget their names, compare them to our own attempts at home. We marvel at statues and trees and the shape of windows, and enjoy the sound of gravel crunching beneath our feet.

Rousham House is a favourite, mainly for its celebrated gardens, which were enhanced by William Kent in the 18th century and recall the glories and atmosphere of ancient Rome. Surprises are encountered at every turn: here, a stream; there, a glade. Porticoes, ponds, cascades and moss-covered statues of gods and gladiators can all be found at mysterious, beguiling Rousham. The house itself is a jewel box, crammed with endless pieces of dazzling gilded furniture designed by Kent.

Chastleton House – a remarkable Jacobean pile – is a hop and a skip from our cottage and often the first port of call when we have guests staying. Guests with a penchant for faded tapestries and impressive ceilings, anyway. Until 1991, the house had been owned by the same family for almost 400 years; now in the care of the National Trust, its rooms appear as if they were vacated only moments before. The Long Gallery, with its barrel-vaulted ceiling, is a gasp-inducing sight to behold. I announce that I find the children's dressing-up box in the corner of the room inelegant, but am sporting a ruff in a matter of seconds.

Painswick Rococo Garden is another favourite. Squeezed into a Gloucestershire valley and strewn with fabulous, frivolous follies, the garden was designed in the 1740s as a pleasure garden, a place for secret liaisons and riotous parties. The Red House, one of the garden's structures, is a magical, curious building, like something out of a Grimm fairy tale.

I don't pretend to be a historian, nor a garden expert, but every time I visit these houses and gardens I take some new fragment of inspiration away with me. The colour of an iris in spring, perhaps, or the serpentine shape of a chair leg. I feel a lot of things, too: mostly a sense of serenity mixed with awe, and a deep connection to the past.

OTHER *Gardens*

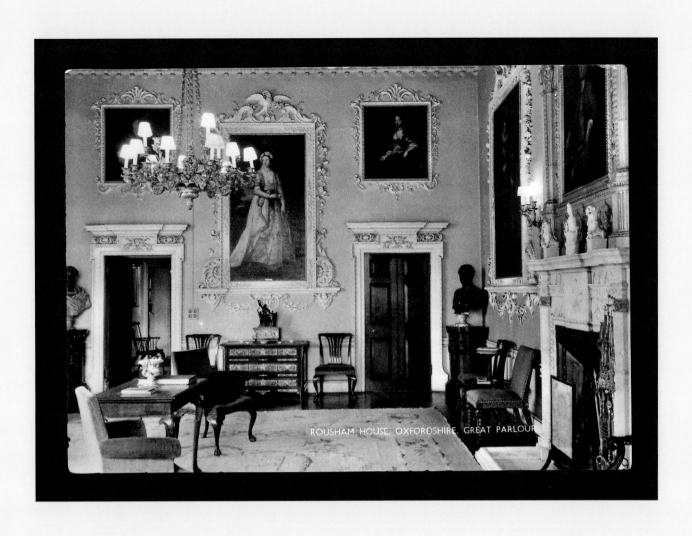

ROUSHAM HOUSE, OXFORDSHIRE. GREAT PARLOUR

ROUSHAM HOUSE, OXFORDSHIRE. PIGEON HOUSE GARDEN

31

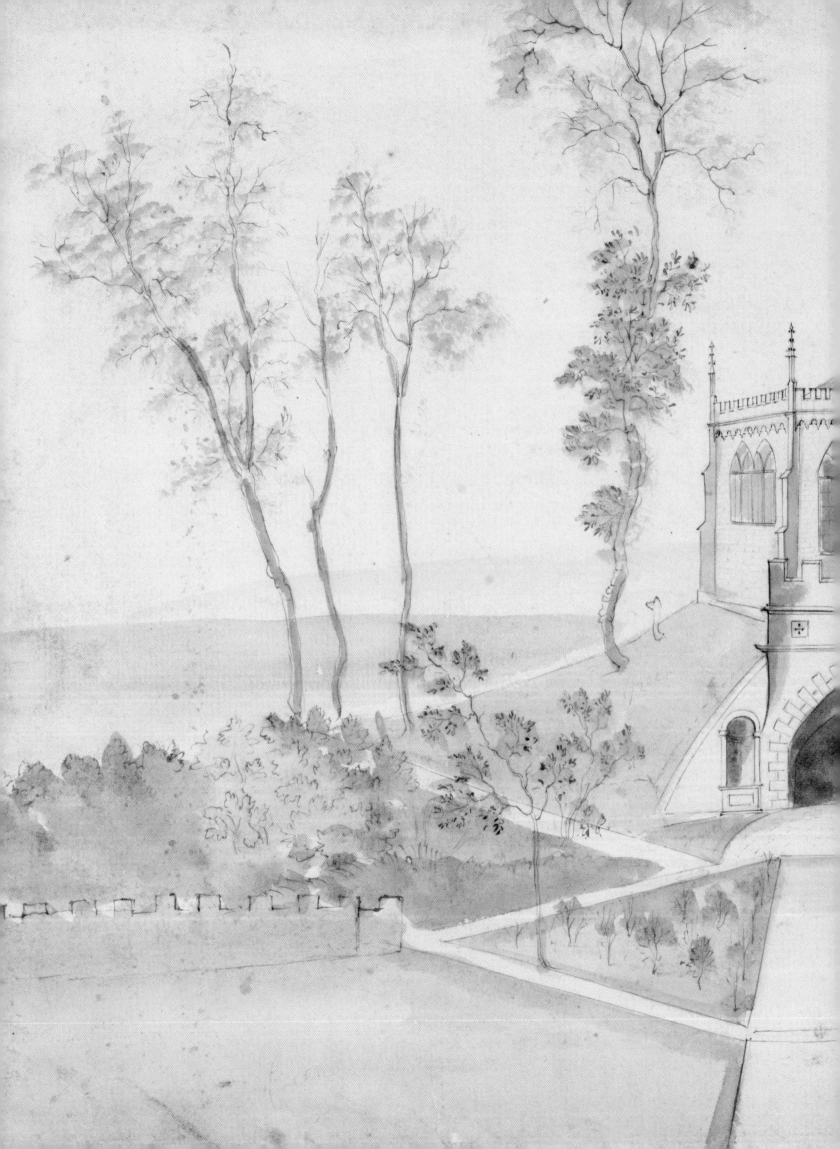

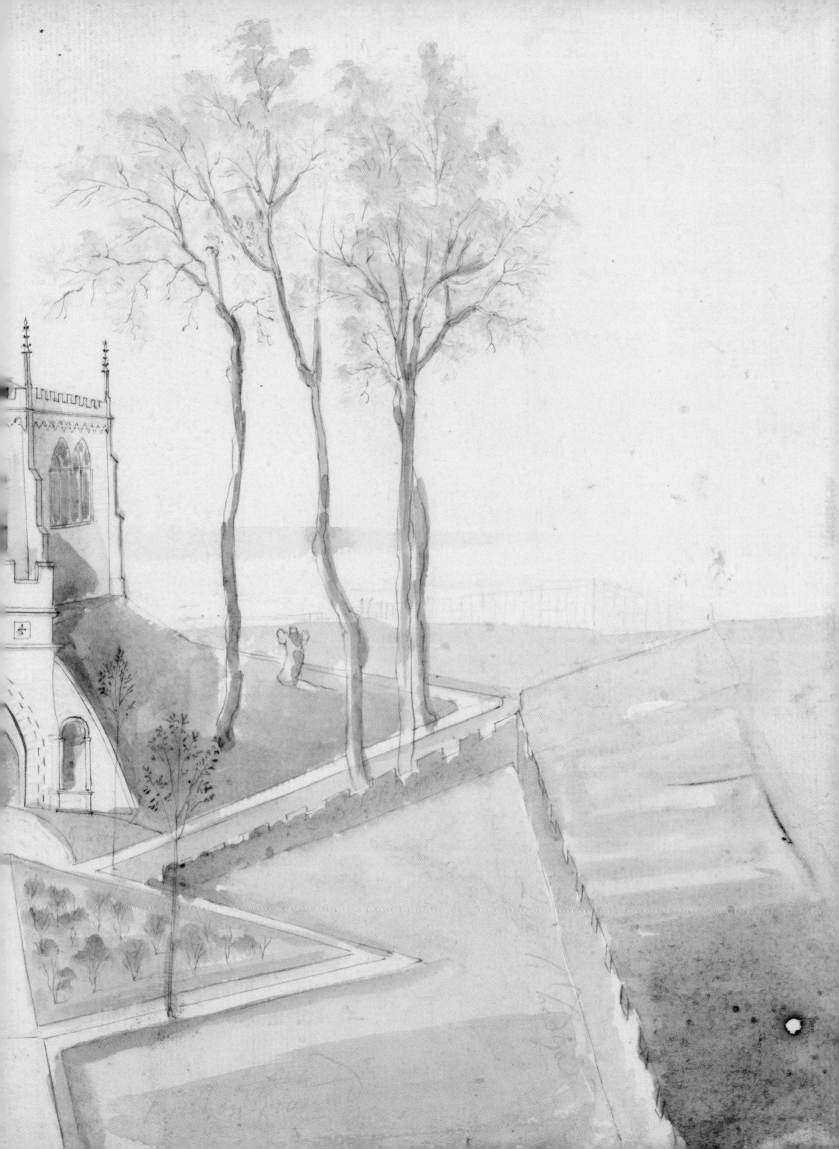

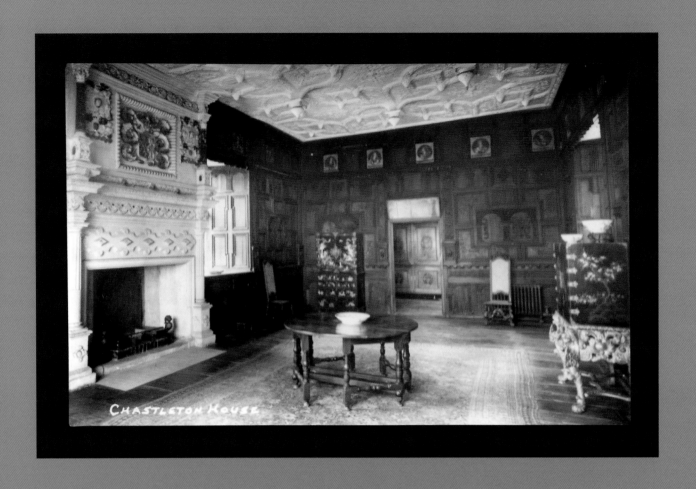

CHASTLETON HOUSE

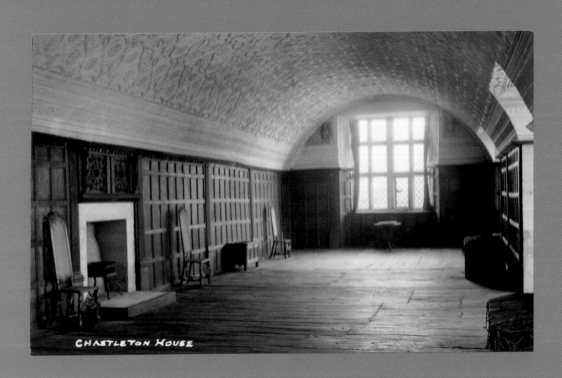

CHASTLETON HOUSE

34

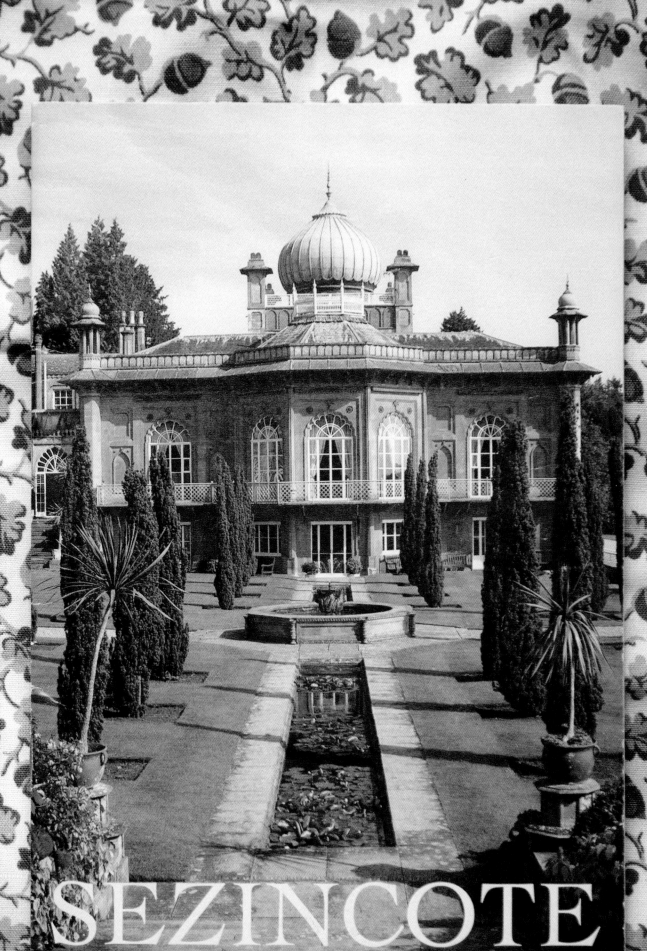

SEZINCOTE

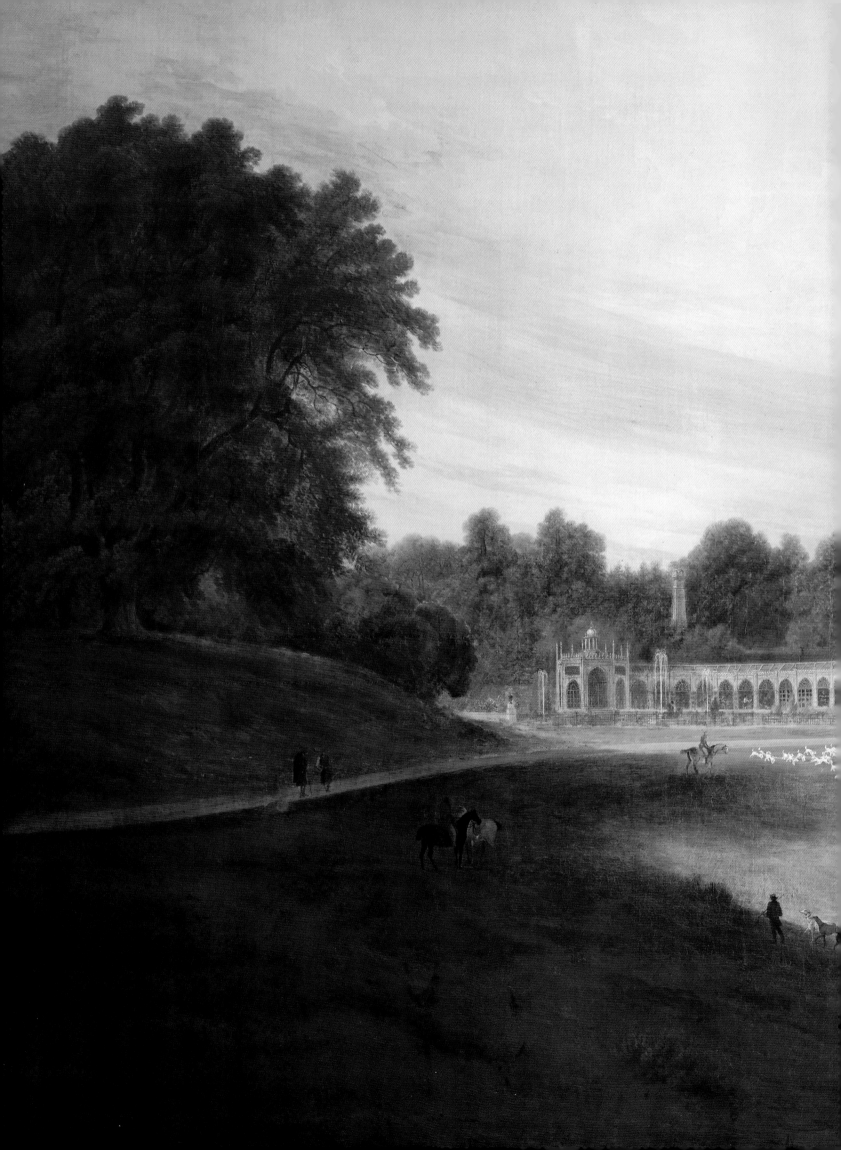

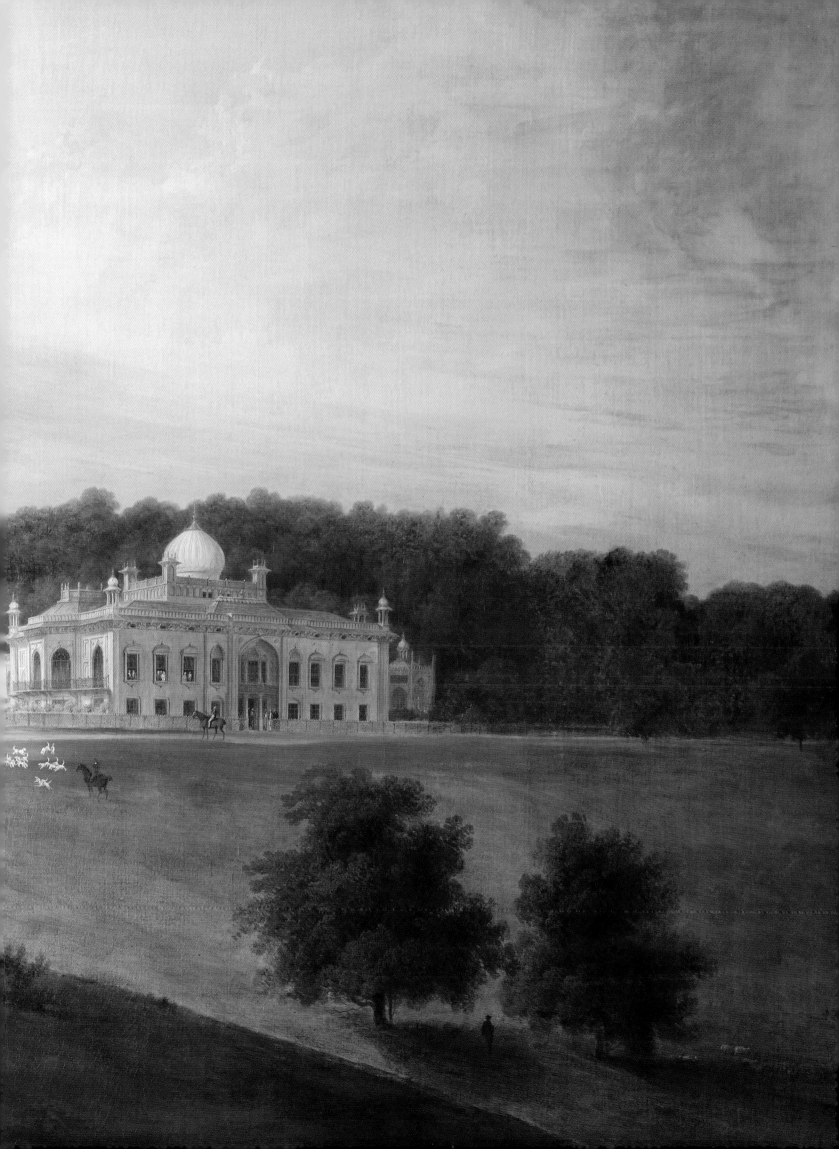

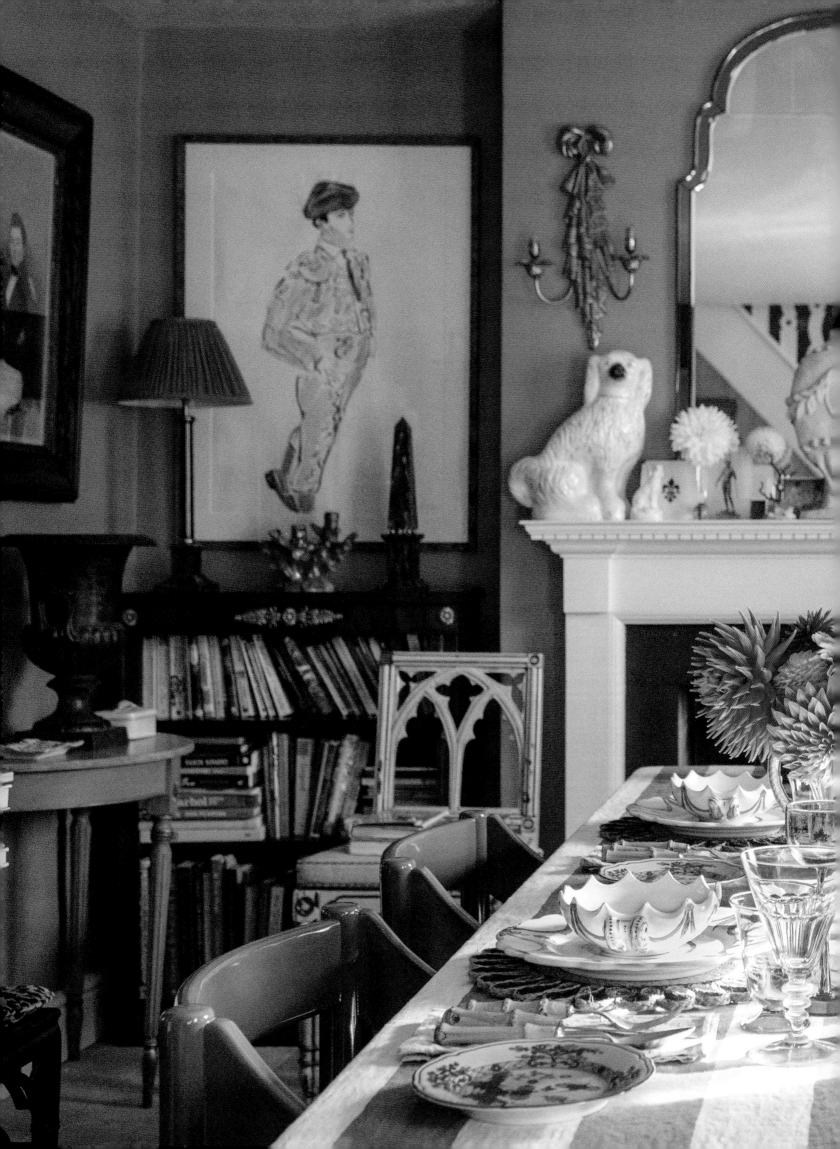

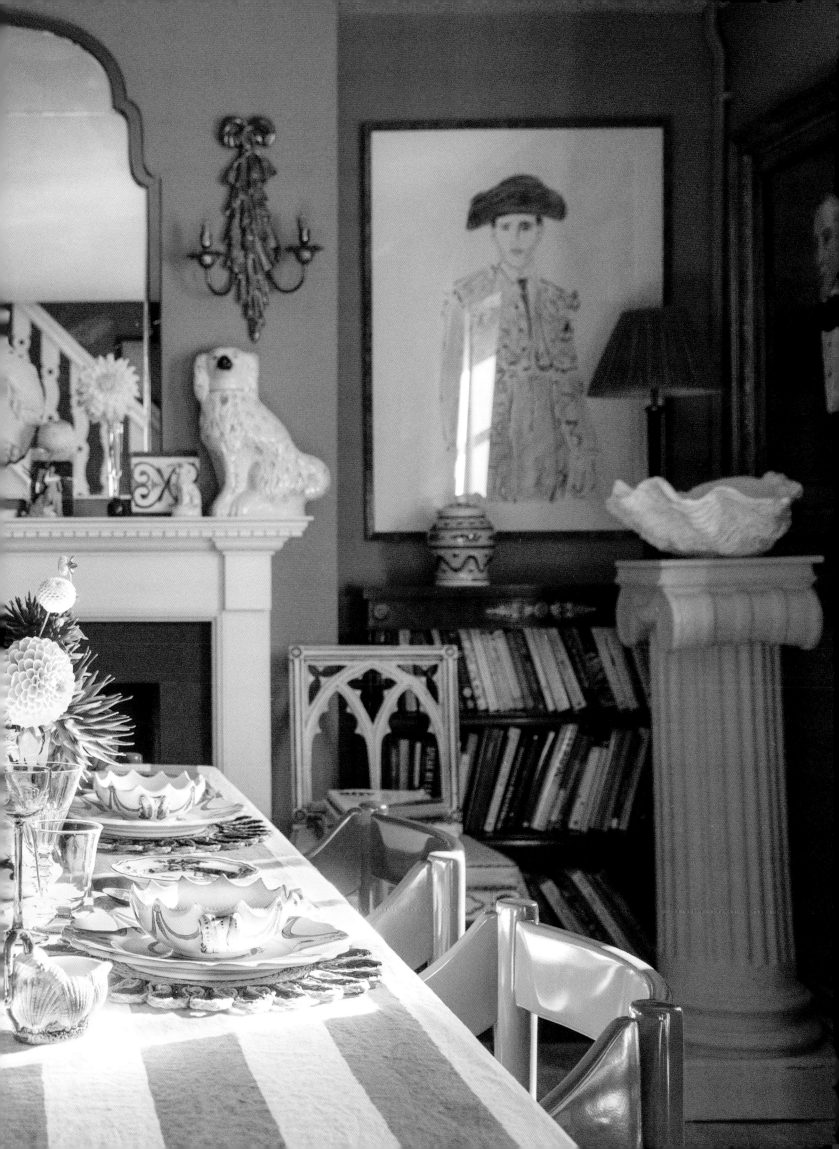

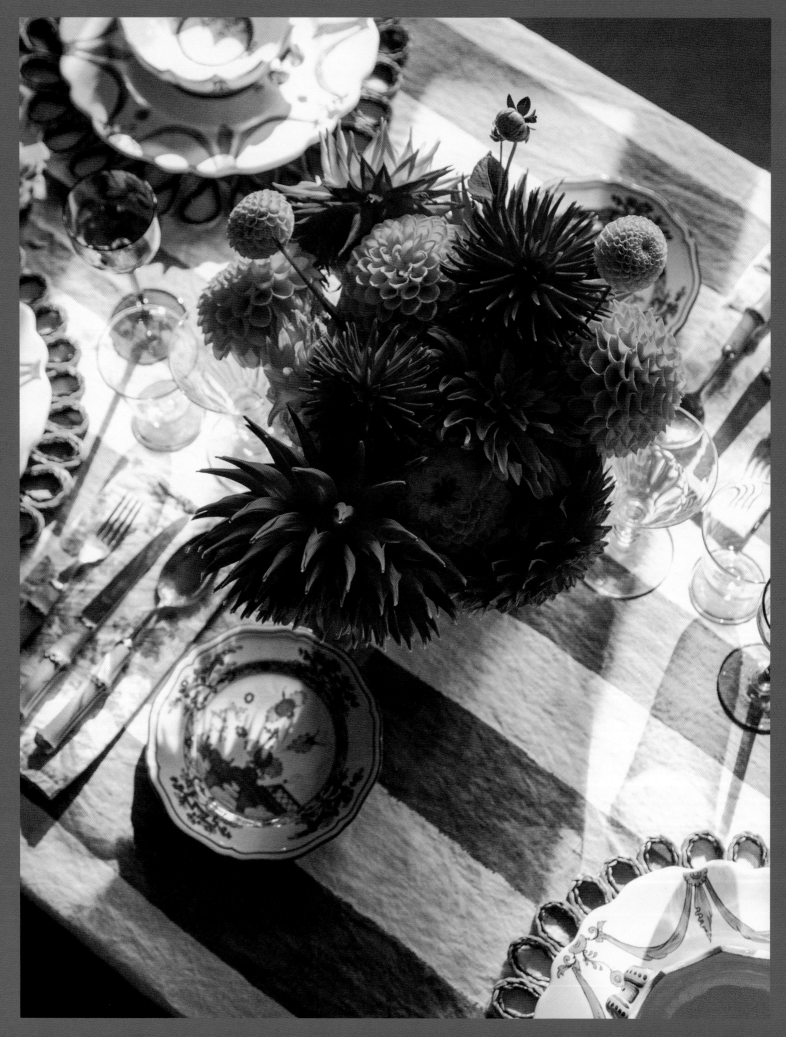

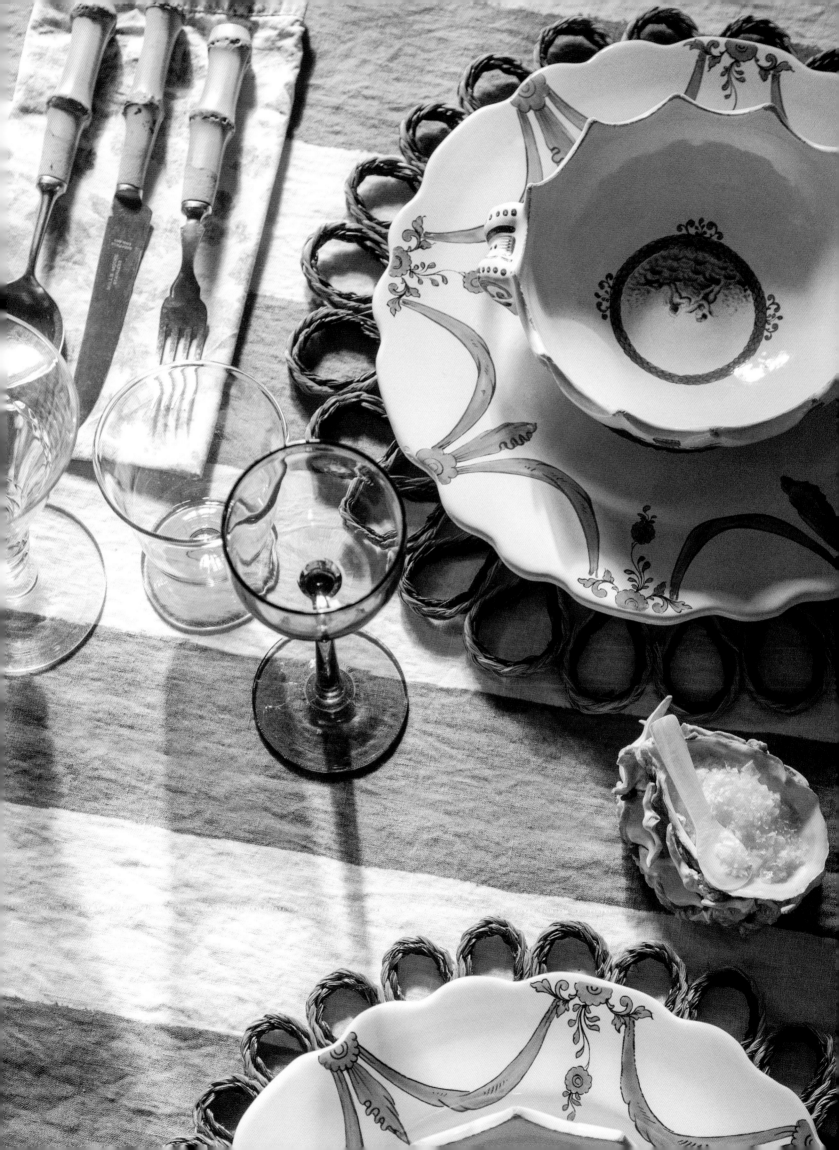

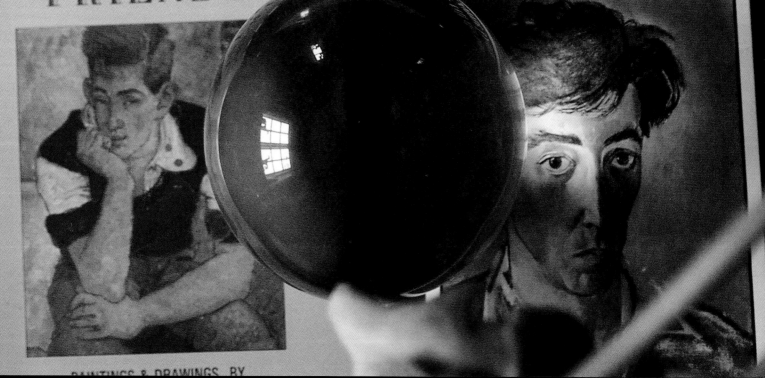

BAROQUE
1685-1715

English Country

joie de vivre

éditions aubrey walter

POST~WAR
FRIENDS

Dance till the Stars
Come Down

PAINTINGS & DRAWINGS BY

VALLEYS
& Books

The valleys of the Cotswolds
have produced many an artist,
writer and poet, but none more
famous than Laurie Lee. Born in 1914
and brought up in the Gloucestershire village
of Slad, much of Laurie Lee's rustic writing
is rooted in this once isolated patch of rural
England. His books – all rolling green hills,
violins, treacle biscuits and lashing rain –
have captivated generations. I am probably
most fond of his evocative writings about
Christmas in the Cotswolds. I can almost
hear the peal of Painswick's church bells, the
crackle of the roasting goose on its spit in
the fire; taste the falling snow on my tongue,
the rich and spiced Christmas pudding, black
as night, engulfed in pale flickering flames.

We often head west to the Slad Valley to retrace
Laurie's steps. We'll wander down to the village
pond and back up the valley in the direction of a
hearty lunch at the Woolpack, Laurie's old local,
a place full of character where the quietly inventive,
locally sourced food is good and the views even
better. Stumbling out of the pub later on, I'll wink
at a gravestone in the churchyard across the road.
Cheers to you, Laurie.

*'Outside there is no surprise in the coldness of the morning.
It lies on the valley like a frozen goose. The world is white and
keen as a map of the Poles and as still as the paper it's printed
on. Icicles hang from the gutters like glass silk stockings and drip
hot drops in my hands as I breathe on them ...'*

'A Cold Christmas Walk in the Country'
Village Christmas and Other Notes on the English Year
LAURIE LEE (Penguin Classics, 2015)

EDITH SITWELL

THE
PLEASURES
OF
POETRY

CONTENTS
MILTON and the AUGUSTAN AGE
THE ROMANTIC REVIVAL
THE VICTORIAN AGE
672 pages

The Male Form

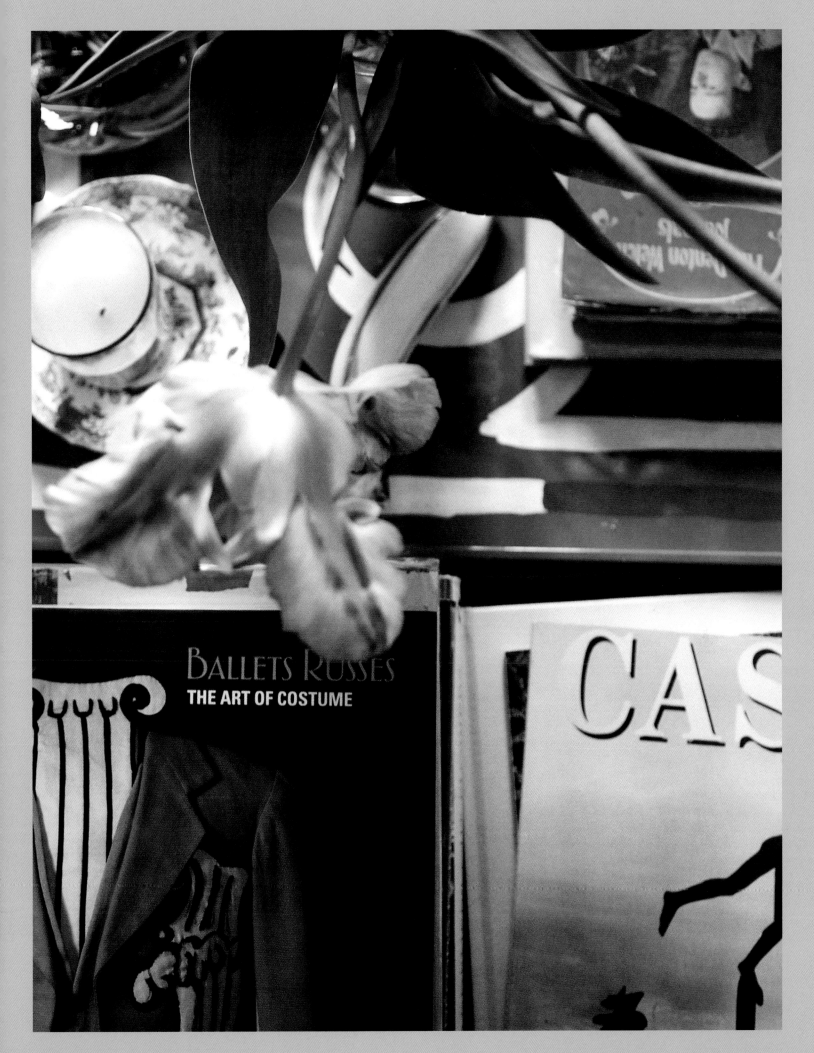

BALLETS RUSSES
THE ART OF COSTUME

CAS

POTS AND PANS
OF CLASSICAL ATHENS

AMERICAN SCHOOL
OF CLASSICAL STUDIES
AT ATHENS

The Masque

No. 4
Designs for the Theatre
by
REX WHISTLER
Part Two
With an introduction by
JAMES LAVER

The Curtain Press, London
TWO - MCMXLVII - SHILLINGS

The Denton Welch
journals

GORE VIDAL

The
Judgment
of Paris

William Beckford

JAMES LEES-MILNE

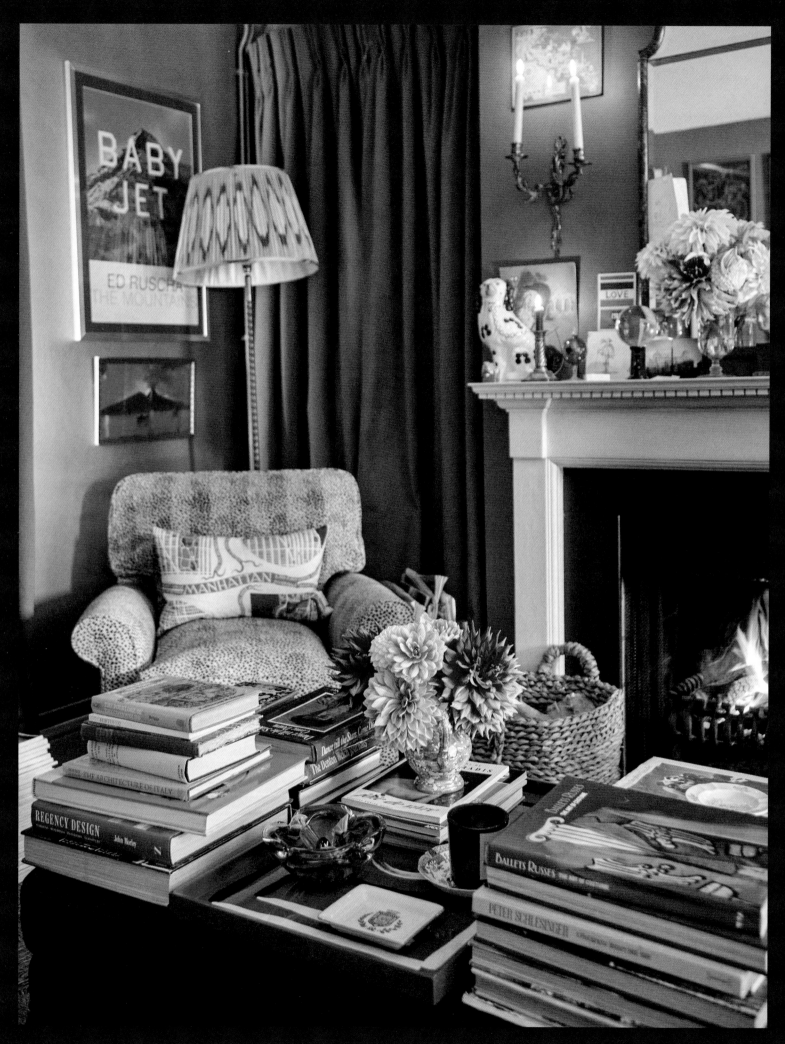

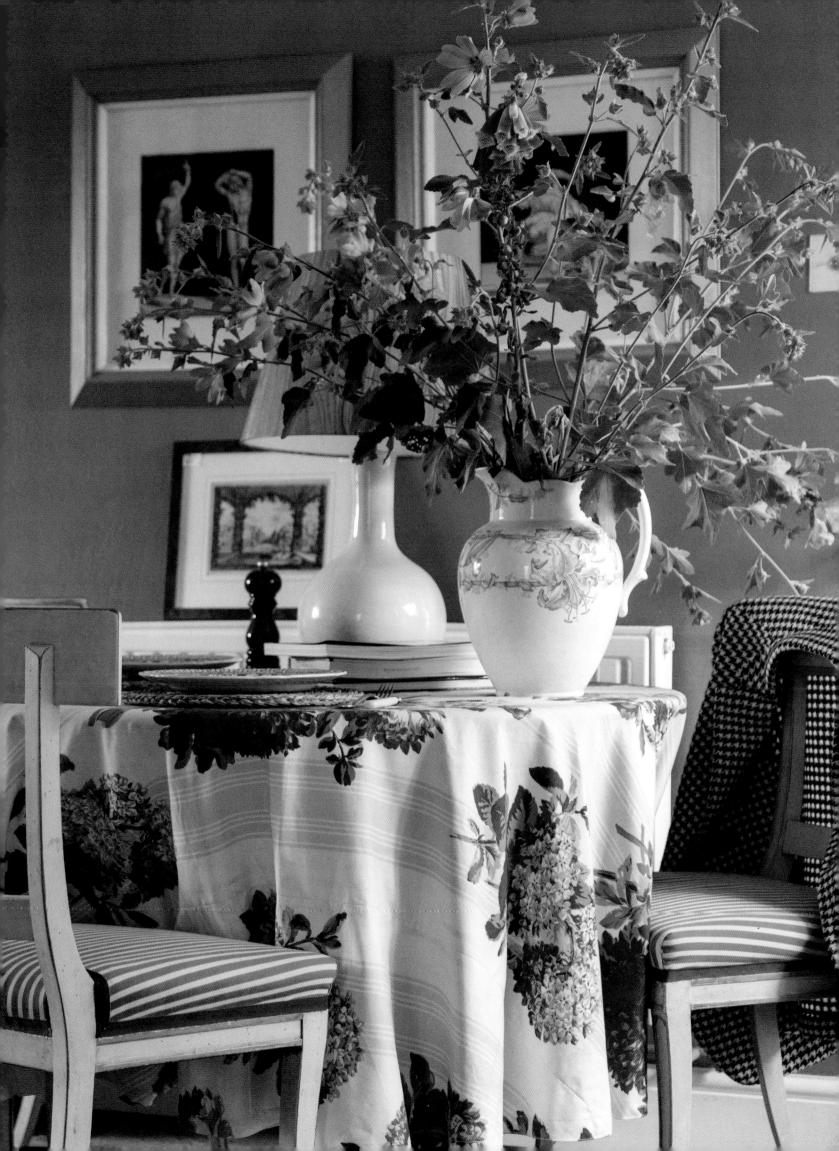

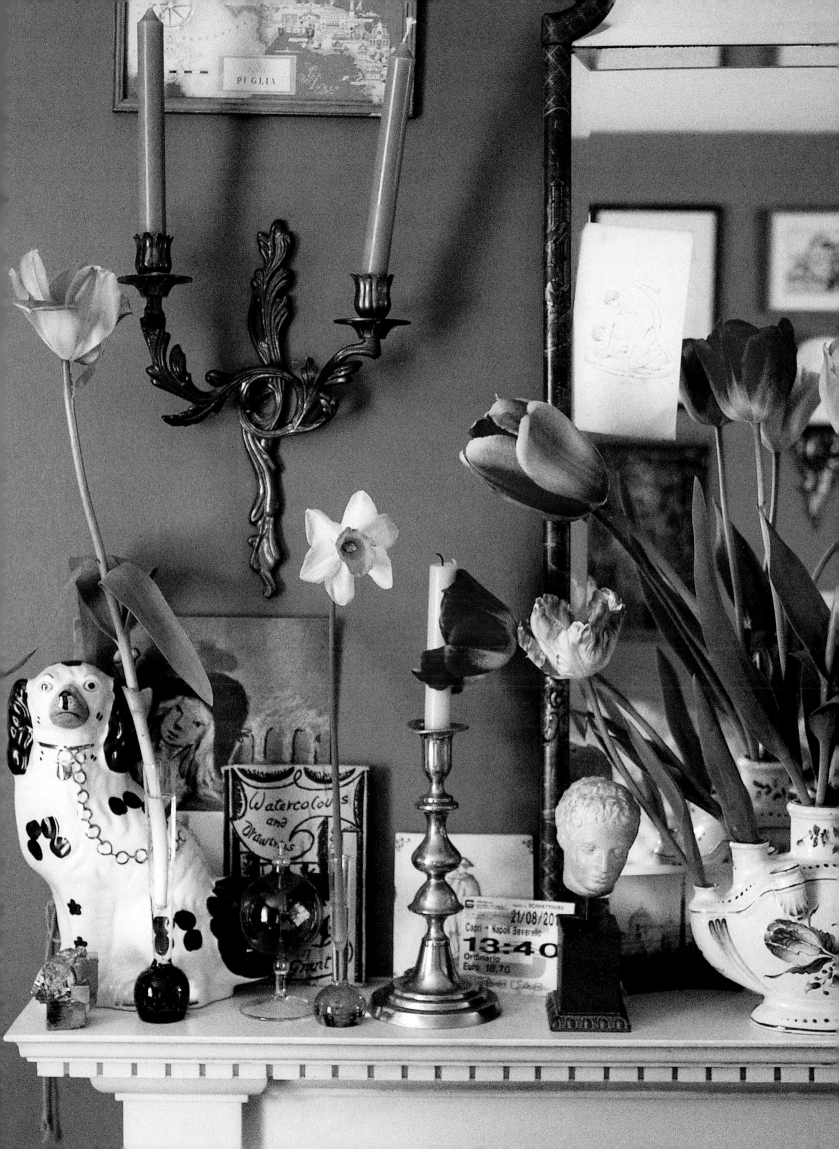

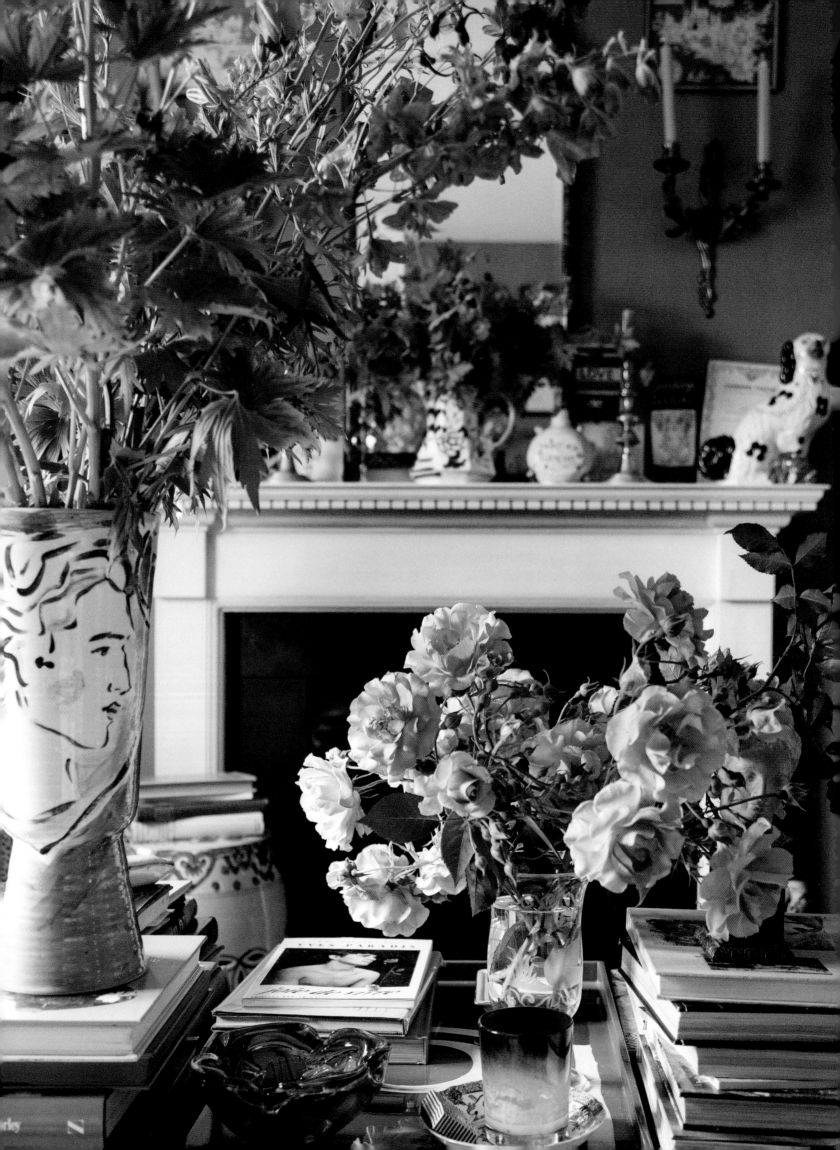

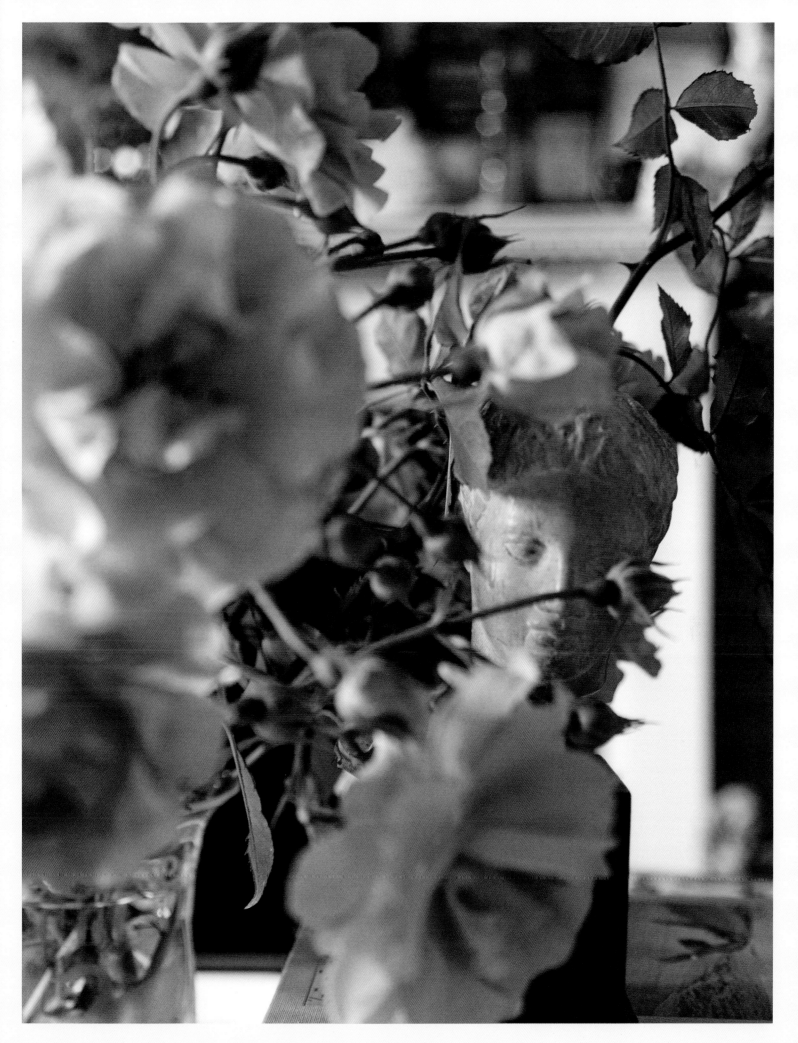

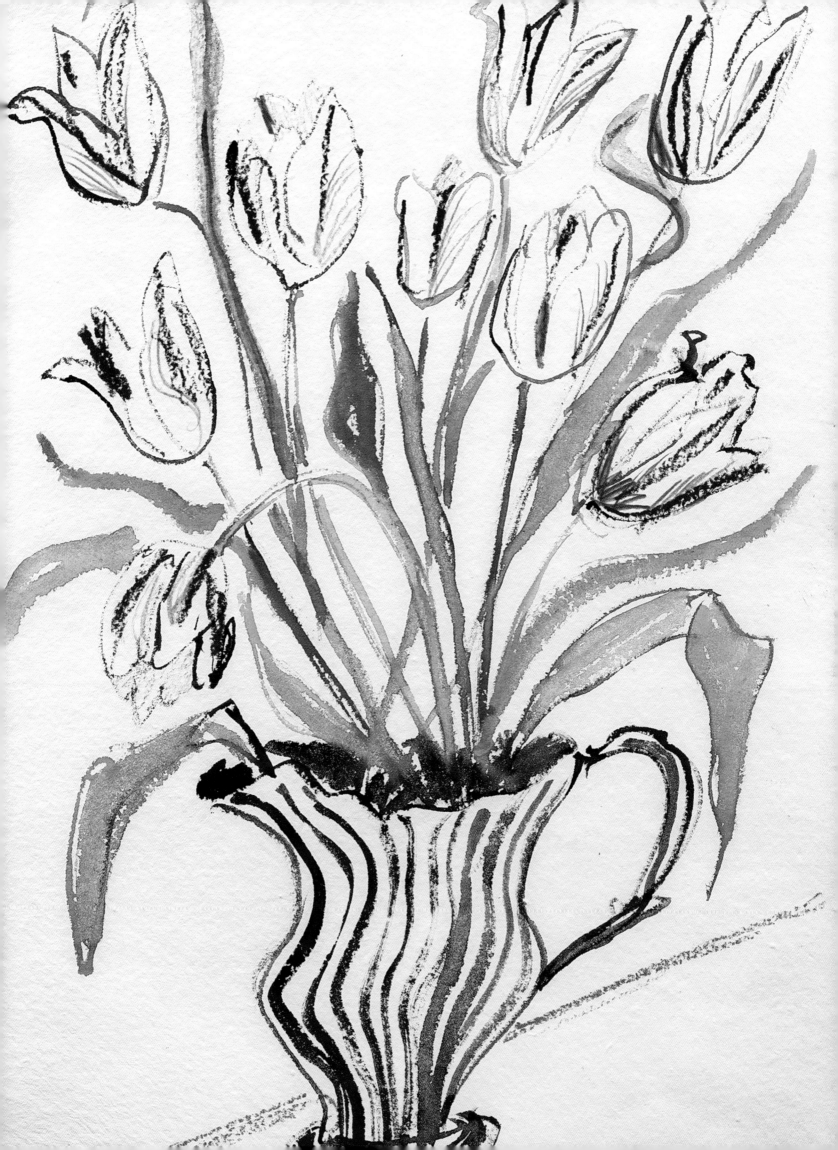

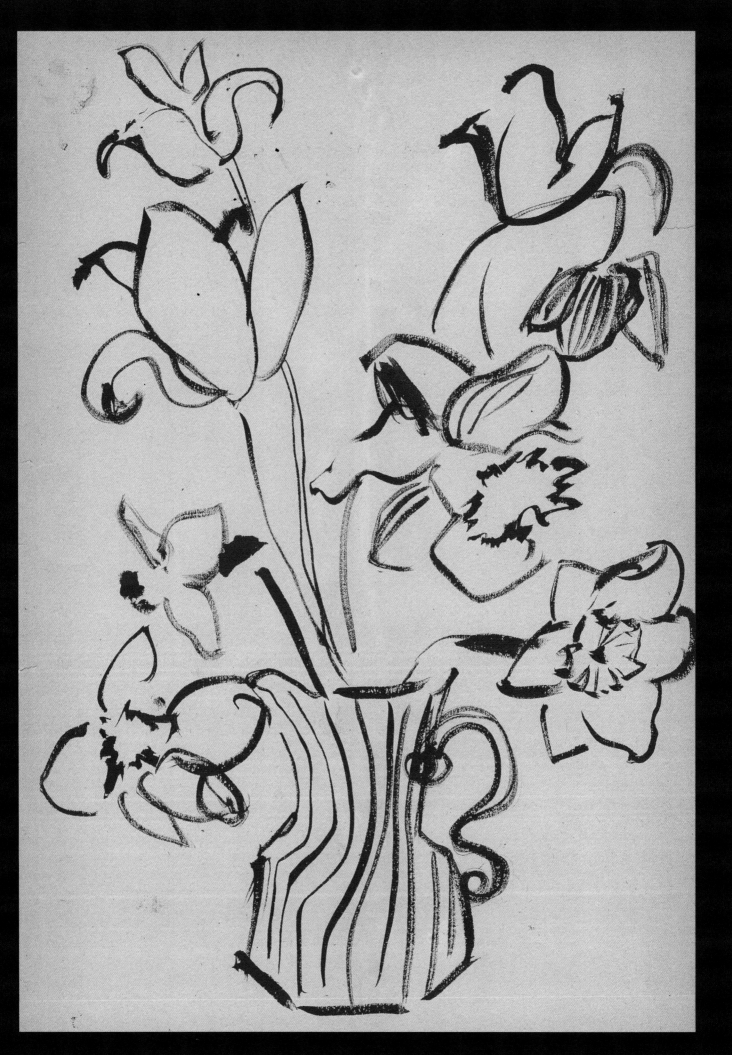

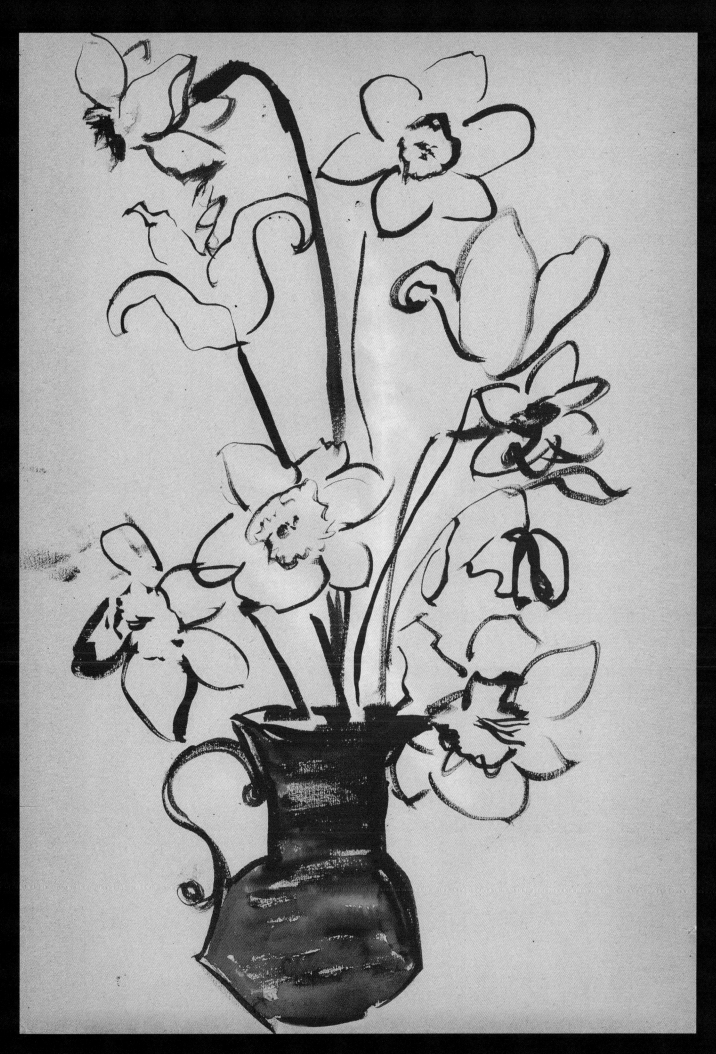

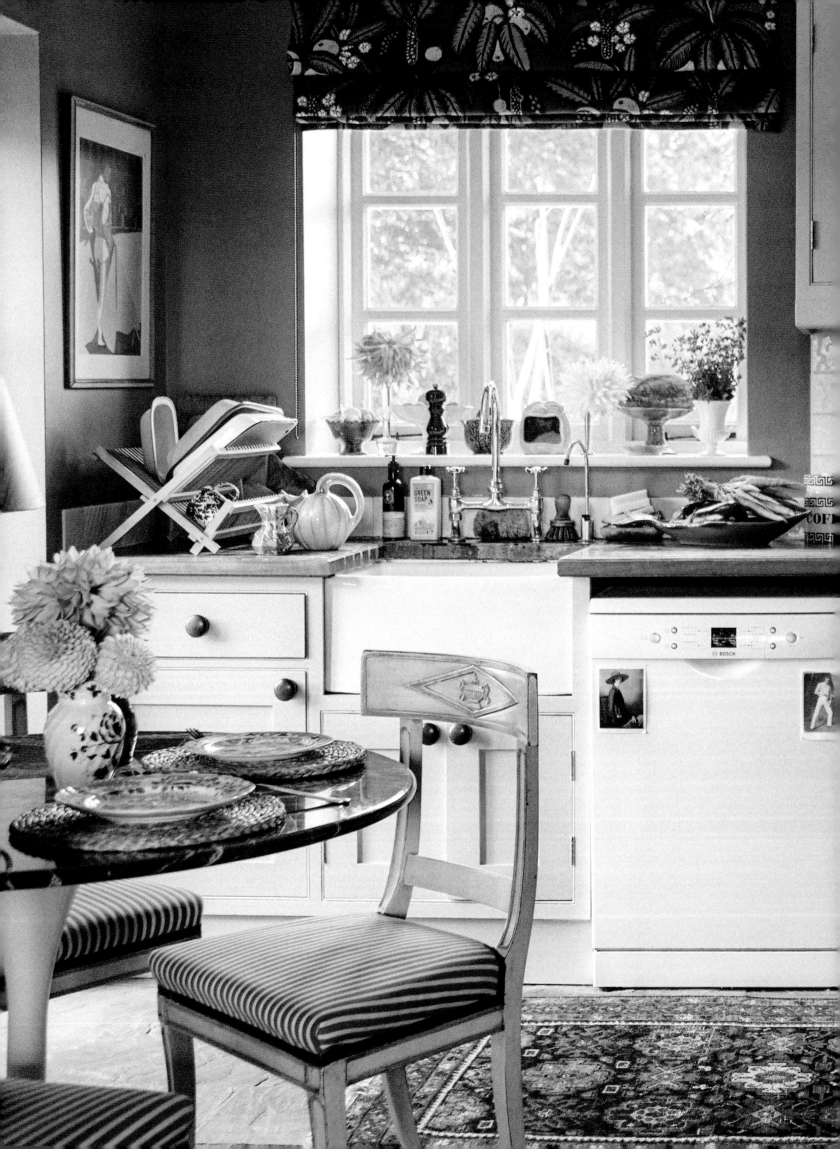

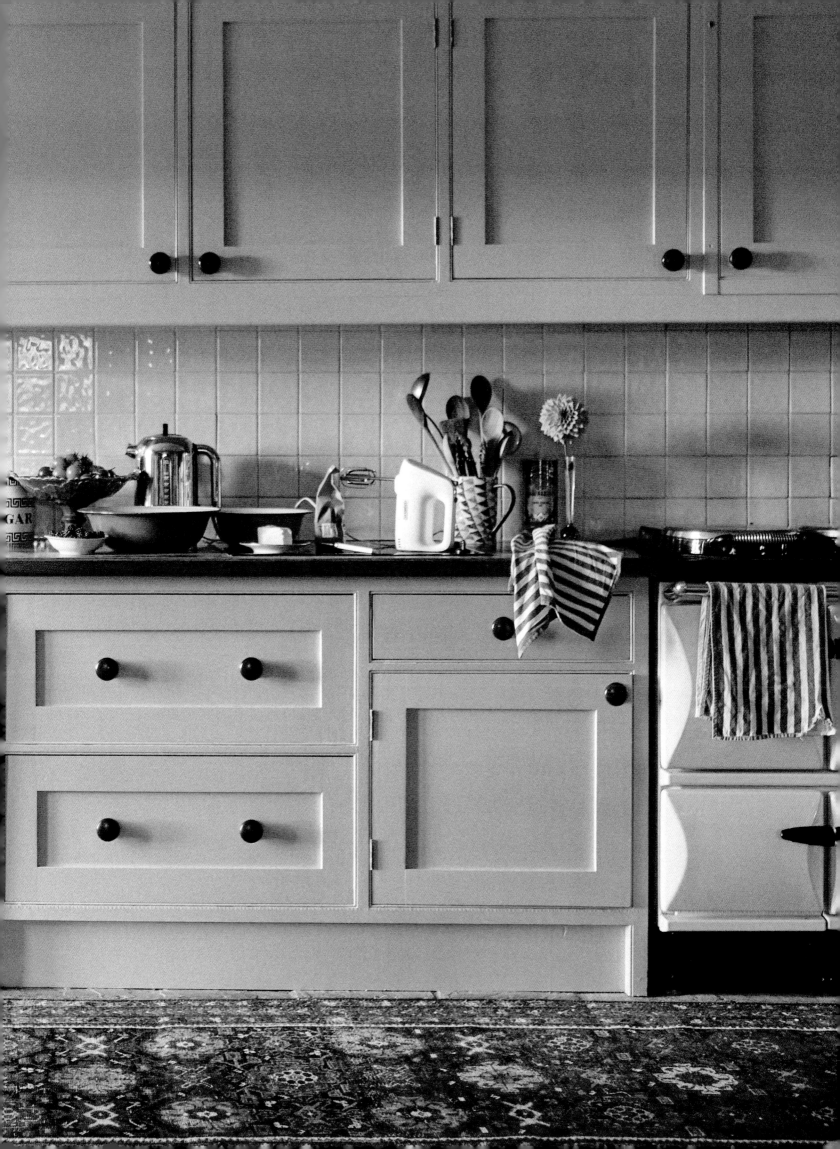

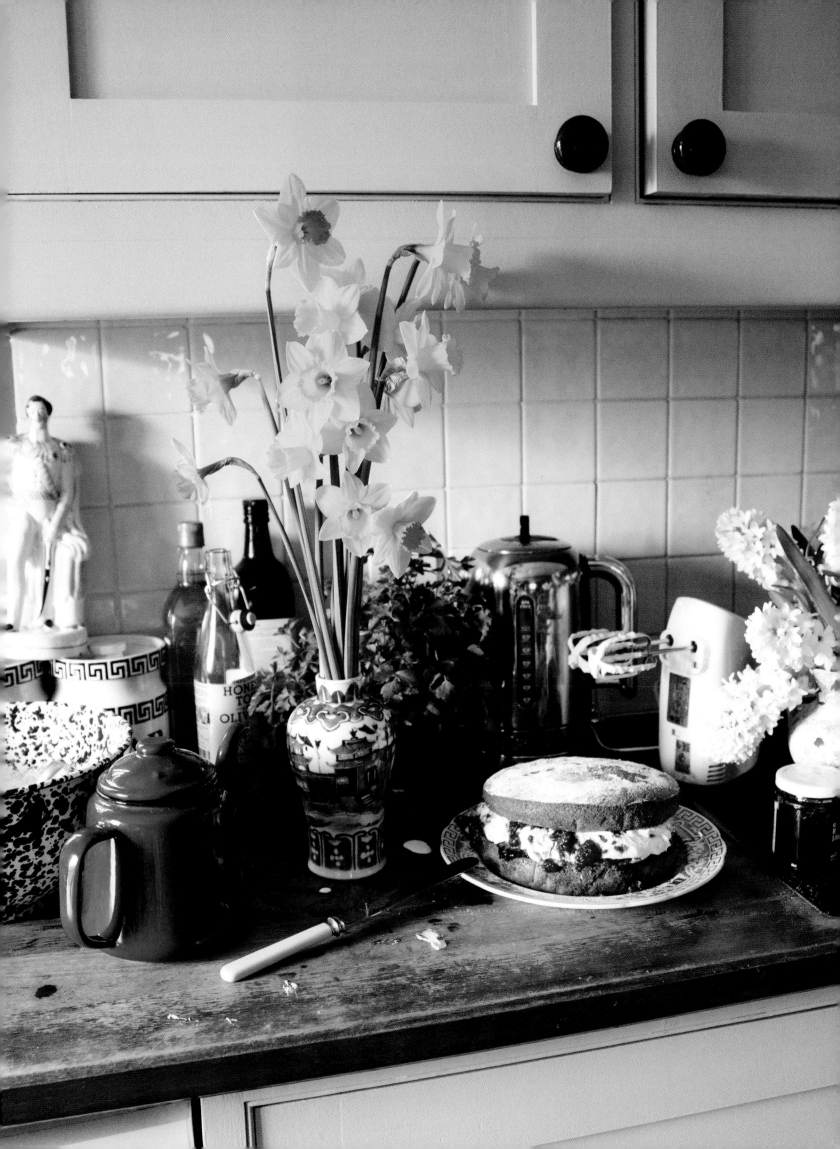

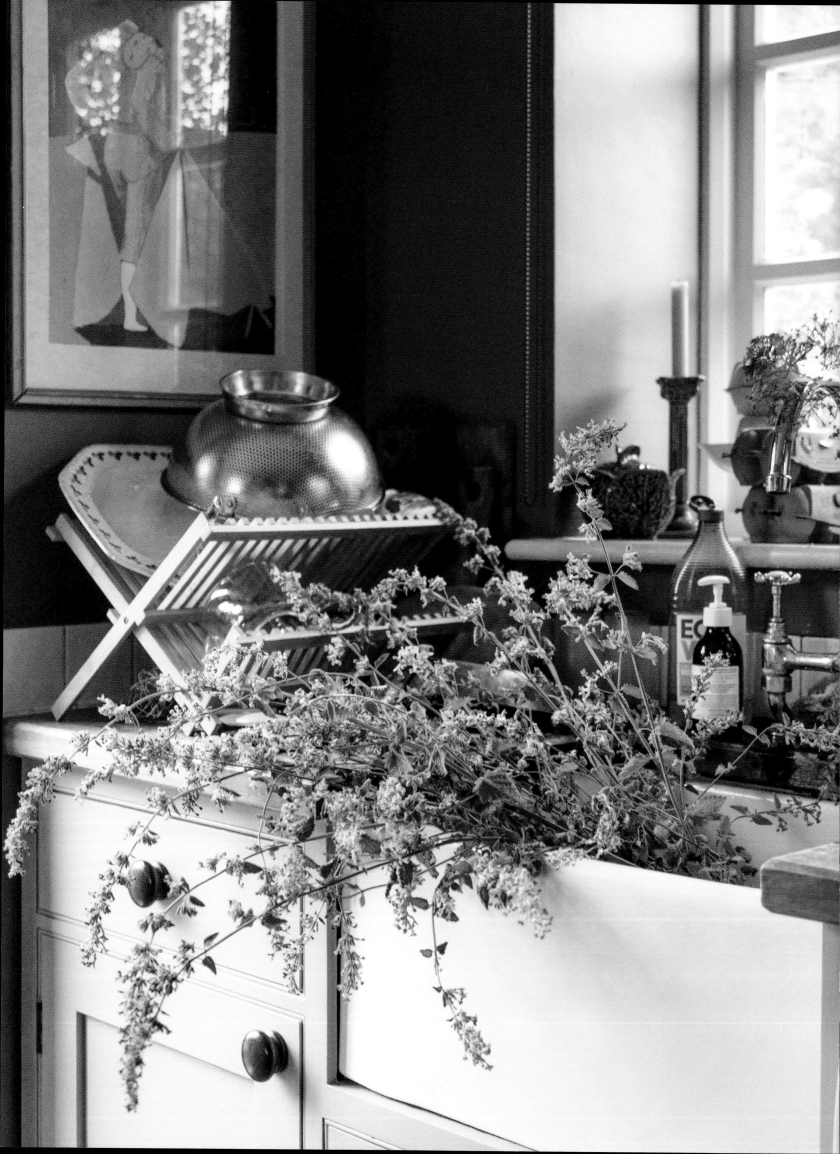

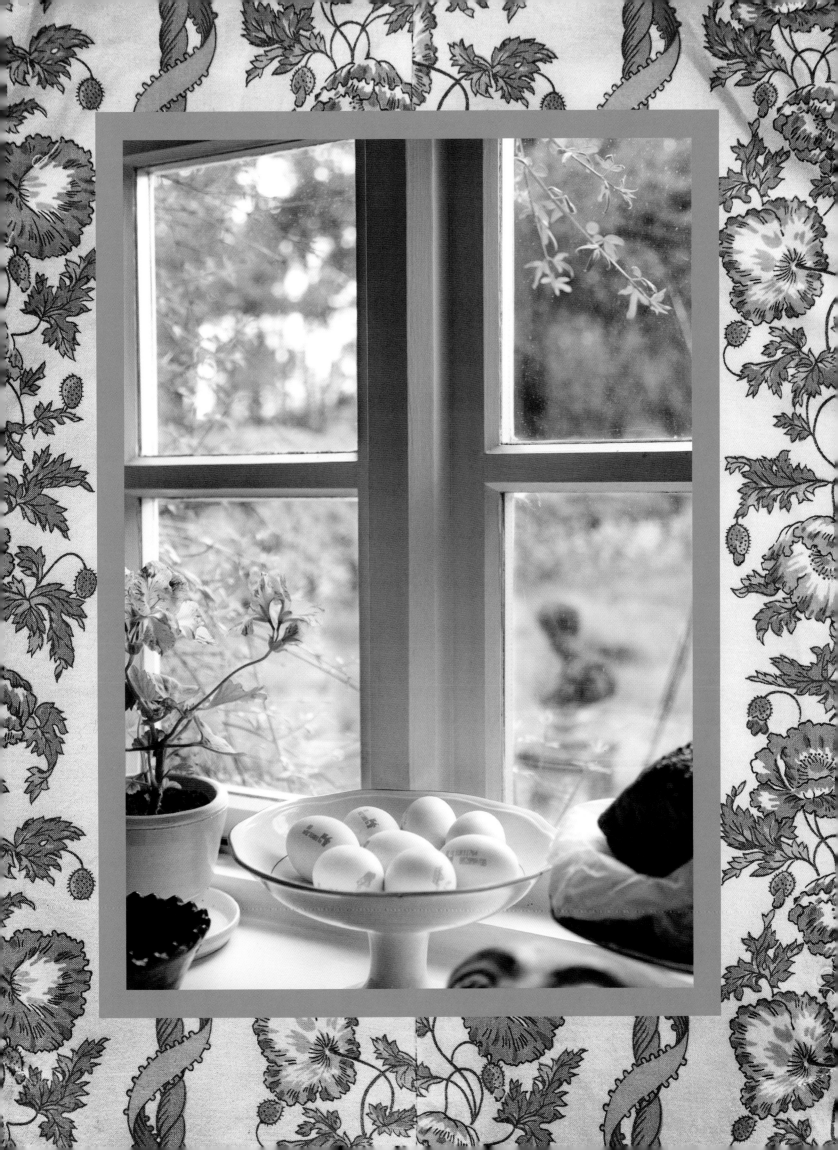

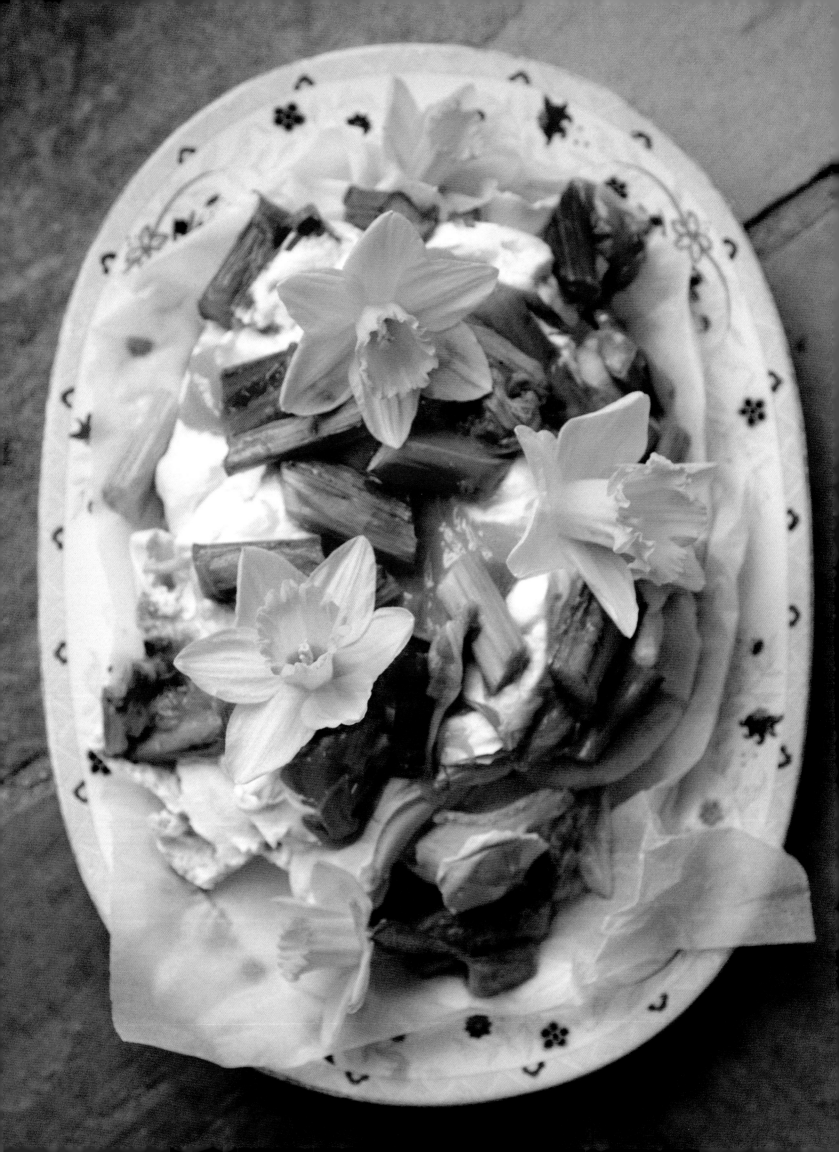

INGREDIENTS

5 sticks forced rhubarb	250g (9oz) caster sugar	400ml (14fl oz) double cream
2 tbsp honey	1 tsp cornflour	1 vanilla pod
5 free range egg whites	1 tsp white wine vinegar	1 jar orange curd & 1 orange

METHOD

✳ *Preheat the oven to 200°C (400°F).* ✳ *Cut the rhubarb into 5 cm (2 in) pieces, place in a roasting tray and drizzle with the honey. Roast for 10 minutes, then allow to cool.* ✳ *Turn the oven down to 100°C (210°F).* ✳ *In a clean, dry bowl, whisk the egg whites to soft, snowy peaks. Gradually whisk in the sugar until the meringue is thick and glossy. Add the cornflour and vinegar and whisk again.* ✳ *Line a baking tray with parchment paper. Spoon on the meringue mixture (if you're me, you'll gobble up whatever is left behind), and form into a rough oval. What you're after here is a glistening imperfect wodge of a Titanic iceberg.* ✳ *Bake for 3 hours until dry and crisp, then turn the oven off and leave the meringue inside to cool. Meanwhile, whip the cream and add the seeds from the vanilla pod.* ✳ *To assemble, place the meringue on your best platter. Mix the vanilla cream with the roasting juices from the rhubarb, then spread it over the meringue.* ✳ *Merrily dollop the orange curd onto the cream, ladle on the rhubarb pieces and grate zest from the orange over the top (save the juice for breakfast).*

RHUBARB PAVLOVA

I love a pavlova. An easy thing to make (it's mostly an ornamental assembly job), yet its simplicity belies its pure grandeur: a showstopper of a pud, if ever there was one, and most definitely the perfect end to a long, languid lunch.

Fruit-wise, I like to use whatever is in season at the time of making. Between January and March, this would be forced rhubarb, which I love for its elegant delicacy and pink colour, ranging from neon to pale rose across a single stem. Predominantly found in the 'Rhubarb Triangle', a small area in West Yorkshire, forced rhubarb is grown in the ground before being placed into darkened forcing sheds. It is harvested by candlelight, because too much bright light can cause bitterness. Can one imagine a more romantic fruit? (Although, technically speaking, rhubarb is a vegetable …)

Once you have prepared the pavlova, before you dive in, take a moment to enjoy the fabulous colour combination you have created: the electric orange of the curd running into the rhubarb's soft pink, set against a chilly backdrop of ivory meringue and pearly, pillowy cream. Finish with flowers, if you like, but make sure they are edible (unlike the daffodils shown here, which were added on a whim for table decoration only and are thoroughly toxic!).

Serve the pavlova in precarious, wobbly wedges, with a little coffee, perhaps – or, better still, Frangelico, that deliciously moreish hazelnut liqueur, pale gold in colour and made in the Piedmont region of northern Italy. I find that a thimble or five per guest usually does the job.

This recipe was inspired by the chef and food writer Gill Meller. Other favourite pavlova combinations include cherries with flaked almonds and chocolate meringue with raspberries.

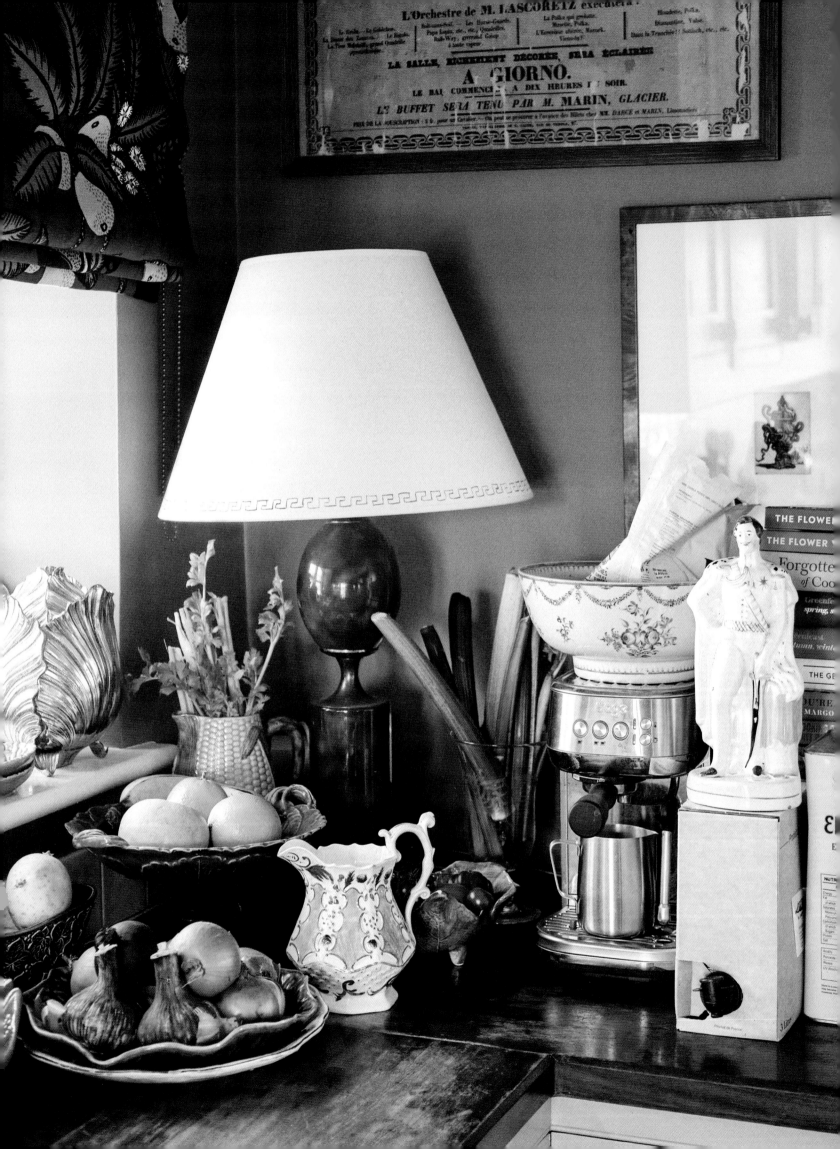

L'Orchestre de M. LASCORETZ exécutera
LA SALLE, RICHEMENT DÉCORÉE, SERA ÉCLAIRÉE
A GIORNO.
LE BAL COMMENCERA A DIX HEURES DU SOIR.
LE BUFFET SERA TENU PAR M. MARIN, GLACIER.

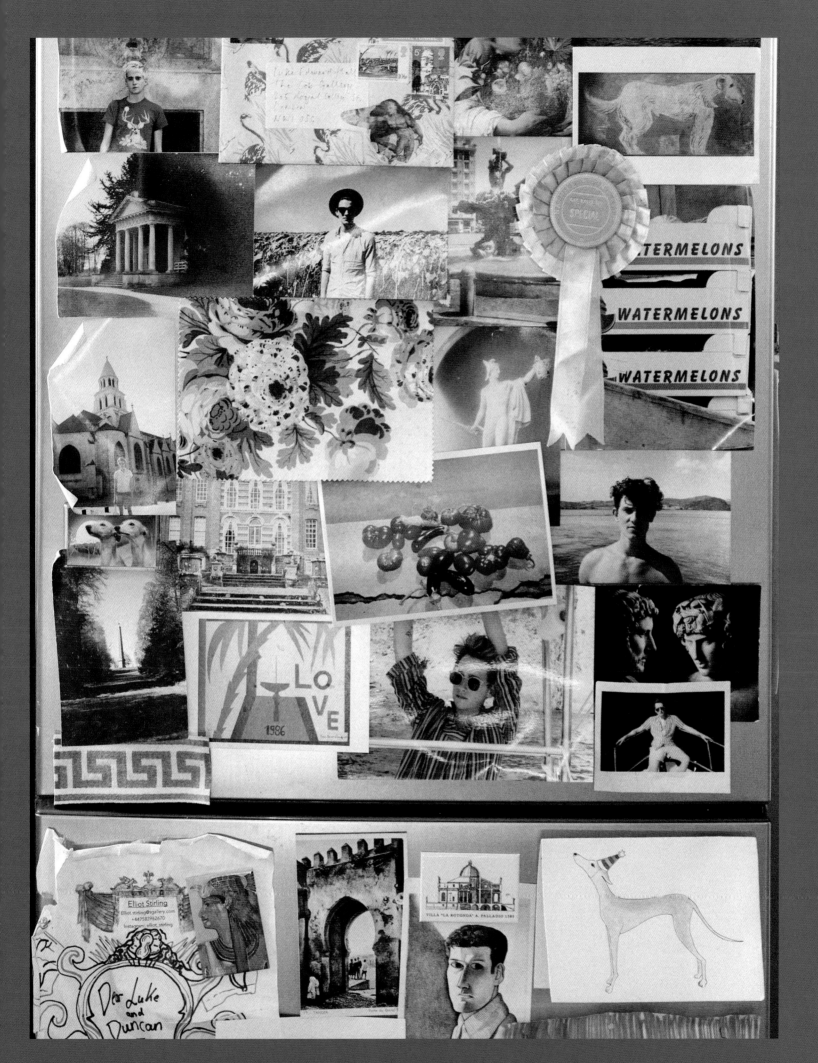

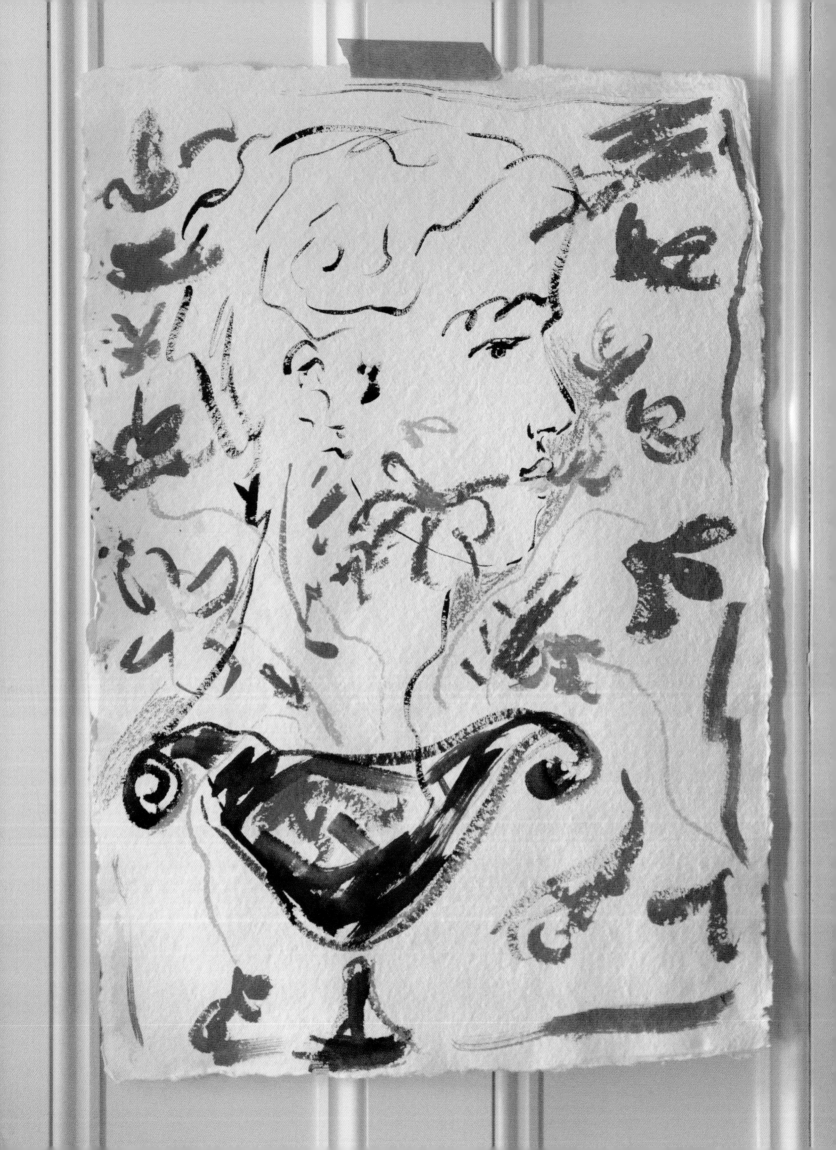

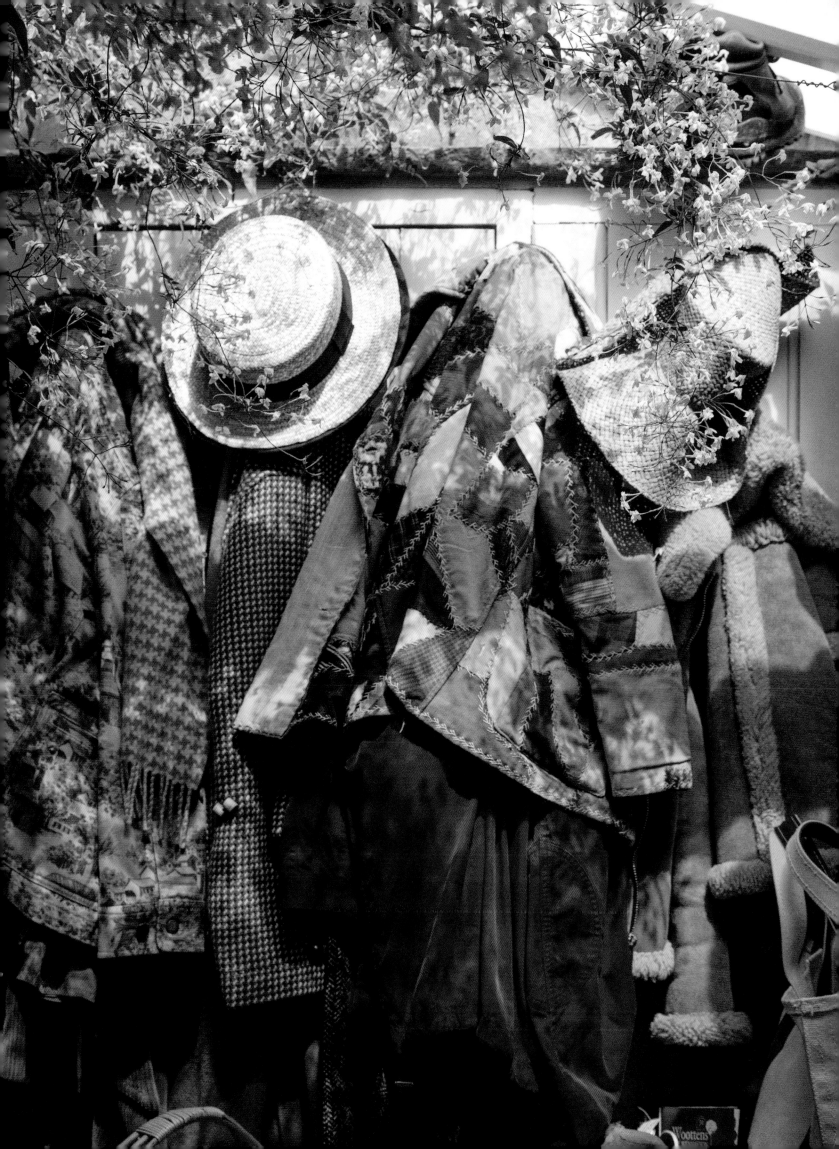

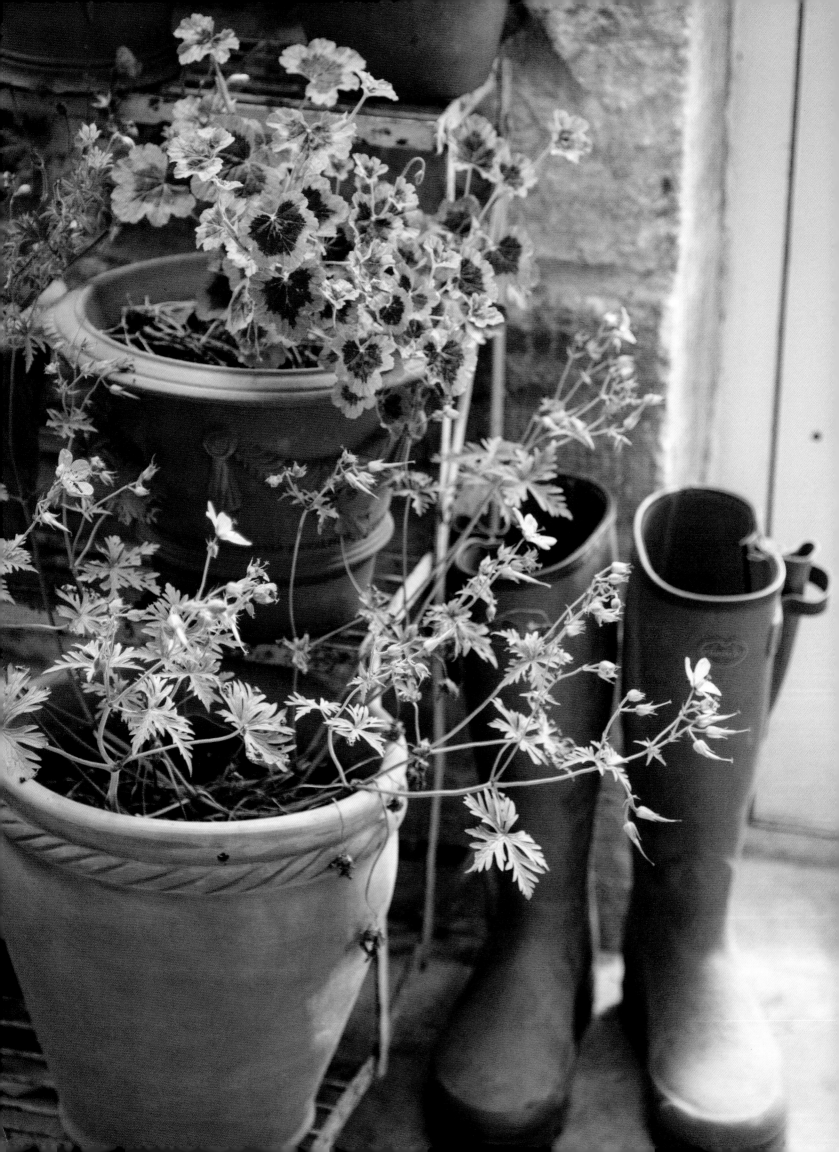

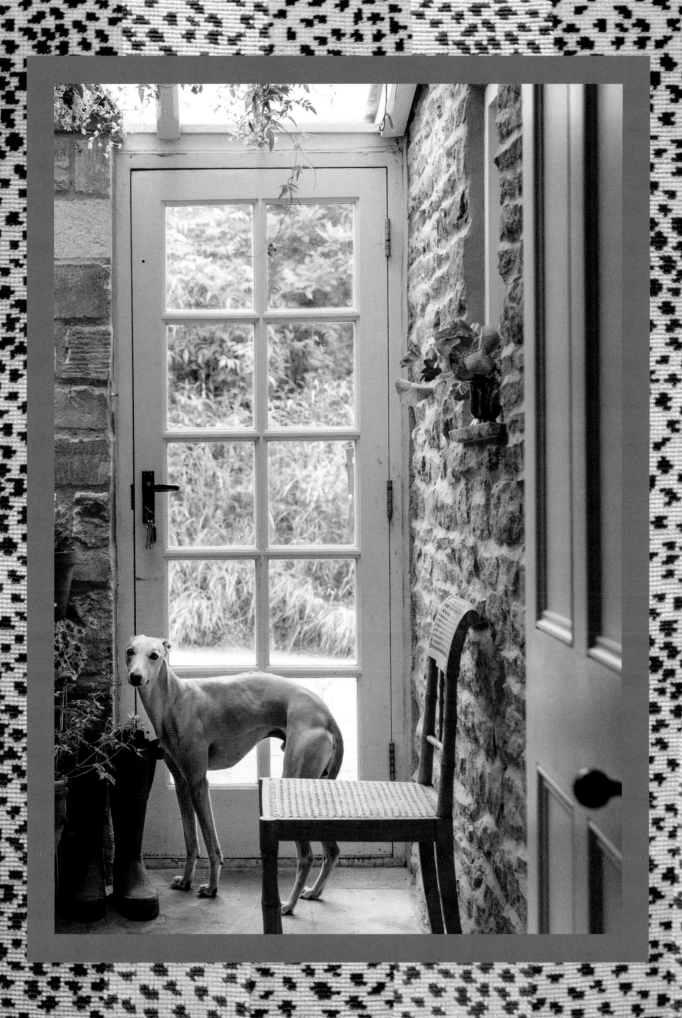

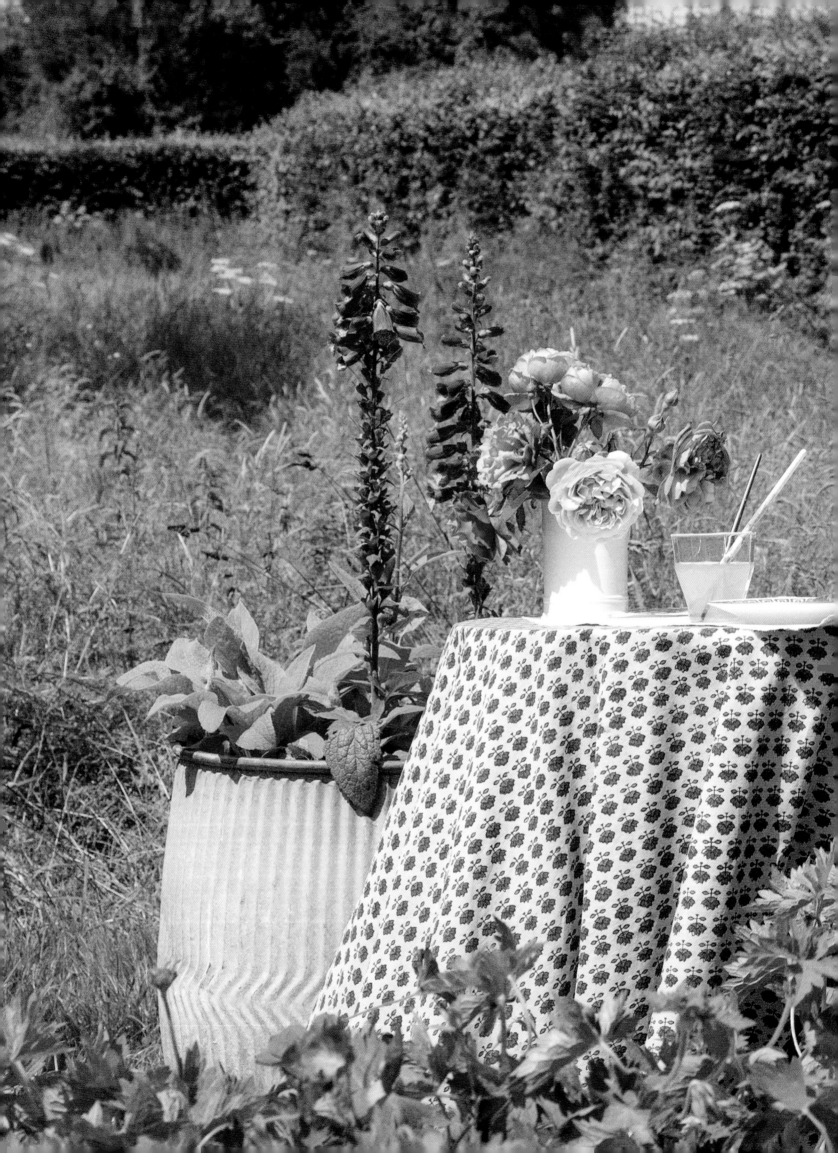

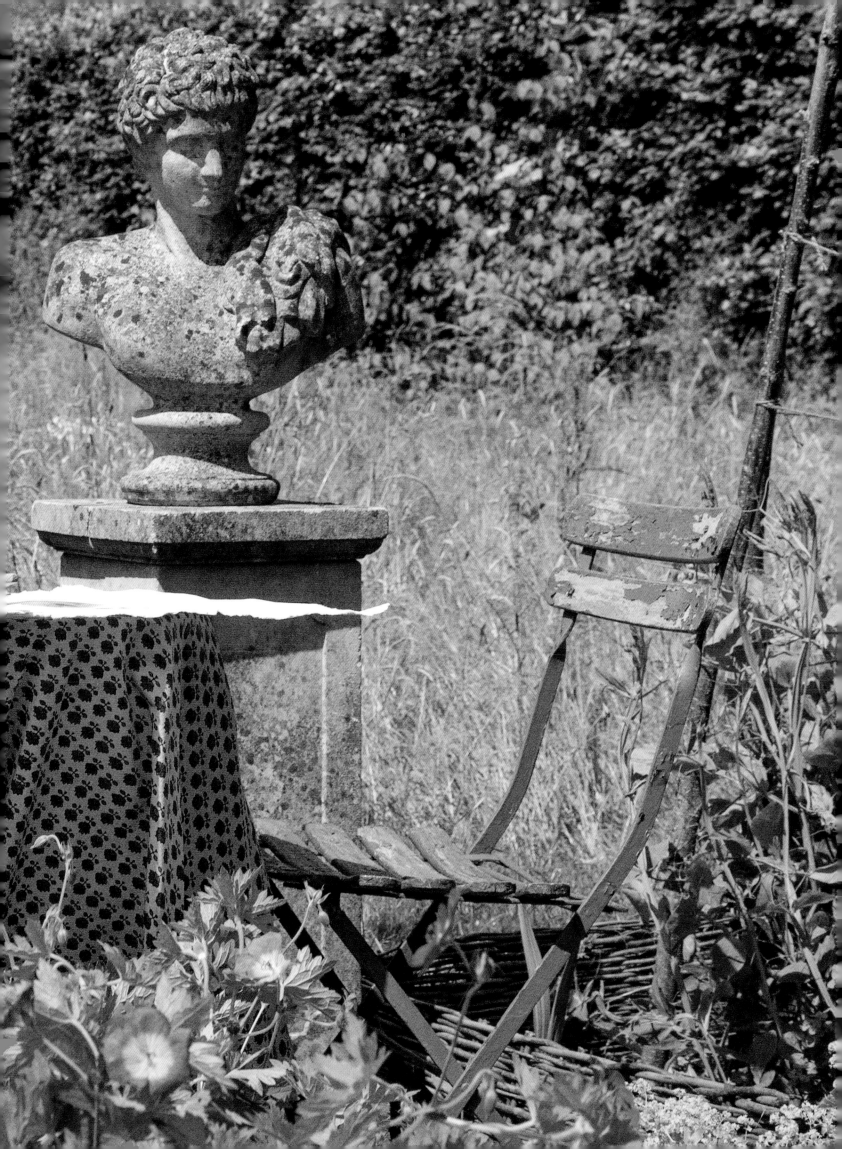

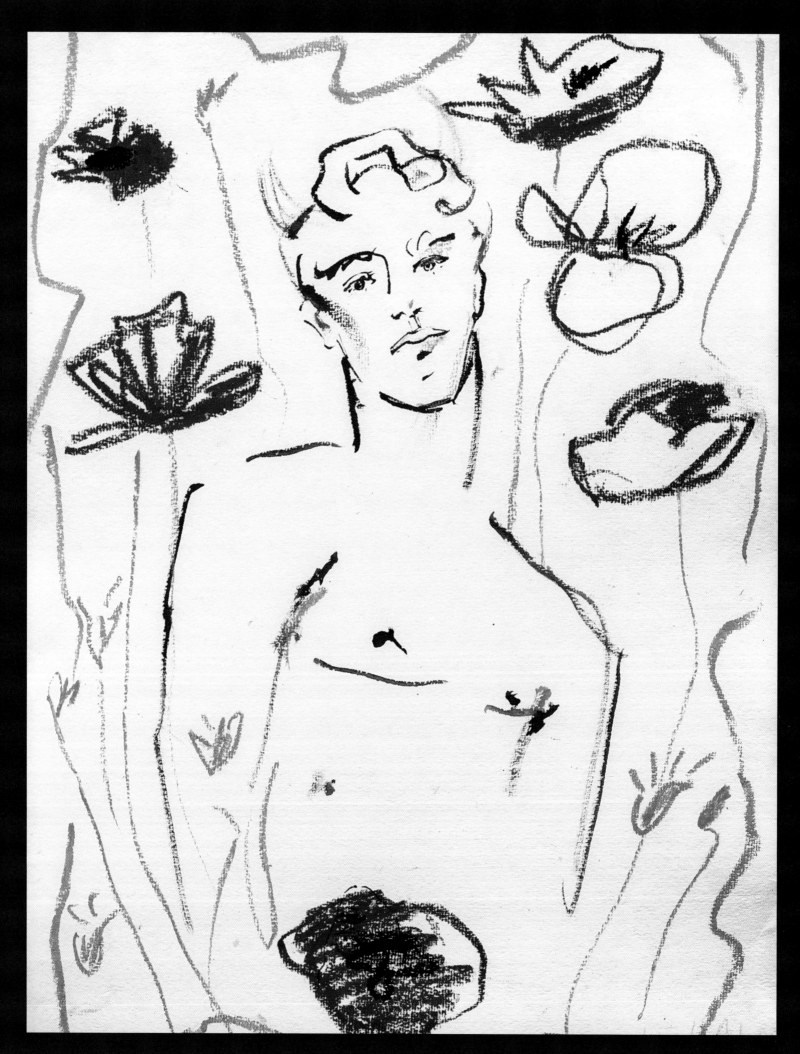

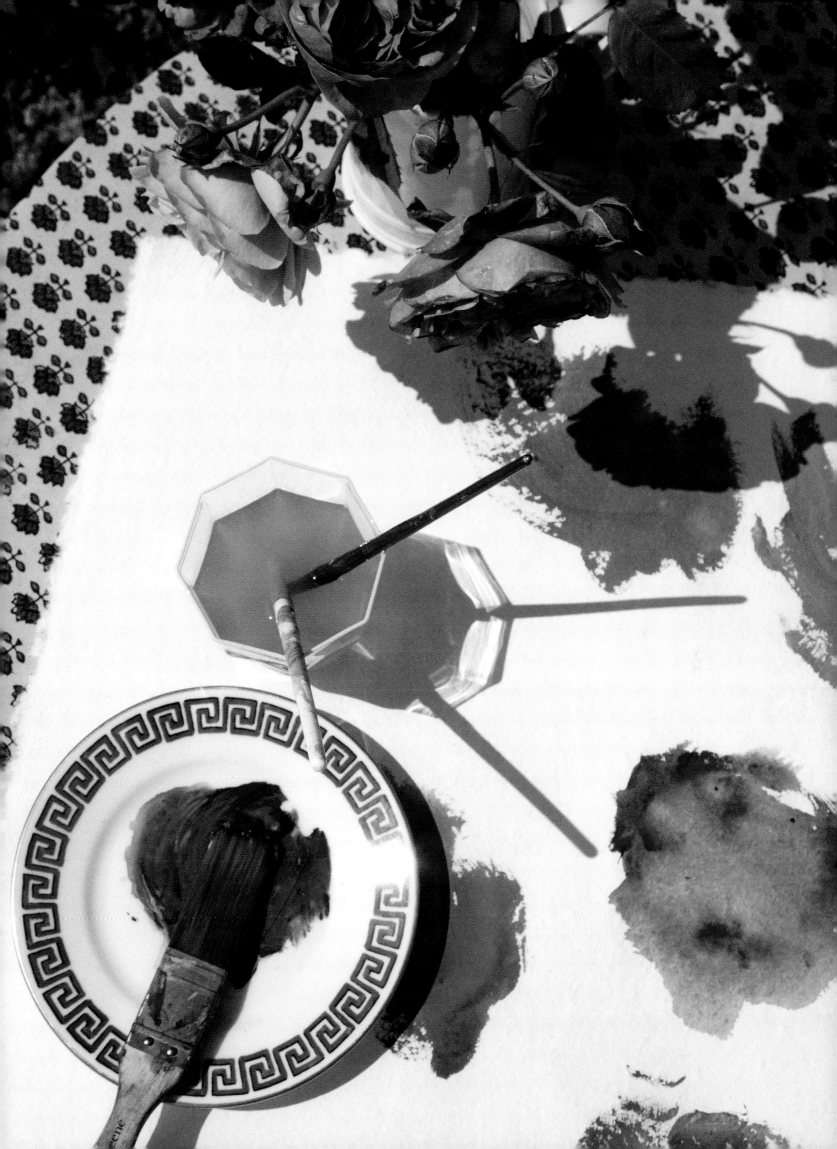

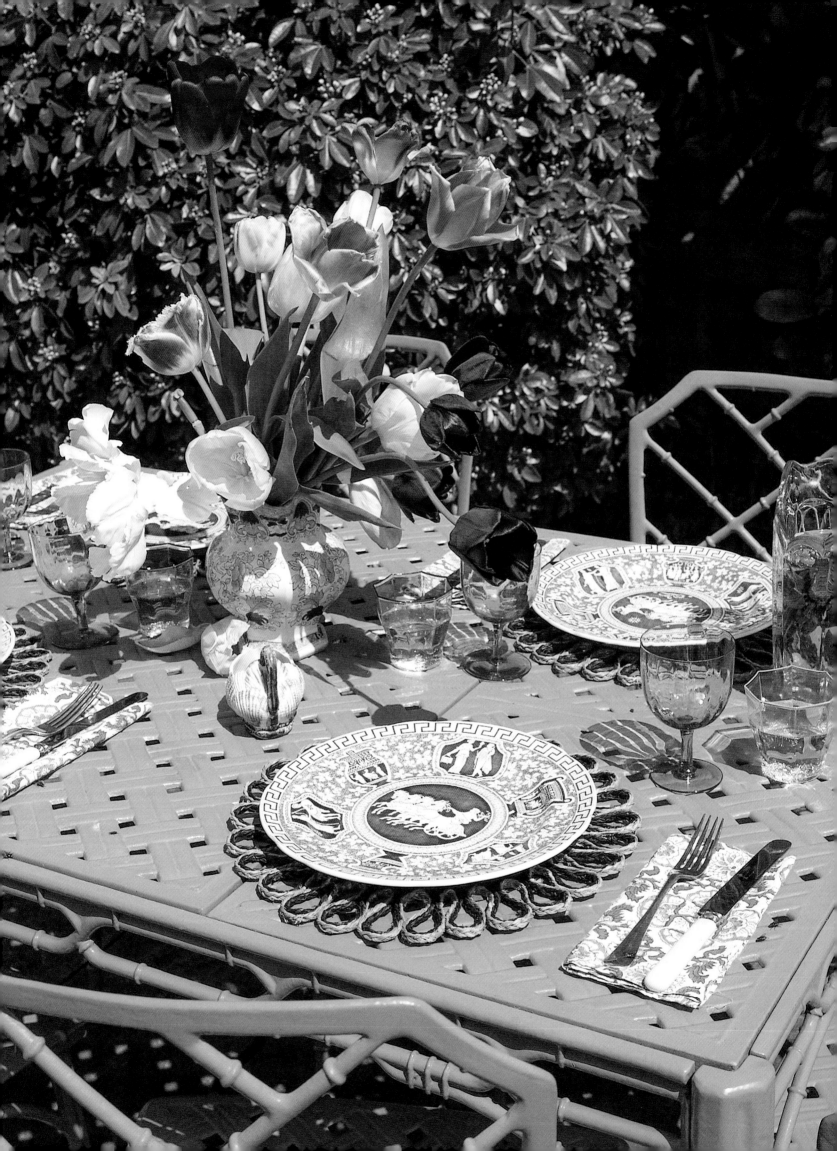

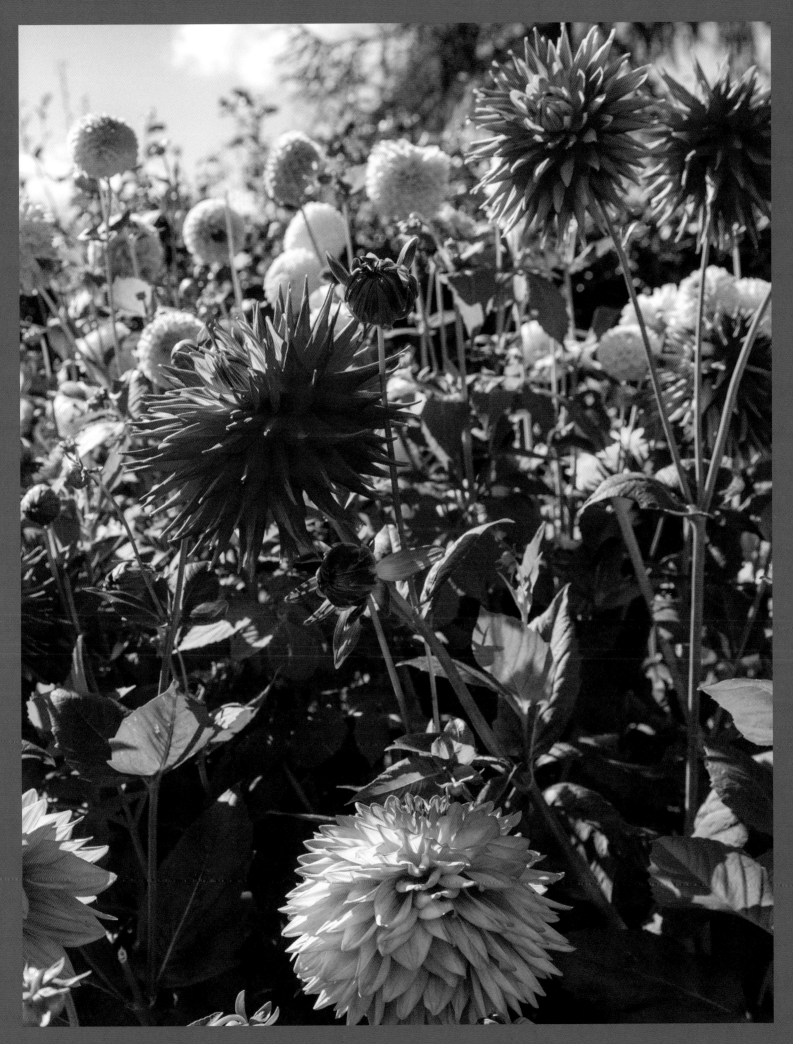

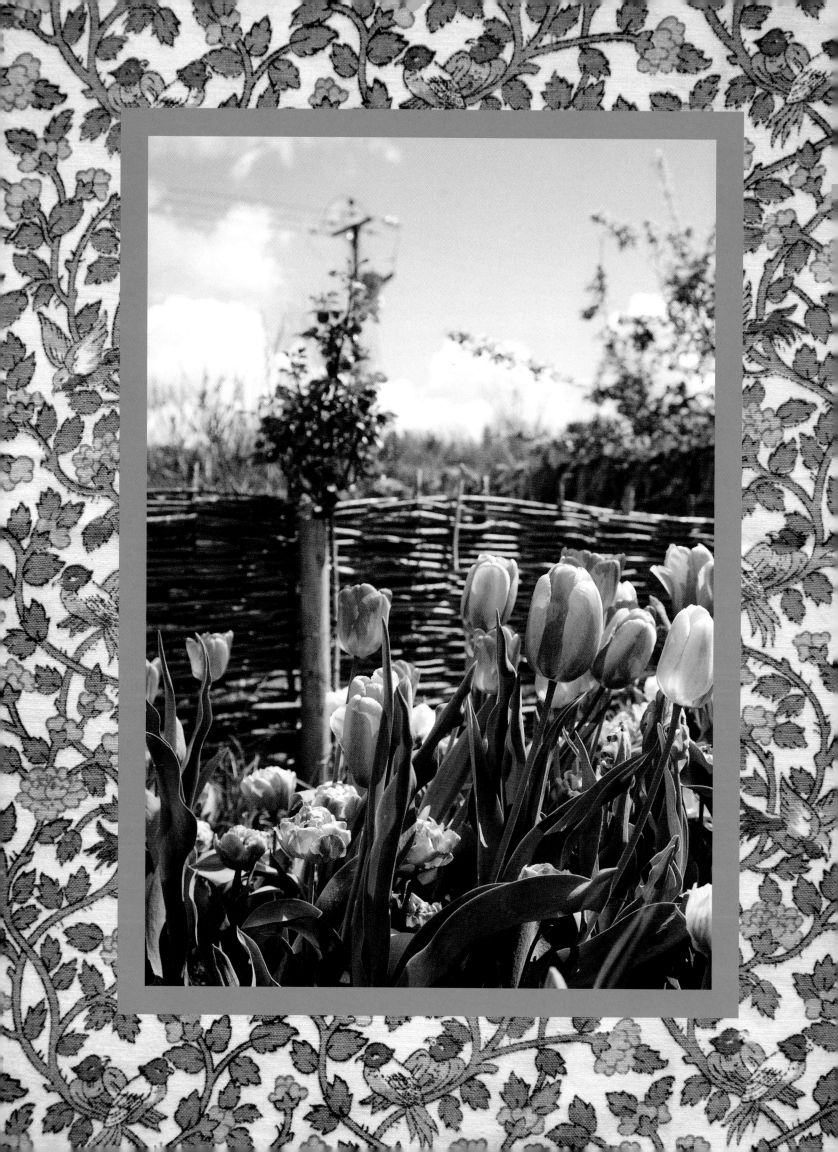

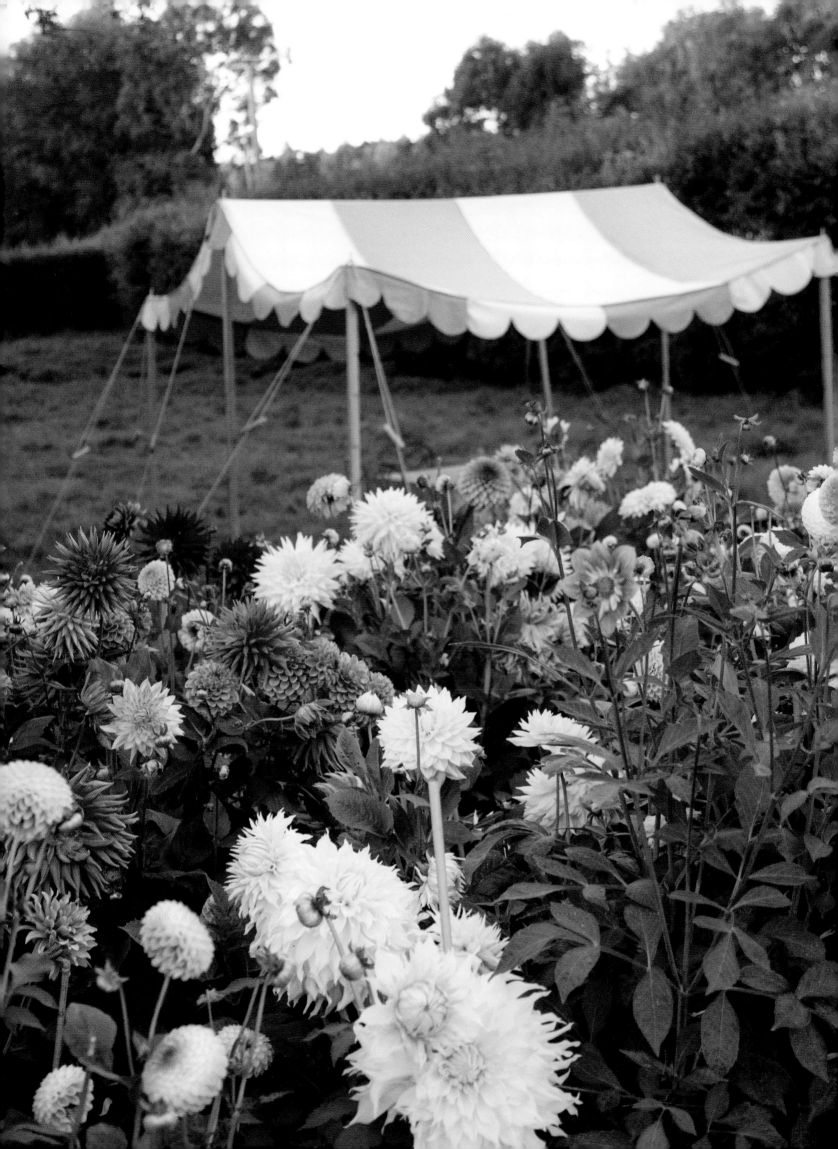

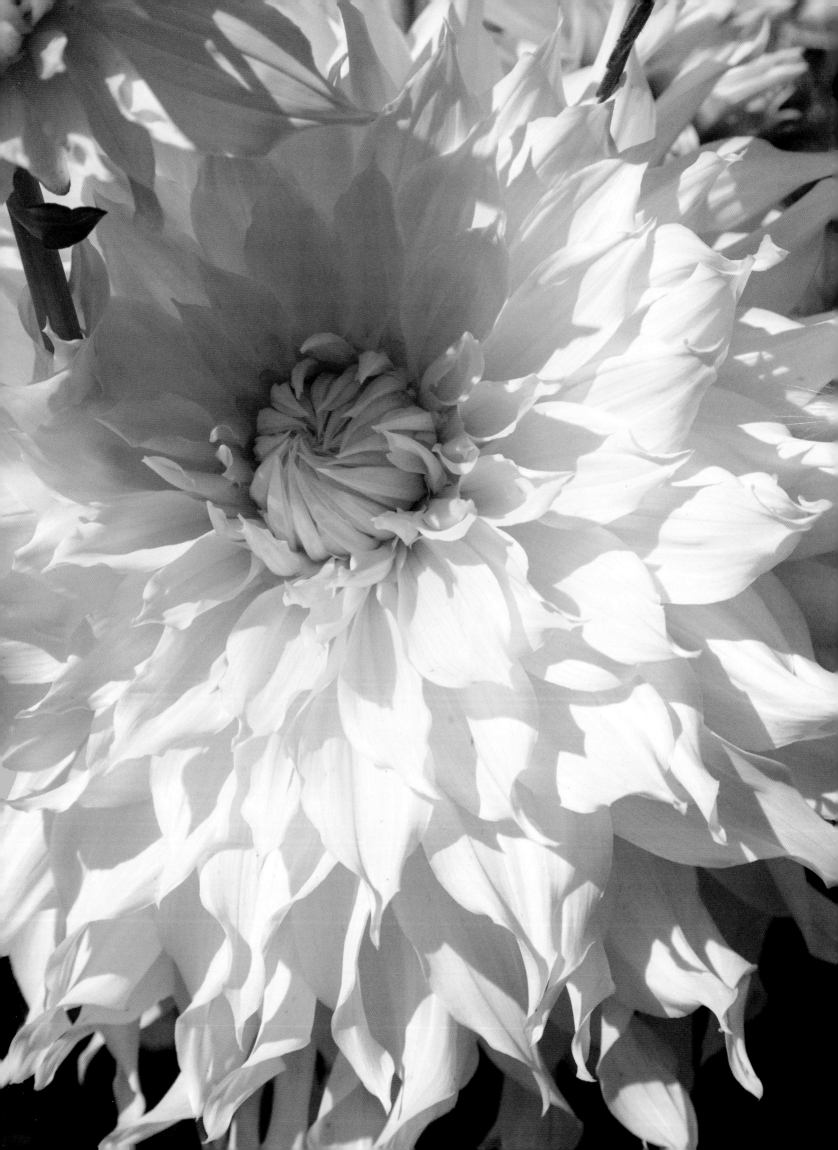

Our London garden is just a collection of weather-battered pot plants huddled together on a balcony the size of a postage stamp. Occasionally we give this patch some attention in the spring, but it has never been a showstopper. We instantly loved our new garden when we first arrived in the Cotswolds: its view over green fields, the old stone walls, the high beech hedges. Yet we inherited only grass and paving slabs, and our joint experience amounted to keeping alive the odd geranium or sunflower on that London balcony.

We pored over books and threw ourselves into making our first proper garden with enthusiasm and a great deal of help from friends, who advised on where to site our vegetable garden, what our borders could look like, and when to plant our first bulbs. A cottage garden was the idyll we hoped for: foxgloves and delphiniums, lavender and peonies, and plenty of roses.

I think of the wheel of the garden year and there are too many precious moments to highlight. In the autumn the tulip bulbs arrive, and we spend a couple of days digging trenches and tucking them into the earth, safe in the knowledge that in a few short months we'll be gathering armfuls of blooms in colours as brilliant as the finest Italian ice creams. Waking up to frosty fields in November, savouring a cup of coffee in my dressing gown on the steps by the back door, pheasant neighbours diving in and out of hedges. Spring, of course, the best time of all: the garden comes to life in a blaze of colour and there is cow parsley everywhere, frothy and delicate. Snipping roses the colour of freshly churned West Country butter and arranging them in a favourite bashed silver beaker. Summer sweet peas – my most-loved scent in the garden – and nasturtiums with flowers the colour of marmalade. Picking the first peas and eating them straight from the pod. Our delight at the courgette flowers, so easy to grow yet rare as hen's teeth in the shops; we'll stuff them with ricotta and anchovies and deep-fry them, pretending we're in Amalfi. Dahlias in September, all complex geometry and blooms in acid yellow and shocking Schiaparelli pink.

in the GARDEN

In all truthfulness, I don't really know what I'm doing. Duncan has taken to the garden in a wonderful and very practical way, and knows about mulching and other mystical activities. We're both learning constantly. I sometimes wish that I had more time to work on it all, but we do what we can and enjoy it as much as we are able. The garden grounds and soothes us. I can never quite get over how much joy growing flowers gives us, and that's the thing, too: every year we get to start afresh. It's never sad when tulip time is over, because I know that next year we'll grow even more varieties, in better colours. The wheel never stops.

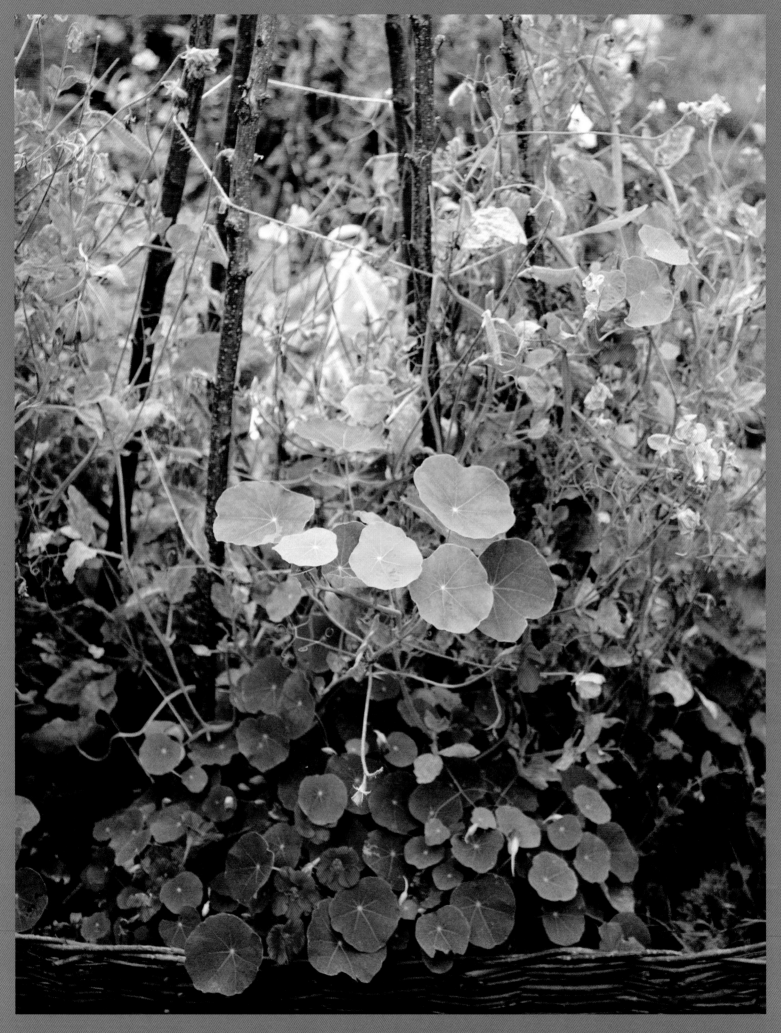

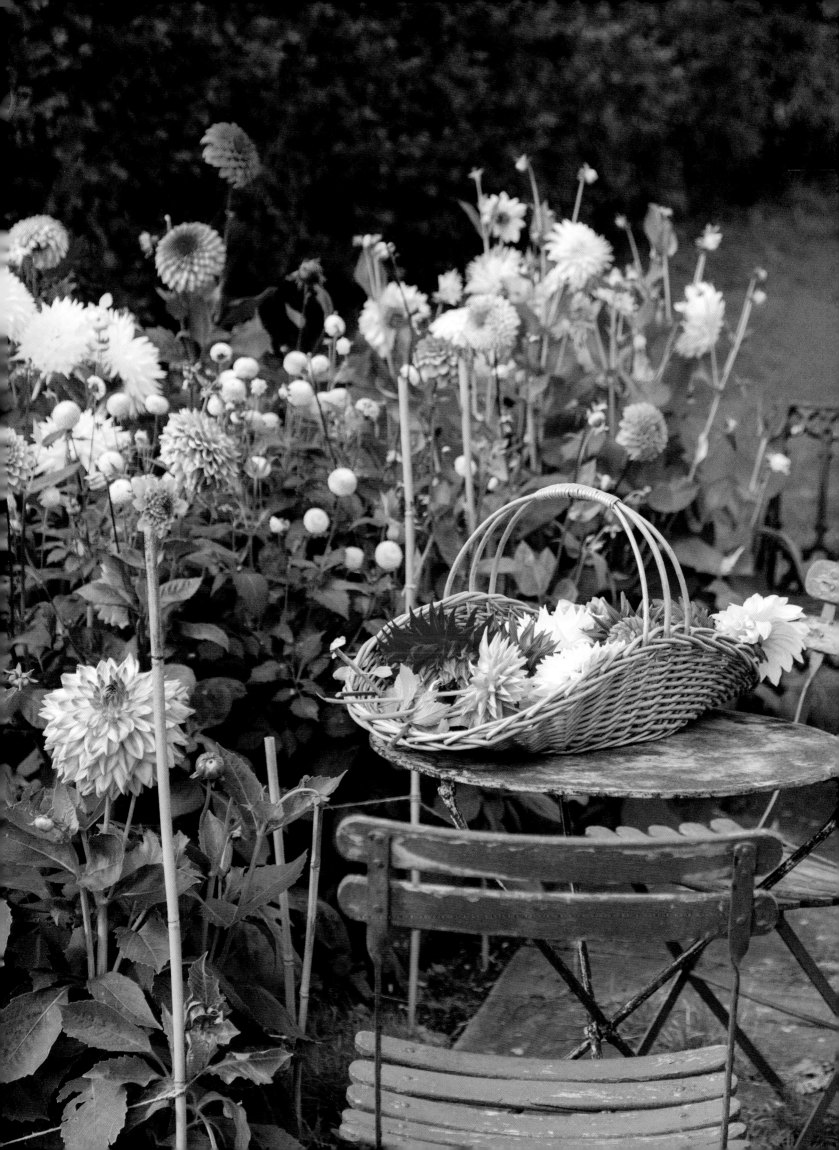

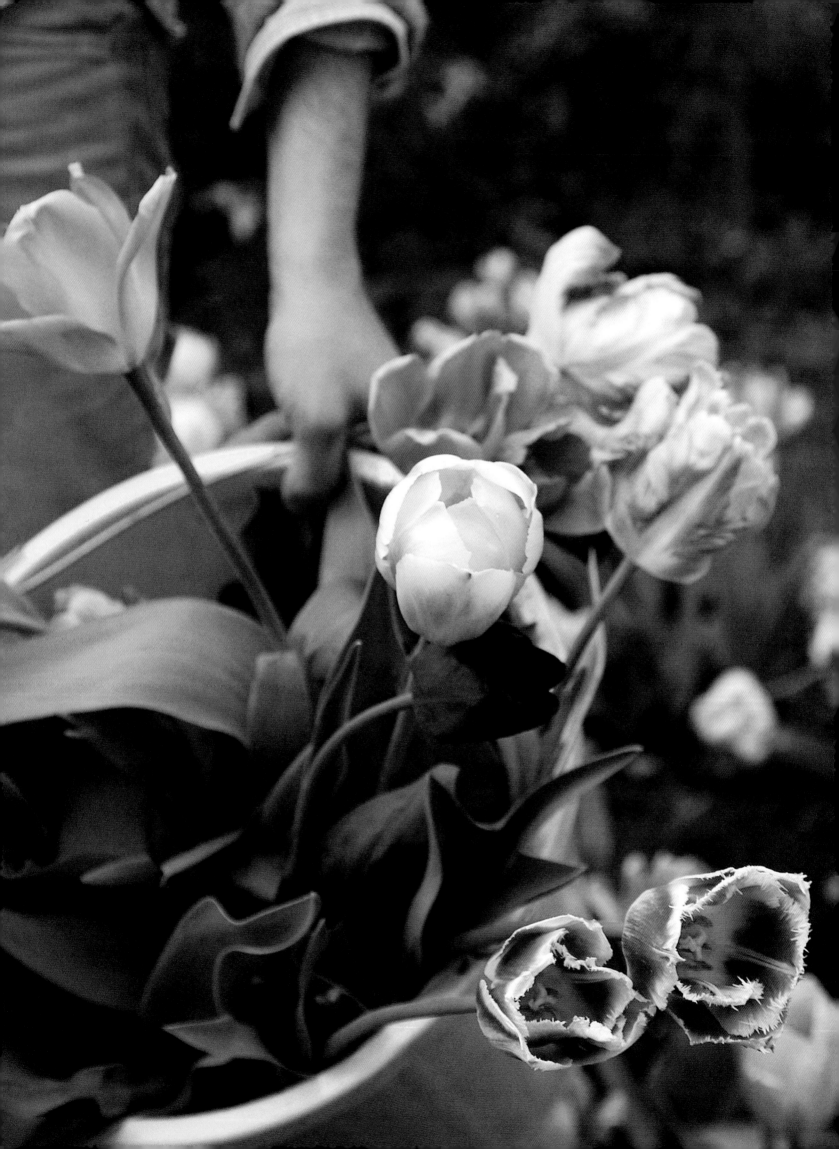

THE ENGLISH FLOWER GARDEN
THE ROSE & SWEET PEA

J.O.BAKER
F.R.H.S.

NAN FAIRBROTHER

MEN AND GARDENS

BY THE AUTHOR OF *AN ENGLISH YEAR*

A RARE AND ENCHANTING BOOK THAT CELEBRATES THE
ENDURING PLACE OF GARDENS IN MAN'S LIFE
AND TRACES THEIR CHANGING FORMS
AND USES IN DIFFERENT LANDS
AND DIFFERENT AGES

NEW YORK · ALFRED A. KNOPF · PUBLISHER

Some Flowers.

by
V. Sackville-West.

V. SACKVILLE-WEST

The Garden

SIR GEORGE SITWELL

ON THE MAKING OF GARDENS

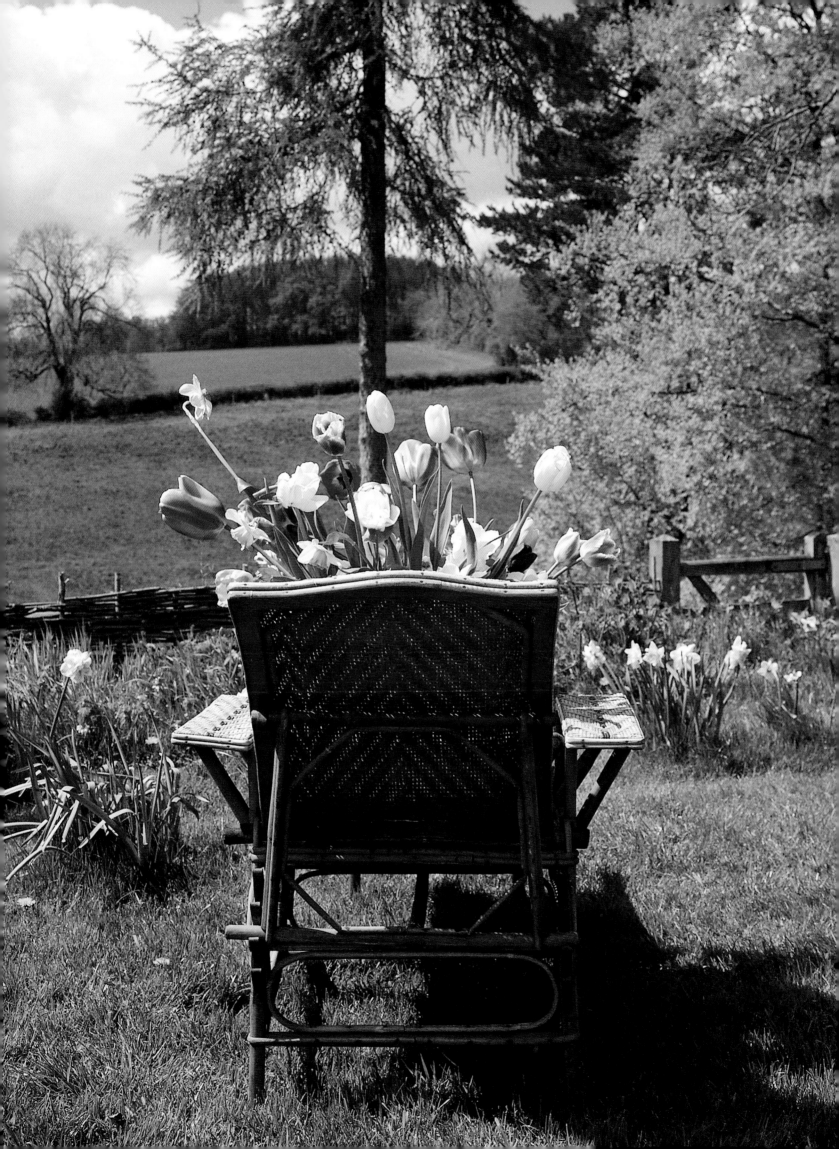

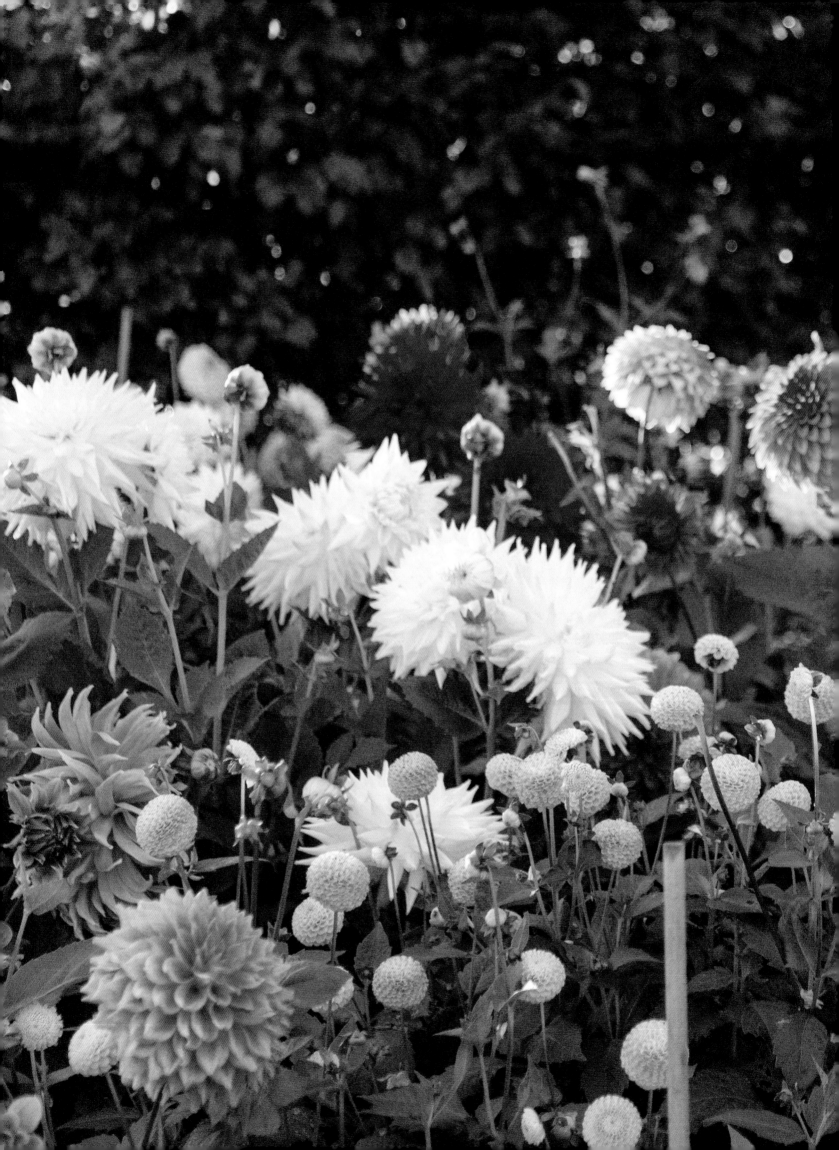

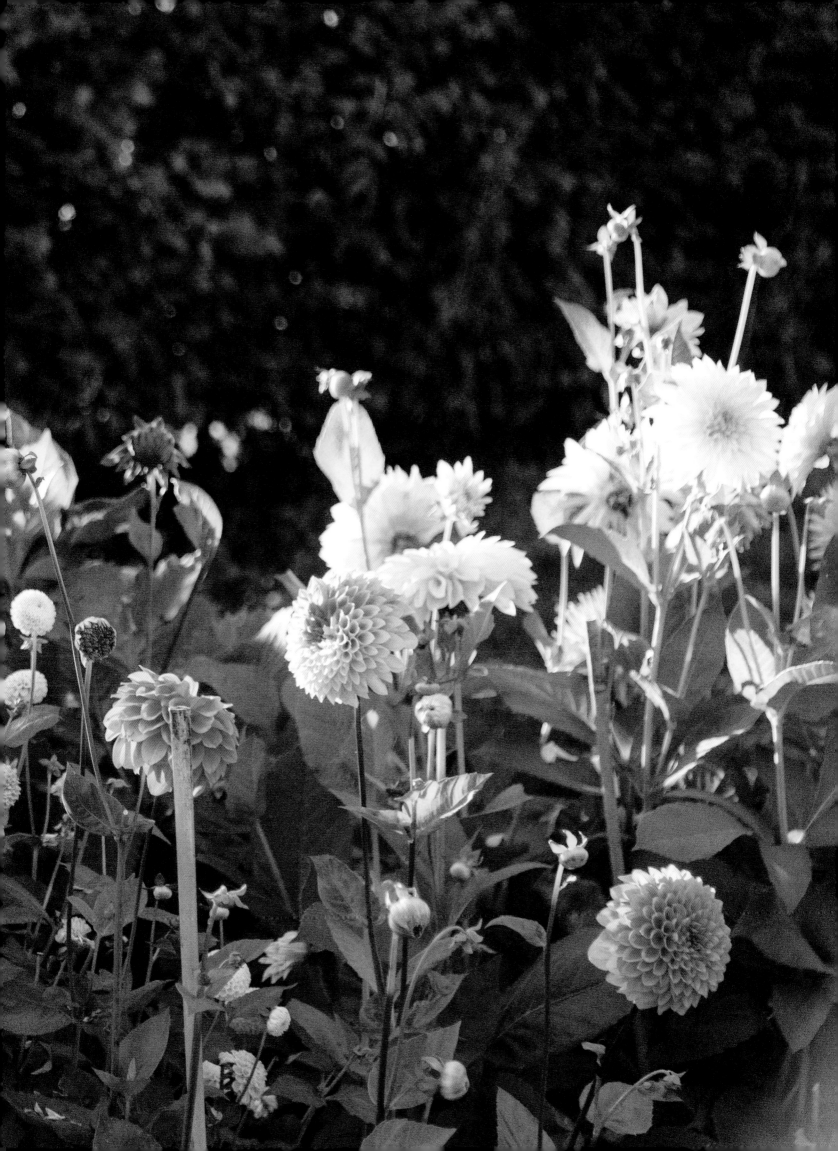

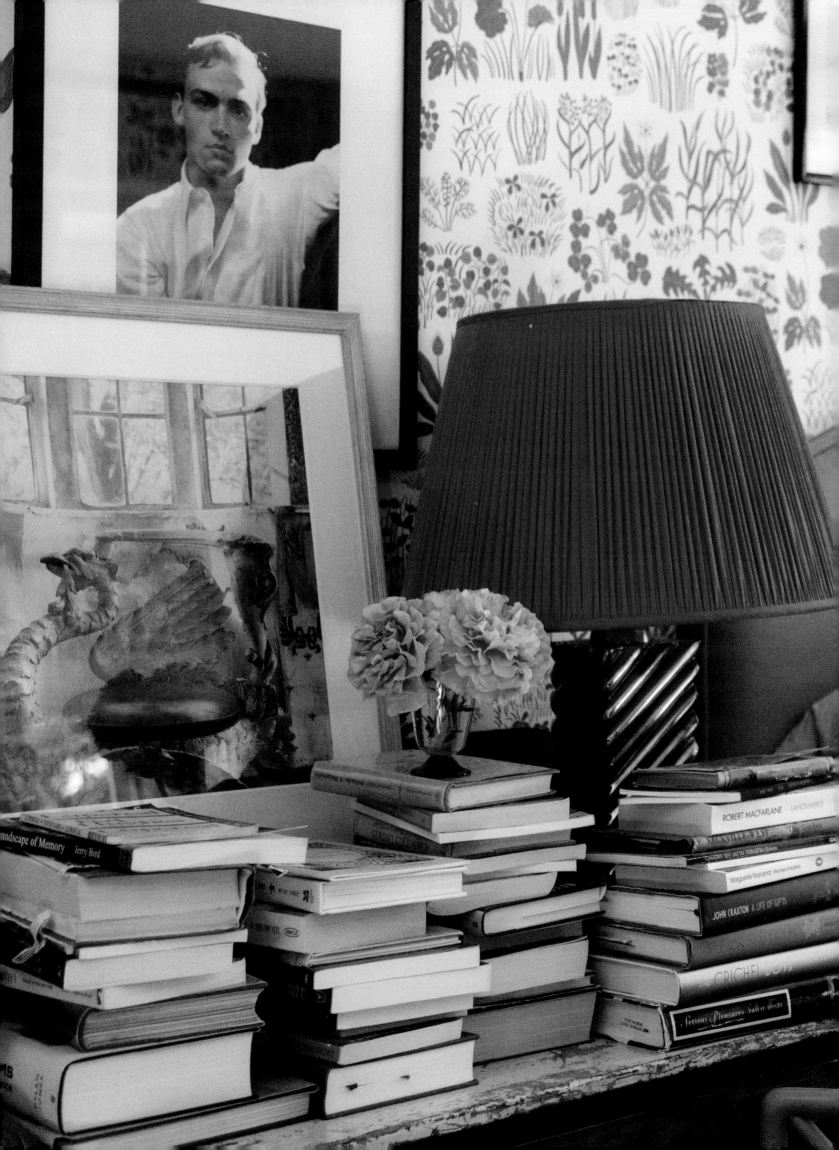

Landscape of Memory Jerry Bird

ROBERT MACFARLANE LANDMARKS

SACKVILLE-WEST

Marguerite Yourcenar

JOHN CRAXTON A LIFE OF GIFTS

CRICHEL

Serious Pleasures

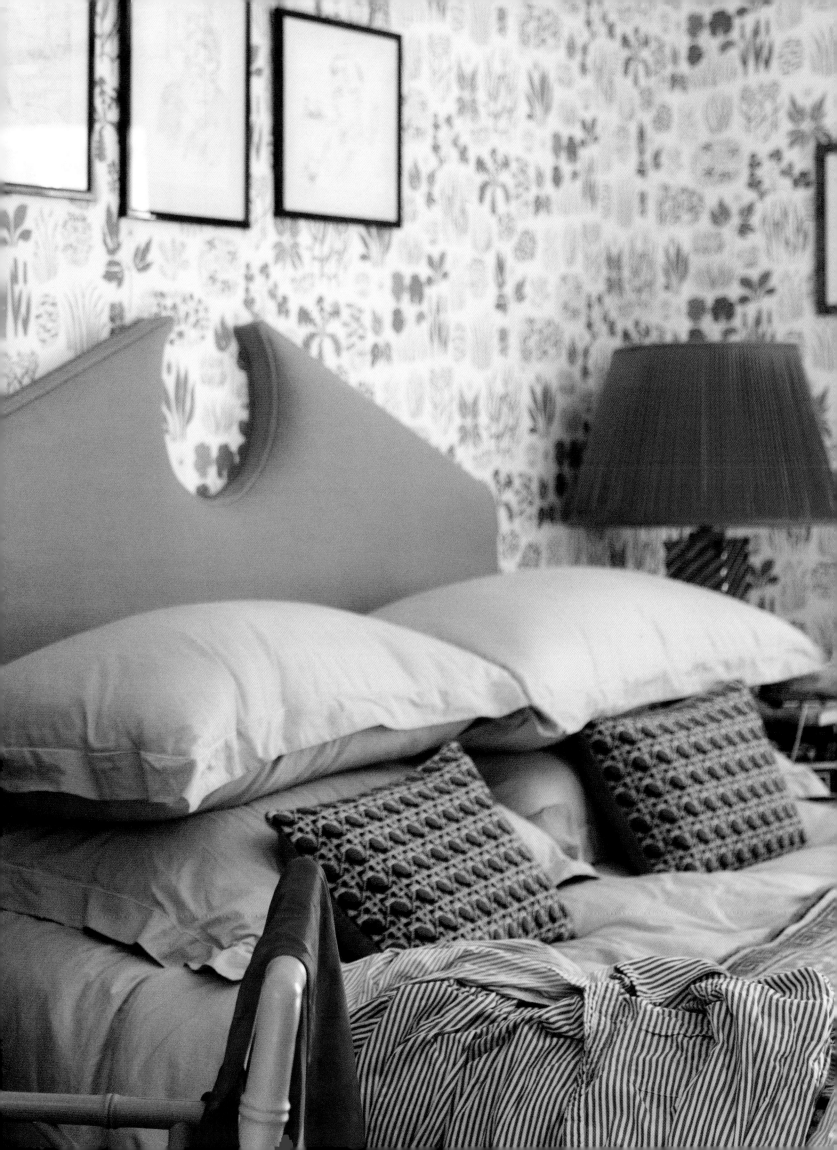

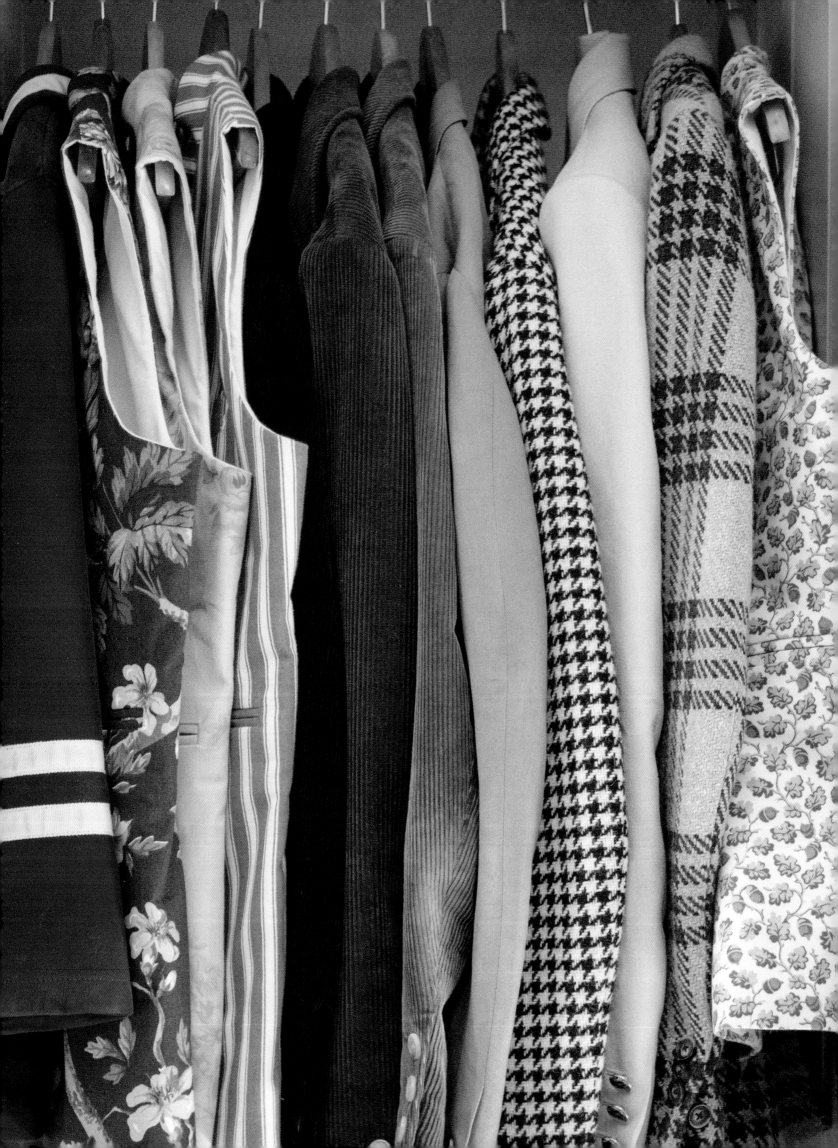

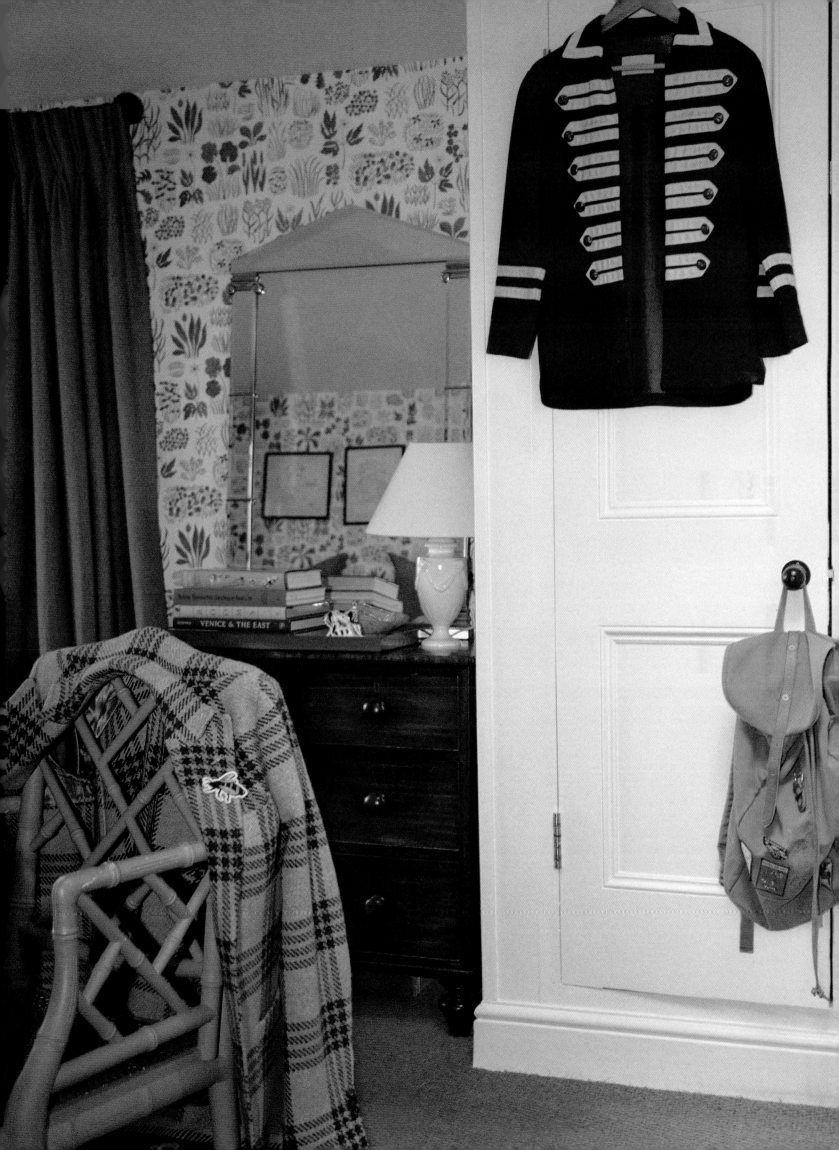

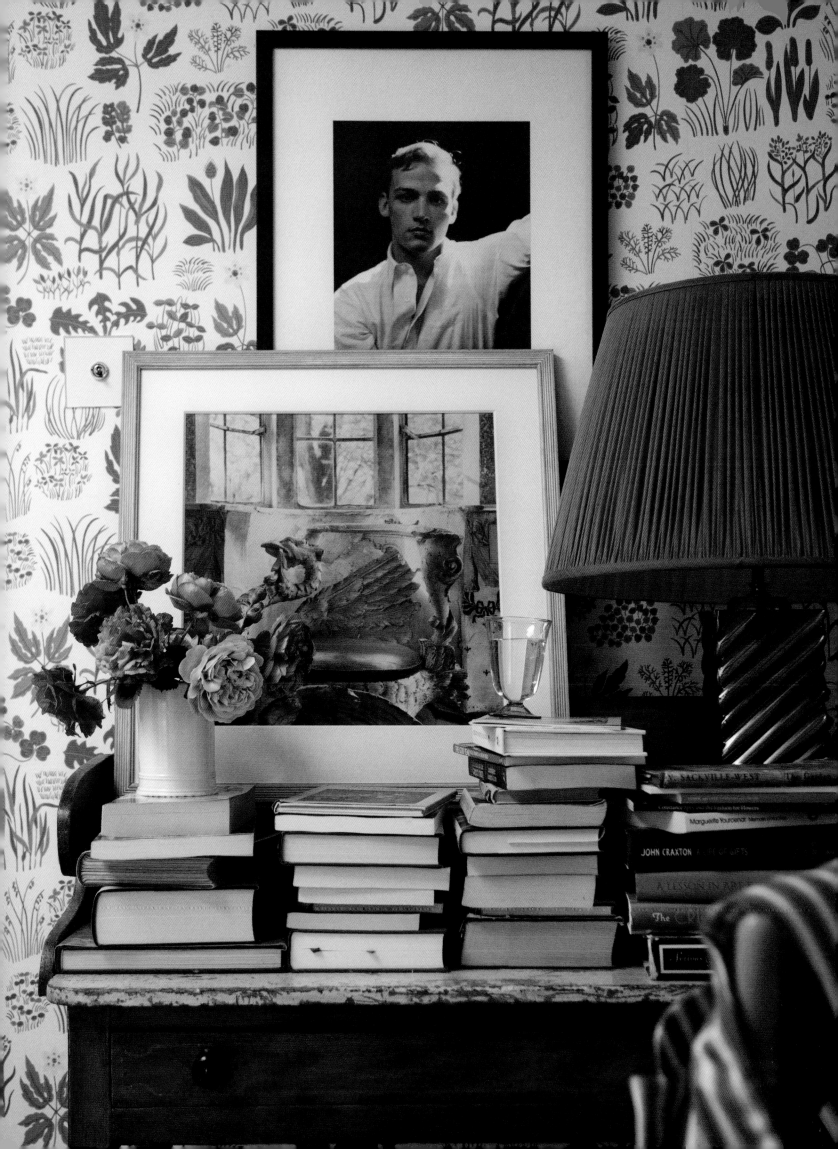

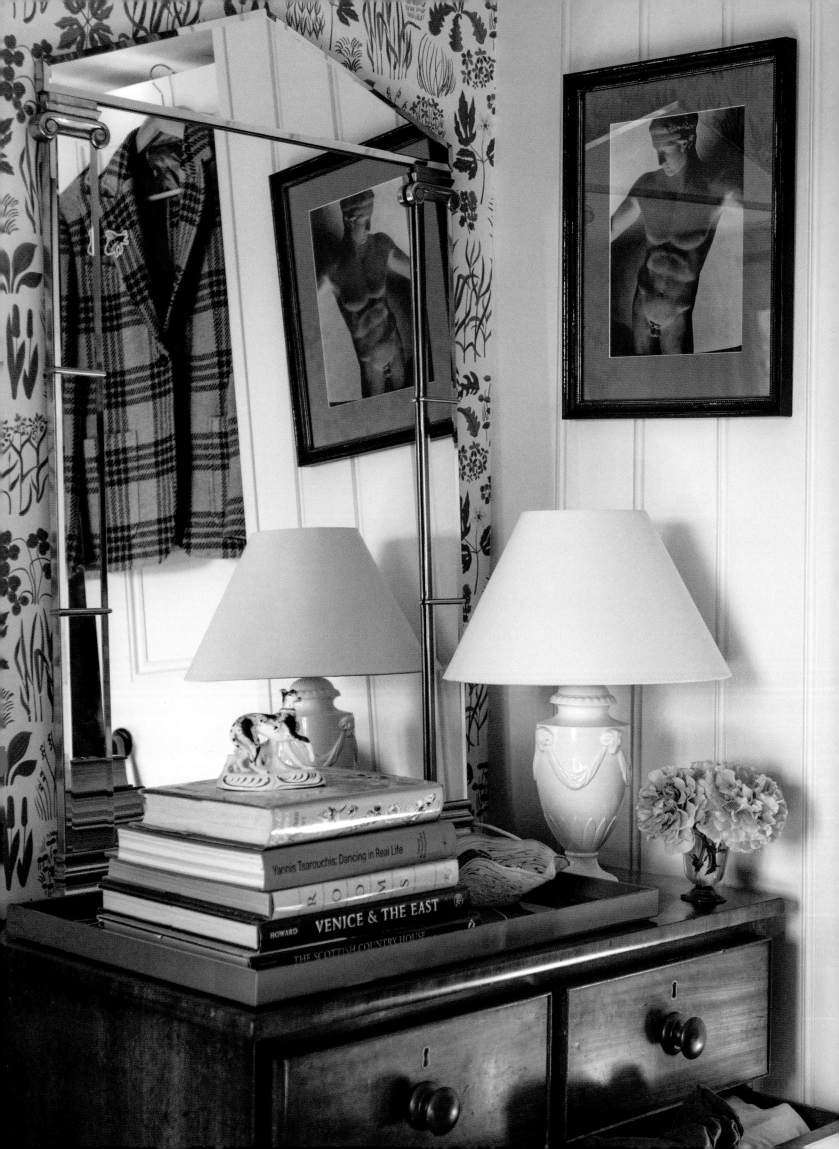

Yannis Tsarouchis: Dancing in Real Life

VENICE & THE EAST

THE SCOTTISH COUNTRY HOUSE

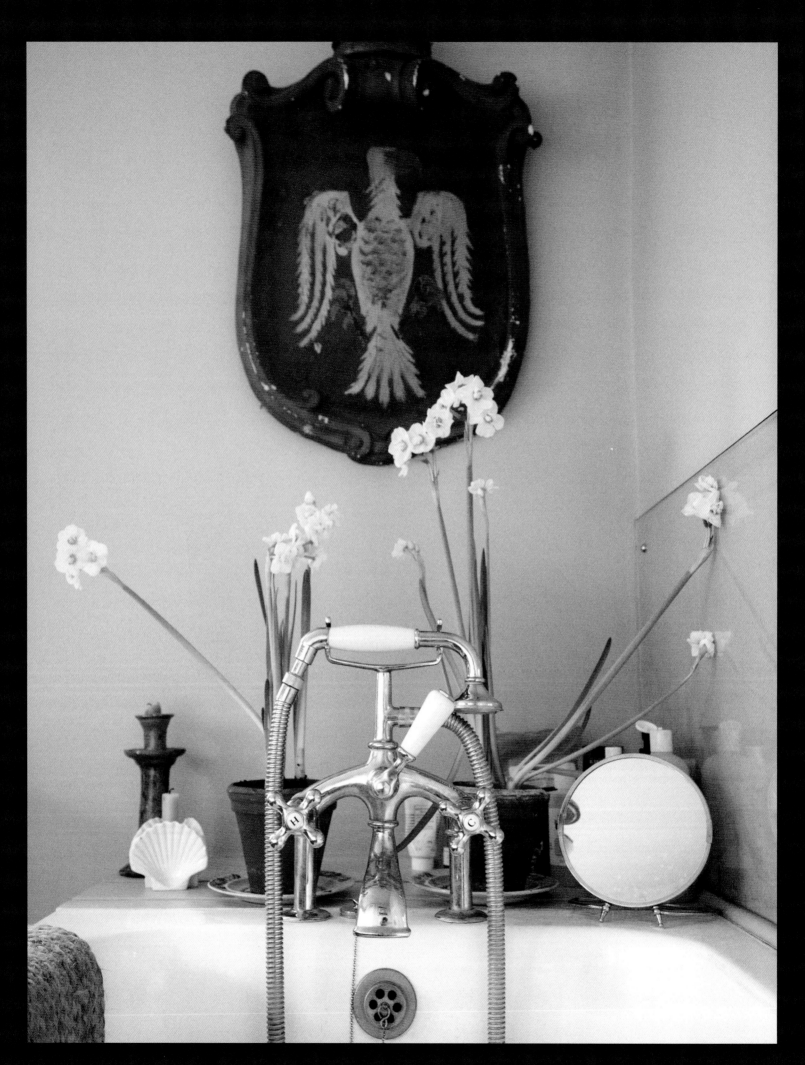

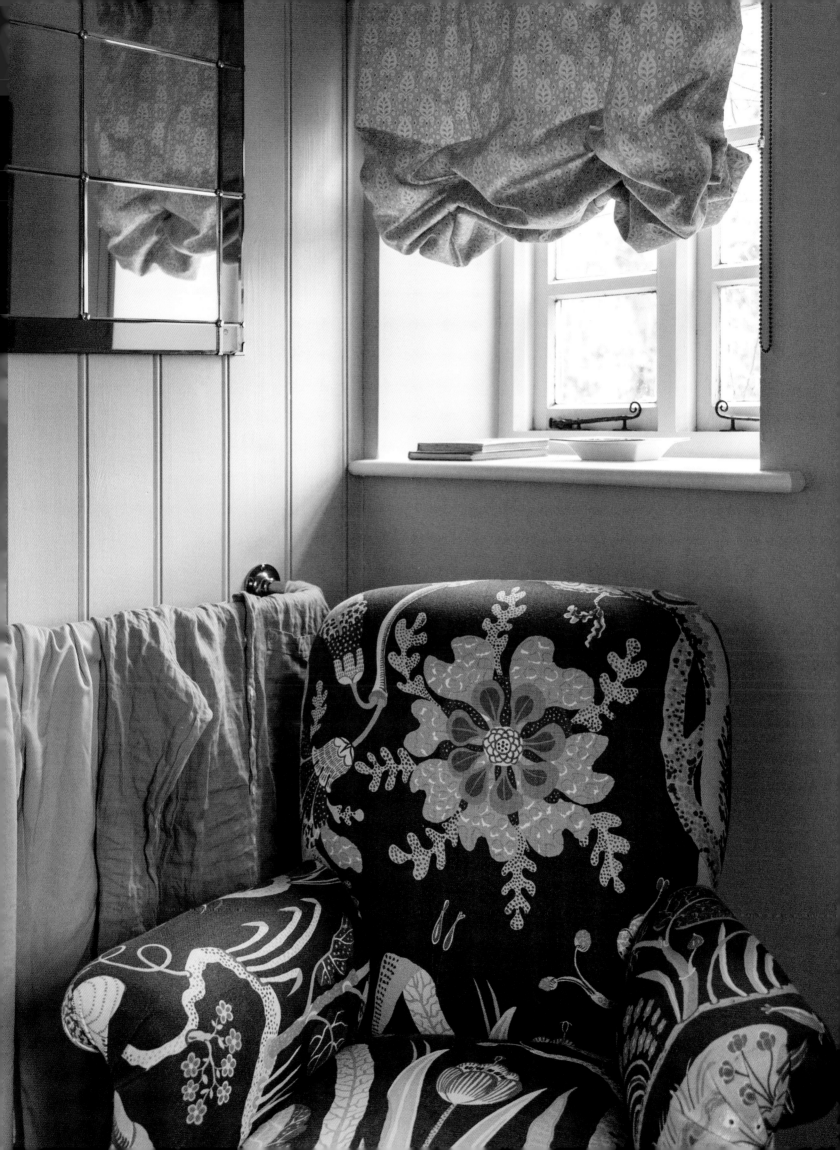

England's
Dances
FOLK DANCING
TO-DAY & YESTERDAY
by
Douglas Kennedy
DIRECTOR ENGLISH FOLK DANCE & SONG SOCIETY

EDGAR HOLLOWAY

MAGIC STONES
& *Haunted Forests*

I have long been fascinated by myths, legends and folklore. As a child I soaked up tales of white witches, mythical creatures and haunted castles. I've always had an active imagination, and all those fragmented stories plunged me into another more ancient and magical world, a sacred landscape in which dragons might be found sleeping in crystal caves and trees might talk.

Over time, this child's wonder morphed into a deep appreciation, not only of our old folk tales but of nature in general, our connection to the world around us, our pagan past and the ways in which we try our best to keep this rich heritage alive. As a teenager I took joy from reading old stories, but also in small pagan gestures: gathering smooth stones from beaches and decorating them at home; holding solo and very quiet celebrations on the days of the solstices and equinoxes. Life is busy, but I still try to mark the passing of the year with, at the very least, a walk or a burning candle.

I turn to our ancient English legends and customs for inspiration for my drawings and paintings: the folk dances and May Day rituals, King Arthur and the Green Man. One of the many things that I love about living in the country is that this 'other world' feels very present. We'll take visiting friends ten minutes up the road to see the Rollright Stones – an ancient complex of Neolithic and Bronze Age megalithic monuments – and try our best to count the stones in the King's Men circle (legend has it that no one shall live who counts the stones three times and finds the number the same). The site consists of three main groups: the King's Men stone circle, the Whispering Knights burial chamber, and the single King Stone. There are countless legends associated with the stones, but the most well-known centres around an Iron Age king who one day set out with his army to conquer the whole of England. Whilst marching through the Cotswolds, the king met a witch who told him that if he could see the village of Long Compton after seven strides, she would crown him King of England. Realising that the village would be visible just over the brow of the hill, the king strode forward to claim his prize. A mound of earth magically rose up directly in front of him, and the witch instantly turned both the king and his men into the standing stones that we still see to this day.

Then there is Wychwood Forest. For millennia the forest covered much of West Oxfordshire with its grasslands, heaths, marshes and woodlands. Today it survives only in fragments, and abounds in haunted tales. Visitors might feel a hand reaching out to touch their shoulder, or hear the thunder of a thousand invisible horses. Trees are even said to bleed when cut. That said, we regularly take Merlin for a sprint through the forest and, whilst it's certainly a beautiful and peaceful place, no doubt with a little magic in its leaves, I am yet to feel a ghostly presence …

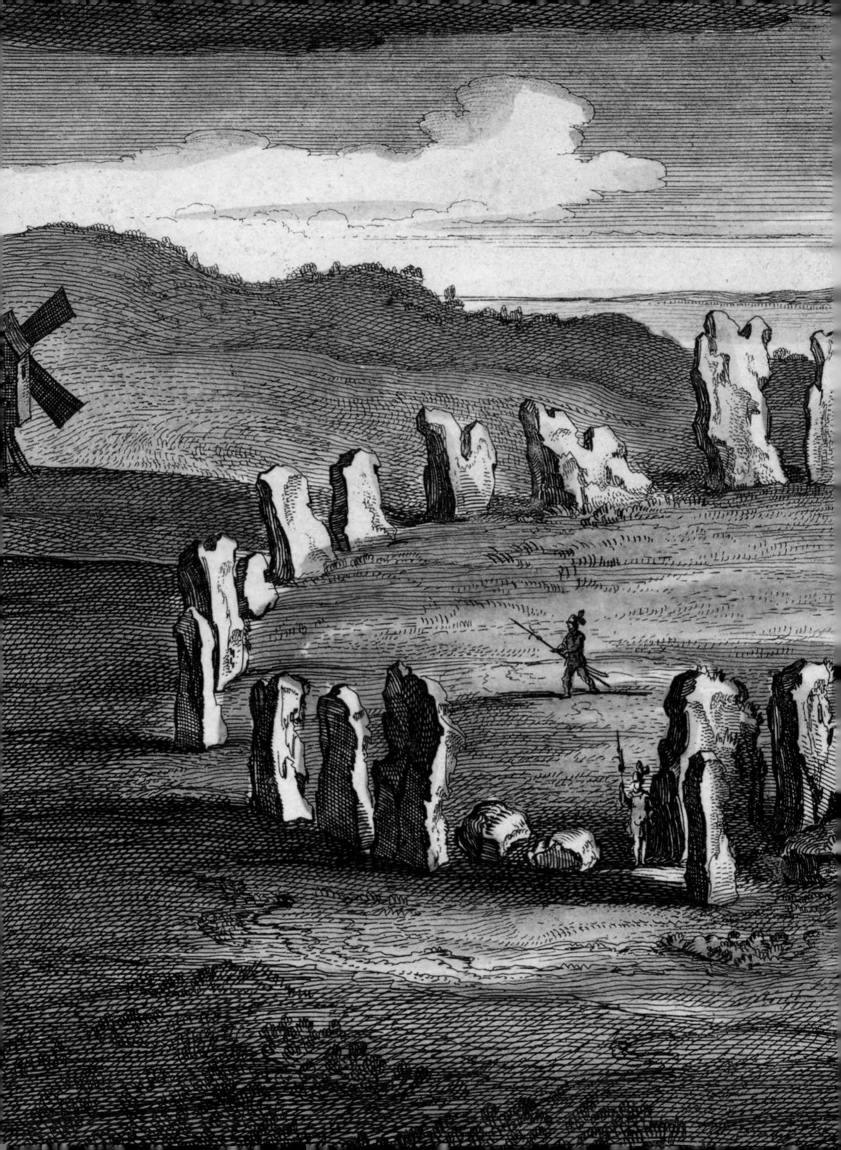

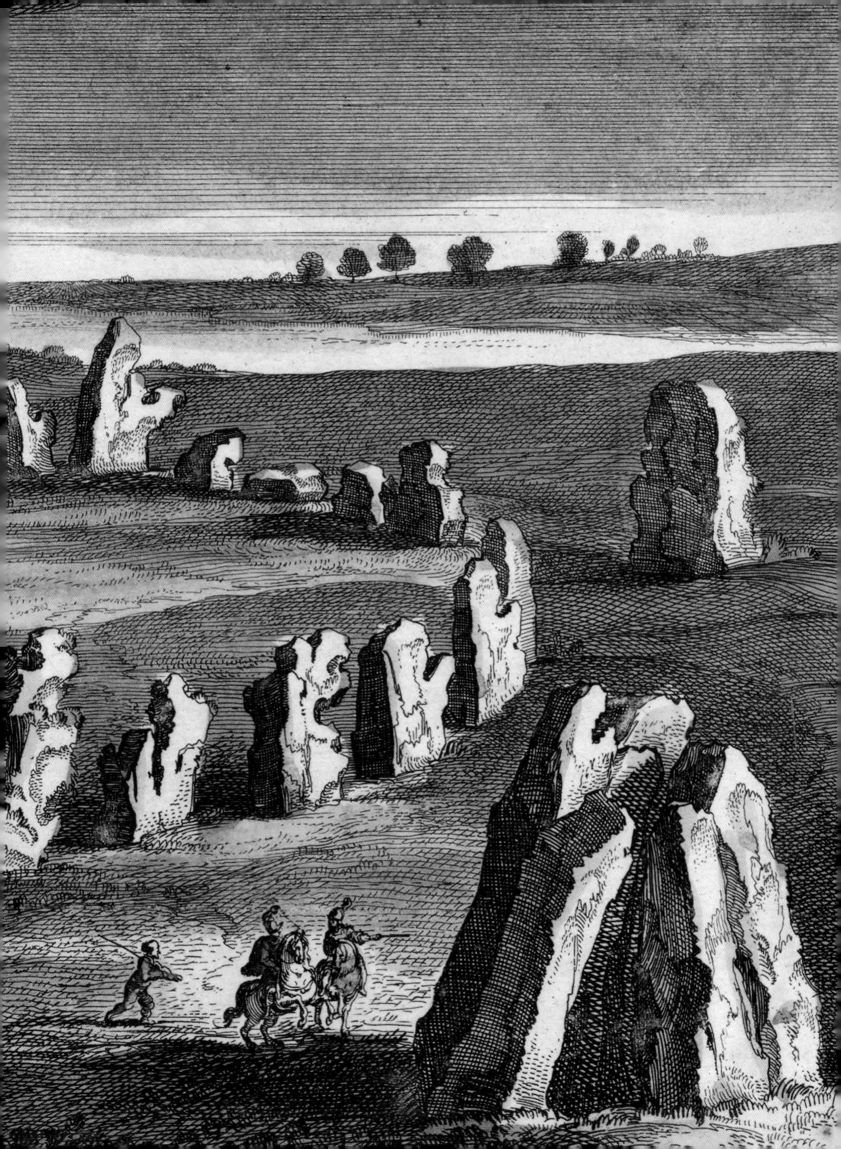

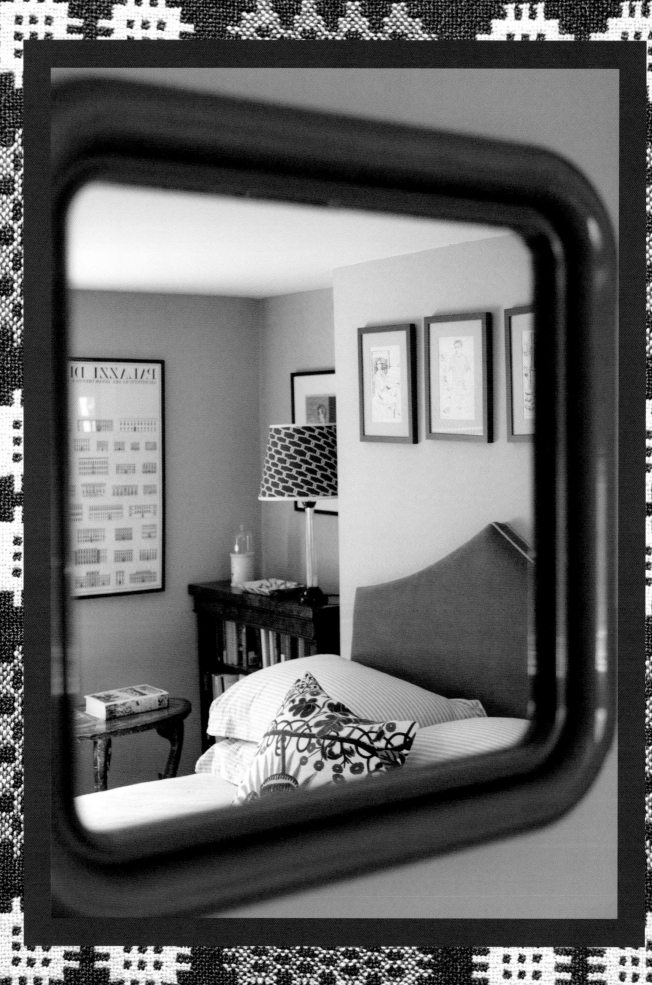

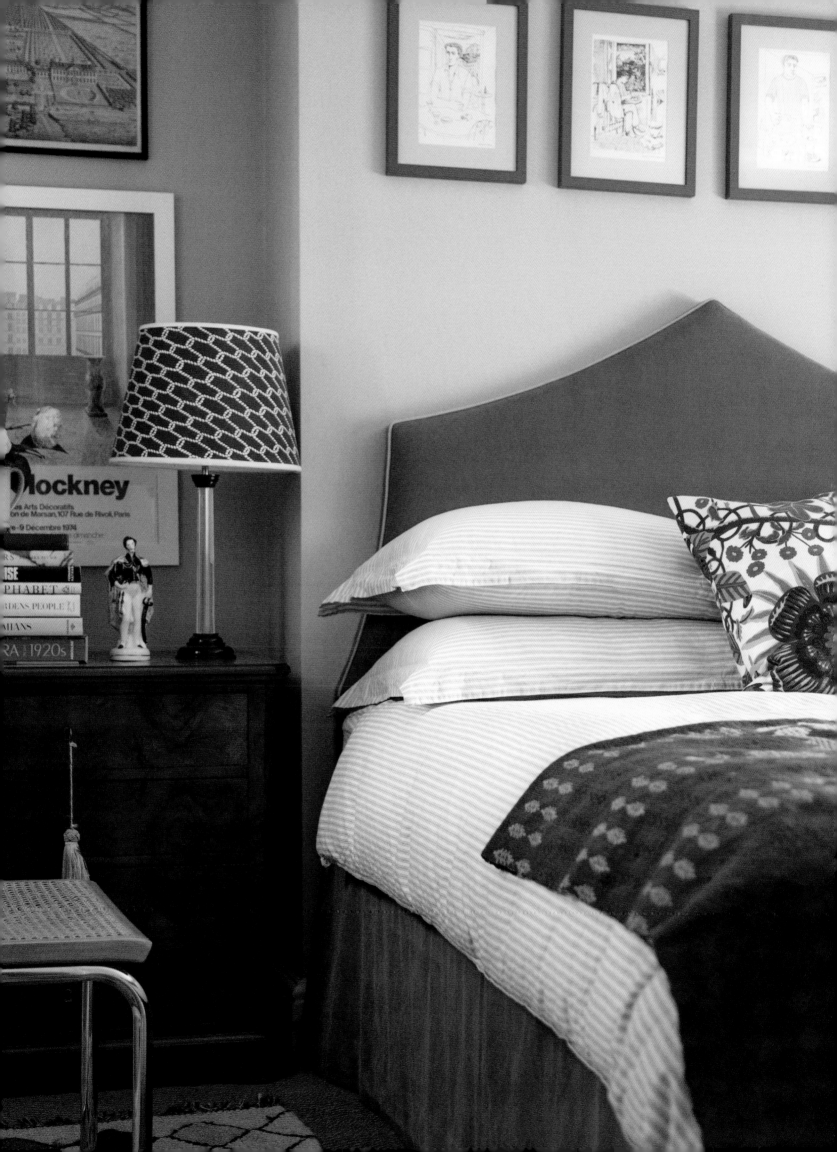

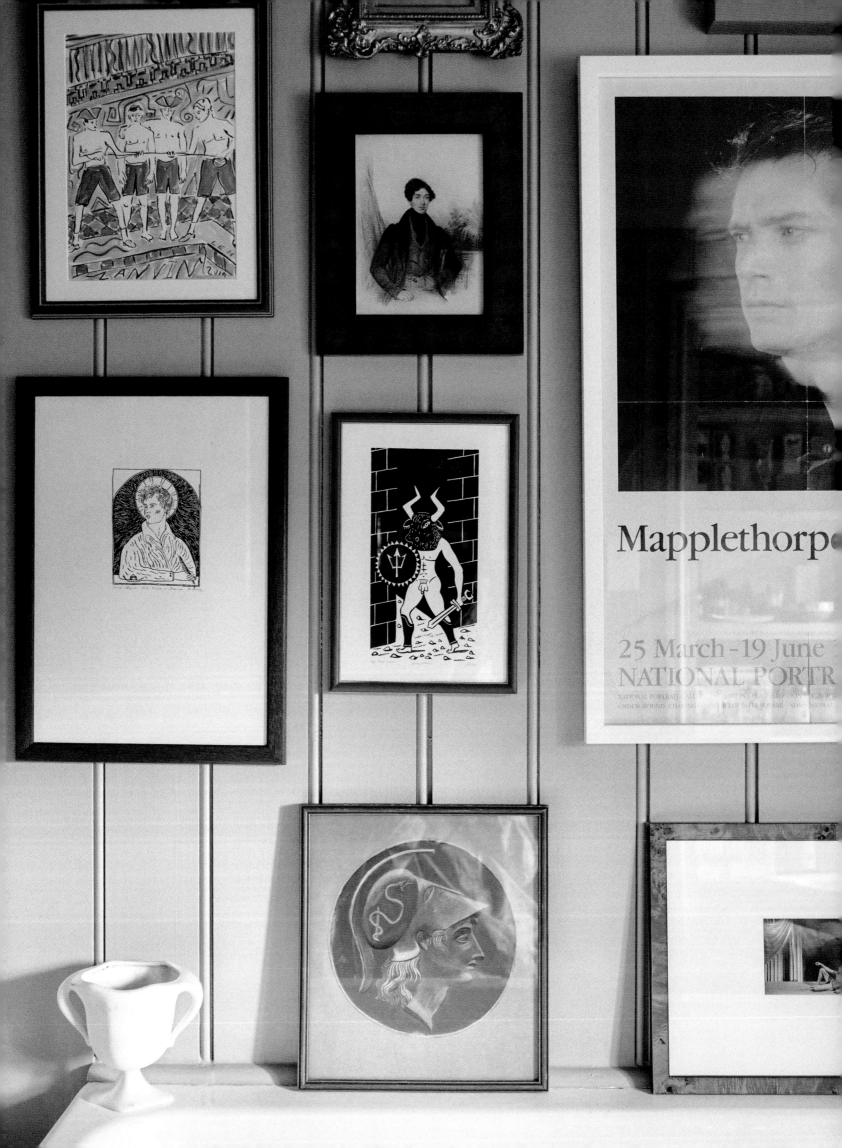

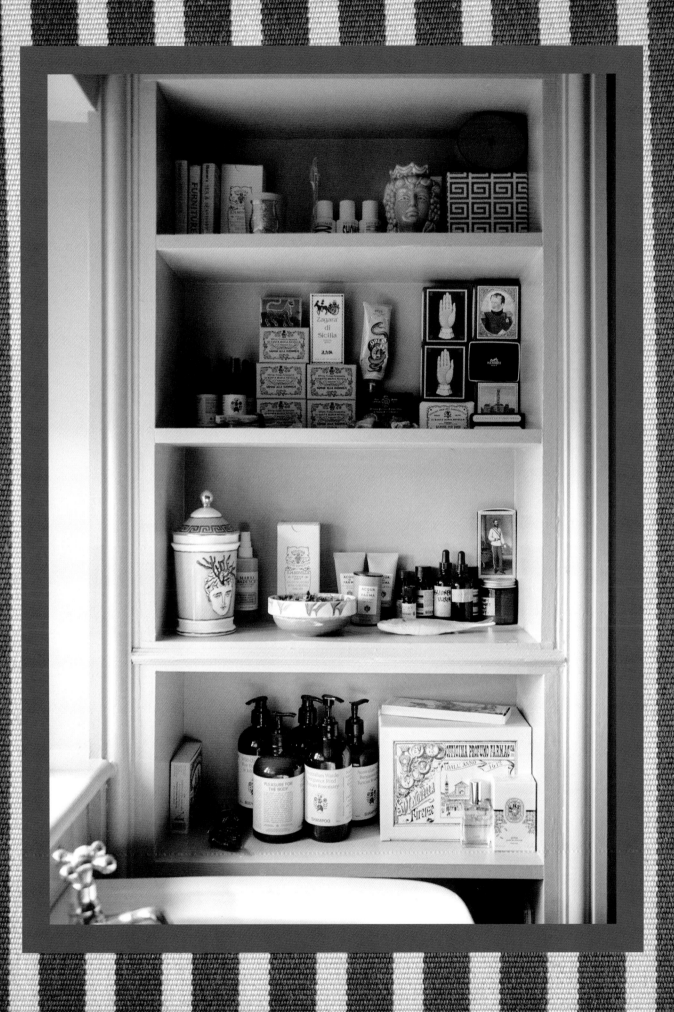

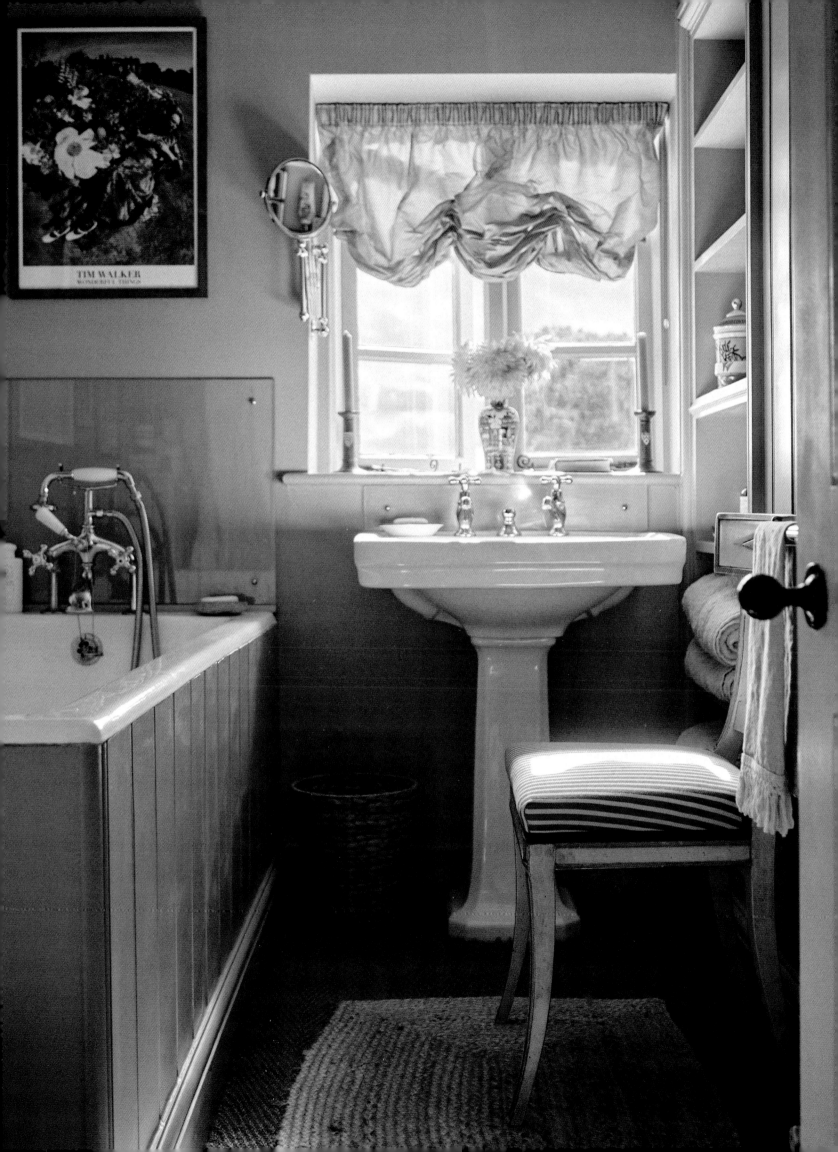

town

There are murals in the hallway depicting Antinous, a pair of Green Men and a whole lot of faux marbling. The bed, of course! A ridiculous thing, 1960s-inspired, a mass of pink silk and cotton printed with pineapples that matches the room's wallpaper.

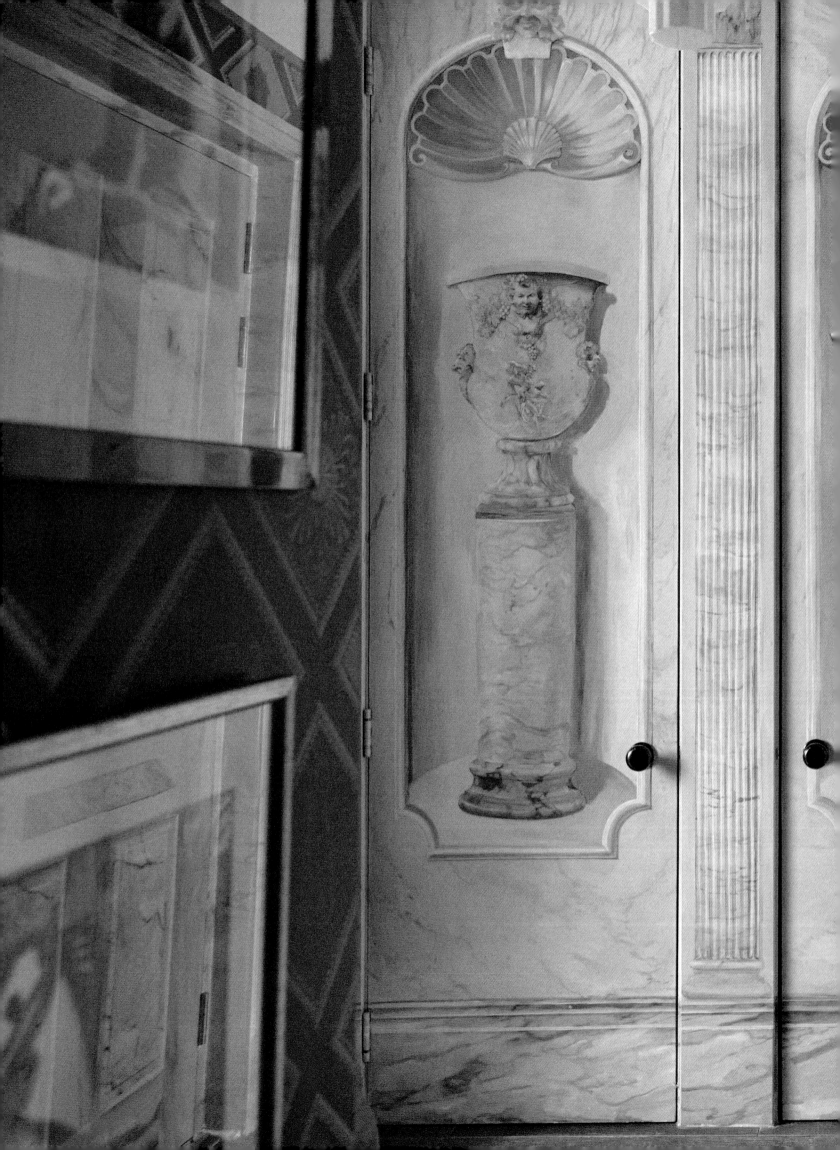

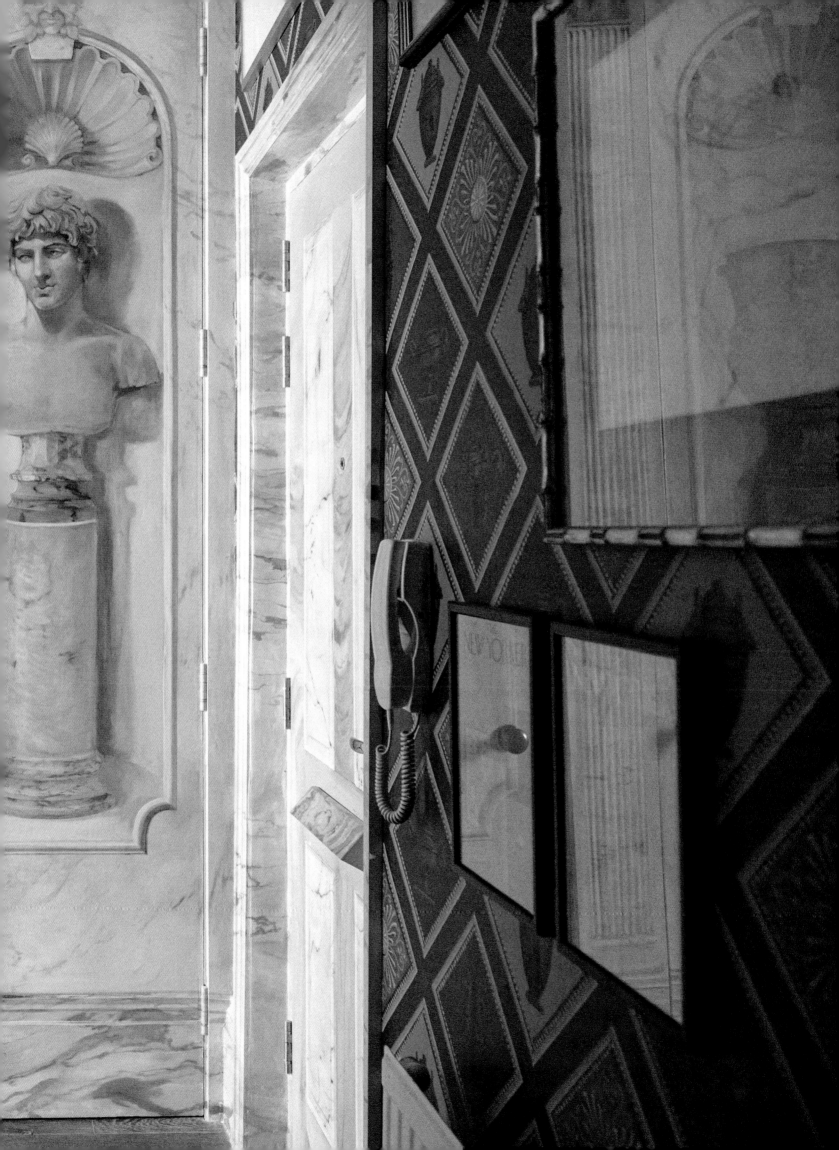

Palazzo CAMDEN

Duncan and I have lived in the same flat in Camden for a long time. When we first met (back in 2008), Duncan was already living here, and I moved in a year or two later. Our terrace is Victorian, and of dark brick, with Italianate stylings here and there. From the windows at the front, we look out at trees and sky; at the back, windows frame a pleasing picture of neighbours' gardens, slotted together like a jigsaw puzzle, a church behind them poking its pointy spire above grey rooftops.

Unlike the cottage – a blank canvas that Duncan and I filled together over a fairly short period – the flat has had various incarnations, rather like an artwork that has been painted over many times, over many years. A while after I moved in, the interior became a project that we could work on jointly; I still remember the first piece of furniture we bought as a couple. The flat was the backdrop to my twenties. I spent my last couple of years as a student living here – the new Central Saint Martins campus had conveniently moved from Soho to nearby King's Cross (although I much preferred Soho!): I'd work at school, then come home and draw at the coffee table in front of the arched windows. Later on, I savoured the twice-daily twenty-minute cycle between the flat and my workplace in Bloomsbury, passing the Victorian Gothic magnificence of St Pancras and the less magnificent sludge

of Euston Road. Many a summer evening was spent on the flat's little balcony with friends, surrounded by pots of jasmine and foxgloves, the gentle murmur of the city rising up from the streets below.

These days, the interior of the flat feels like a really wonderful reflection of our combined tastes and interests. There are flowery and neoclassical wallpapers in bright, dusty colours; there's the custom kitchen we designed together, with its enormous pediment and ornamental urns and bamboo tiles. There are pieces of furniture and mirrors designed by Duncan (and his business partner Charlotte Rey), alongside drawings and ceramics by me. There are countless

odds and ends collected over time: the ceramic octopus from Capri; the glass chicory leaves from Venice; the silver head of garlic from a store on New York's Upper East Side. There are murals in the hallway depicting Antinous, a pair of Green Men and a whole lot of faux marbling. And the bed, of course! A ridiculous thing, 1960s-inspired – a mass of pink silk and cotton printed with pineapples, matching the room's wallpaper. Piles of books, naturally, and vases of flowers brought up from the country.

We did a lot of work on the flat in 2021, and whenever Duncan and I discussed our ideas we returned again and again – half in jest – to our favourite key words: 'Palazzo Camden'. We loved the idea of taking inspiration from faded old rooms on the Grand Canal and reinterpreting here on a scruffy terrace in North London. Of course, us being us, we can never stick to one theme, so there are interlopers: the bedroom's wallpaper is French, and I'm not sure you'd find Staffordshire figurines in a Venetian palazzo. Or perhaps you might? The general idea was more about atmosphere than detail: we wanted to make three glamorous rooms, rich in jewel colours and a variety of textures.

The flat is a painting that gets added to and added to. It will never be 'done'. We will keep on improving, tinkering, layering. We will keep on painting over.

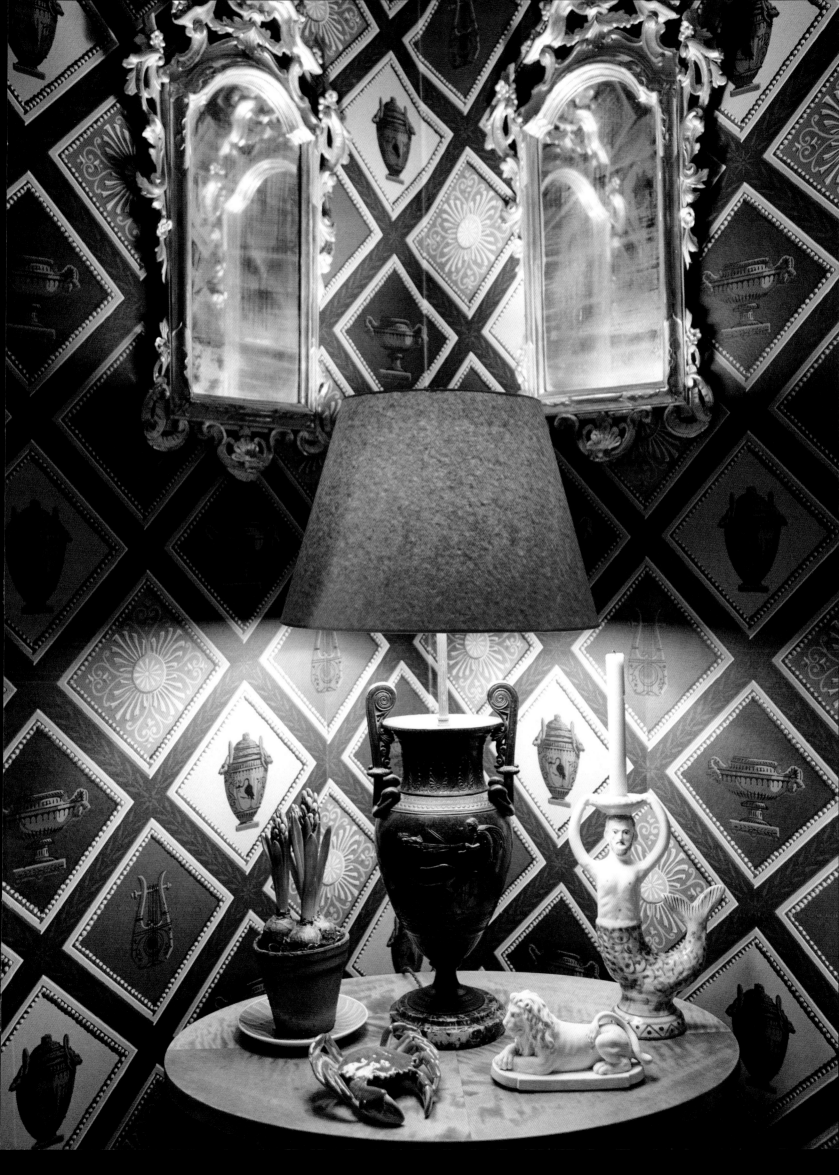

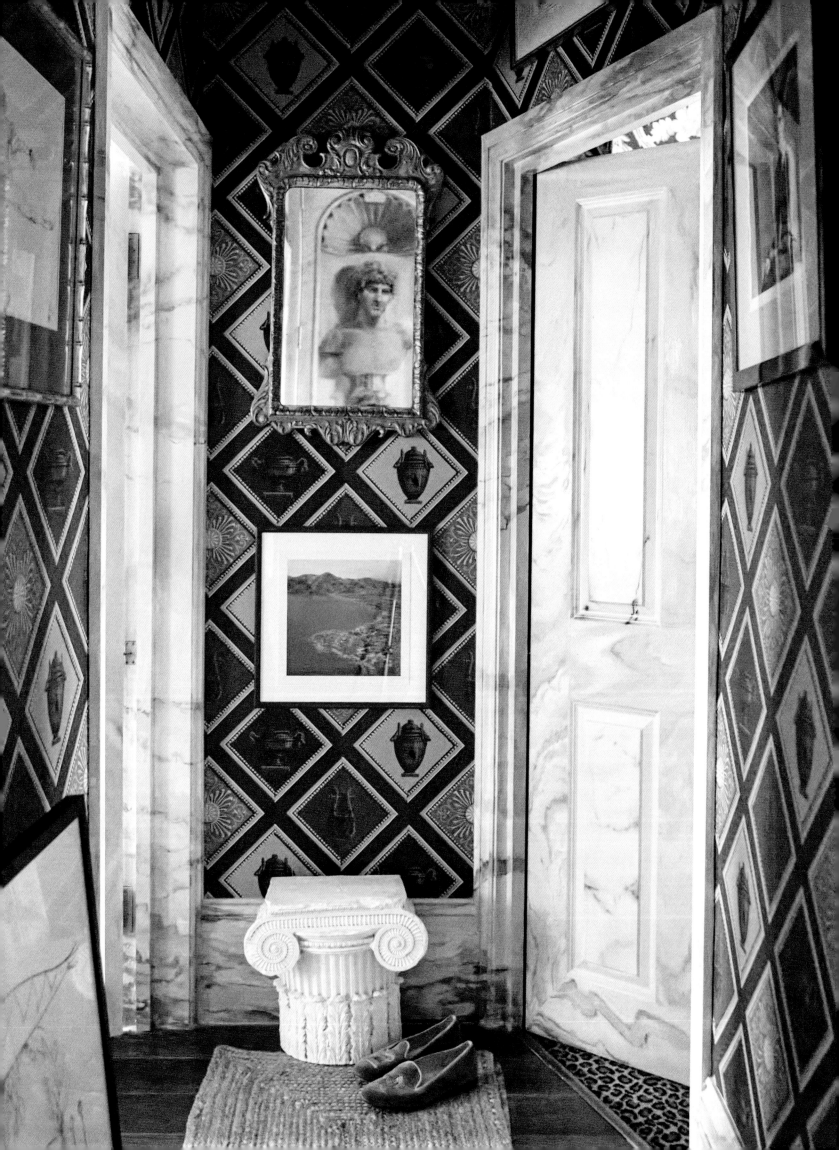

Bloomsbury

Every year, I make a pilgrimage to Charleston Farmhouse in East Sussex. Charleston was the country meeting place of the Bloomsbury Group, that famous mixed bag of writers, artists and intellectuals active in the first half of the 20th century. Vanessa Bell and Duncan Grant – two members of the circle – moved there in 1916, and the house is stuffed full of their decorated walls, fireplaces, door panels and furniture. It's the most enchanting place to spend an afternoon, and the garden is a delight.

The Bloomsbury group – so named, as they primarily lived and worked in the green garden squares and glittering town houses of Bloomsbury in central London – blurred the lines between art and design. They managed to translate art into the domestic space, and this is what appeals to me and provides endless inspiration (along with comfort, when I'm confused about what kind of career path I'm on). A key moment arose in 1913, when Bloomsbury member Roger Fry founded the Omega Workshops, of which Vanessa Bell and Duncan Grant became directors. The workshops produced furniture, pottery and textiles realised by various young artists, including Bell and Grant themselves. Though short-lived, the movement, with its bold colours and abstract shapes, must have appeared shockingly modern in the early 1900s.

Duncan Grant is my favourite Bloomsbury. Whilst I enjoy his oil paintings, it's his drawings that I truly love, with their scratchy lines, soft colours and brilliant urgency. In 2020, over 400 of Grant's erotic drawings were discovered, after being secretly passed down from friend to friend and lover to lover over a period of decades. The awful fact is that, as a gay man, Grant lived the first 82 years of his life a criminal. His lost drawings are a slice of gay history, and have been incorporated into the countless stories told at Charleston – a place, as director Nathaniel Hepburn observes, that was 'an artistic home ... but also one of queer celebration and of a group of people imagining life differently'.

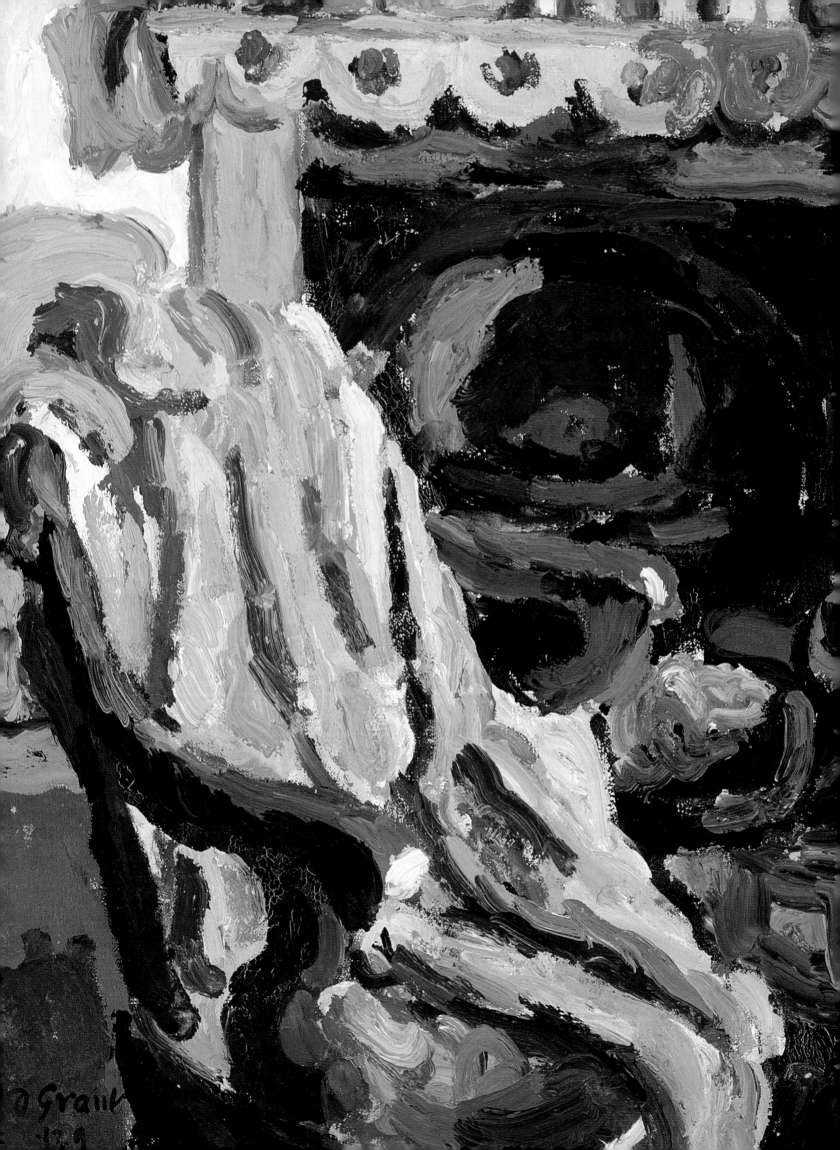

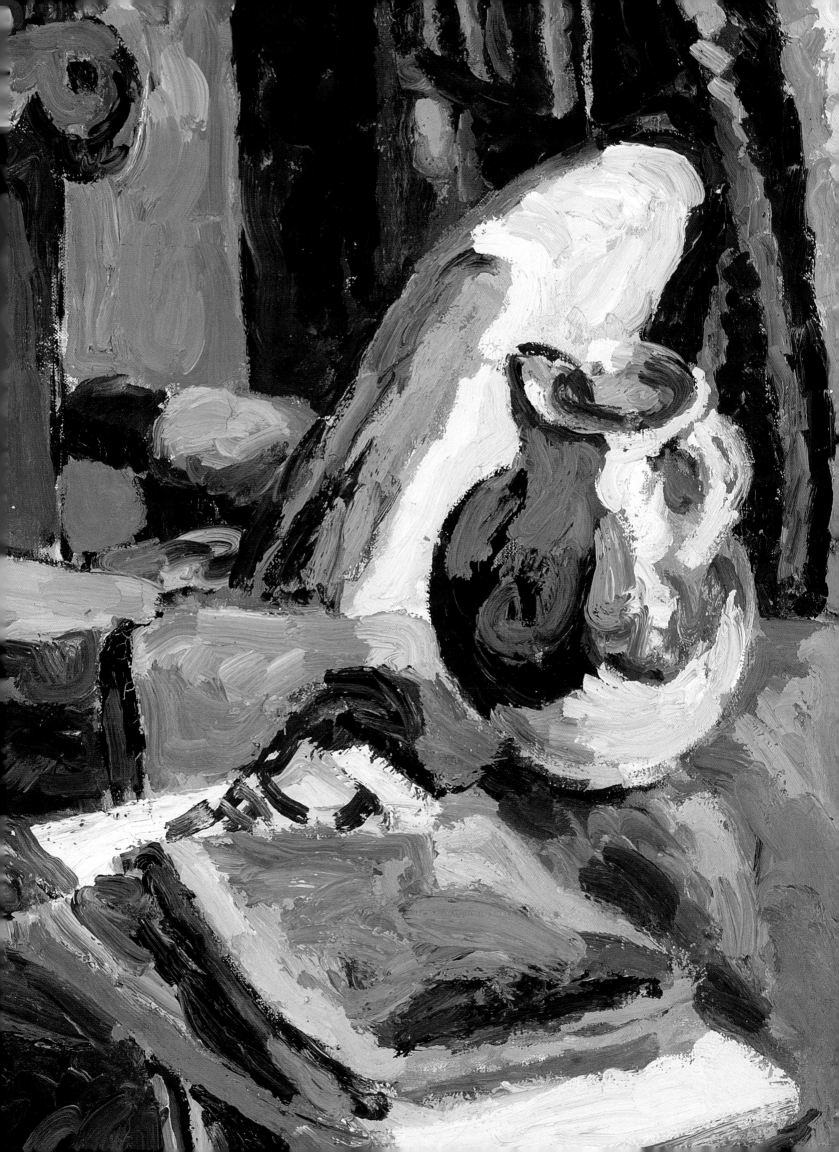

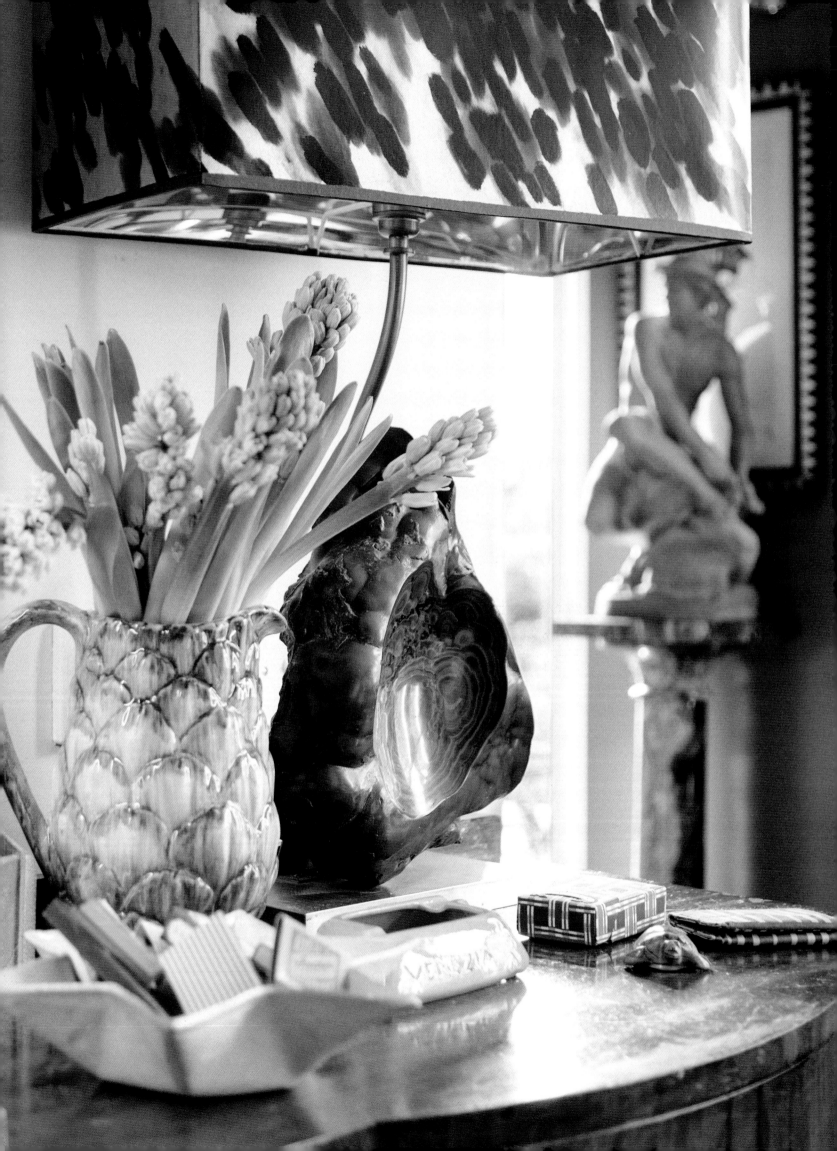

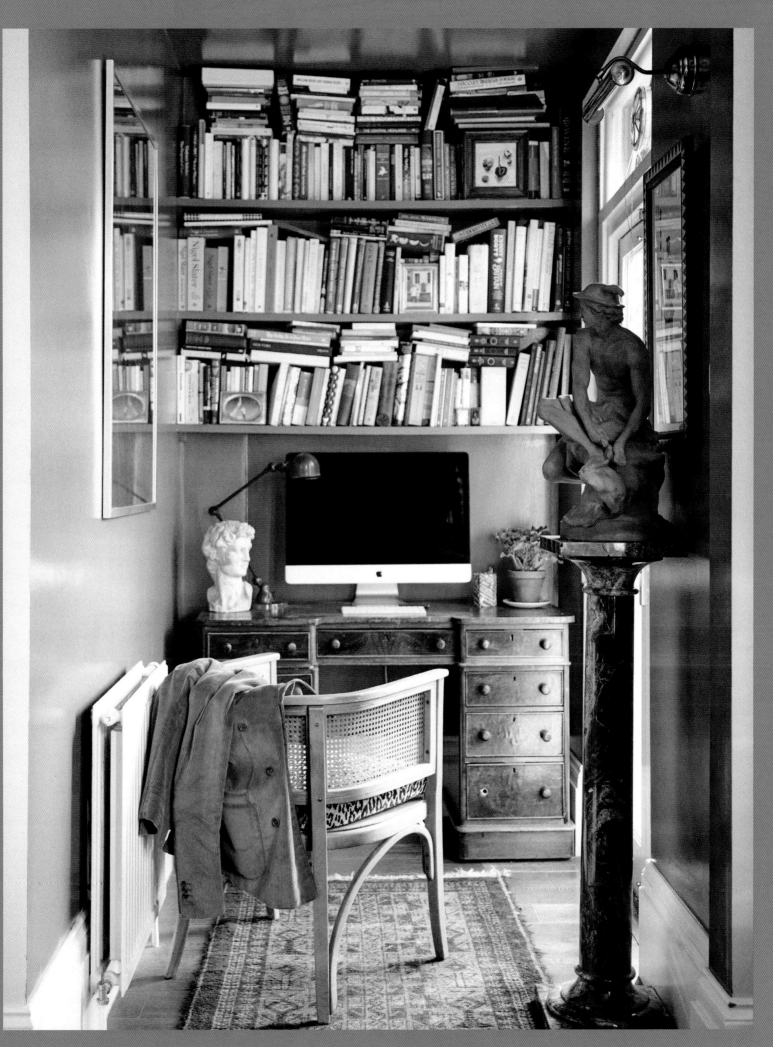

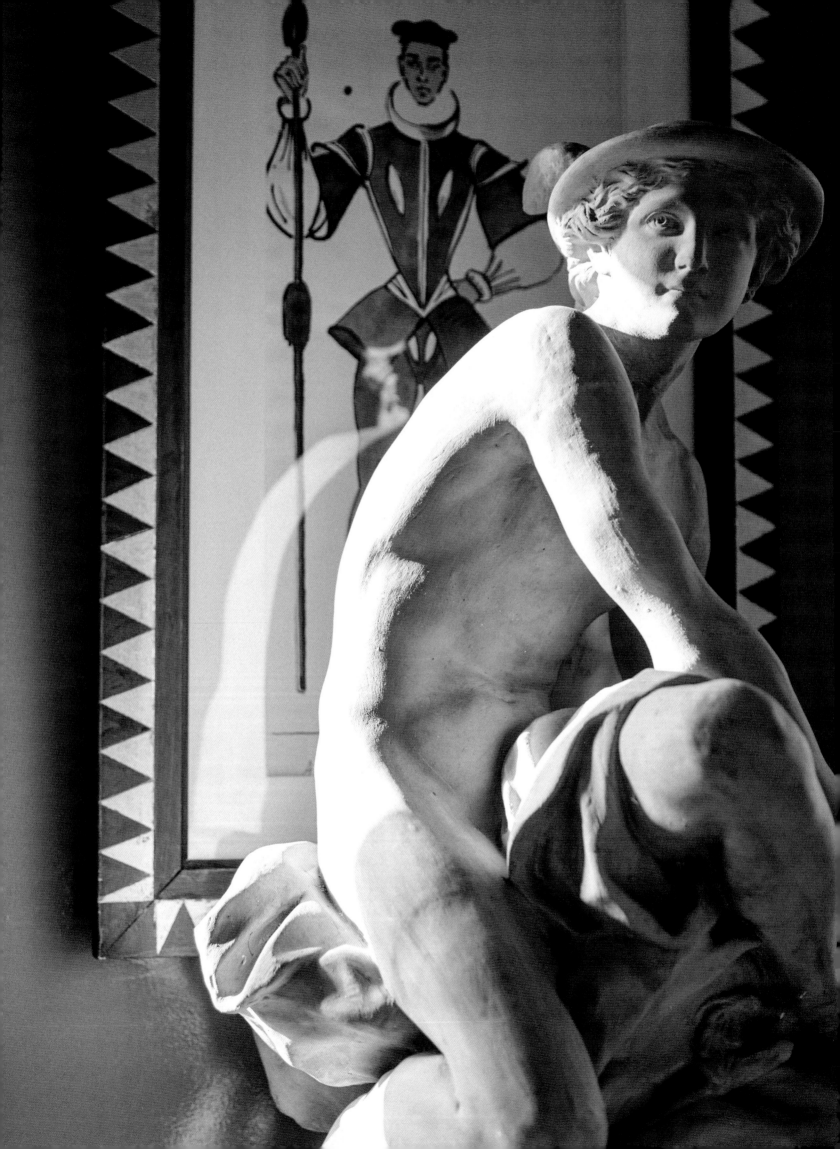

CECIL

I admire a whole bunch of artists, designers and writers, from the past as well as the present, and some have had a particularly profound influence on my own work. The Bright Young Things especially – that group of Bohemian young men and women in 1920s London – have kept me under their peculiar spell for years.

Rex

Although I find all those stories of insane parties and night-time treasure hunts through London most amusing, I am never quite sure about lumping people together and calling them a 'set', and, besides, what I find more enthralling is the group's individual characters, their personal and often extremely touching relationships with each other and, most of all, their creative output. Often described as members of the Bright Young Things, Cecil Beaton, Rex Whistler and Stephen Tennant are – for me – total icons: Beaton, the powerhouse; Rex, the sensitive genius; Stephen, the strange and beautiful bird of paradise.

Stephen

These three boys met in London – Rex and Stephen were students at the Slade School of Fine Art, both somewhat outsiders, and bonded over a mutual love of fantasy and romantic poetry. Cecil met Stephen at a party and was soon invited to stay at the Tennants' country home, Wilsford Manor in Wiltshire. Although they dipped in and out of each other's lives over the years, their first meetings were a series of fireworks that ignited and unlocked creativity in all three of them, and they became integral parts of one another's lives for years afterwards. Incredibly sadly, Rex died in action aged only thirty-nine.

Cecil's work is often swirling around my head. This legendary polymath had the magic touch. Photography, set and costume design, painting, drawing, gardening, interiors – he turned them all to glittering gold. How best to describe his style? Glamorous. Experimental. Extravagant. Romantic. Always ahead of the curve. Rex's drawings, paintings and murals, on the other hand, speak of pure Arcadian fantasy and technical wizardry. Stephen's drawings, I like – admittedly, not nearly as much as Cecil's or Rex's – but as a character he will always be endlessly fascinating.

Oh, I wish I could have met them, could have been there in the late 20s. Yes, the thought of a contrived *fête champêtre* (high summer, Watteau shepherd costumes, powdered faces and big wigs) is a delicious one, but I pine even more for an afternoon in the Long Room of the Daye House (a cottage in the grounds of Wilton House lived in by the boys' close friend, the writer Edith Olivier) – a few hours of chat about art and life, followed by a mystical midnight jaunt to Stonehenge.

Cecil, Rex and Stephen lived for beauty, lived for fantasy, with an innate elegance and sense of romance that, I believe, is unrivalled to this day.

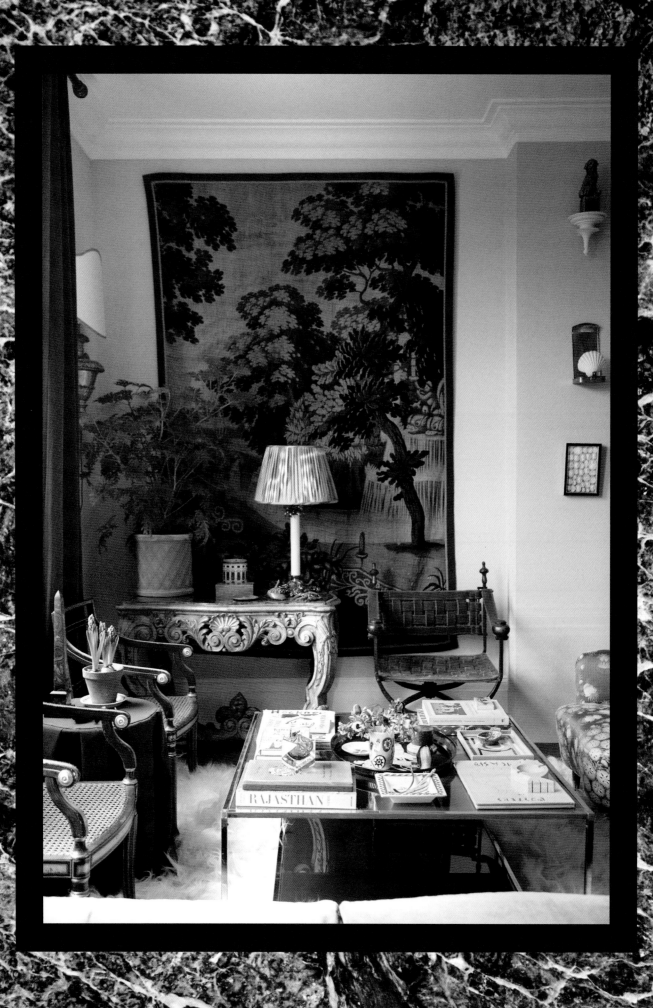

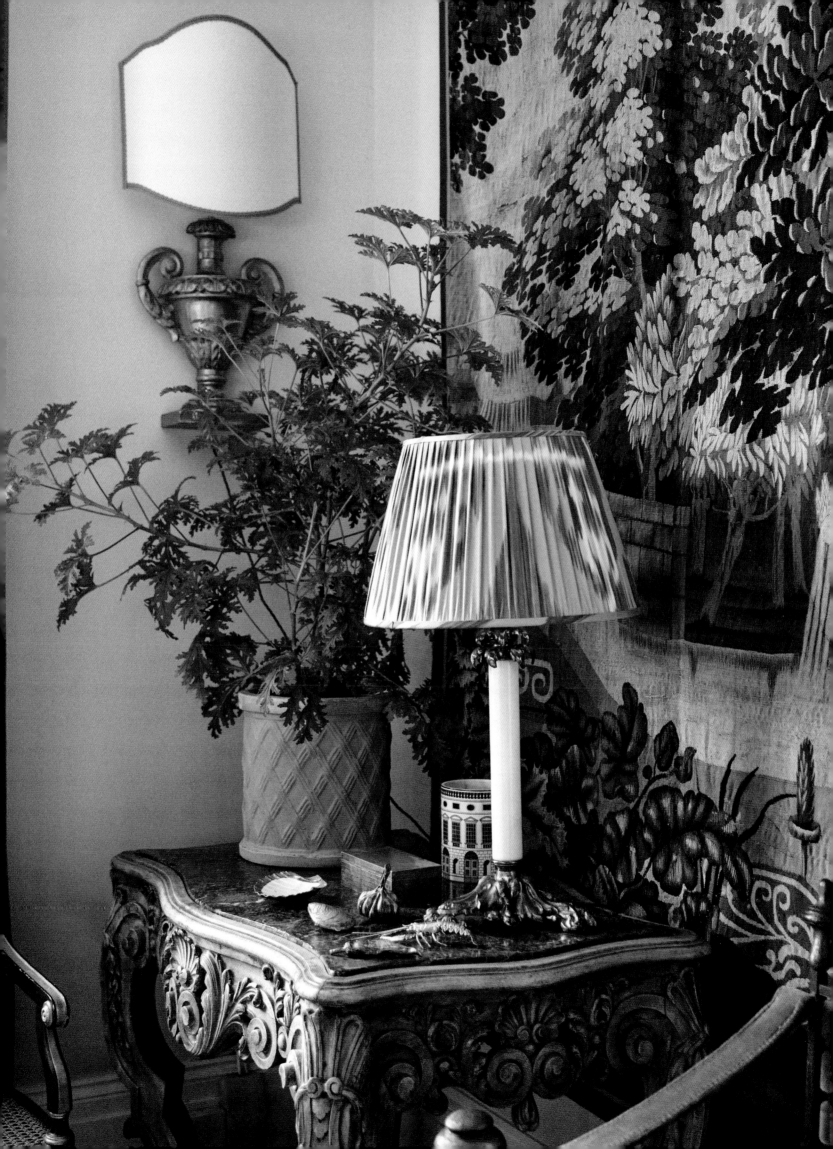

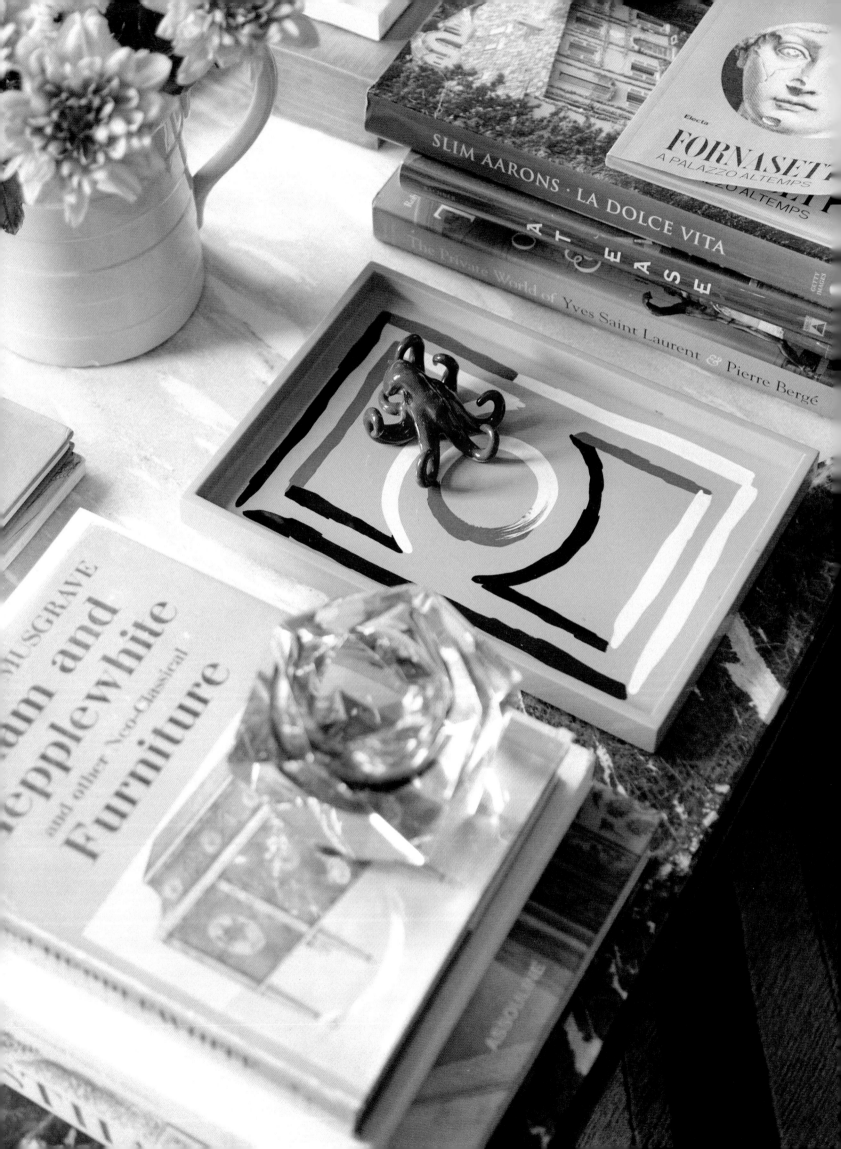

The
DENTON WELCH
JOURNALS
Edited by Jocelyn Brooke

**Truman
Capote**
author of
**In Cold
Blood**

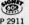
P 2911

**Other
Voices,
Other
Rooms**

A Signet Book
Complete & Unabridged

THE
*ROCK
POOL*

A NOVEL BY
*CYRIL
CONNOLLY*

HAMISH HAMILTON

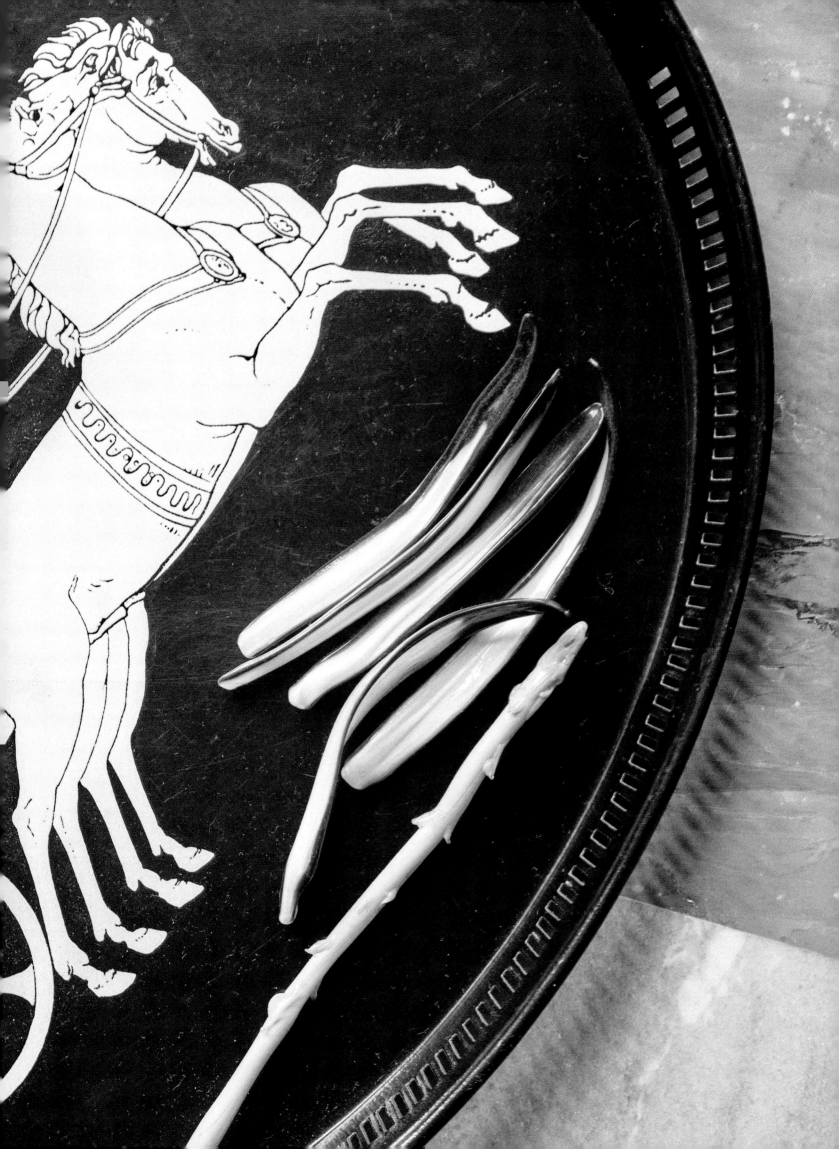

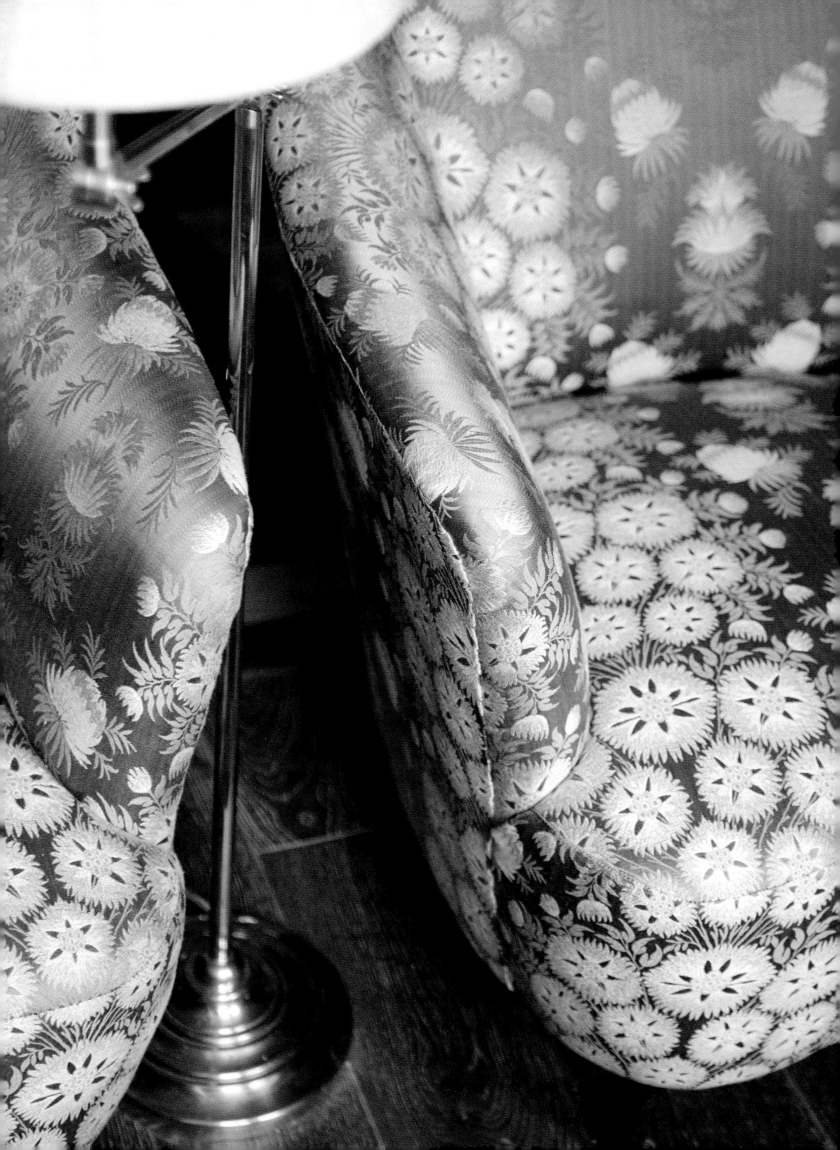

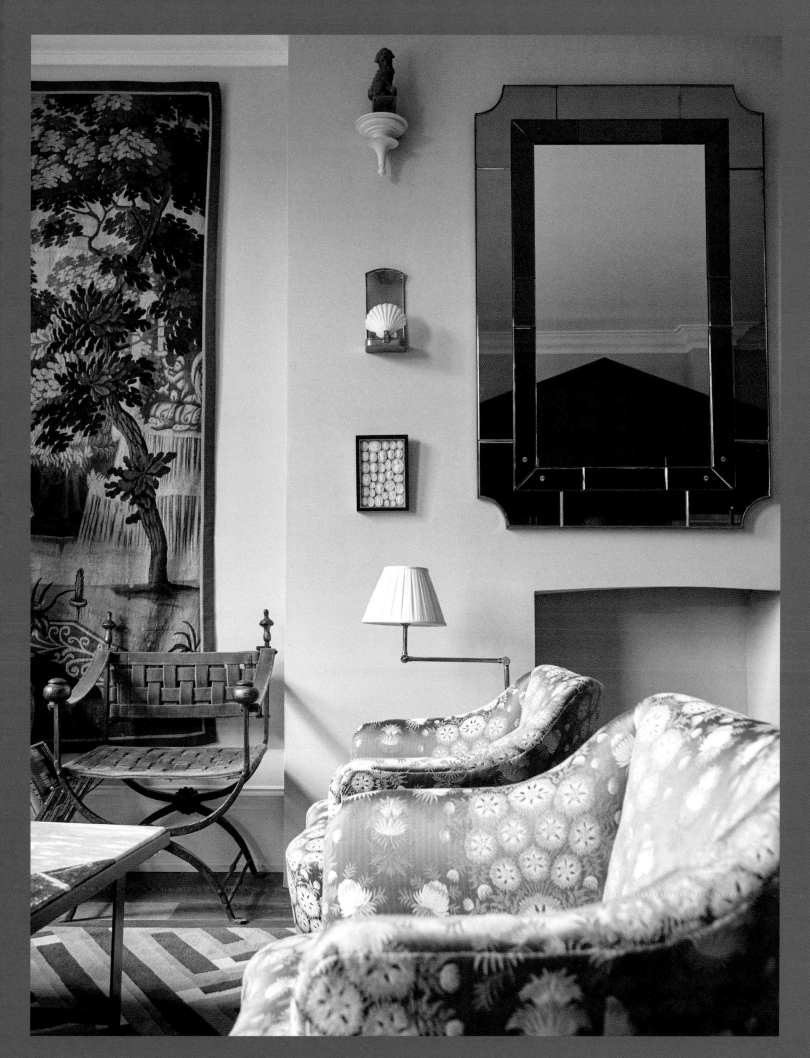

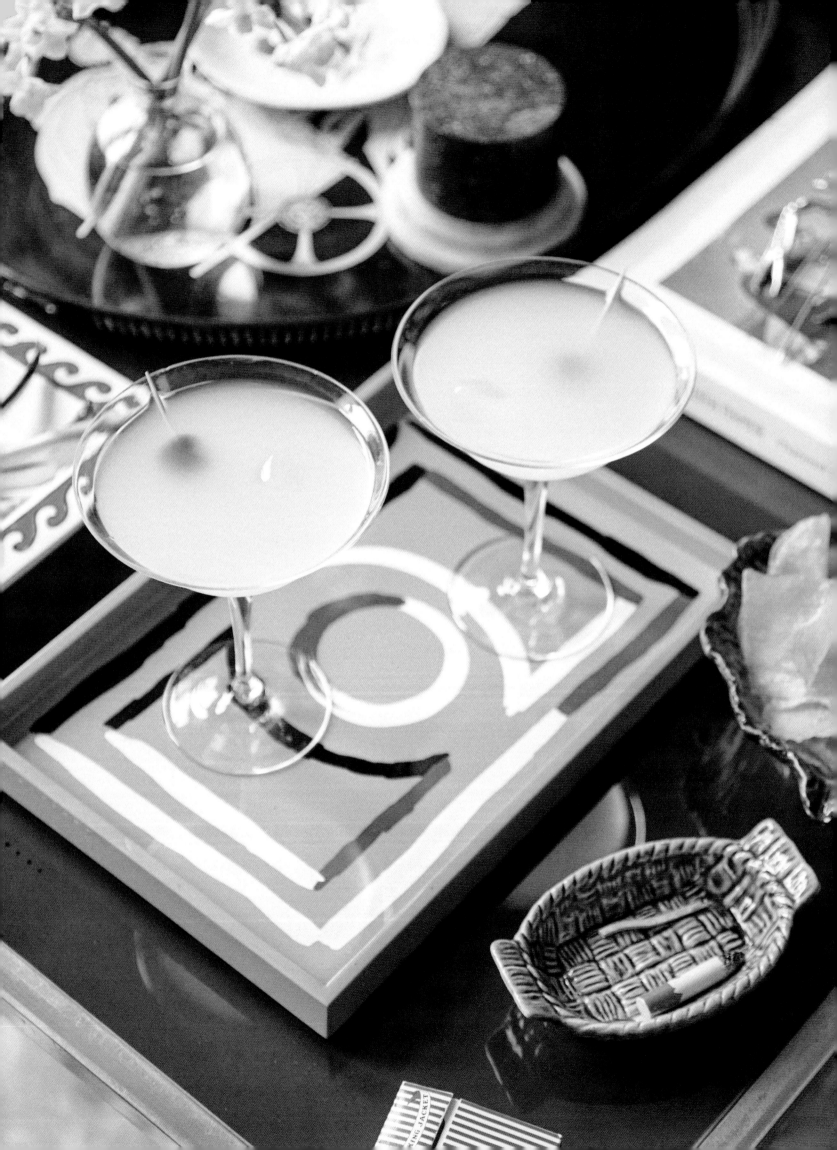

LE TRAIN BLEU

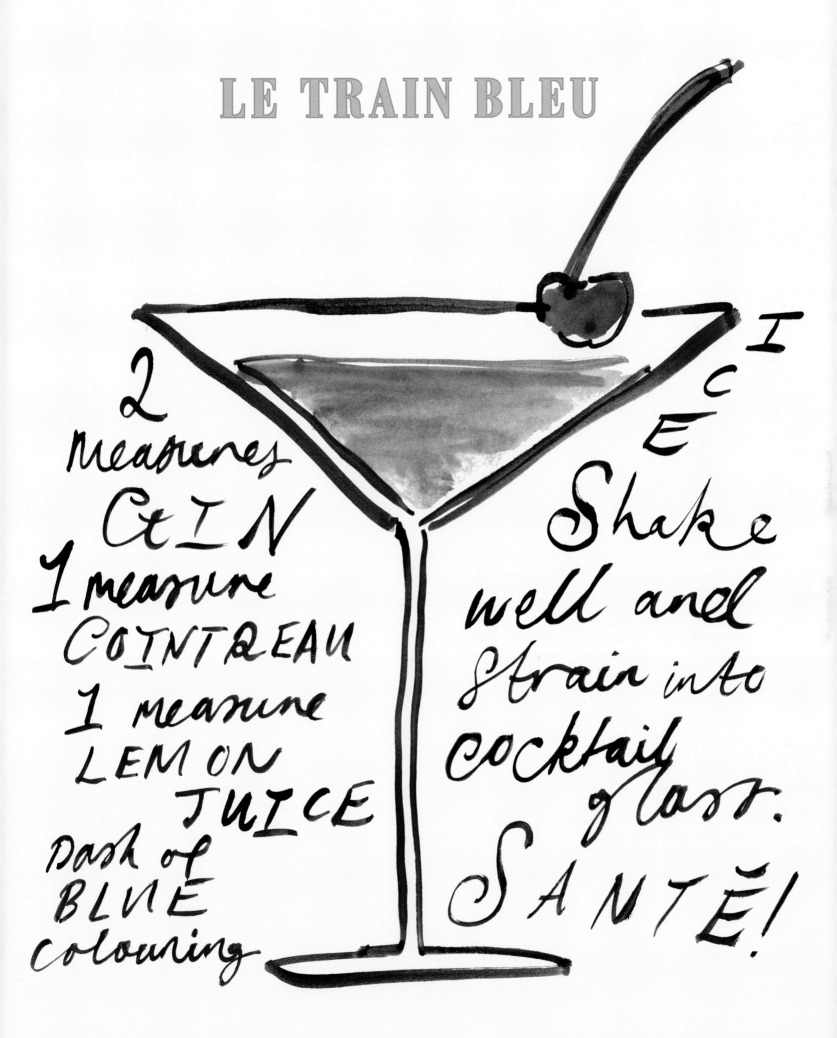

2 measures GIN

1 measure COINTREAU

1 measure LEMON JUICE

Dash of BLUE colouring

ICE

Shake well and strain into cocktail glass.

SANTĔ!

If Sundays in the country are all about
neighbours piling into the cottage, a chicken
roasting in the oven and long and languid lunches,
our flat is a place for easy kitchen suppers with friends. We
might kick things off with a Devil Juice or two – our nickname
for a Martini, affectionately given, because nothing really gets a
dinner going with a bang like a Martini does. (Actually, I'm not
much of a fan. Duncan loves them, but I prefer something bitter
or sour – although I do enjoy the *look* of a Martini, particularly
when garnished with two fat glossy olives on a stick.)

Devil Juice & SPAGHETTI

To eat? If it's a weeknight, a simple bowl of pasta might do the trick. Our house
special is a crab linguine (or spaghetti), made with lots of lemon zest, garlic
and red chilli bashed to smithereens with an old, heavy pestle and mortar, my
favourite kitchen gadget.

We love to cook. It's true that these days we tend to do this at a more leisurely
pace in the country, mostly because we have more space in the cottage (I am a
very messy chef and I won't apologise), and it is also where we spend most of
our weekends, but I still love shopping for ingredients and cooking in London.
There's the bakery around the corner from our flat, with its excellent loaves and
croissants, and the well-stocked greengrocer on Parkway, forever a favourite spot.
And, of course, the Italian deli – a mecca for the truly good stuff: glistening
globes of mozzarella and top-notch salumi.

We've been in the flat for so many years that it is, inevitably, filled with
memories, and many of these relate to food. Those yearly Christmas parties
with their endless glasses of fizz and sloe gin, our few rooms crammed with
friends ... Sunday-morning jaunts down the road to buy newspapers and coffee
and vegetables for lunch, then up the hill to the butcher ... Afternoons spent
making fresh pasta and hanging strands of tagliatelle on wooden spoons slotted
through cupboard handles ... Cakes made for friends' birthdays (I particularly
remember one flourless chocolate number imploding in the oven, a river of
molten butter and eggs) ...

Talking of the festive season, various friends have said to us in the past that when
they visit us (in London as well as in the country) it often feels like Christmas.
Perhaps this is because we feed them up and force them to watch *Poirot* on
repeat. It's the greatest praise we could hope for.

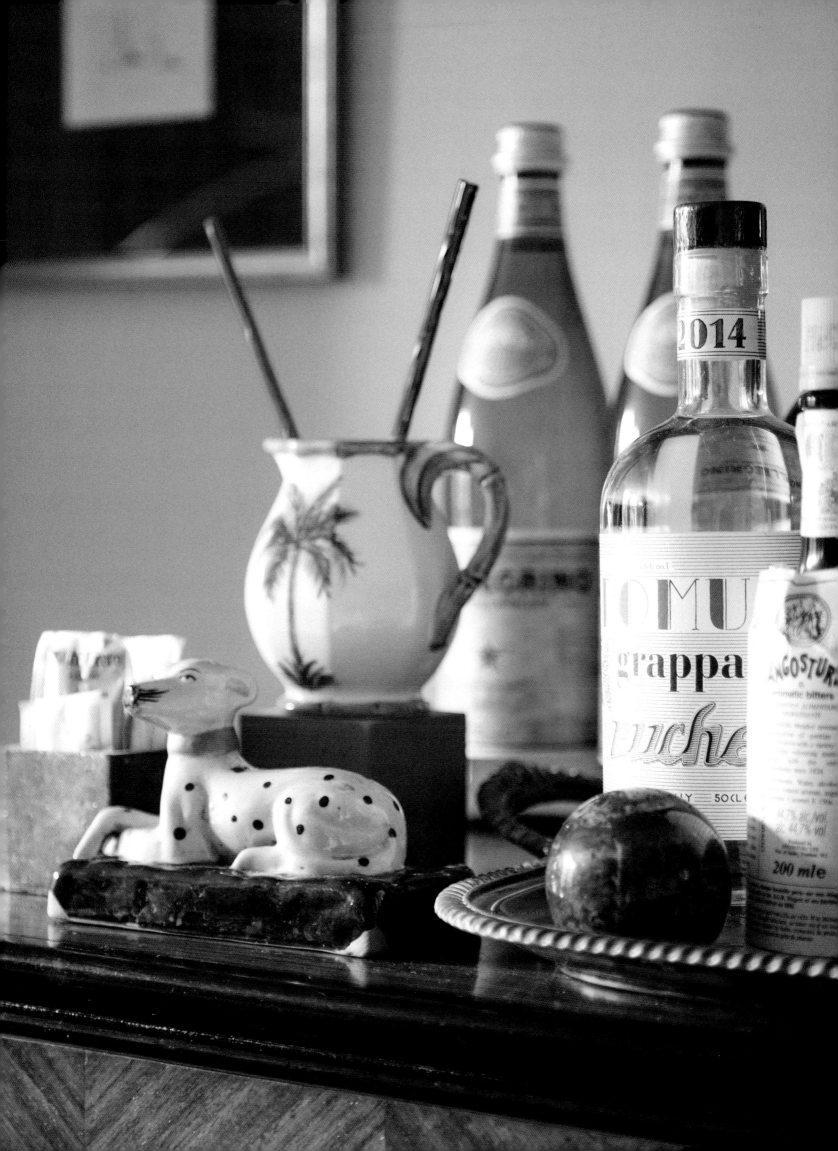

PASTICCERIA

dal 1886 **Tonolo**

Calle S. Pantalon Dorso Duro, 3764
Venezia - Tel. 041.5237209
Chiuso il Lunedì

Conf. da Vaccari • 0532975543 • Ferrara

Caffè Grero
A.D. 1760

Bustina non vendibile ... larmente

Caffè Grero
A.D. 1760

Dolcificante ... Torino
A BASE DI SACCARINA E CICLAMATI

MADONNA INN
M
SAN LUIS OBISPO
100 Madonna Road • San Luis Obispo, CA • 93405
Madonnainn.com

NON VENDIBILE SINGOLARMENTE

FLORIAN

zucchero

DA ADOLFO

Ristorante - Bar - Stabilimento Balneare

www.daadolfo.com - info@daadolfo.com

Conf. da C.C.I.A.A. ...2794 - Via Nazionale - Montecorvino R. (SA)

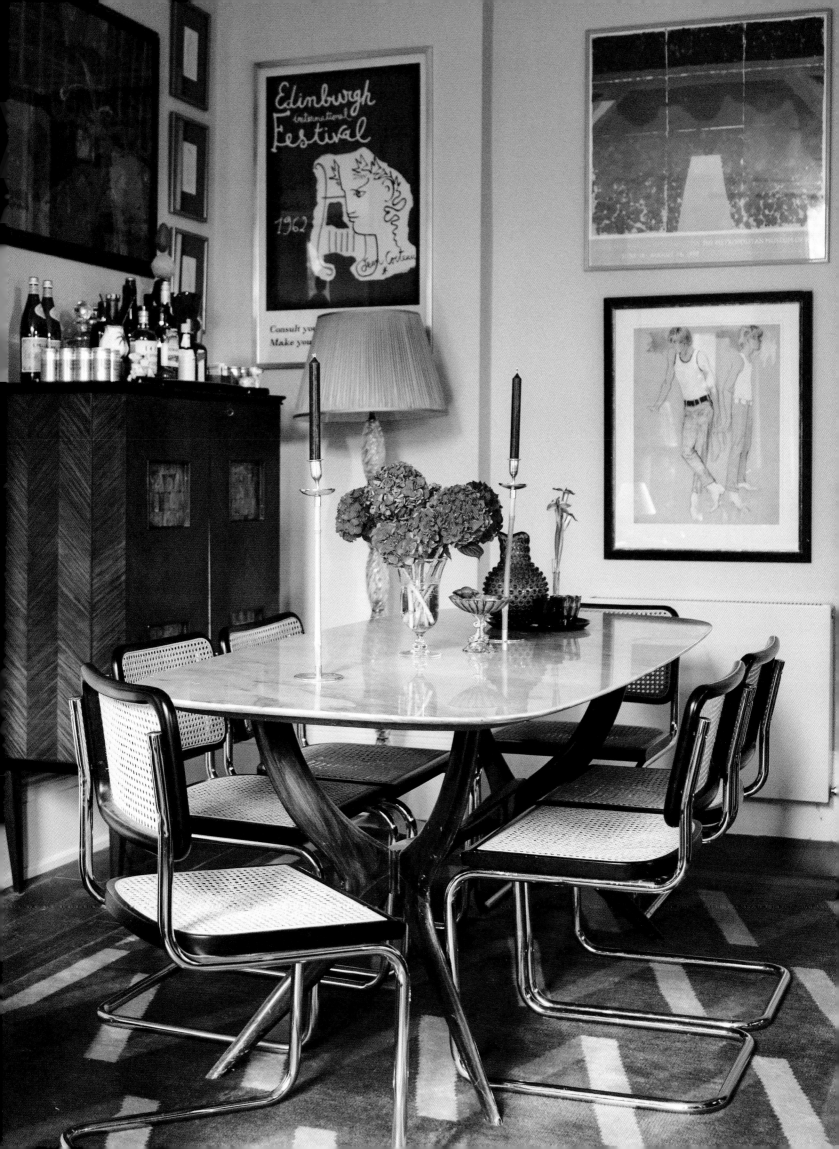

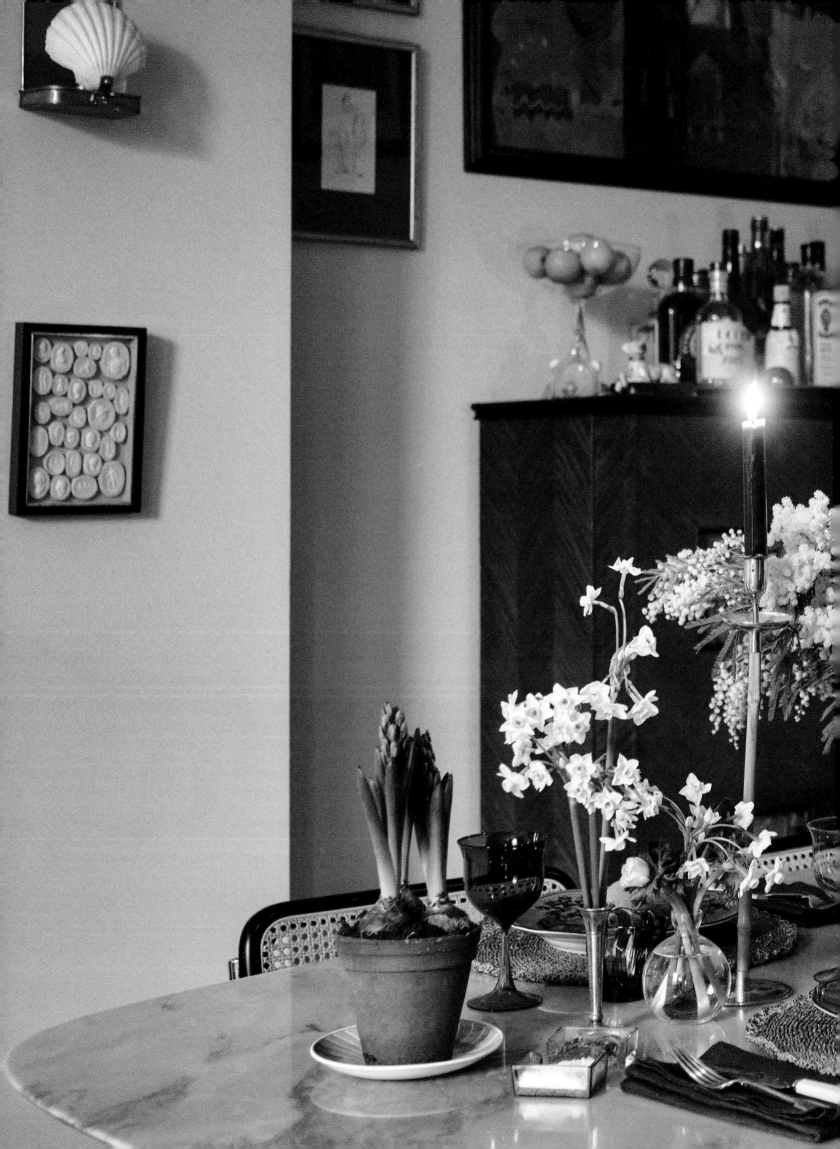

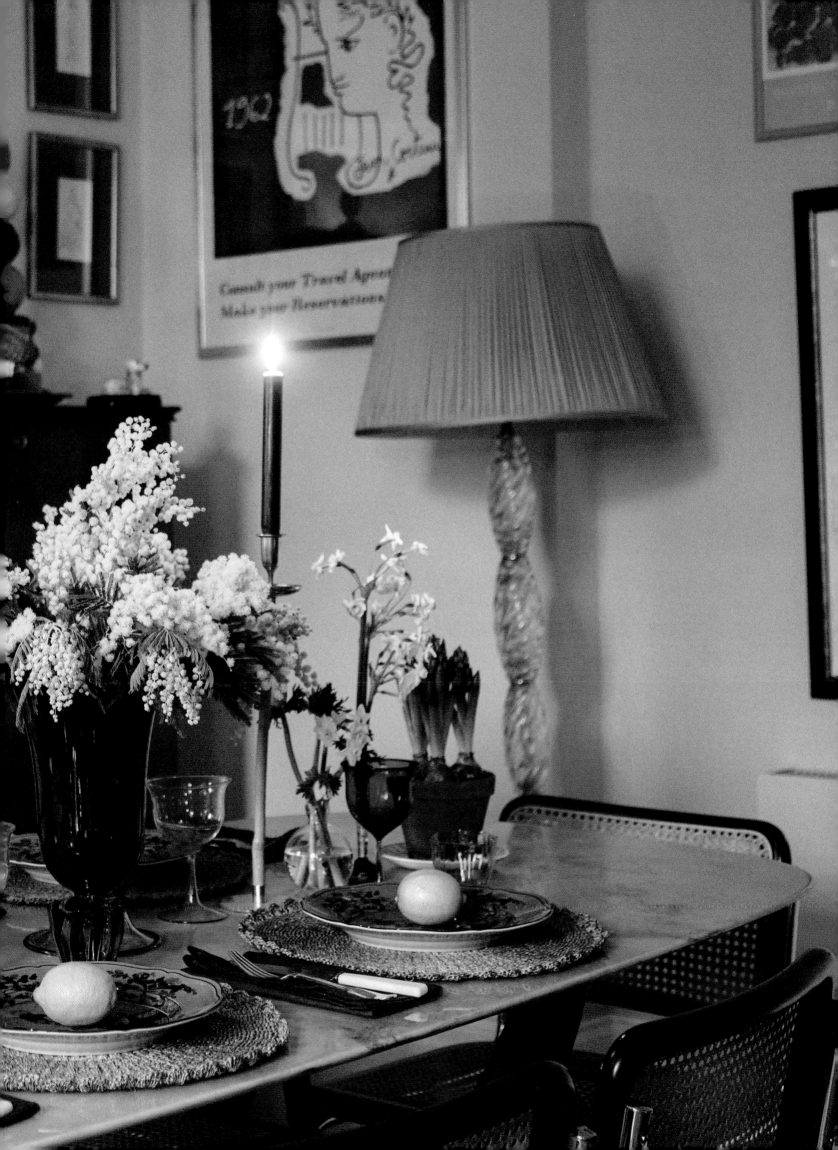

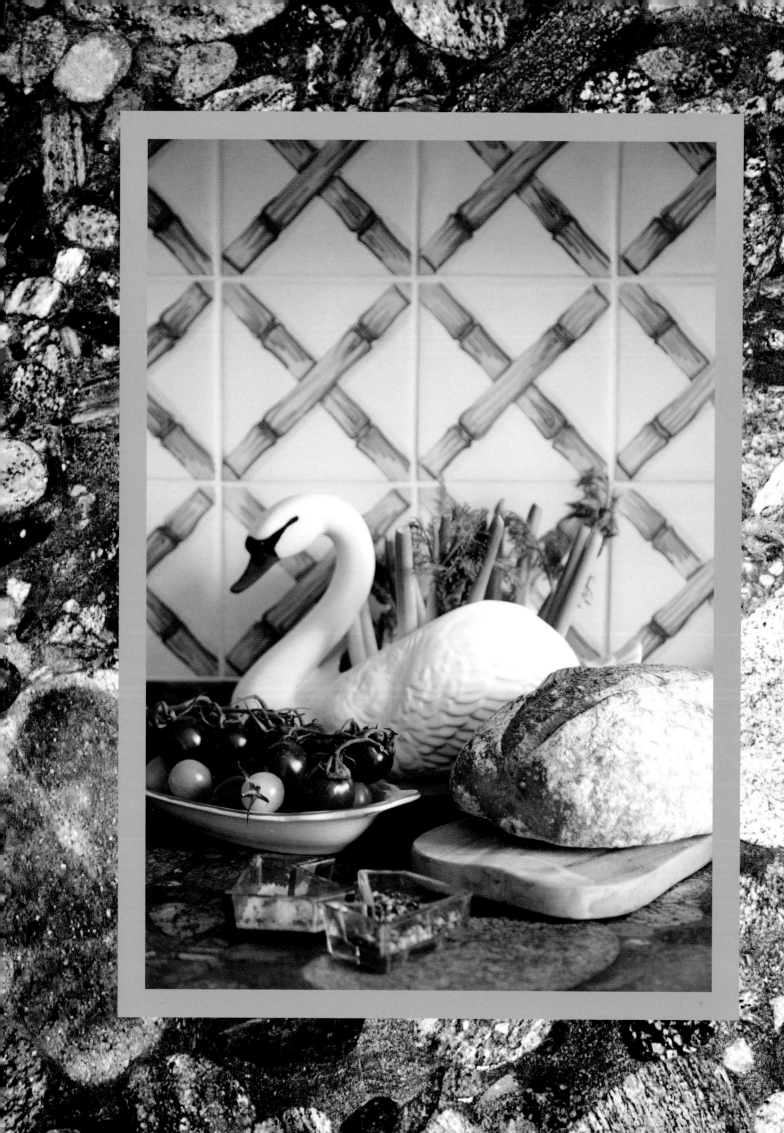

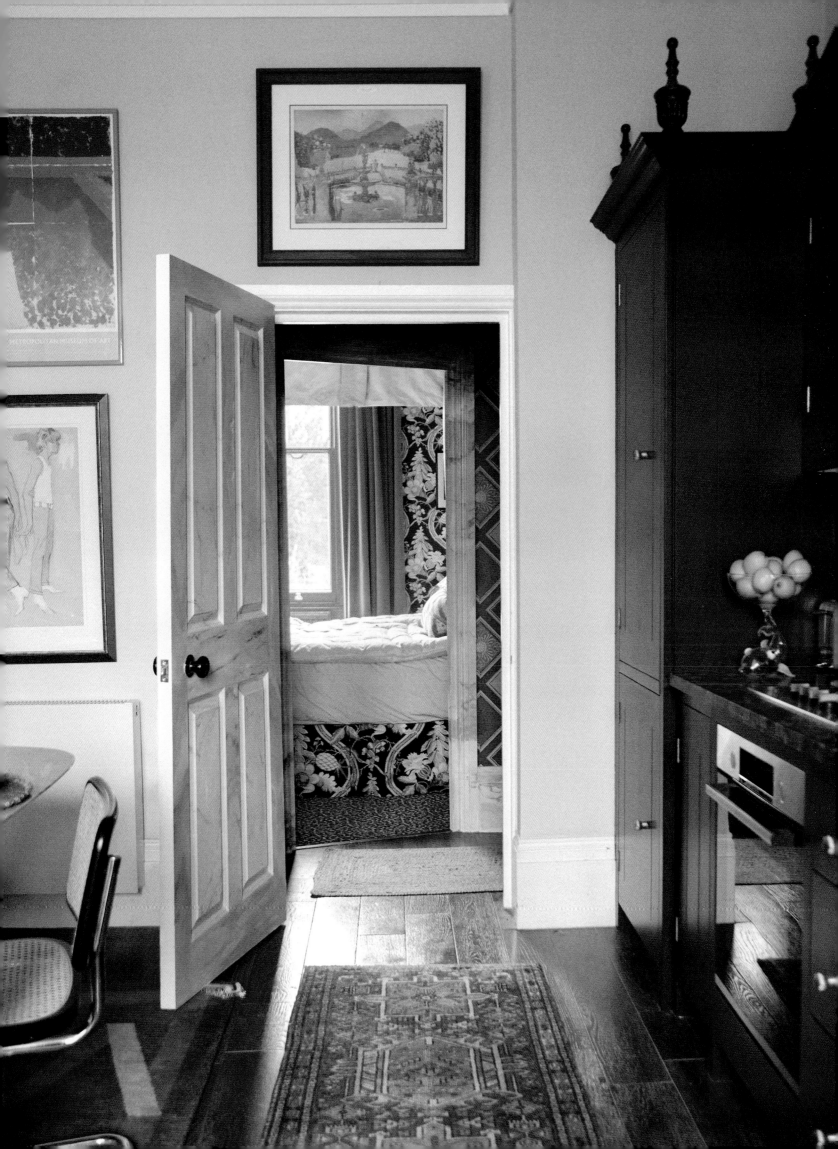

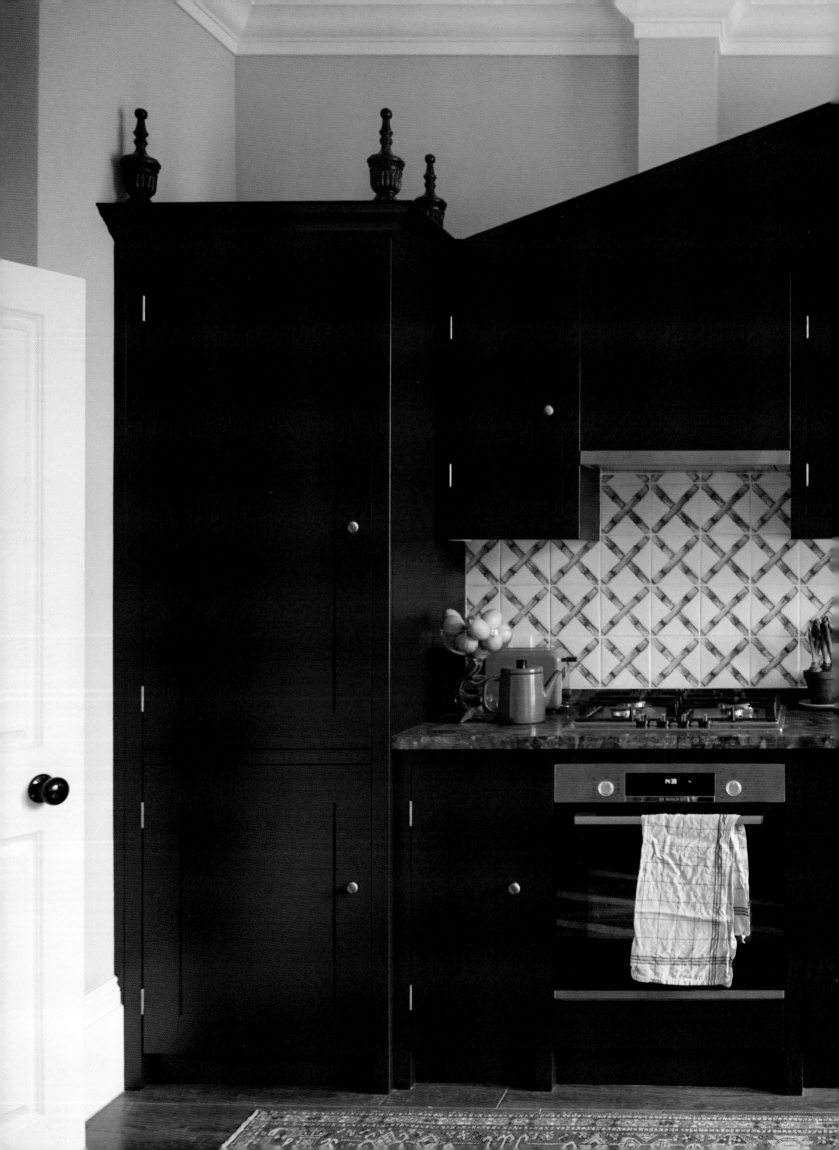

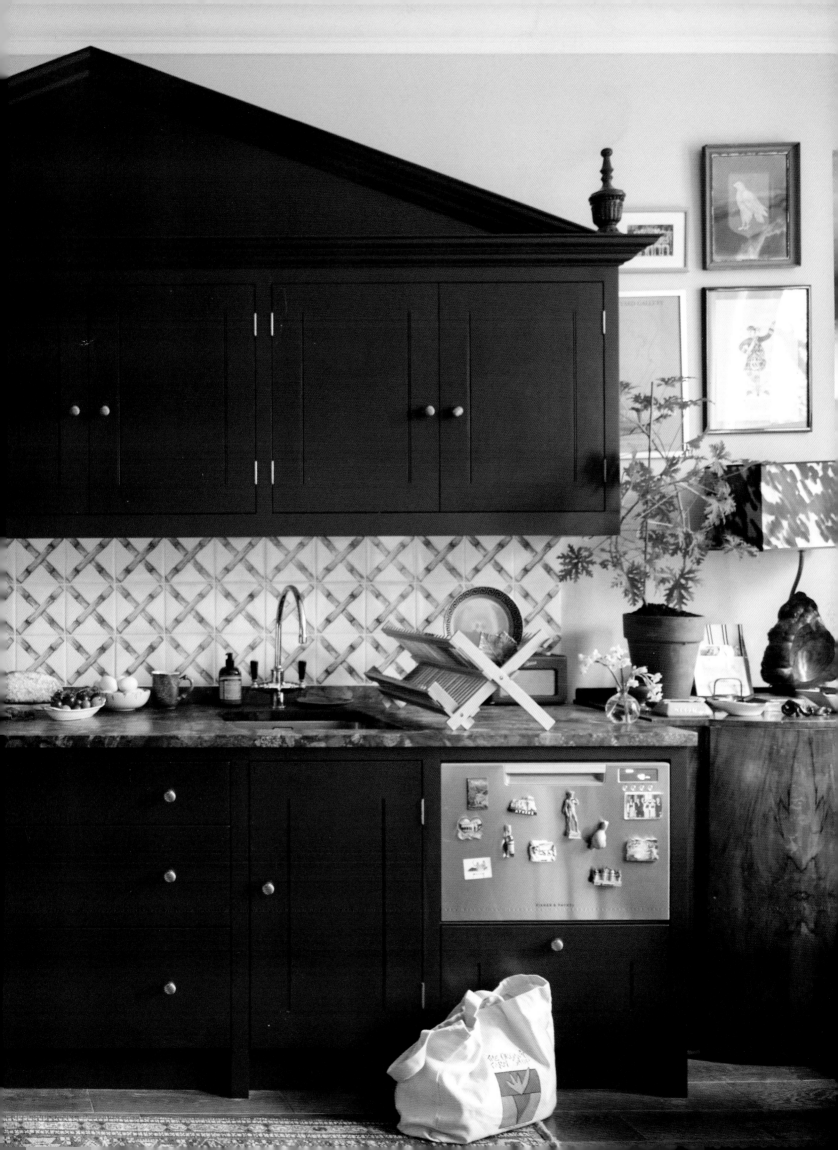

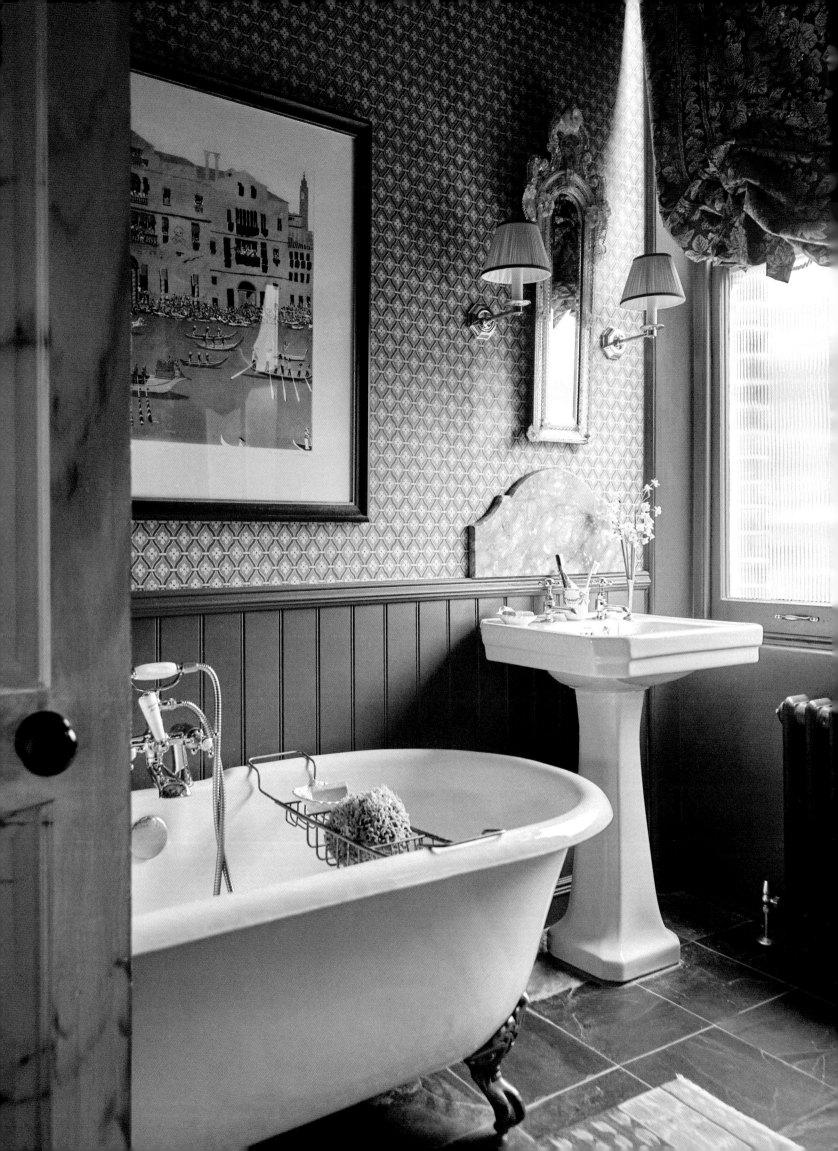

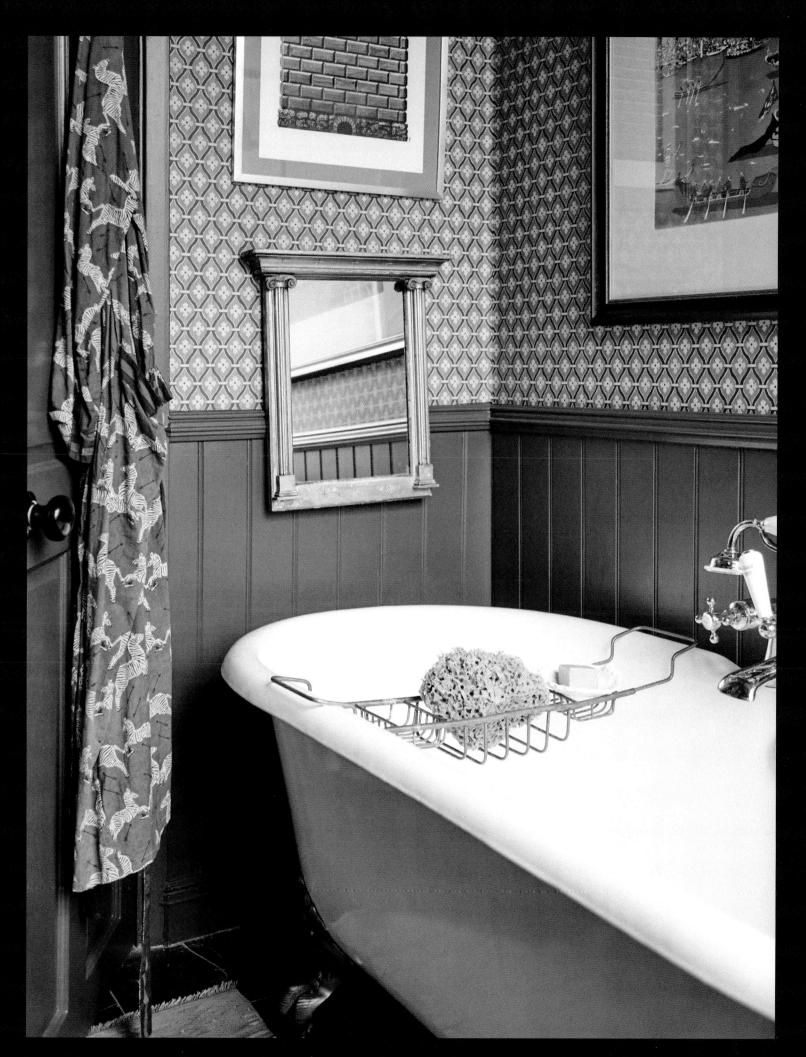

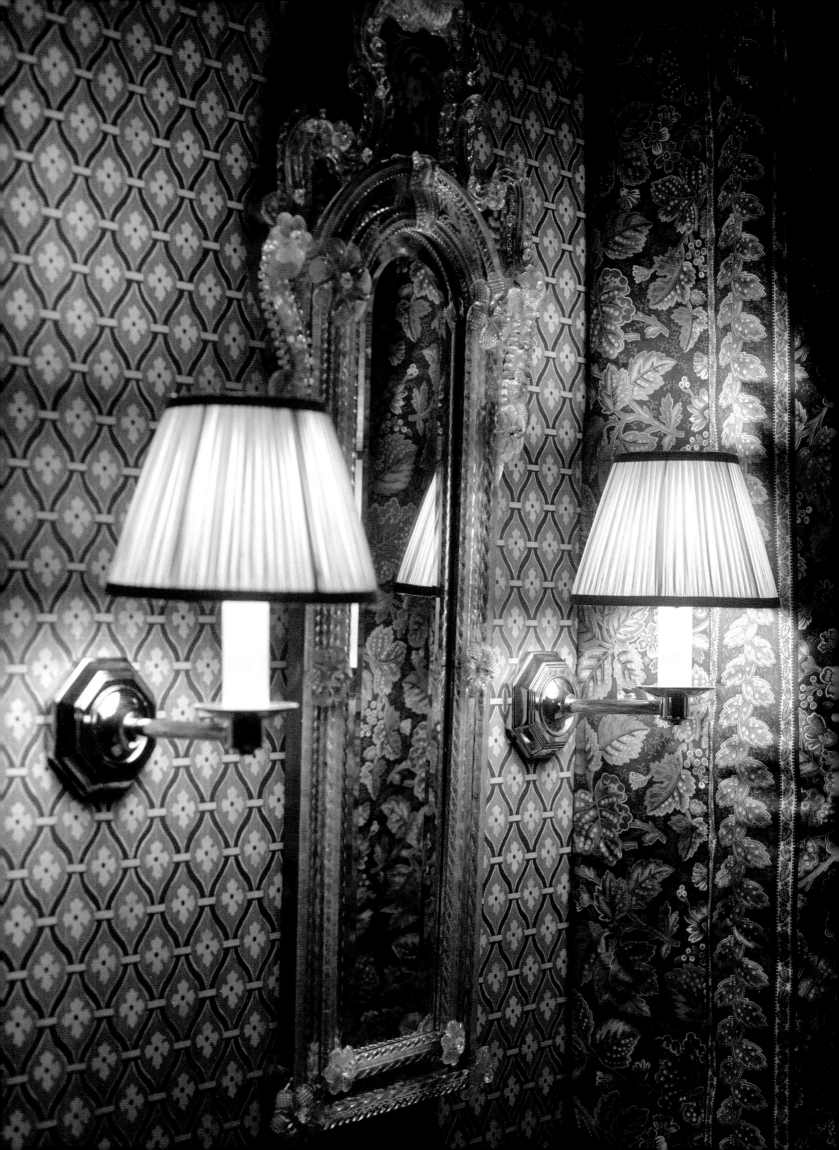

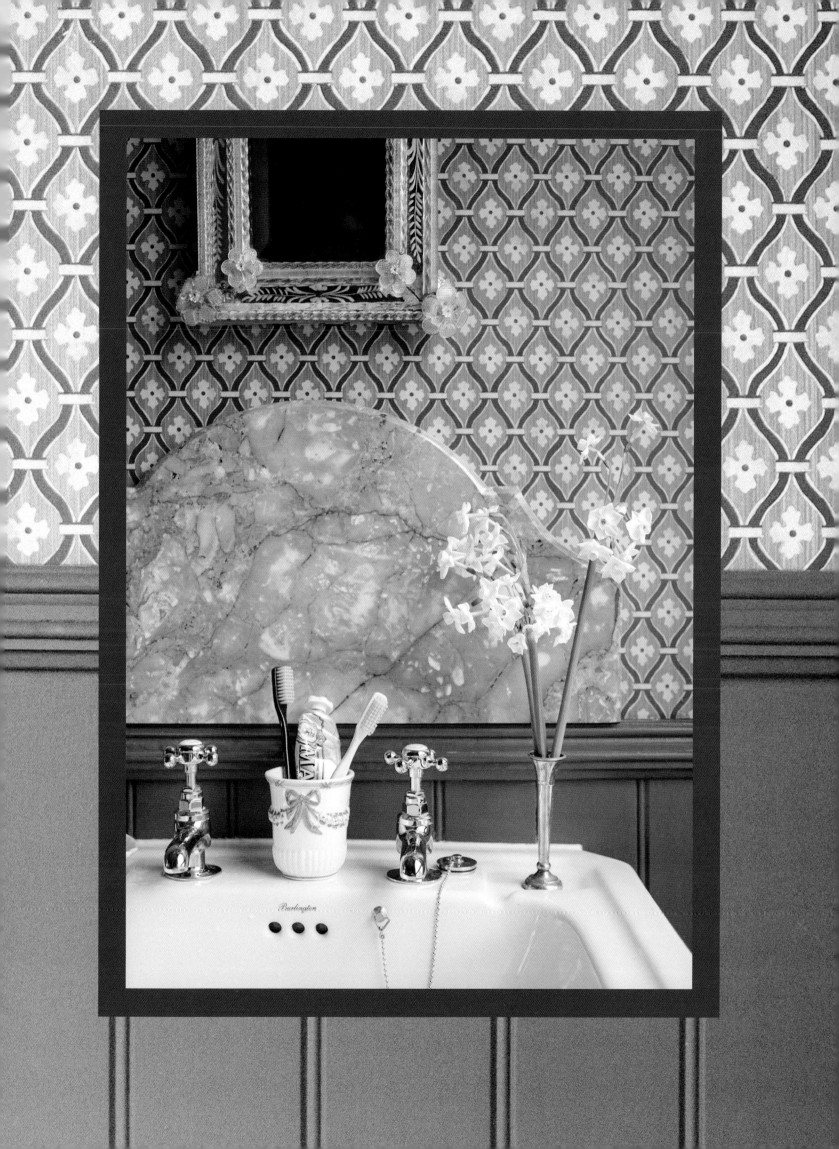

party CLOTHES

I've got a real thing for beautiful, special clothes. My small collection of fanciful items – mostly old but sometimes new – is stuffed away in drawers and boxes: a 19th-century jacket made for the theatre, with beaded decorations and exaggerated shoulders; at least eight cotton shirts with frilly collars and cuffs; a monochrome matador's jacket with Keith Haring-style embroidery; and many a different kind of waistcoat, including a Regency number in grass-green silk embroidered with flowers and an Austrian version with two rows of shiny silver buttons up its front.

I absolutely love a waistcoat. There are, of course, various kinds of sleeveless jacket, and I enjoy them all, from highly decorative and embroidered silk beauties, like those you might find in the collections of important museums, to the humble jerkin in scratchy brown wool. I went through a phase during the pandemic, in fact, of turning fabric scraps left over from past design projects into simple jerkins. Old linens and cottons printed with flowers, stripes and trellis patterns were given a new lease of life, as I tried to combine the utilitarian with the ornate. I wanted to make colourful, flamboyant waistcoats that I could wear to a smart party, but which, with their modest fabrics and relaxed cut, would work just as well as garden gear, unfazed by the odd mud splatter. Eventually I closed the tiny enterprise to focus on a new clothing project, Chateau Orlando. I still wear the waistcoats, though.

A lot of the special pieces in my wardrobe might be too big or small to put on, yet I treasure them dearly because they are beautiful objects. Some are extremely delicate, with fraying threads and pockets missing their lining. The odd piece, I'll still dig out for a party.

Any excuse to dress up.

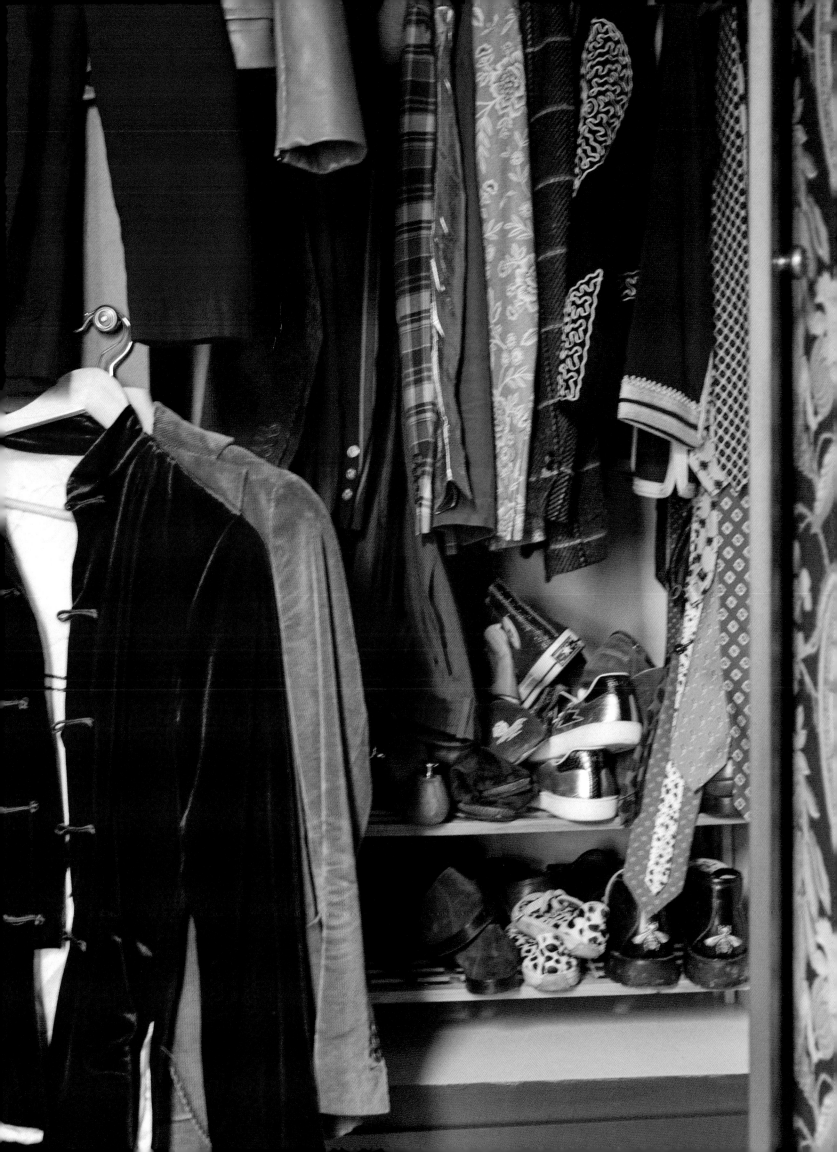

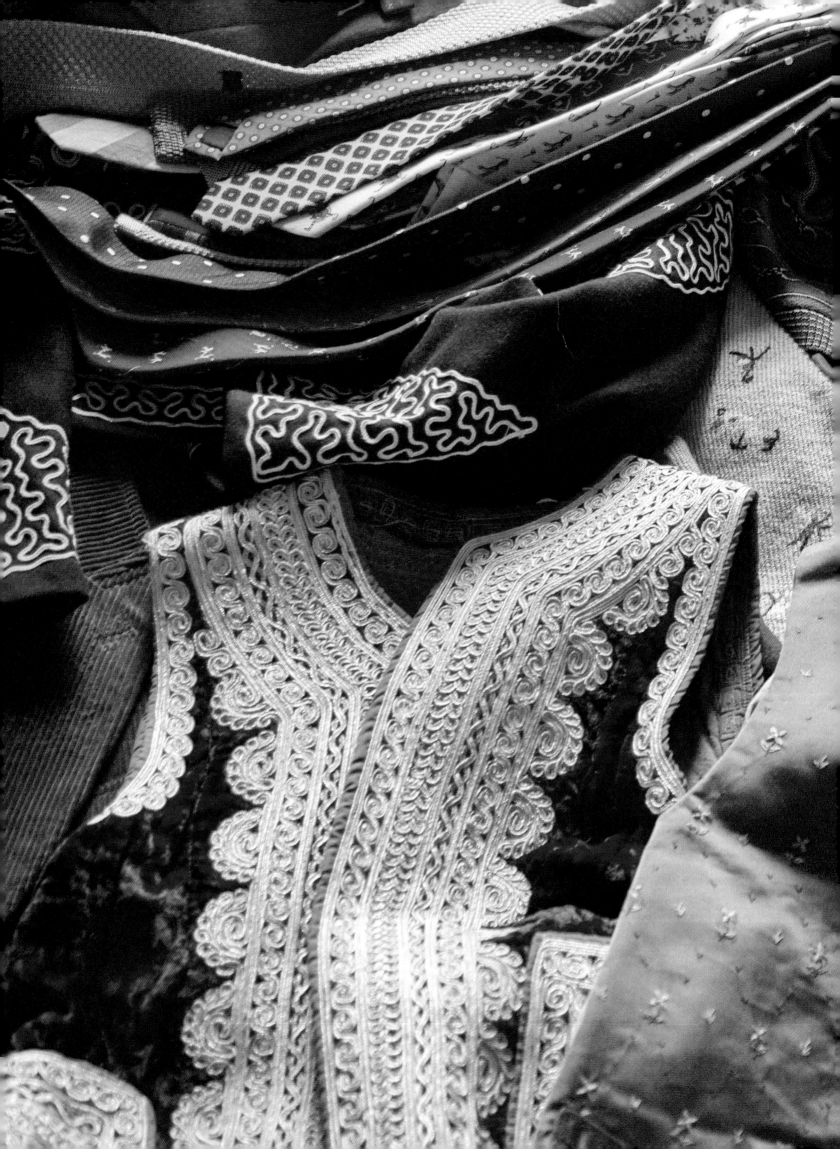

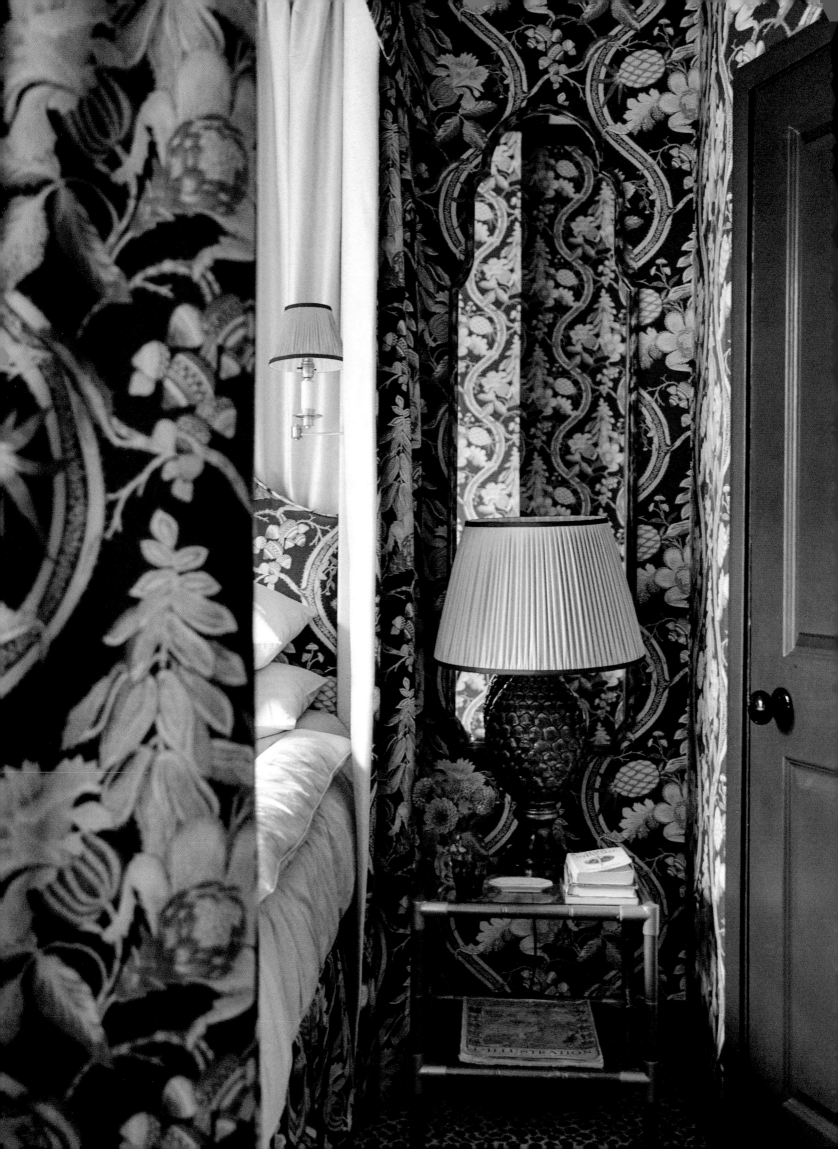

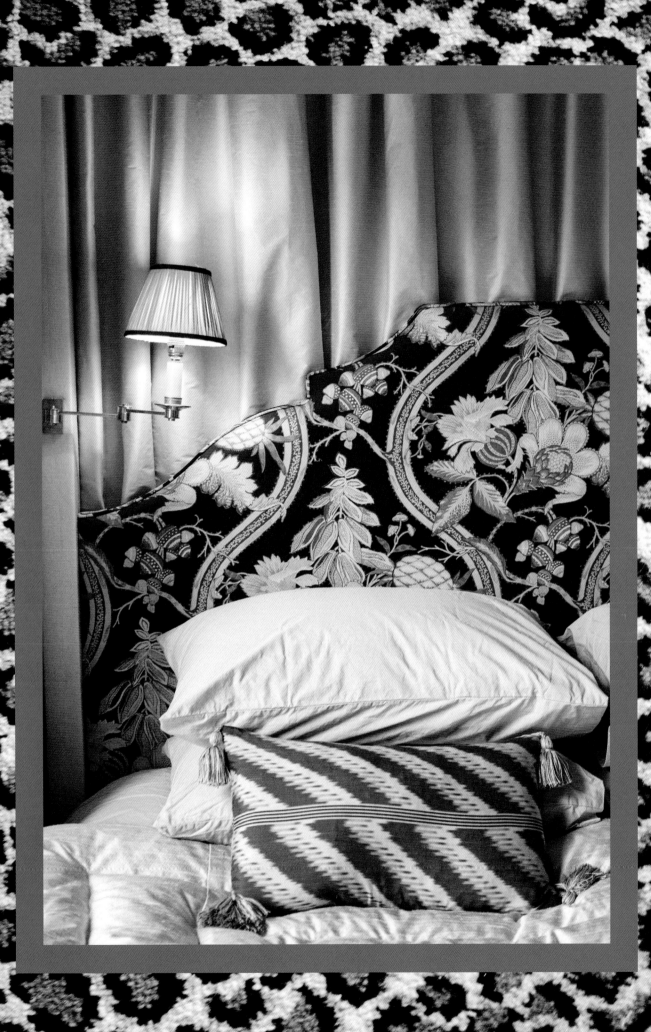

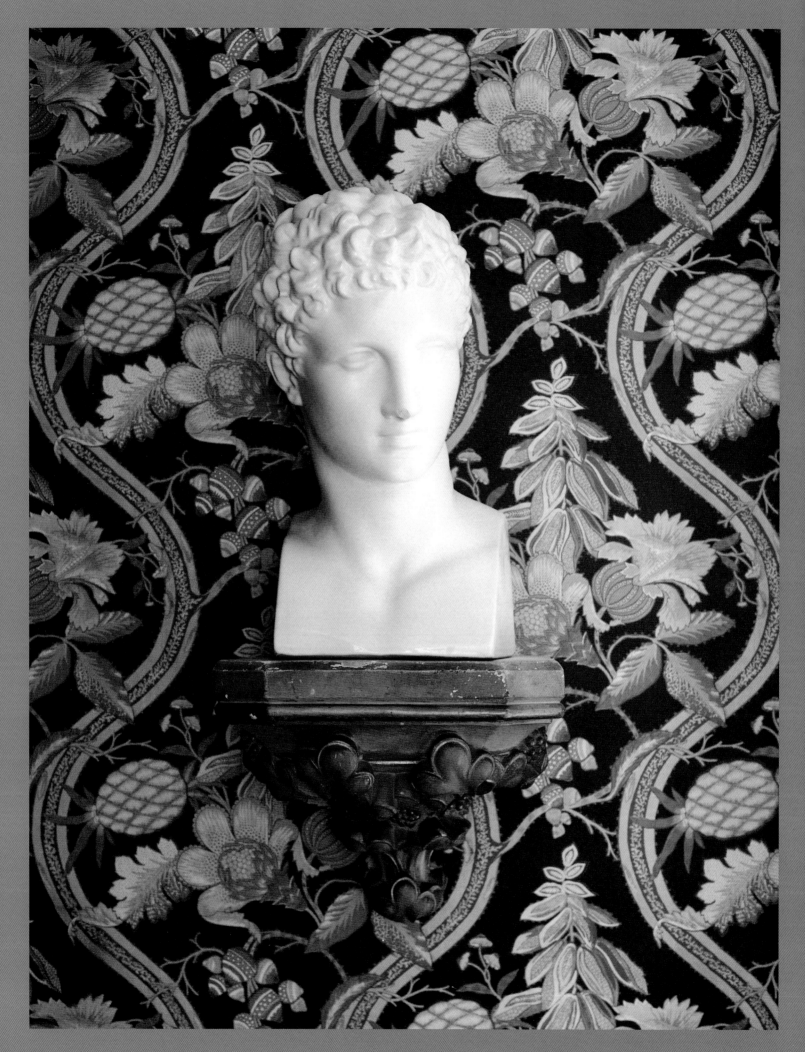

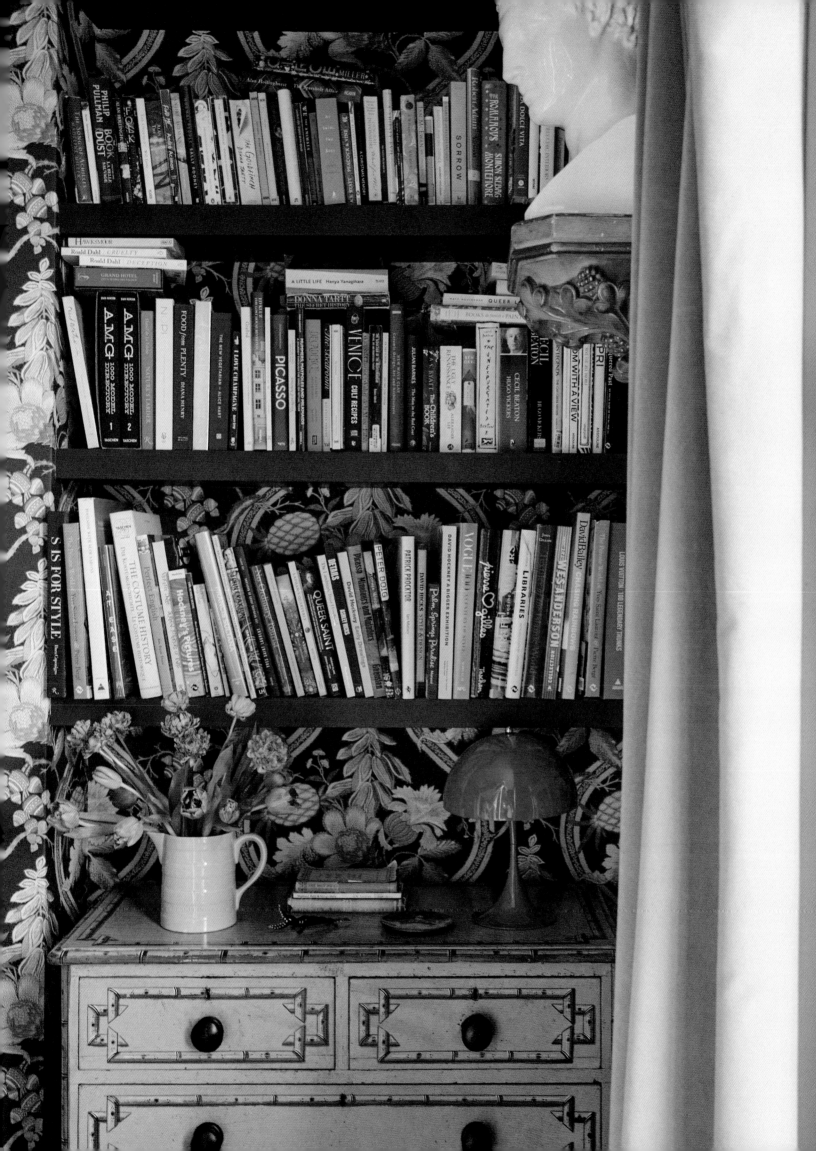

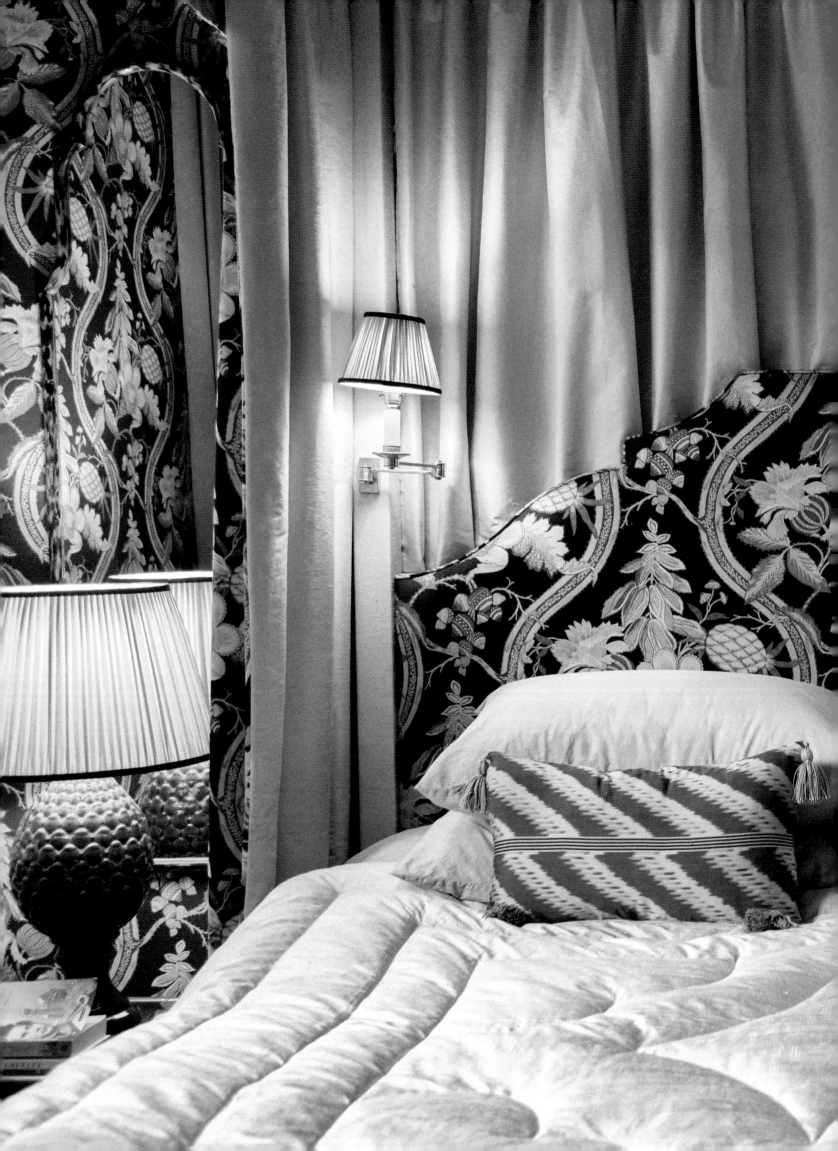

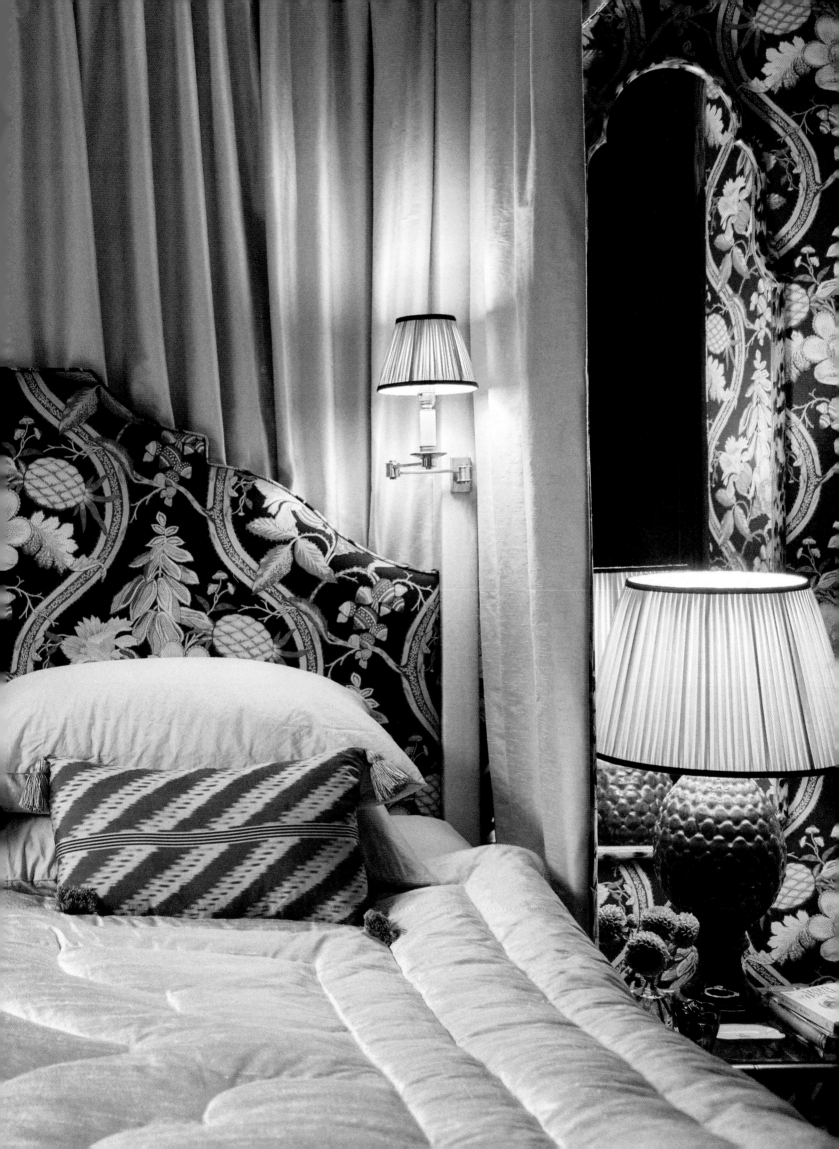

STUDIO

My STUDIO is me
and my work and
all of the things
that inspire it:
postcards from
friends and galleries
and museums; books;
pots of paint and pencils
and brushes; headless
busts; endless odds and
ends; flowers in a vase
transported from our
garden in the front seat
of my Jeep.

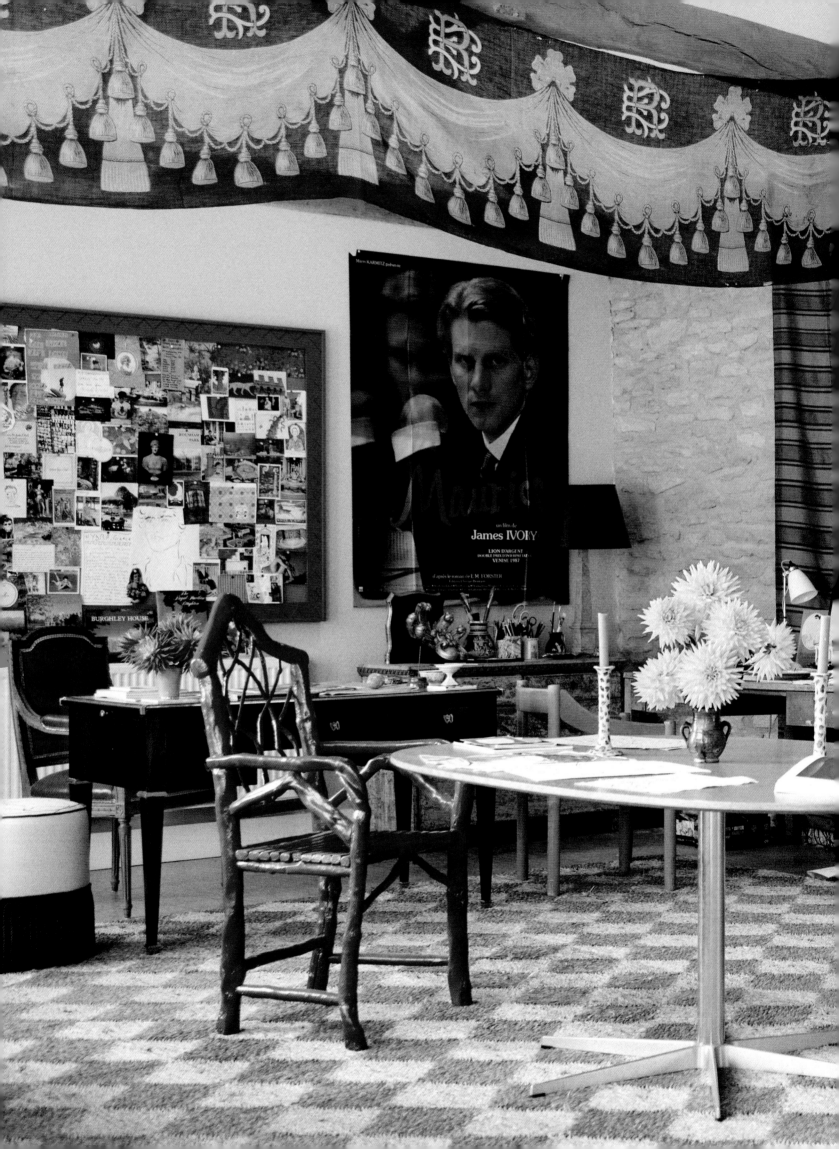

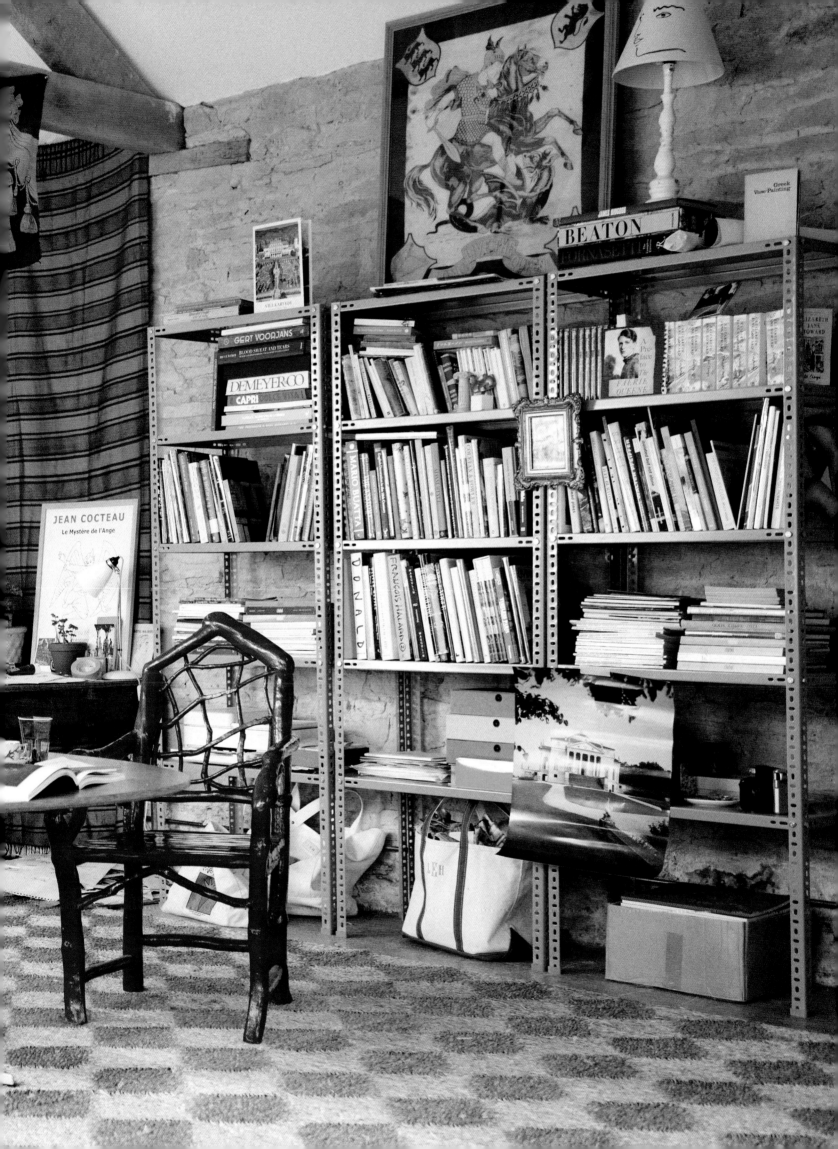

L.E.H. HQ has taken up residence in various locations. When I began working full-time as an artist/designer/something in 2015, our kitchen table in Camden transformed every morning into my desk, my easel and my library. (Duncan worked at a proper writing table round the corner.)

I progressed to a patch, maybe three by three metres, in the back of my friends' art gallery down the road from our flat: it looked like a kind of installation in shades of pink and orange. Later on, I moved my work things into a flat in Highbury, which I shared with a couple of great friends. I enjoyed this time: I cycled to work, and we listened to audiobooks and ate pastries from the good bakery across the road. The pandemic was a strange period for studio life – I worked mostly at our dining table in the country, with my books and materials stored under sheets in an outbuilding. I tried to work in there, but the light wasn't much good, and my tea would practically freeze in its mug when winter came. So I looked around and eventually found a space on a farm not far from our cottage. It has stone walls and big windows, with towering black barns and sheep grazing out front. The light is much better compared with my old shed ... and there are radiators.

It is important for a person to have a space (small or big) that is completely theirs, I think. A place to work and think and be. My studio is me and my work, and all of the things that inspire it: stacks of postcards from friends and galleries and museums; my books; pots and pots and shelves of paint and pencils and brushes; my work archive; things I have collected, like ceramic ashtrays and headless busts and bundles of fabric scraps, and endless odds and ends; cut flowers in a vase, transported from our garden in the front seat of my Jeep.

My biggest luxury? The four desks. I always wanted a French ebonised number, handsome and shiny and proper, and now I have one. I sit here, underneath my giant pinboard, typing emails and drinking little coffees. An old bashed army desk from the 1950s is the desk I've had since the gallery days – this is where I paint and draw. The dining table in the middle of the room is usually covered with open books and boxes of things I need to look at; I'll waft over from another desk and dip in and out. Last, a simple glass table by a window plays host to fabric swatches and paint charts, and will be in use most heavily when I'm working on an interior design project. I'm generally involved with several things at once, and it's key to physically separate stuff. Plus, lots of desks means lots of chairs, and I love a good chair. The bright-red coral-like ones you'll see in the following photographs came from Morocco.

The studio is a chance to showcase what I'm about, but mostly it's a messy, practical space – a space to squirrel myself away in and make things. A space for me.

182

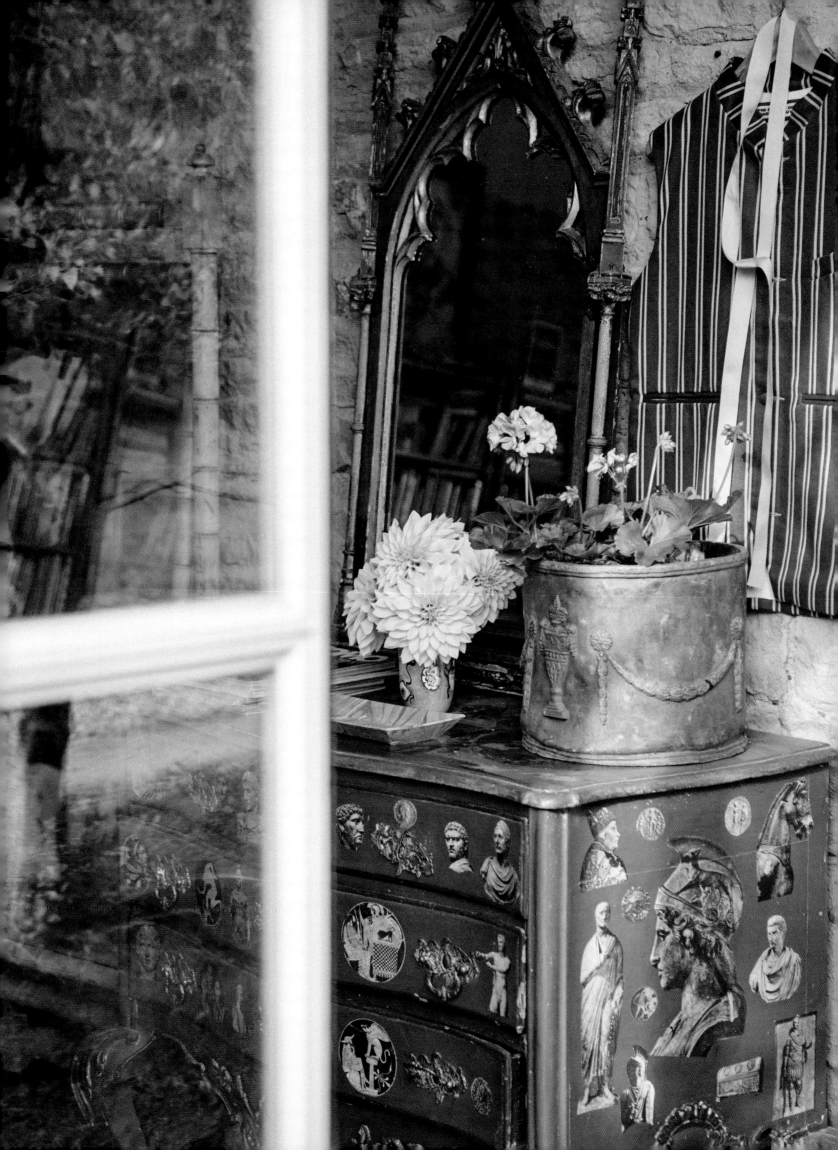

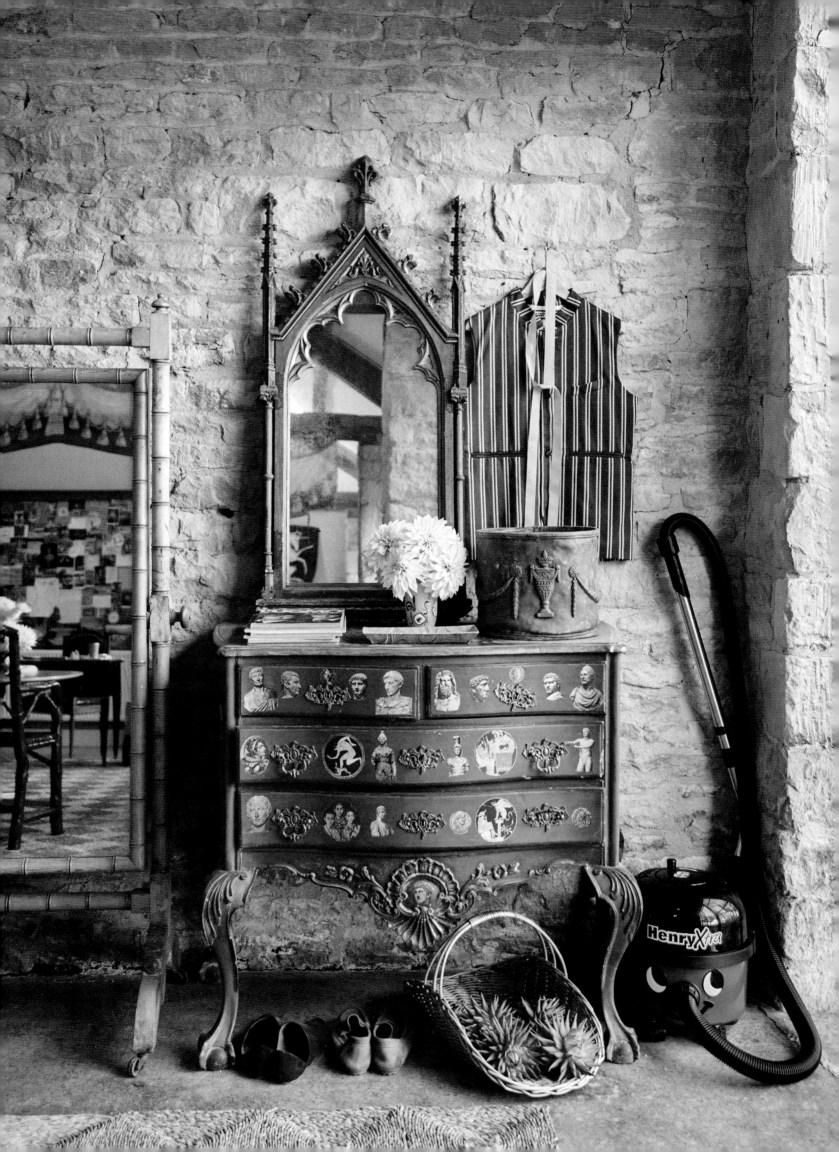

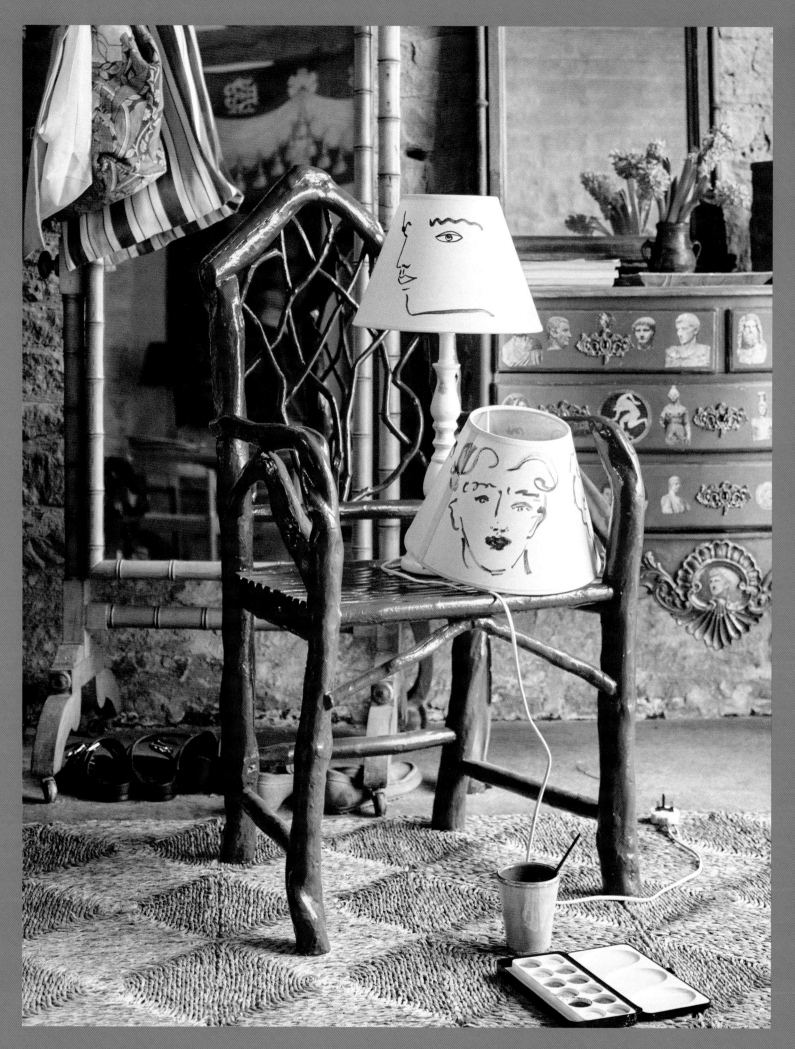

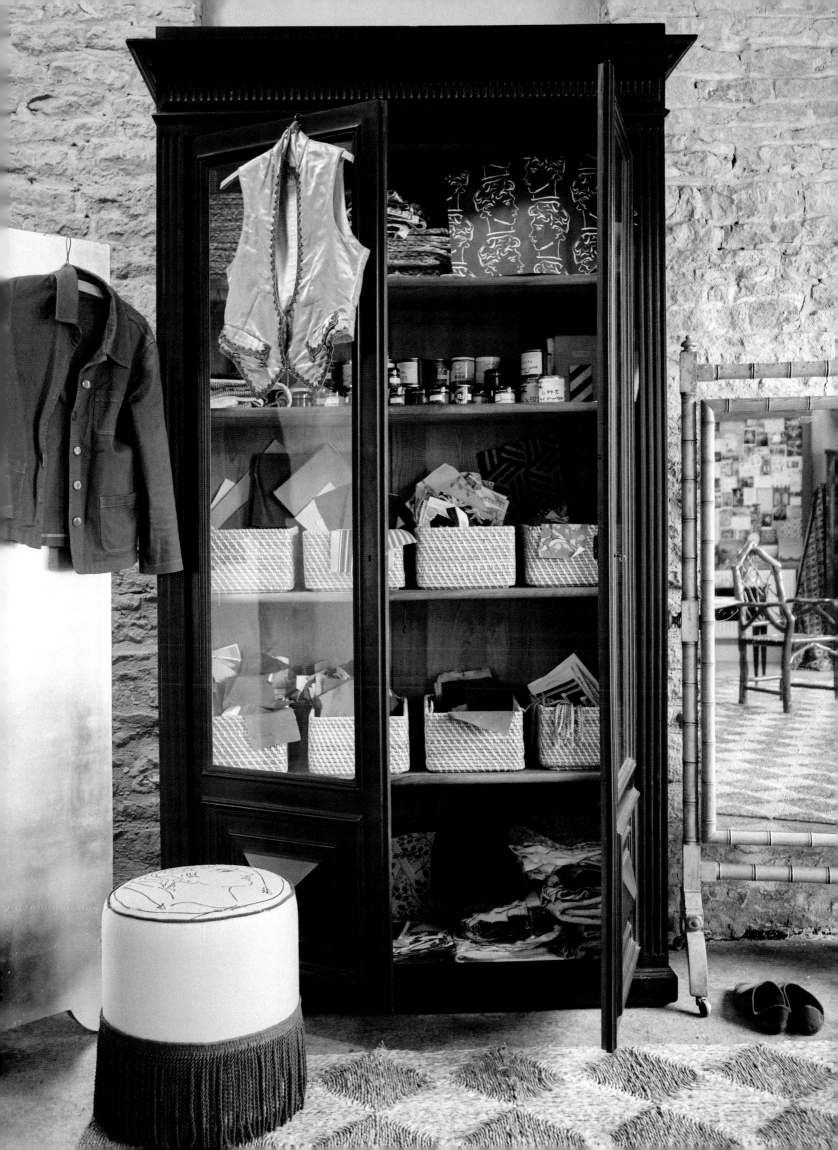

Books
books
BOOKS

When people ask me what I collect, my first answer is usually books. My idea of absolute, total heaven is a second-hand bookshop, particularly one that deals in old and rare tomes. The cottage is full of books, mostly novels and biographies and books about gardening and cooking, whilst my studio is given over to my collection on favourite artists, photographers and designers, buildings, movements and fashion, both past and present. There are stacks of magazines, too, and boxes of books-but-not-quite-books: pamphlets and old exhibition and auction catalogues.

There are copies of *Interview* and *The Face* from the 90s; *Horizon: A Review of Literature and Art* from the 40s; *Smash Hits* from the 80s; Habitat catalogues from the 70s. I love my old issues of *Casa Vogue* and *L'Uomo Vogue* most of all. I can't understand Italian (much to my chagrin), but I adore the pictures, the typography, the graphic design.

I find books online, and I have favourite shops and dealers. In every city I visit I track down the best places to find new and old publications, many of which I return to year after year. I love the thrill of scanning bookshelves, delving into piles and sniffing out treasure.

Favourites include an original copy of *Cecil Beaton's Scrapbook* and books by David Hicks, Pierre Le-Tan and Walter Pfeiffer. We have two very special little books depicting the carpet and chair designs of Emilio Terry, the French architect, artist and interior decorator. Books, you see, are key to all of my projects, particularly when I'm starting a new job. I'll leaf through this one, get lost in that one, forget about another, then find it at the bottom of a pile. Books spark ideas. And you know what John Waters said about people with no books at home …

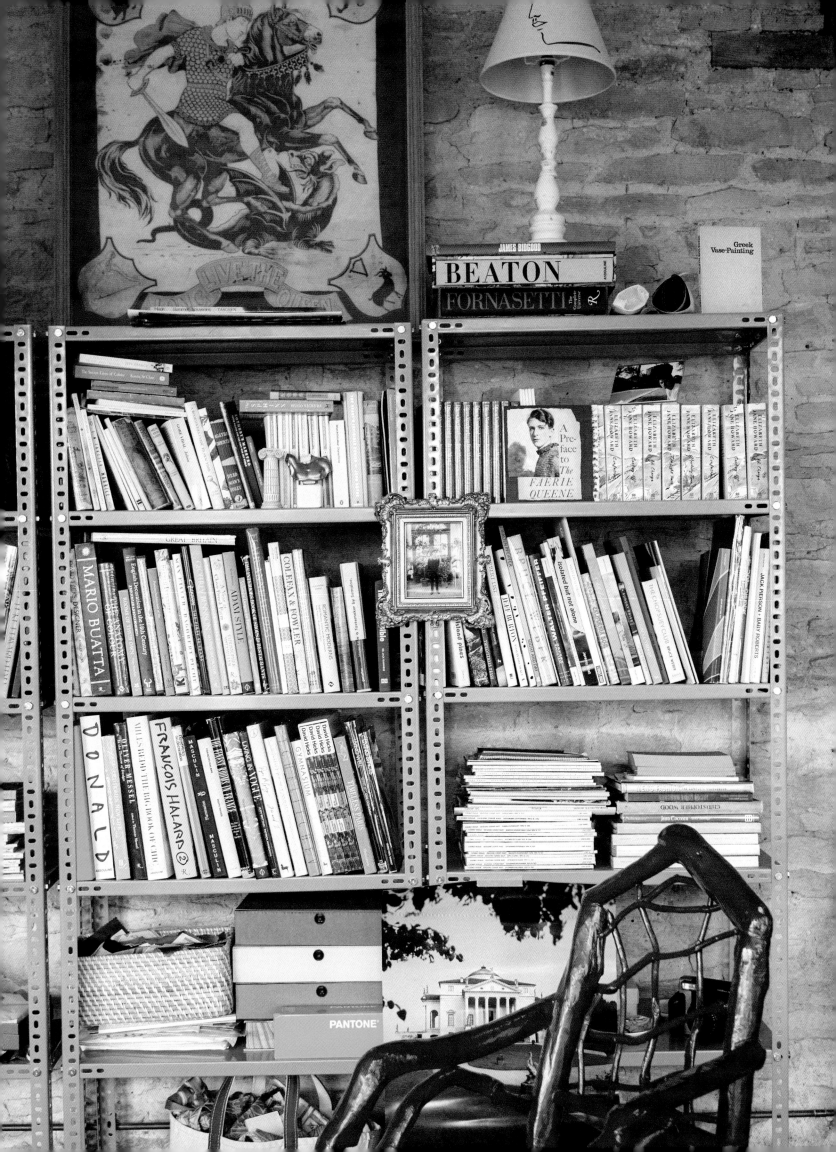

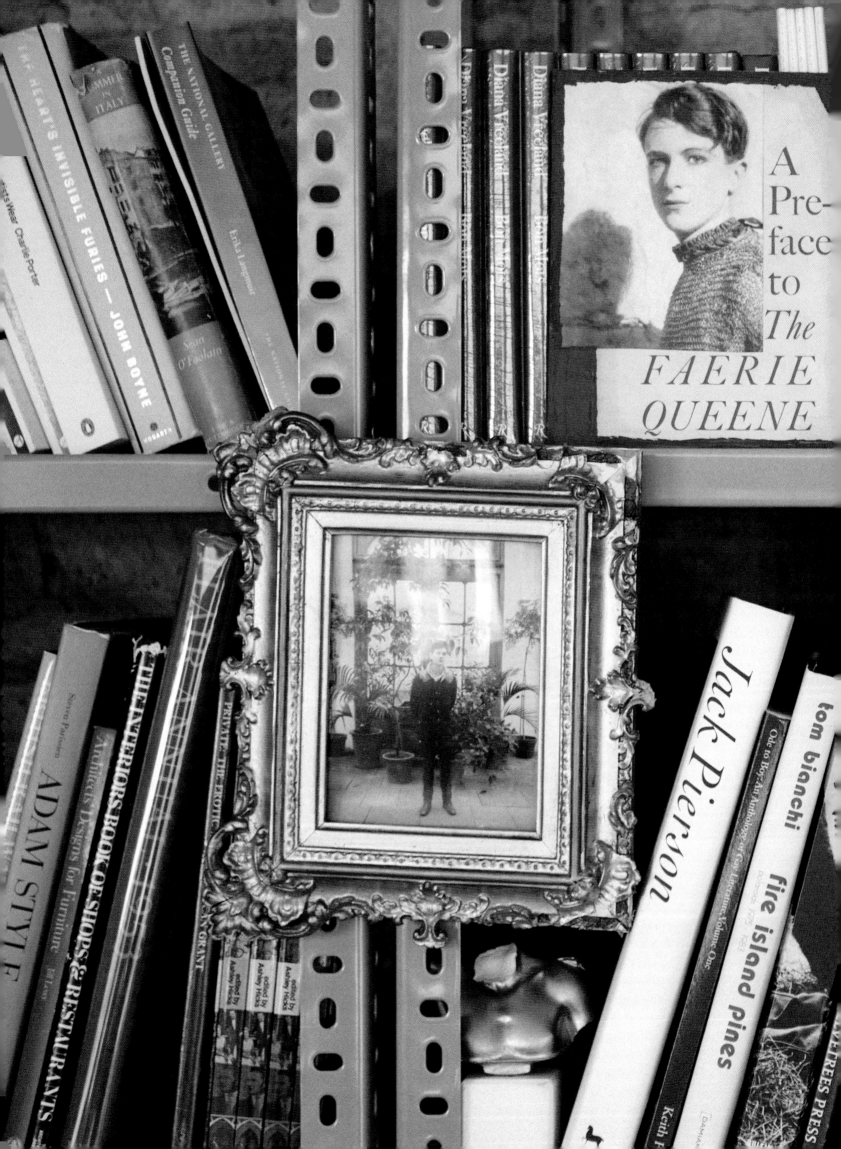

Top shelf (left to right):

- The Queer Bible — ED. JACK GUINNESS
- SNAPSHOTS — GH: William Morris & Andy Warhol
- ...ted but not alone — MODERN ART OXFORD
- FAX & FOWLER — CHESTER JONES
- ...Jeremy Kost
- CHARLESTON The Bloomsbury Muse
- IN VOGUE
- NASIUM — Judy Brittain / Patrick Kinmonth
- LUKE SMALLEY
- ...PACES
- AGATHA CHRISTIE — DEAD MAN'S FOLLY — Collins
- EDITED BY...



- EPIPHANIES
- DUANE MICHALS — QUESTIONS without answers
- HERBERT LIST — DIARIO ITALIANO
- JEFF BURTON — ESSAY BY DAVE HICKEY
- WALTER PFEIFFER — NIGHT AND DAY
- WALTER PFEIFFER
- WELCOME ABOARD — WALTER PFEIFFER · ANTONIN...
- OCTOBER
- SENSIBLE PLEASURE
- ISHERWOOD · BACHARDY
- Mel Roberts CALIFORNIA Boys — Photographs 1955-1990
- TM WALTER
- SUNDAY DRIVE — Luke Smalley
- WONDERFUL THINGS
- PETER JAMES — SAVED
- JACK PIERSON + BABY ROBERTS

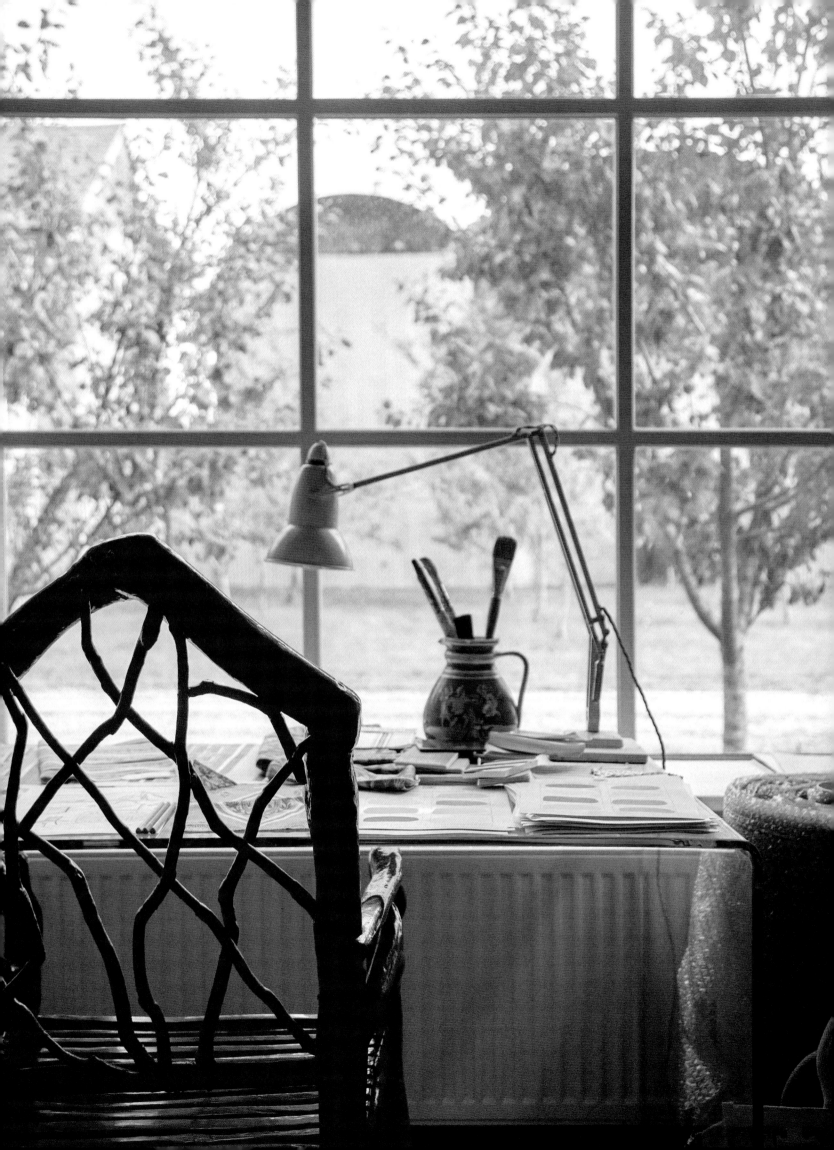

I have always loved this description. The way I put a room together feels similar, in a way, to how I might make Sunday lunch. With a room, I usually begin by selecting a paint colour or wallpaper or piece of furniture that will become the star of the show: a big squishy sofa in a fabulous patterned fabric, say, or a dazzling cabinet, all inlaid marquetry and wobbly glass. That's the roast chicken. There are accompaniments: side tables (roast potatoes); cushions (carrots). And then there are the extra bits that make it all so delicious: collected objects (bread sauce); books (gravy); flowers. A successful interior is more than the sum of its parts – as is Sunday lunch! It's all of the elements working together to create something spectacular. Salsa verde perks up roast lamb, just as zingy lemon-yellow upholstery gives a new lease of life to an old armchair. (I promise I shall stop with the lunch comparisons now.)

It was Nancy Lancaster, the 20th-century tastemaker (and American co-owner of hallowed English interior decoration firm Colefax & Fowler), who likened her method of decorating to preparing lunch:

LIKE mixing A salad

'A gentle mixture of furniture expresses life and continuity but it must be a judicious mixture that flows and mixes well. It is a bit like mixing a salad. (I am better at room than salads).'

When I get home from the farmers' market, shop, whatever, I take a peculiar joy in unpacking items and laying them out on the kitchen worktop. Before putting everything away, I savour that brief moment of seeing the ingredients I've picked out arranged and waiting to be made into lunch or dinner. It's a similar story with the photographs here: I love gathering together wallpaper and fabric samples, paint charts and sketches – a few of the many ingredients needed for a fabulous room. One has to have imagination and the ability to visualise, after all, both with cooking and making rooms!

My favourite rooms are all about the mix: a mix of unexpected and brilliant colour combinations; a mix of furniture from different periods; a mix of textures; a mix of patterns. I want bright, shiny, hard edges alongside soft, velvety fabrics. I want graphic geometrics and faded florals. It's not that I need to squeeze every conceivable design idea into one space but, rather, that contrast is king: I never want a room to be too pretty or handsome – there needs to be that acidic edge. It works the other way around, too: an alarming scheme might be tempered by sober elements. And there are further considerations: lighting, scent, music … At home, I take great delight in giving good thought to them all, particularly when it's time for a party and the cottage (or flat) must step up for the occasion.

Comfort, of course, is also key. We mustn't forget. What is the point of an aesthetically pleasing room that is uncomfortable? It's a bit like when I come across a jacket in appealing colours that, at first glance, looks kind of fabulous, but on closer inspection is oversized to the point of lunacy and covered with unnecessary zips. I'm not going to feel good wearing it, just as I'm not going to feel happy in a room that isn't comfortable. I suppose not *every* room needs to make one feel comfortable, in the same way that a picture in a gallery has absolutely no obligation to make one feel joyful or even at ease. But, let's face it: generally we all strive to feel comfortable and happy, and at home surely comfort and happiness are the most important requirements of them all?

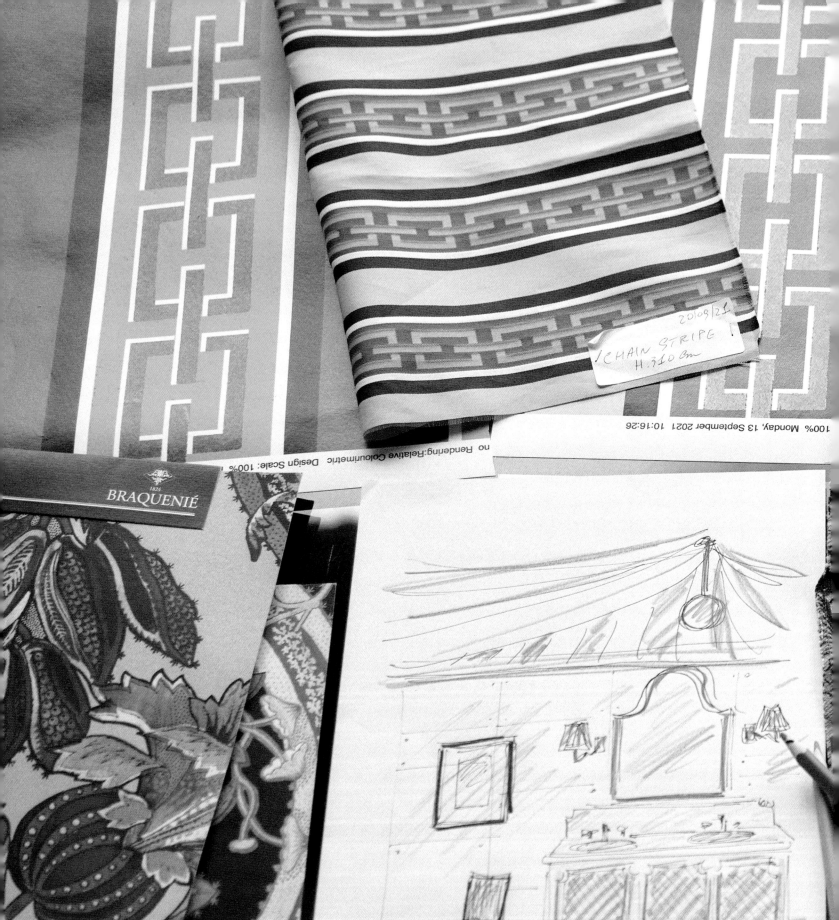

CHAIN STRIPE !
H. 310 cm
20/09/21

BRAQUENIÉ
1824

100% Monday, 13 September 2021 10:16:26
no Rendering:Relative Colourimetric Design Scale: 100%

MEN'S BATHROOM

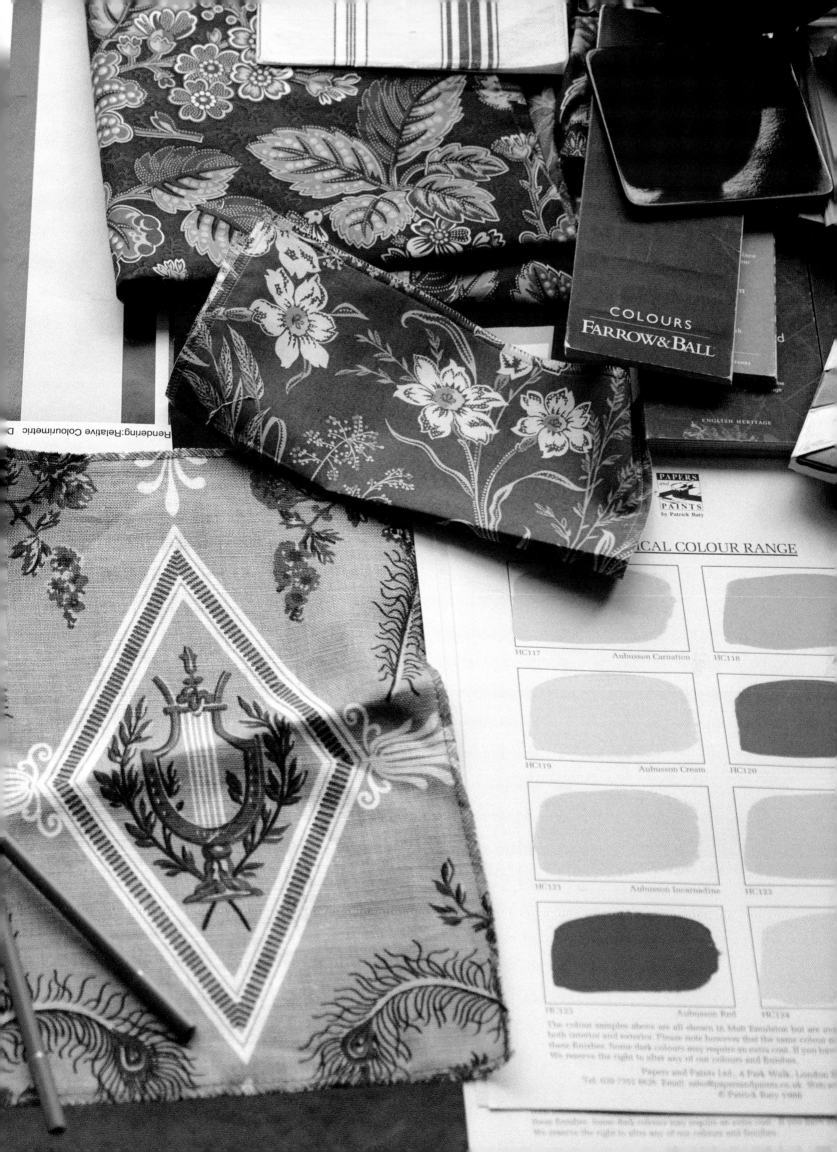

Rendering:Relative Colourimetric D

COLOURS
FARROW&BALL

ENGLISH HERITAGE

PAPERS
and
PAINTS
by Patrick Baty

ICAL COLOUR RANGE

HC117	Aubusson Carnation	HC118
HC119	Aubusson Cream	HC120
HC121	Aubusson Incarnadine	HC122
HC123	Aubusson Red	HC124

The colour samples above are all shown in Matt Emulsion but are ava
both interior and exterior. Please note however that the same colour m
these finishes. Some dark colours may require an extra coat. If you ha
We reserve the right to alter any of our colours and finishes.

Papers and Paints Ltd., 4 Park Walk, London
Tel: 020 7352 8626 Email: sales@papersandpaints.co.uk Web:
© Patrick Baty 198

Base Emulsion, some dark colours may require an extra coat
We reserve the right to alter any of our colours and furniture

RUBELLI – MADE IN ITALY

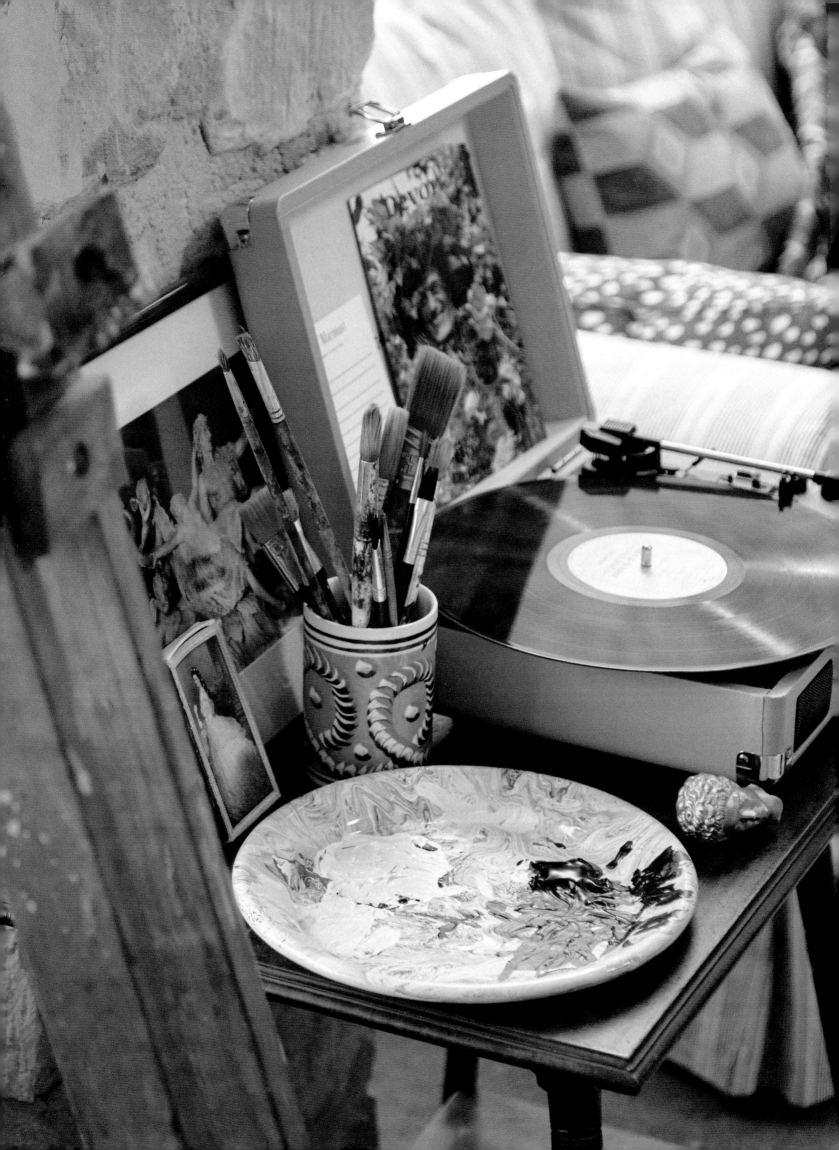

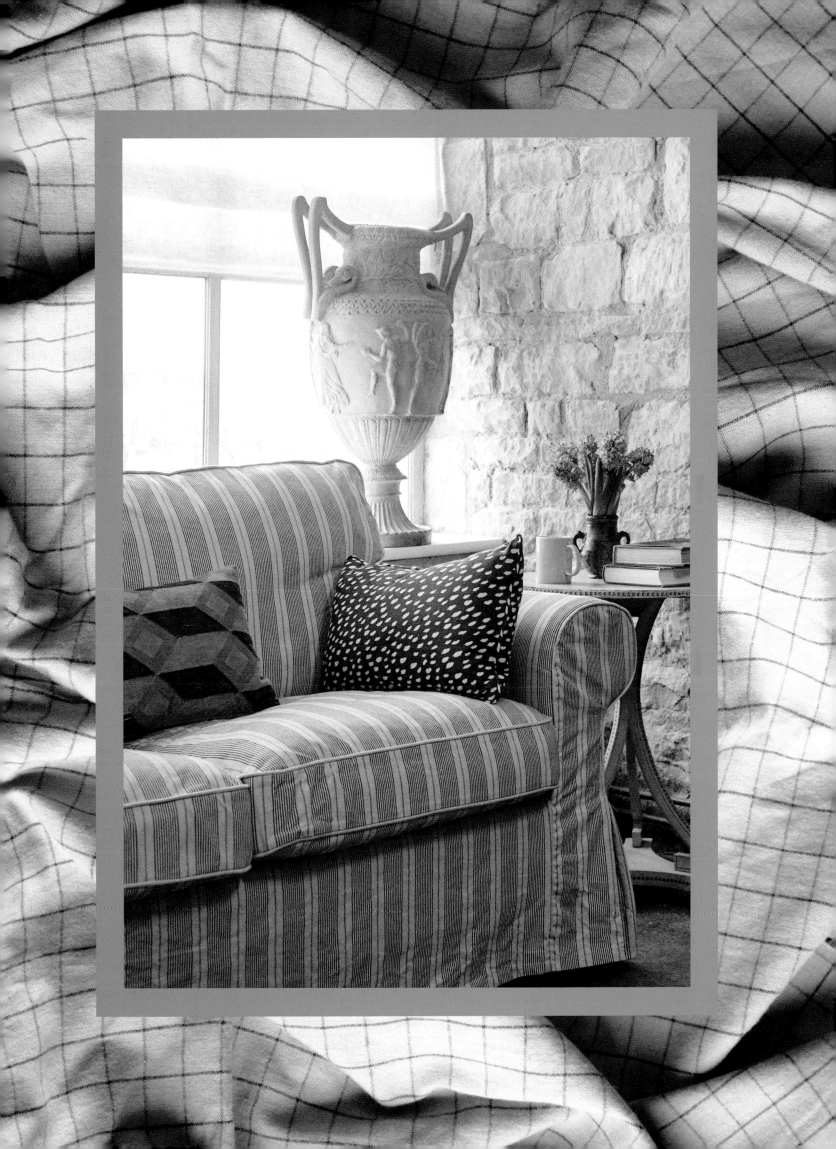

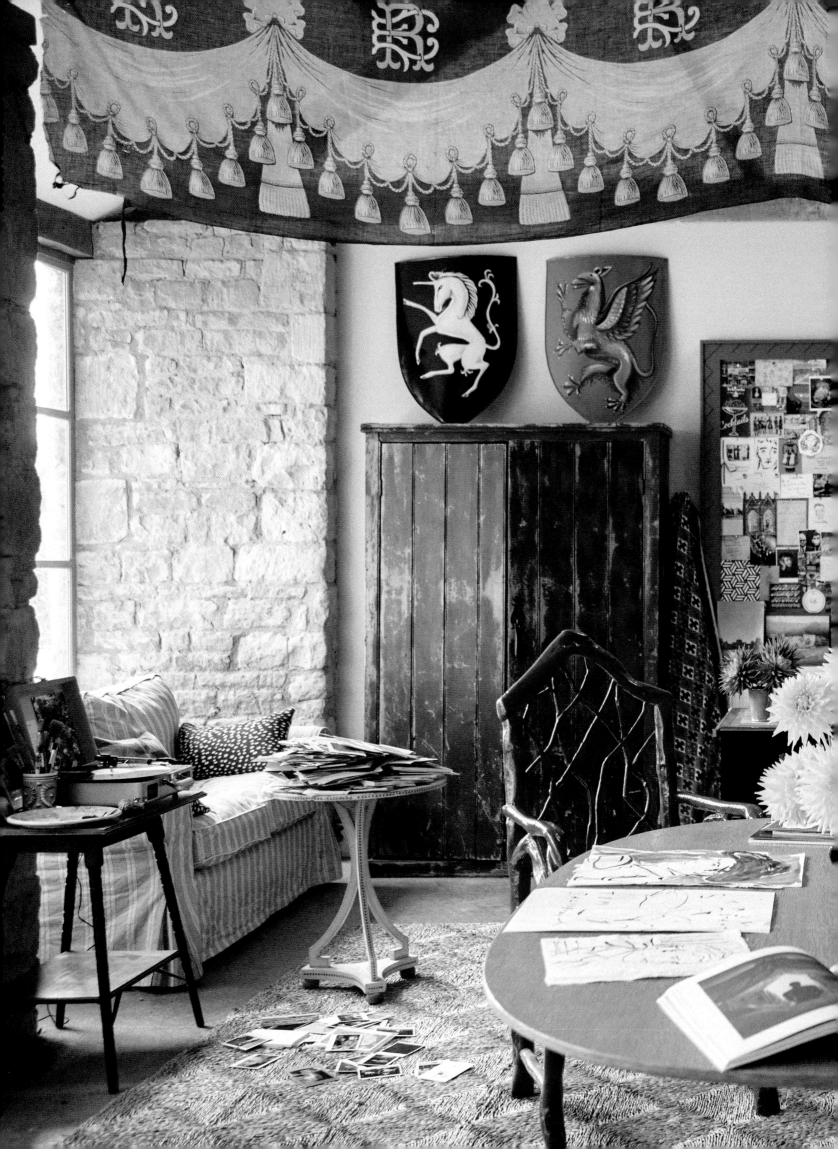

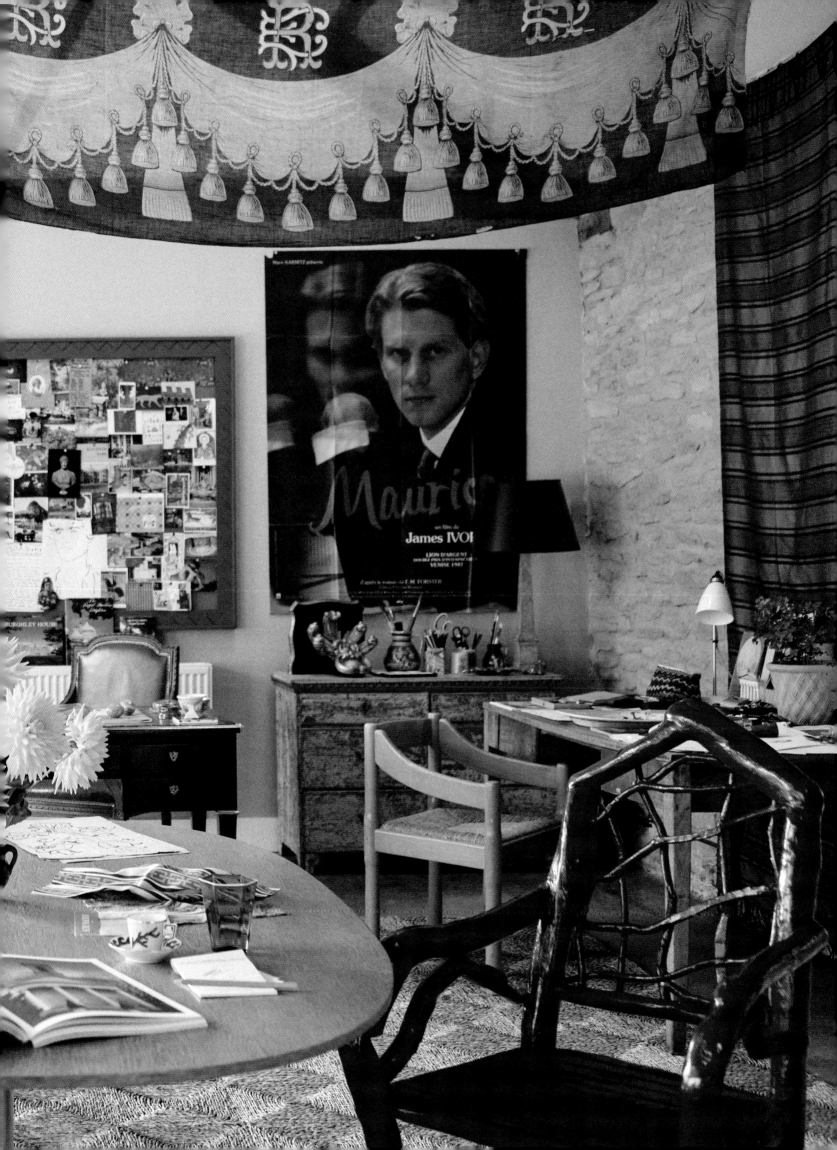

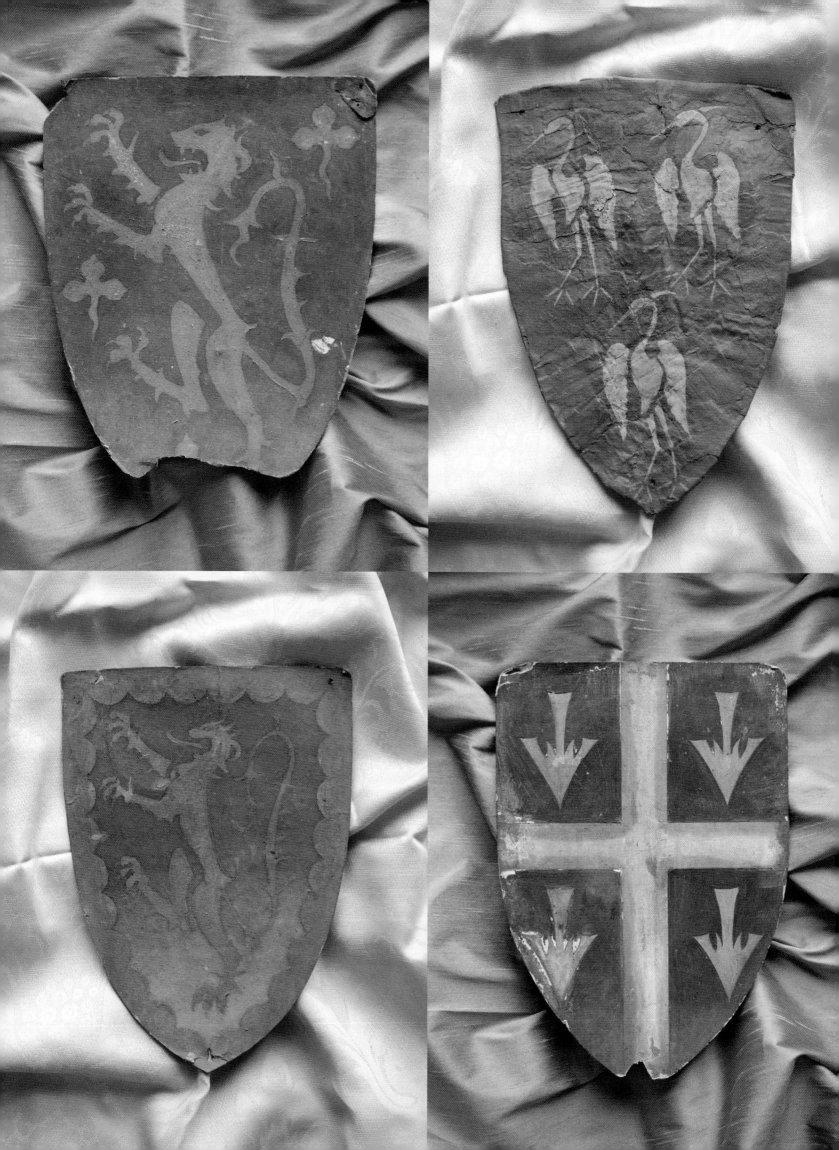

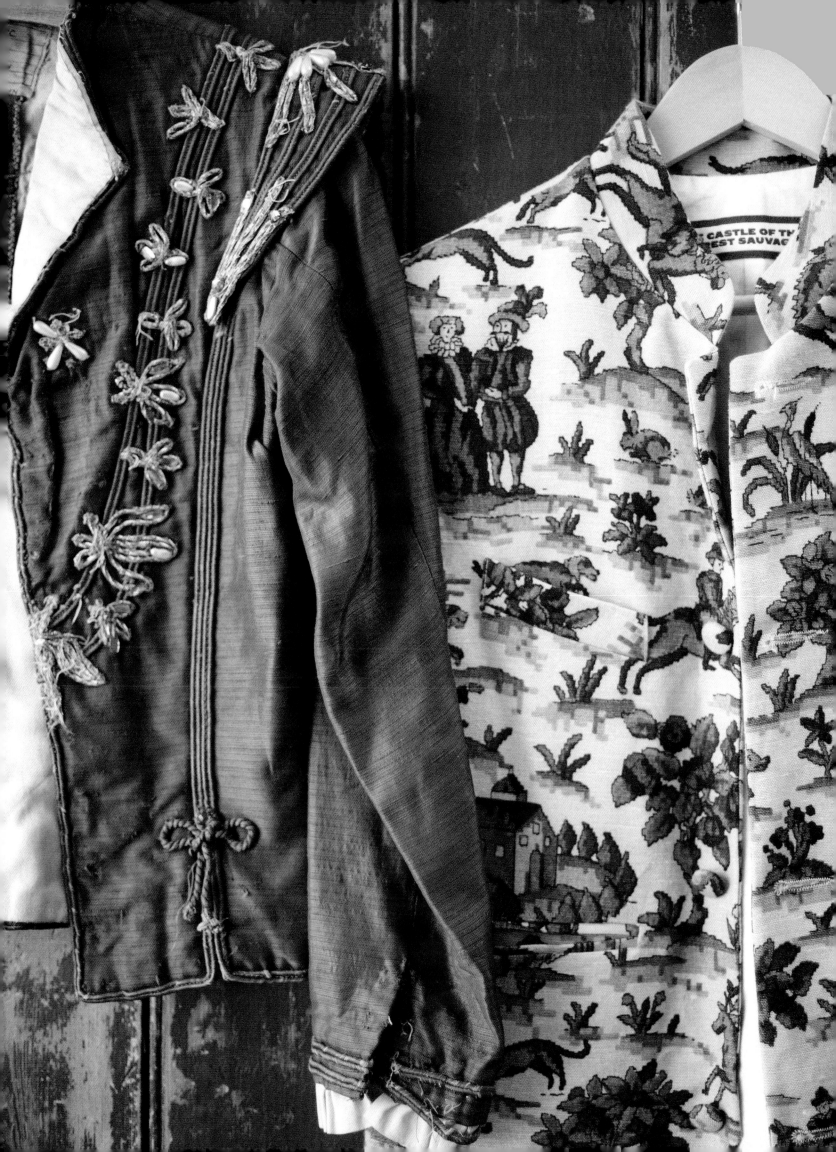

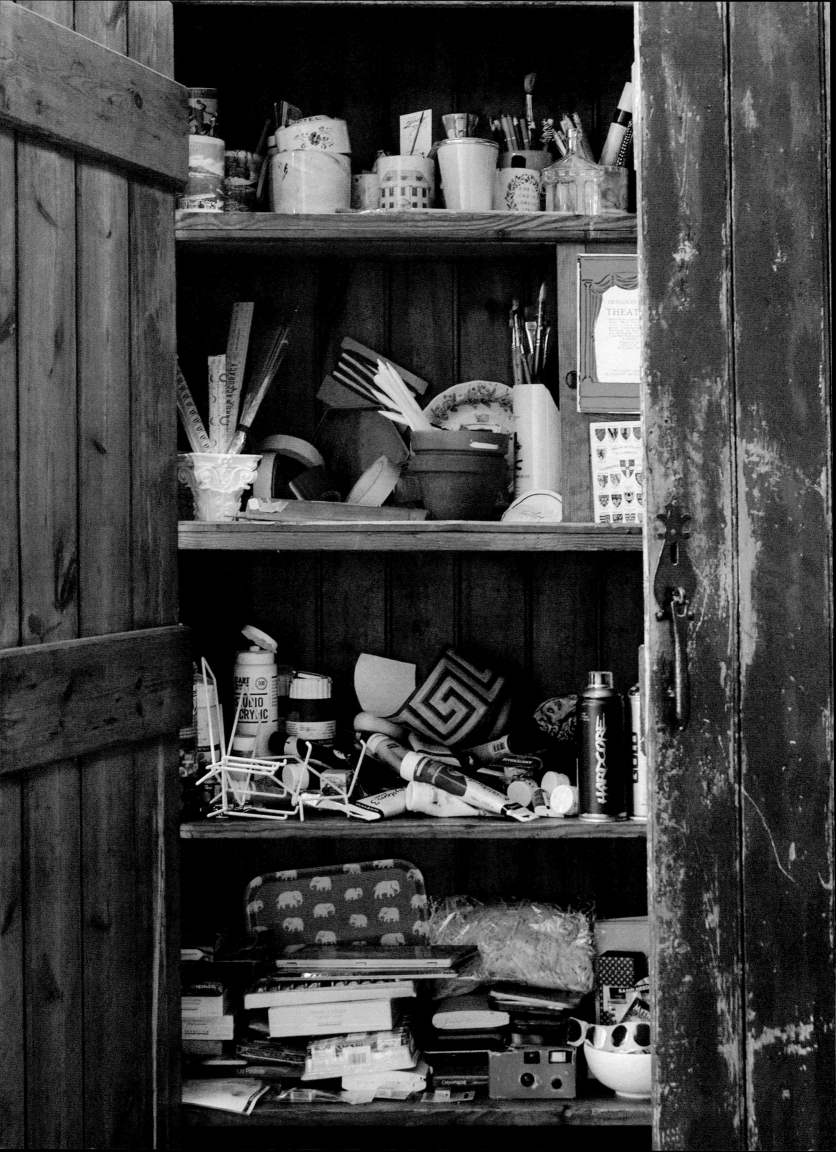

THE Art cupboard

I keep my drawing and painting supplies in a creaking old Victorian pine cupboard. Can you fall in love with a cupboard? When I came across this particular handsome piece on a salvage dealer's website, I rather think I did: the deep-green paint had flaked away and left the most brilliant pattern and patina, giving the wood an almost tortoiseshell-like appearance.

Inside is a mess, but I don't mind. There are tubes and cans and bottles of paint; pencils and pastels and crayons. Disposable cameras waiting to be developed. White spirit, clay, envelopes and flowerpots filled with felt-tip pens. Hammers, rolls of tape and novelty mugs picked up on holidays, which I use for mixing paints. I love opening those old wooden doors and delving inside. It's a treasure trove, and my equivalent, I suppose, of a physician's cabinet or cook's larder. And, as in a larder, where one might find among the jars and cans some very special ingredients – a pouch of golden saffron strands, or pot of local honey – amidst my endless odds and ends I also have precious things: a vintage set of crumbly pastels in a bright-red tin; an old wooden box of Conté pencils; a green envelope filled with sheets of shimmering gold leaf. (I'm back on the food comparisons; it's probably no wonder that, if I could work in any other arena, I have no doubt that it would be food.)

I use a mix of materials to make my work, and I relish the process of starting a piece, then blindly rummaging around in my cupboard and grabbing whatever I can find to add colour and texture to a drawing. Each piece is imprinted with the materials that have made it, and sometimes these materials come with a story. Every time I travel, I try my best to visit a local art supplies shop with the aim of picking up something unique – something I can't find in England, perhaps: wonderfully heavy, creamy sheets of paper made in Florence, or a special French crayon. I'm always adding to my cupboard. In fact, I have a feeling that soon I might need another one.

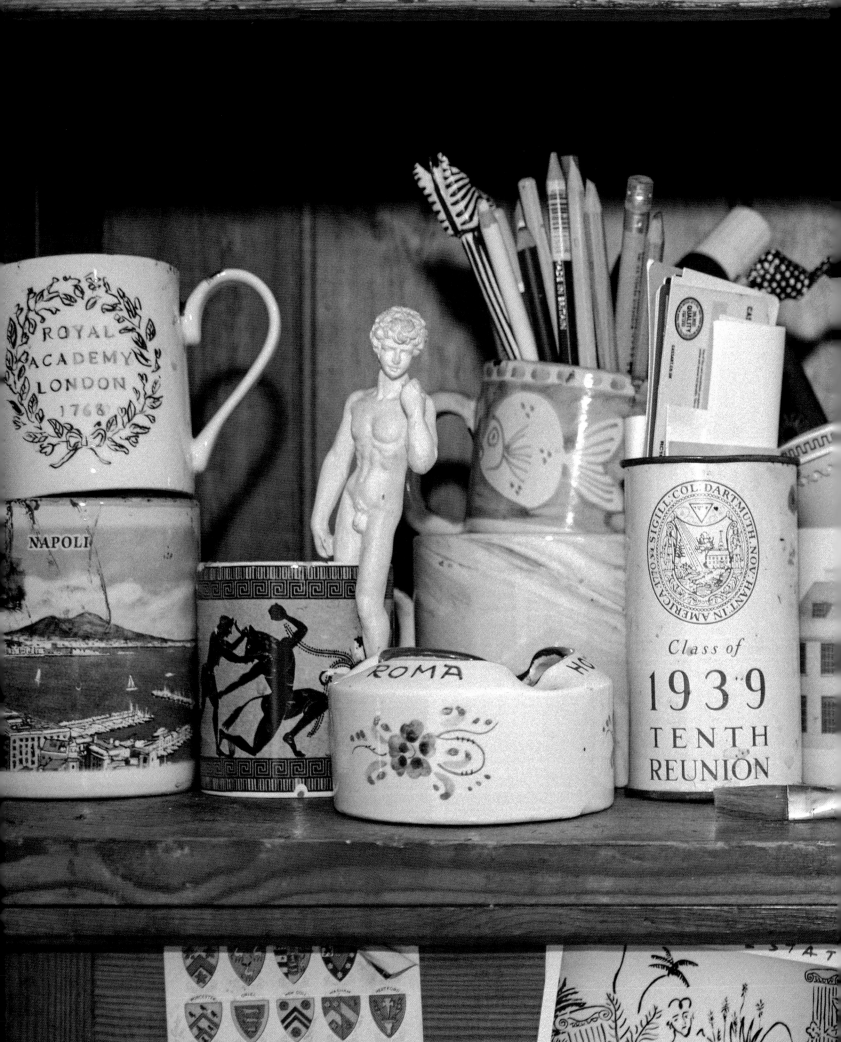

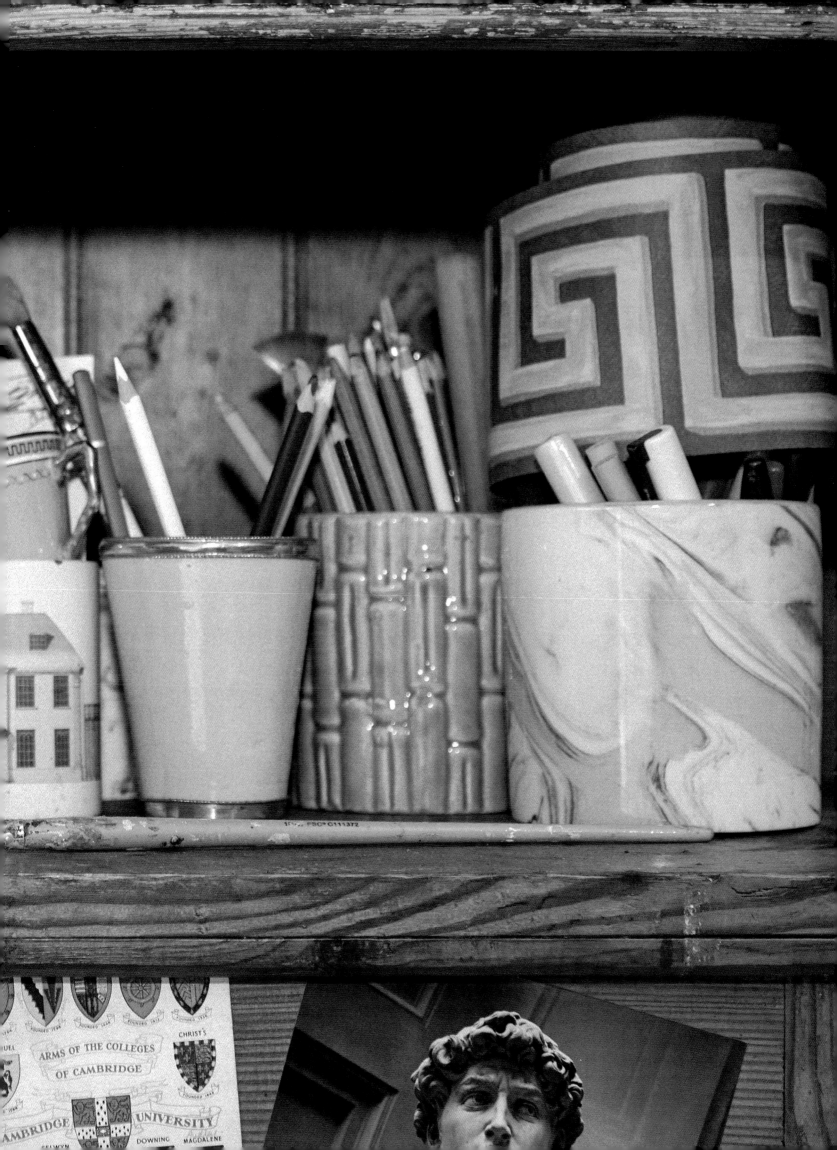

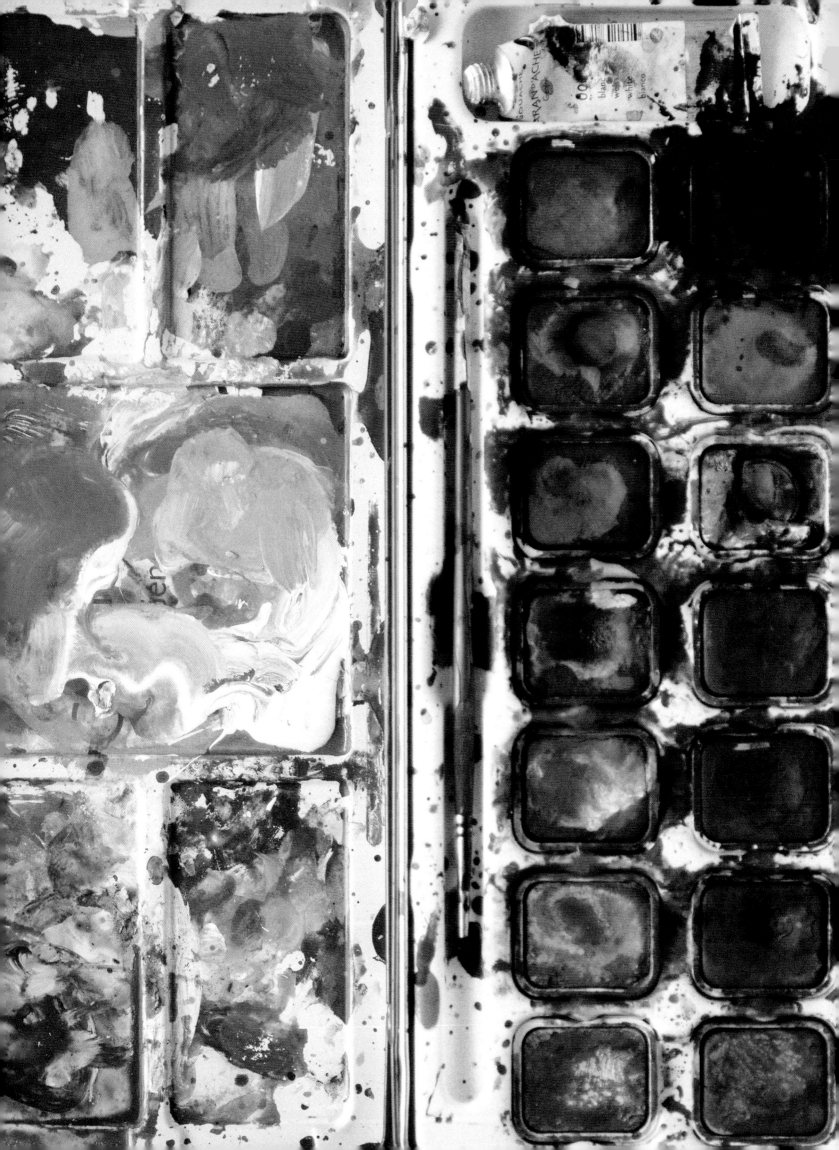

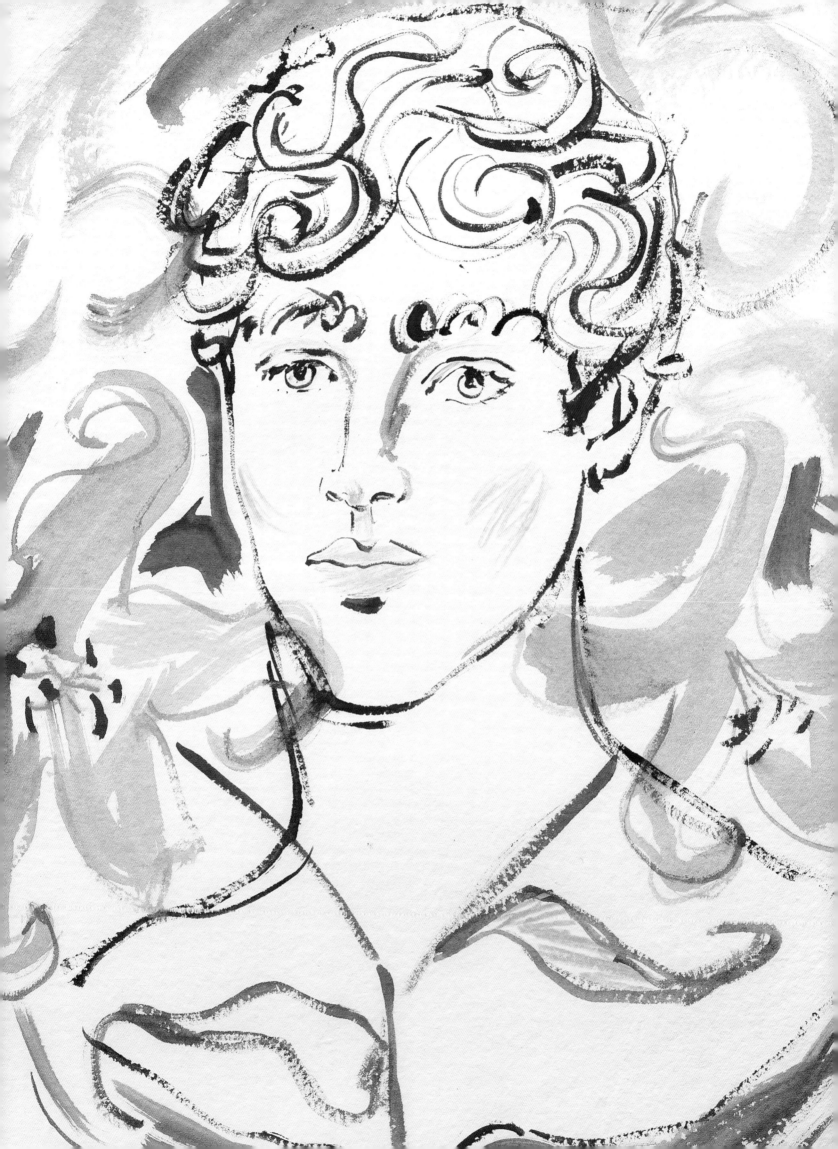

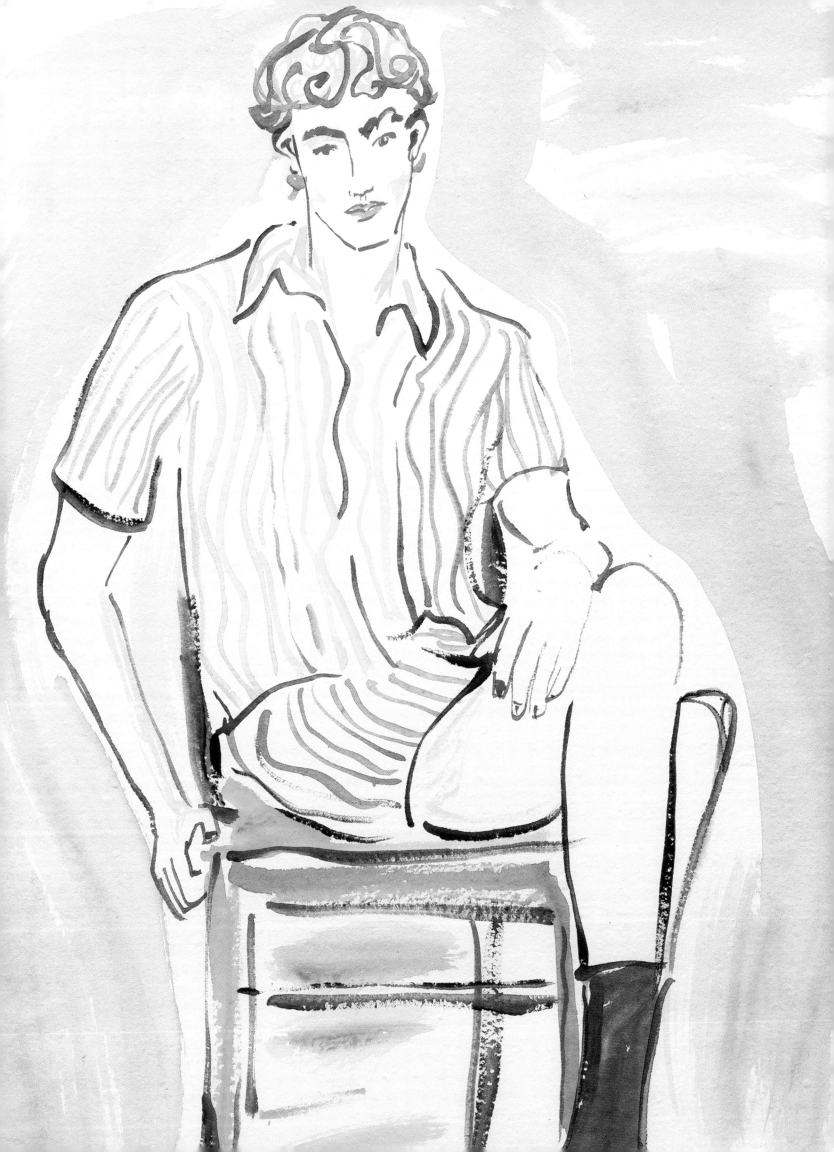

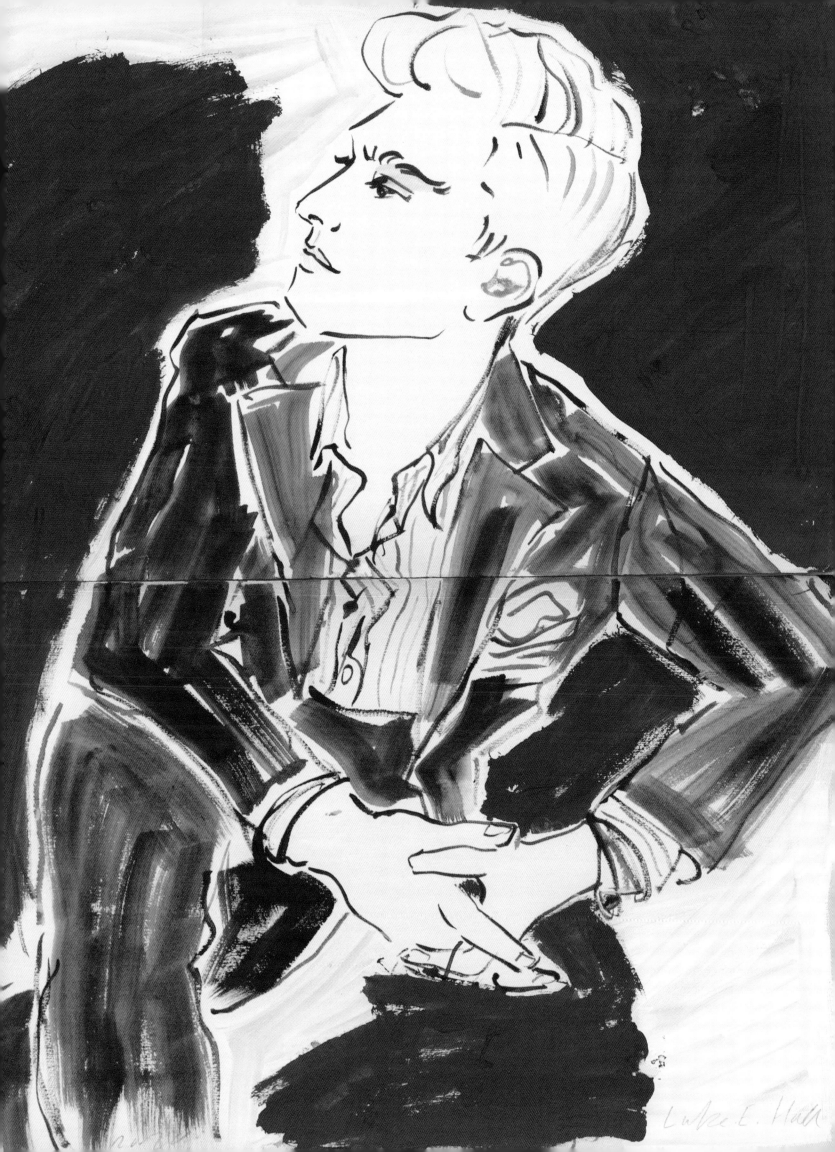

LEFRANC - PARIS

MÉDAILLES D'OR MÉDAILLES D'ARGENT

EXPOSITIONS UNIVERSELLES EXPOSITIONS

1889 - 1900

EXPOSITIONS QUATRE GRANDS PRIX 1839, 1844 & 1867

1849, 1864 & 1878

PASTELS SURFINS

TENDRES, DEMI-DURS & FERMES

AVIS. — Les Pastels étant très fragiles, leur expédition a lieu aux risques et périls des acheteurs. En conséquence, il ne sera accepté aucun pour-compte ni retour.

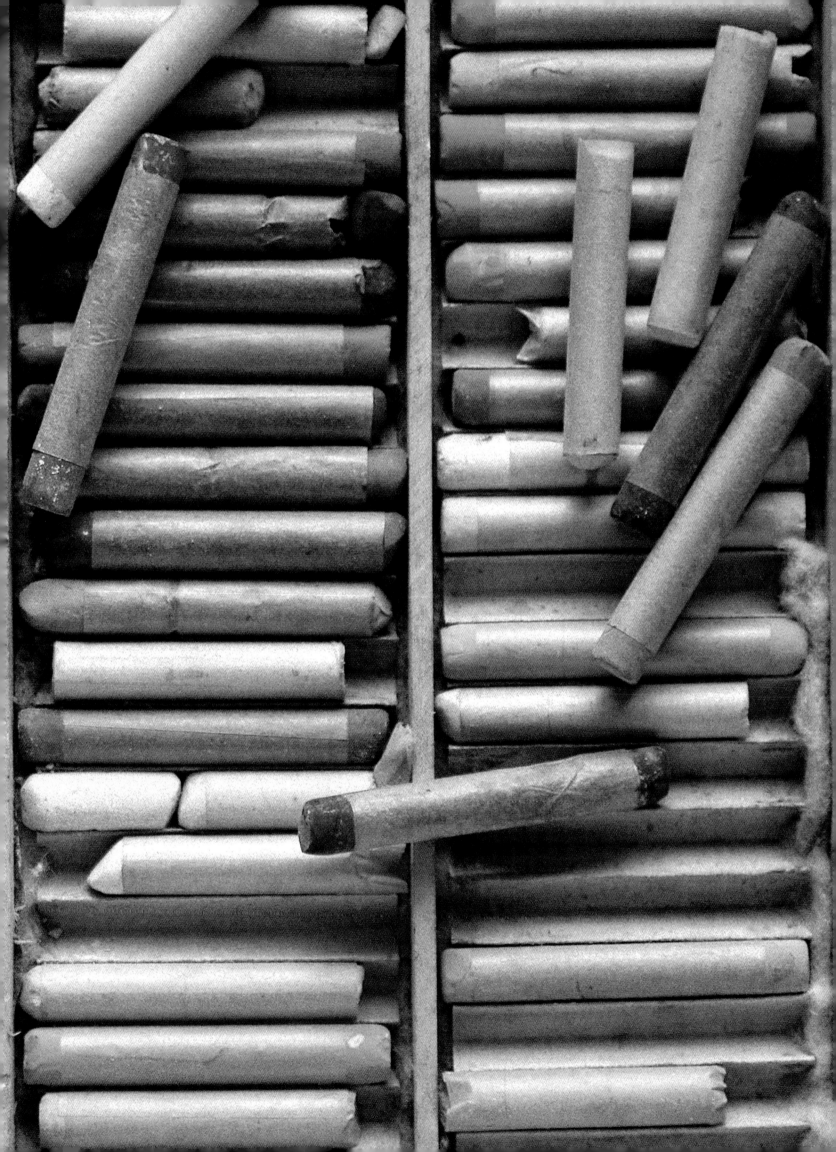

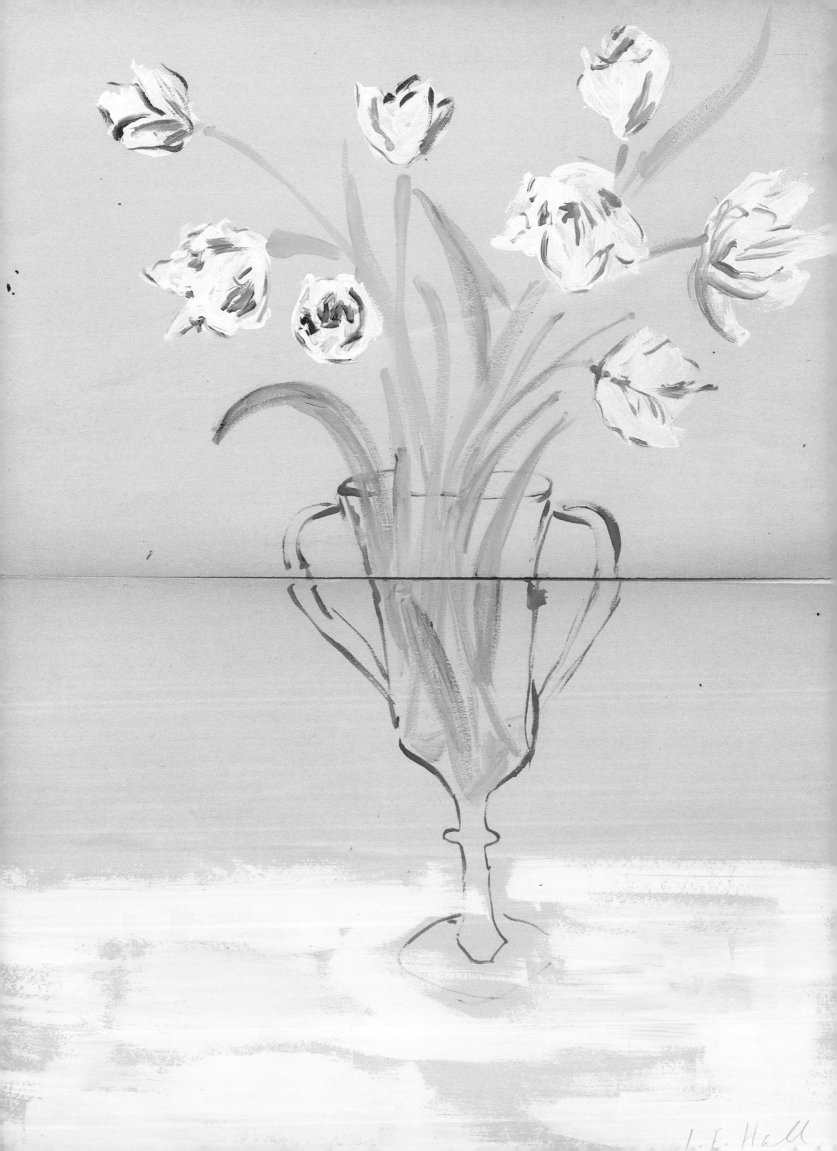

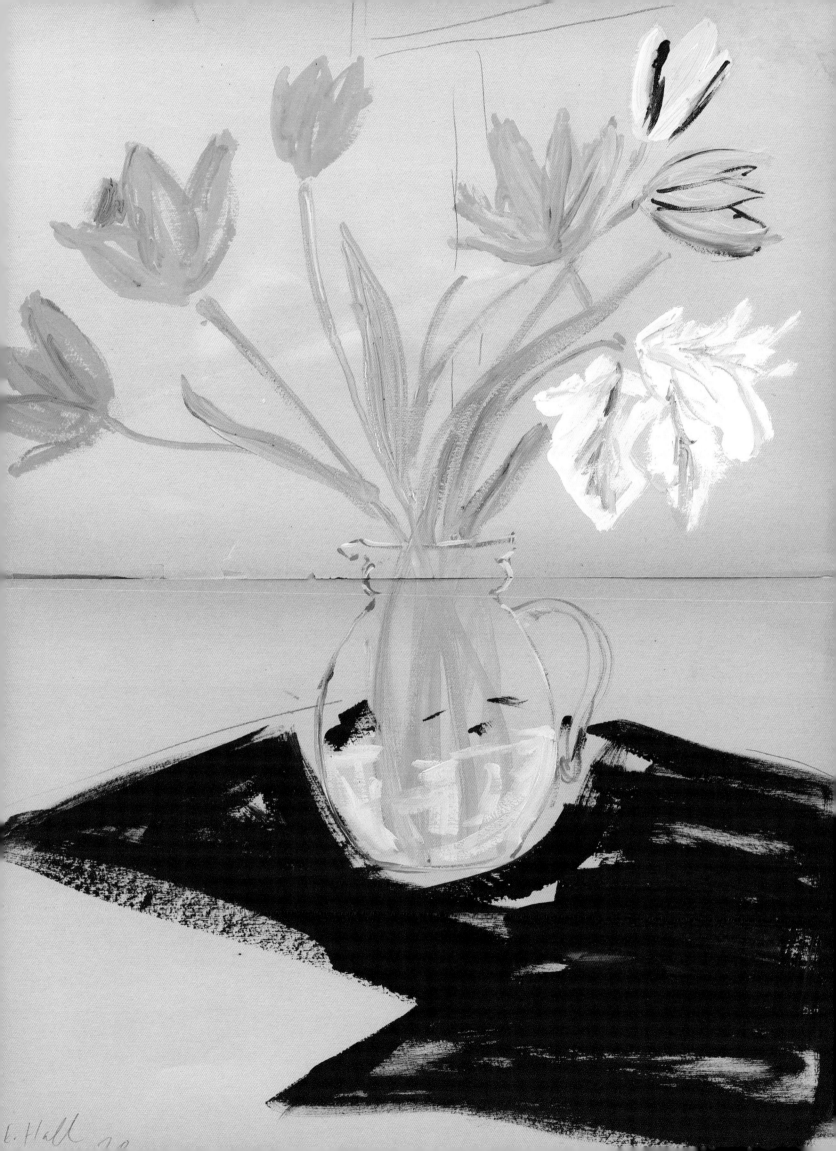

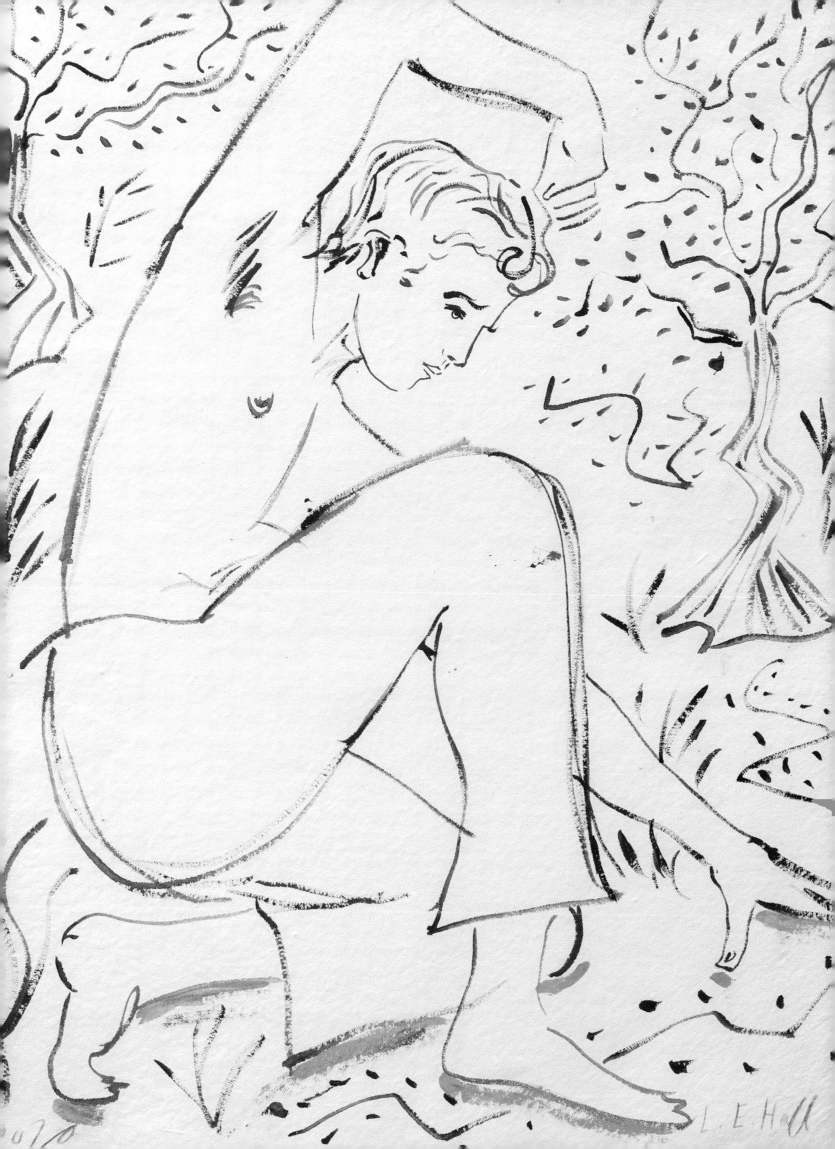

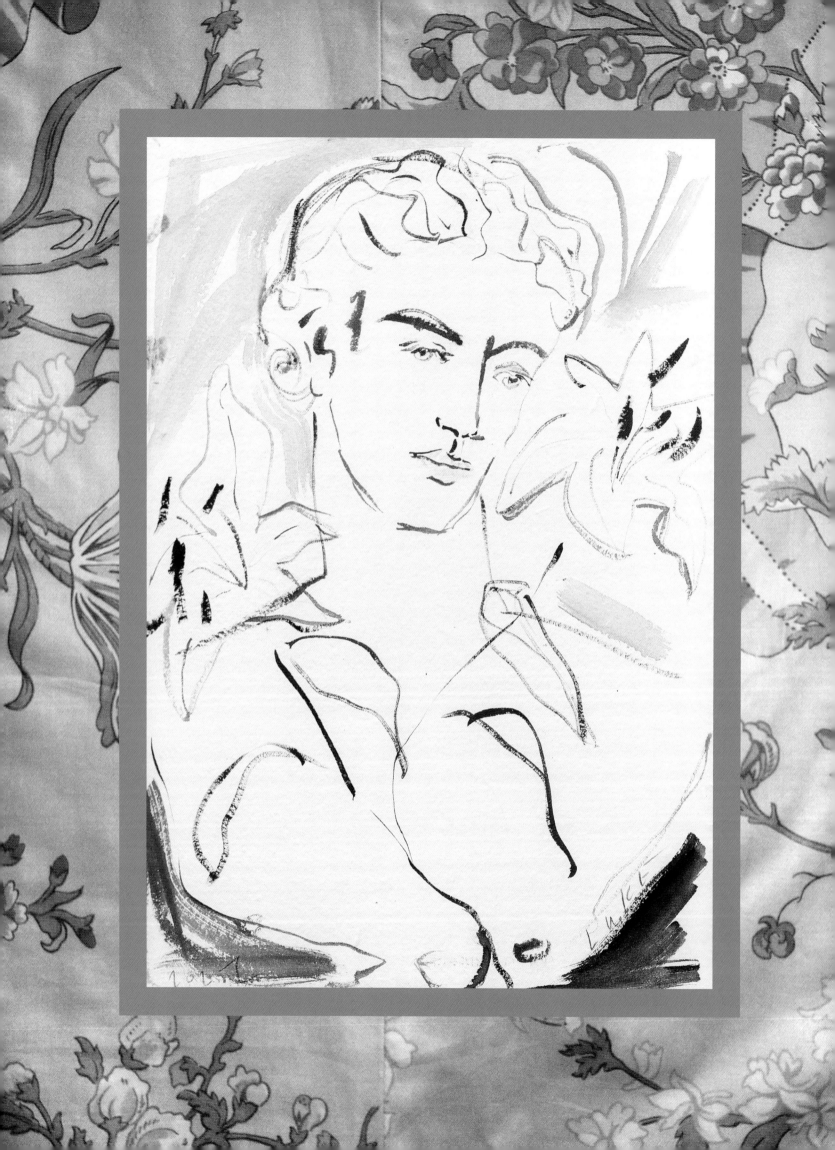

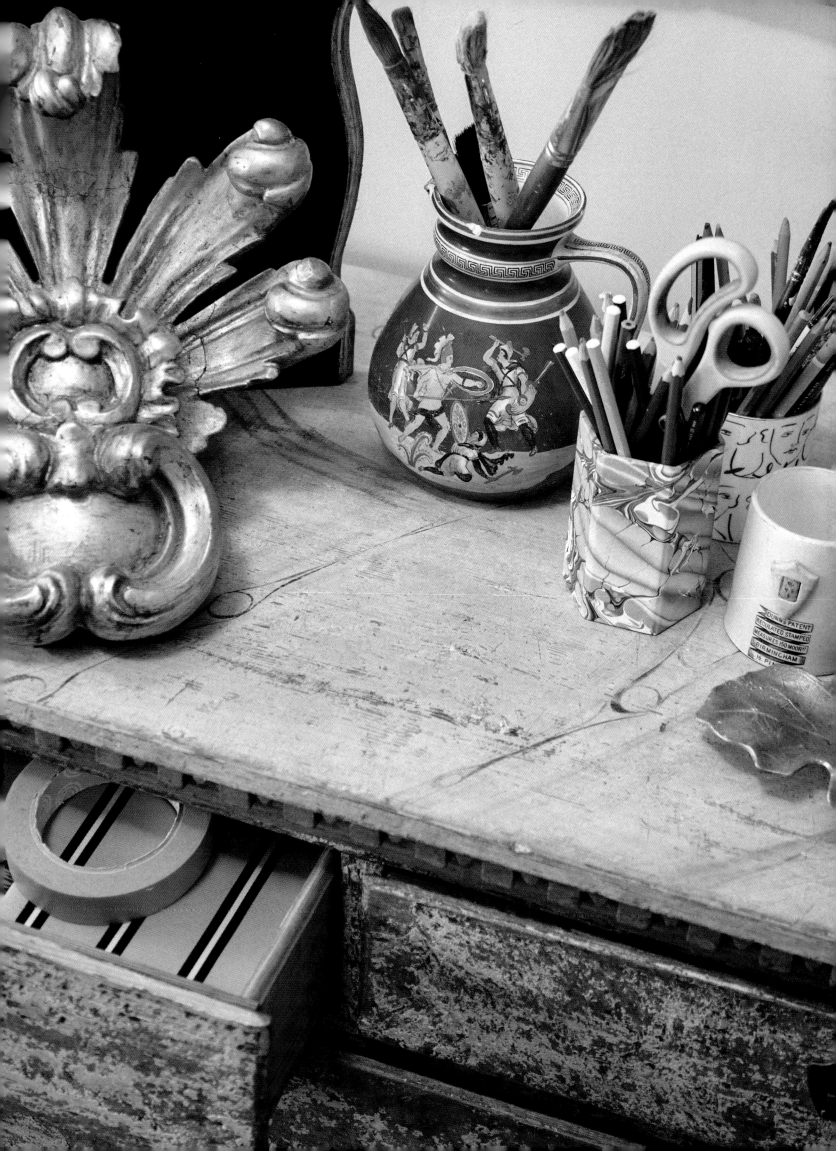

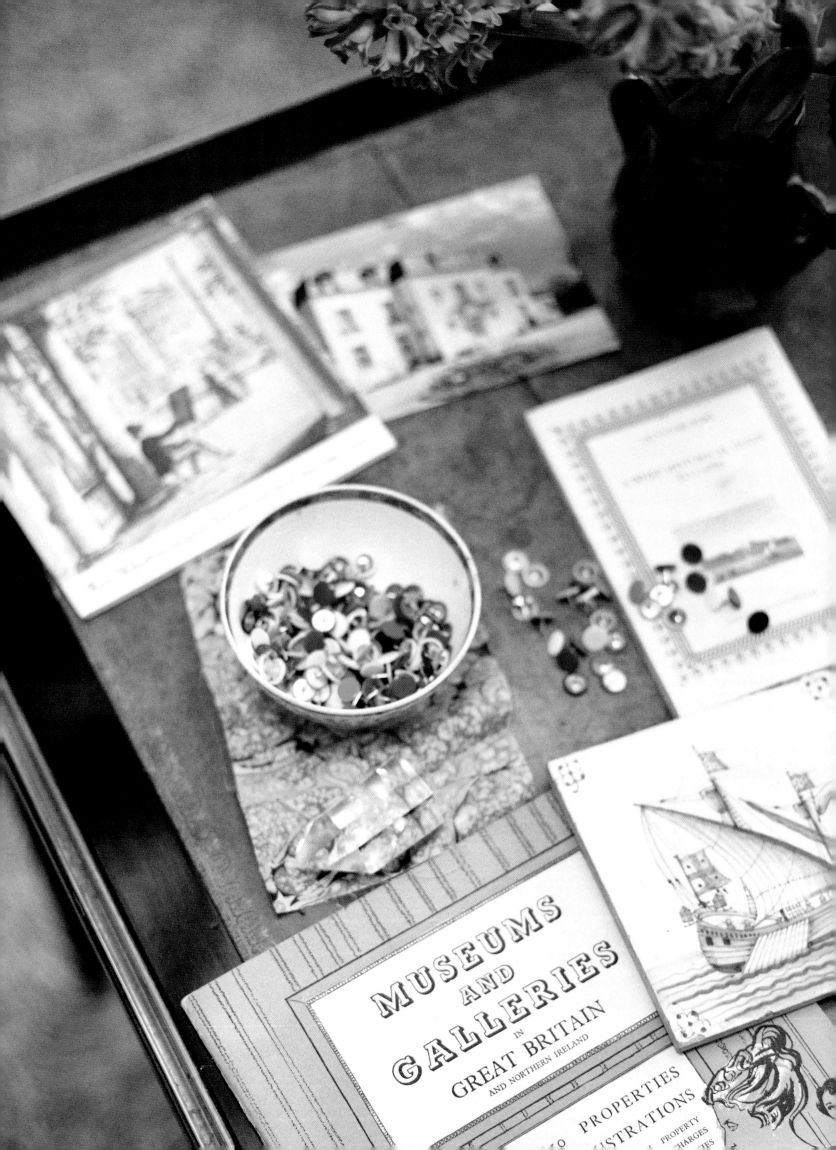

PINBOARD *Wizard*

When I make things, I am often bringing together a bunch of references, filtering and chewing up and creating work that I hope feels distinct. I begin all projects with research, but I'll go down a path and end up taking a left here, a right there, and suddenly my sources of inspiration are all over the place. I enjoy this process hugely. Yes, there are key elements that run through my output – a love of colour and pattern and a keen interest in the past, for example – but I'm constantly finding new things to be inspired by. A book, a flower, an entire design movement.

This importance to be surrounded by things that inspire is why my studio is filled with stuff (and my homes, too!). I have a tendency to hoard. There are boxes of postcards and ticket stubs, Polaroid pictures and postcards. I'm always adding to them. Every now and again I will take an hour to sift through them; I'll see if anything grabs me, and these items then get put on my pinboard. The pinboard is an ever-changing scrapbook. It's better than a book, though, because it's so big (I commissioned it from a friend who specialises in making beautiful frames). Its size means I can cram lots on, then step back and take it all in, whilst at the same time my brain consciously (or maybe even subconsciously) fizzes and makes connections between the things I'm looking at.

The pinboard at home in the country, on the other hand, is the front and sides of our fridge, and a visitor once described this to me as a three-dimensional living mood board. I love this idea. Every time we get a note (or, at least, every time we get a nice-looking one), it gets added to the fridge. When my little niece visits, she will nearly always do a drawing while she eats her lunch, and this will get added, too. Place cards from particularly fun dinners get slotted in behind the tops of postcards. And this makes me think: it's not just about sticking up things that might inspire my work, but also about creating walls of cosseting material, both at home and in my studio – sort of patchwork nests of bits and pieces that, simple as it sounds, fill me with joy.

227

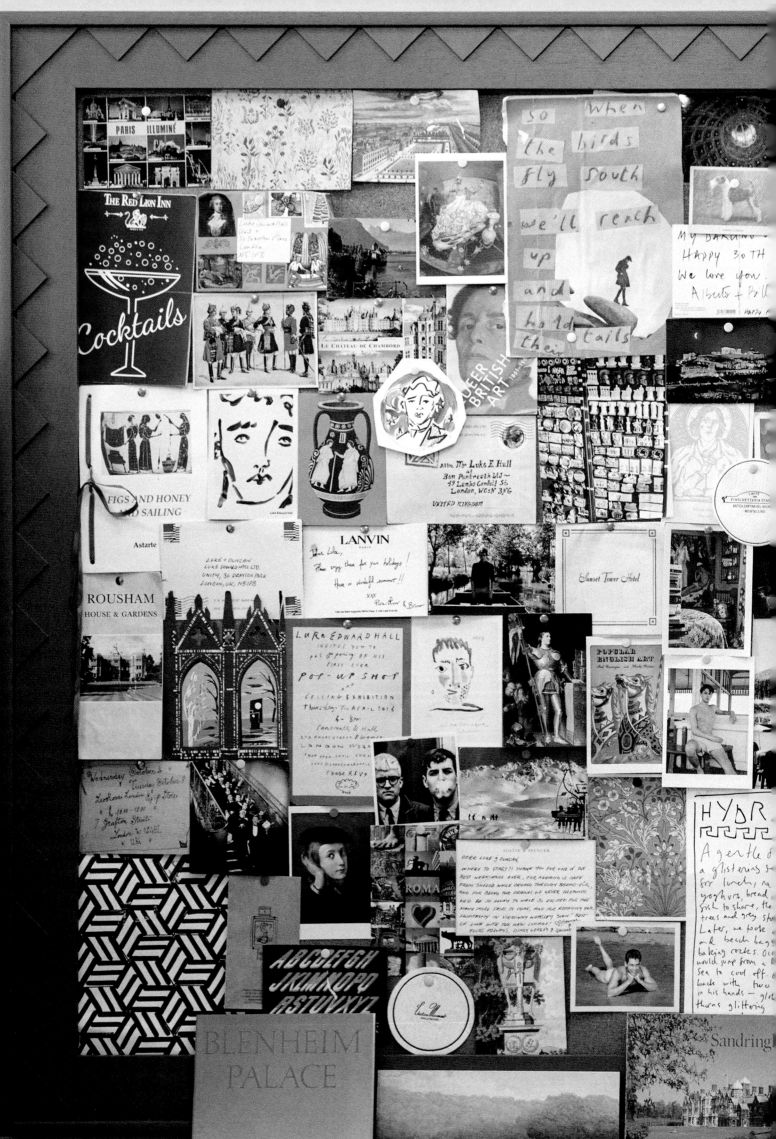

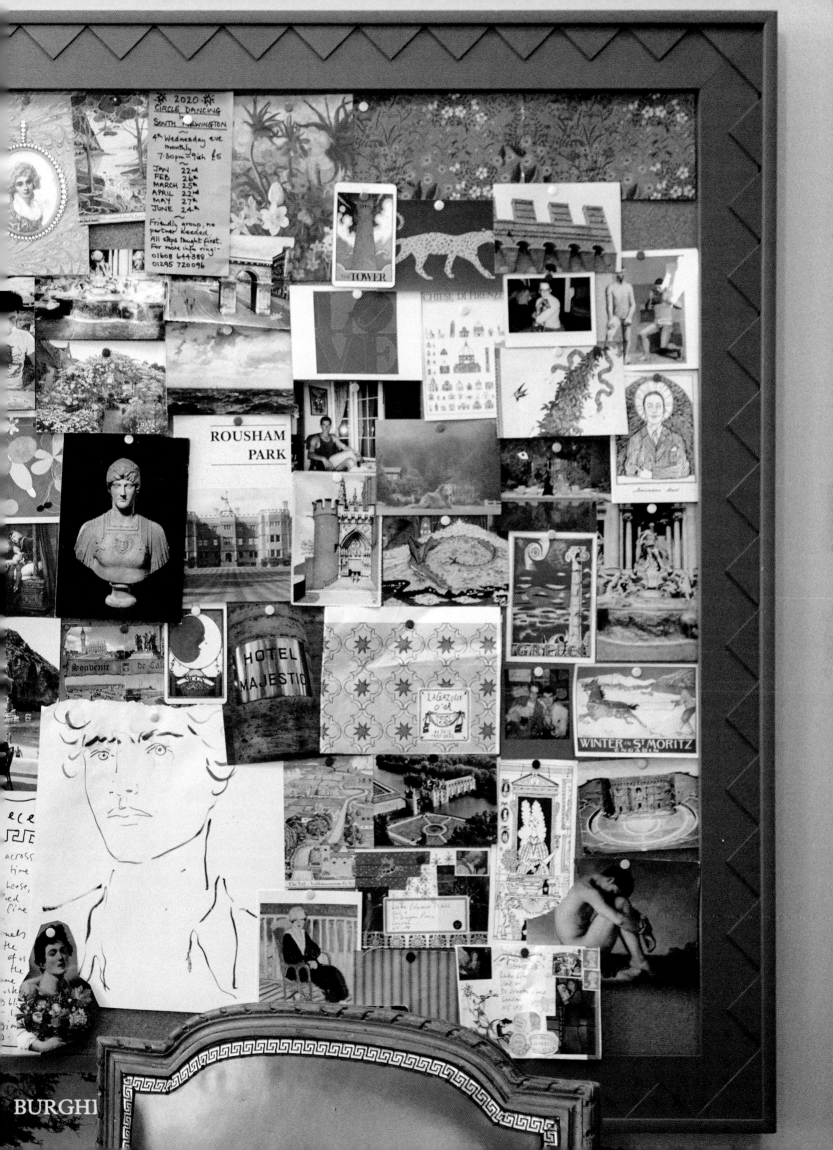

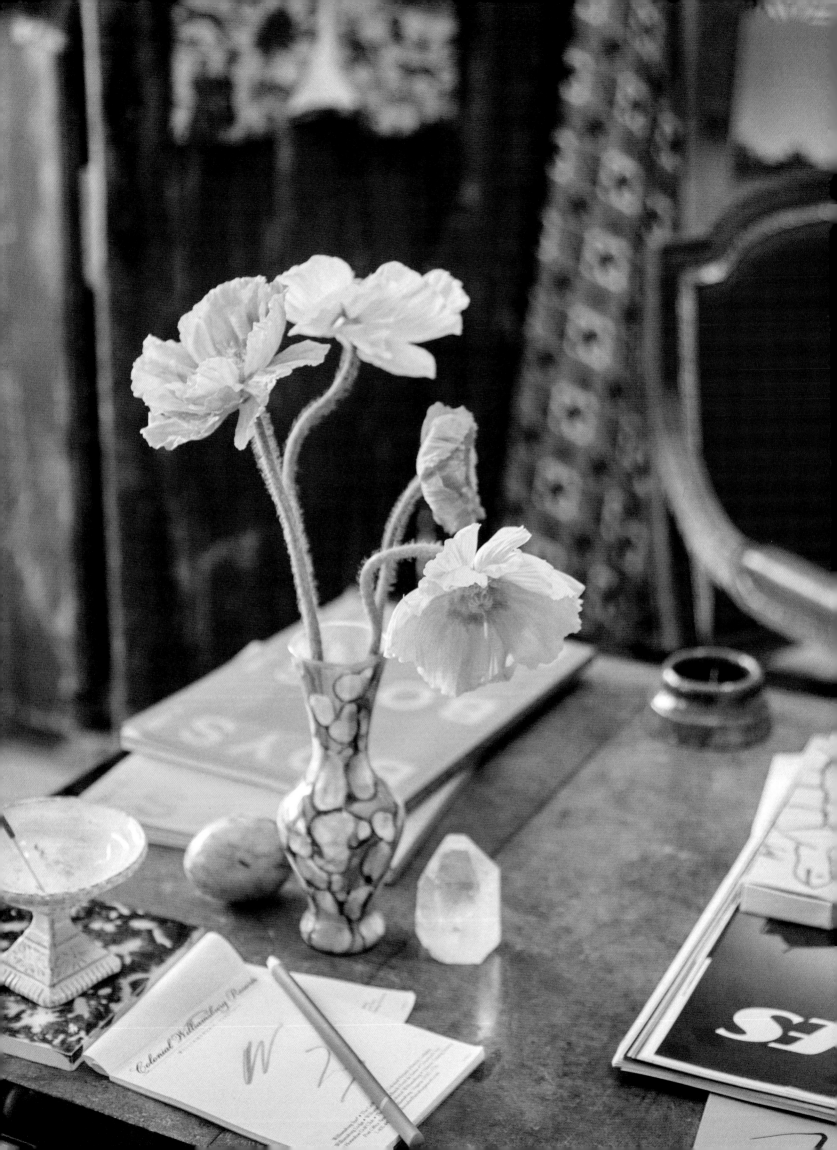

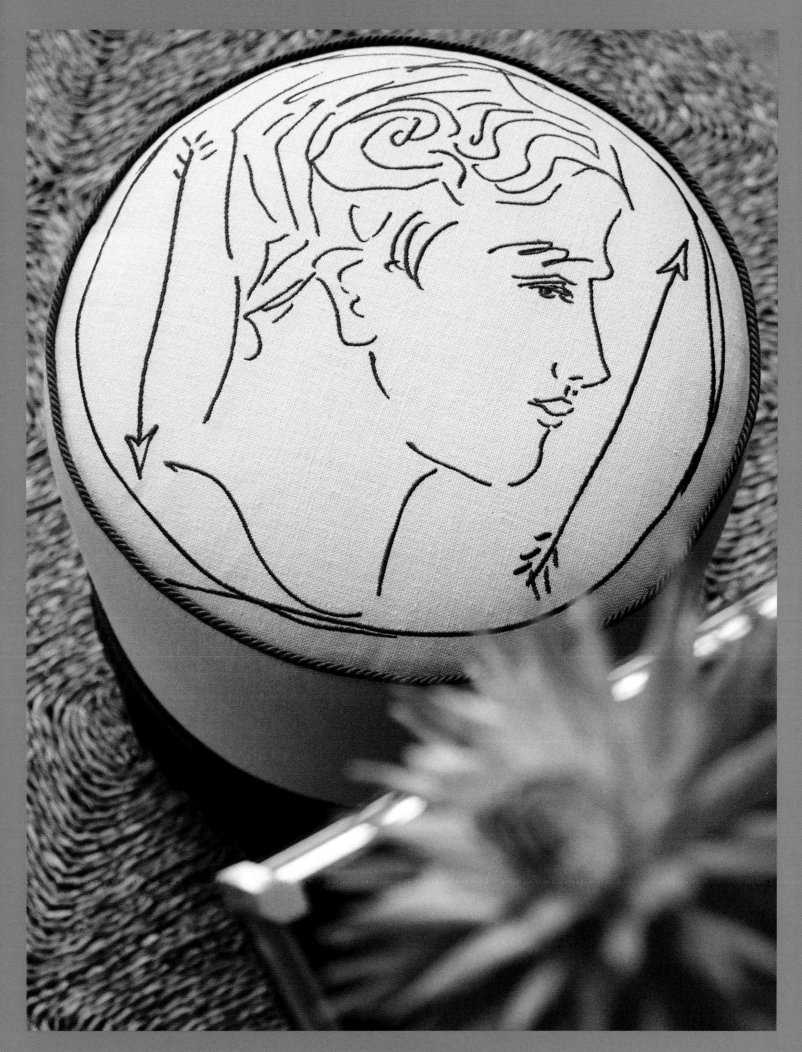

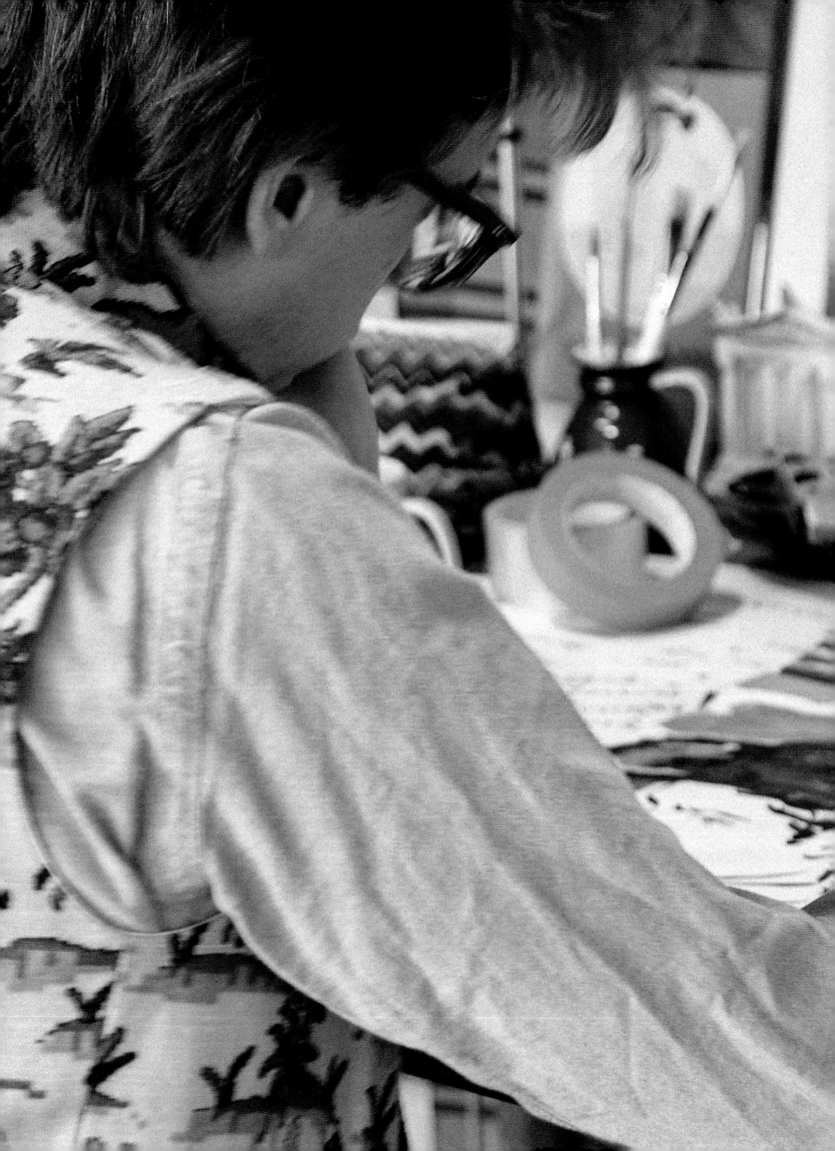

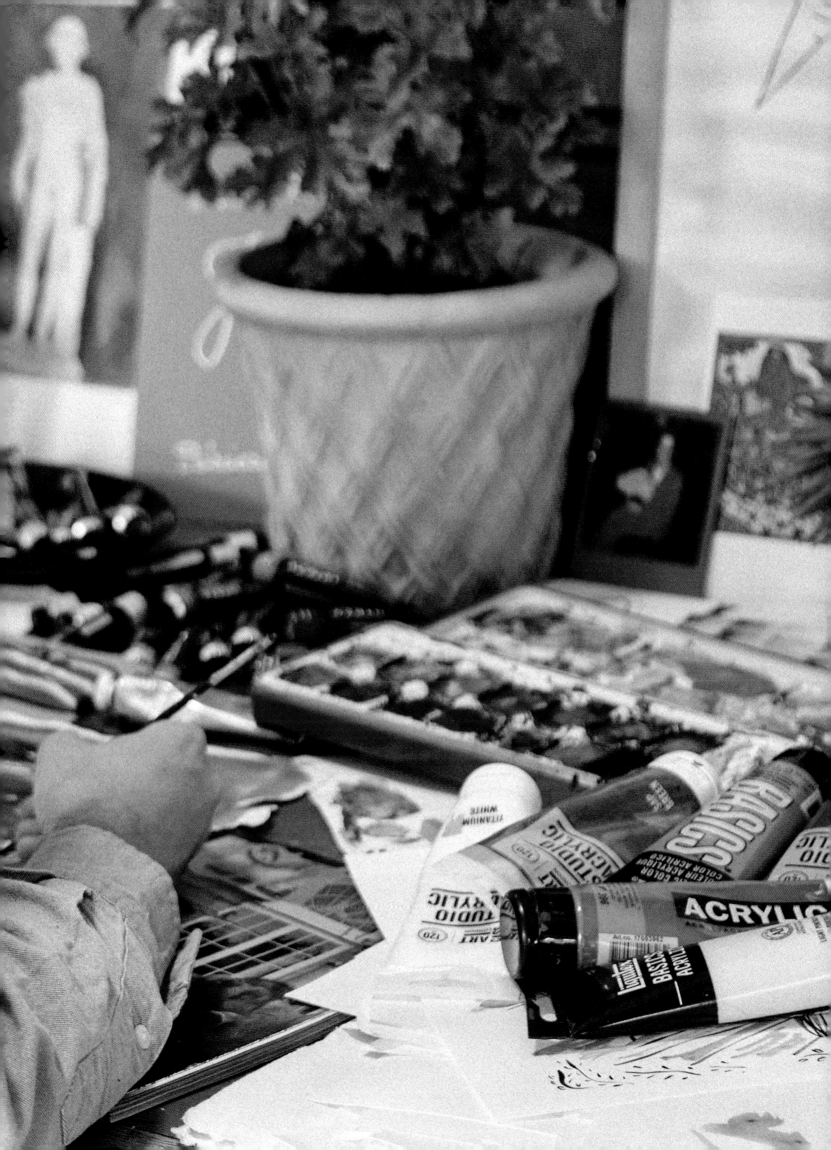

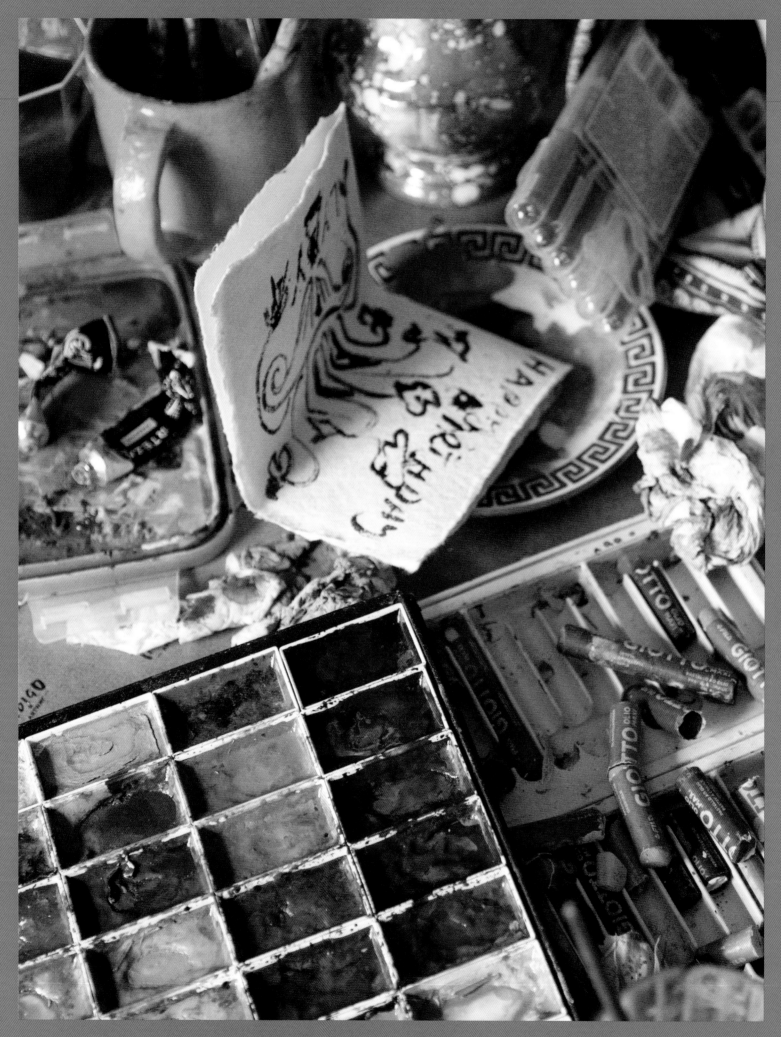

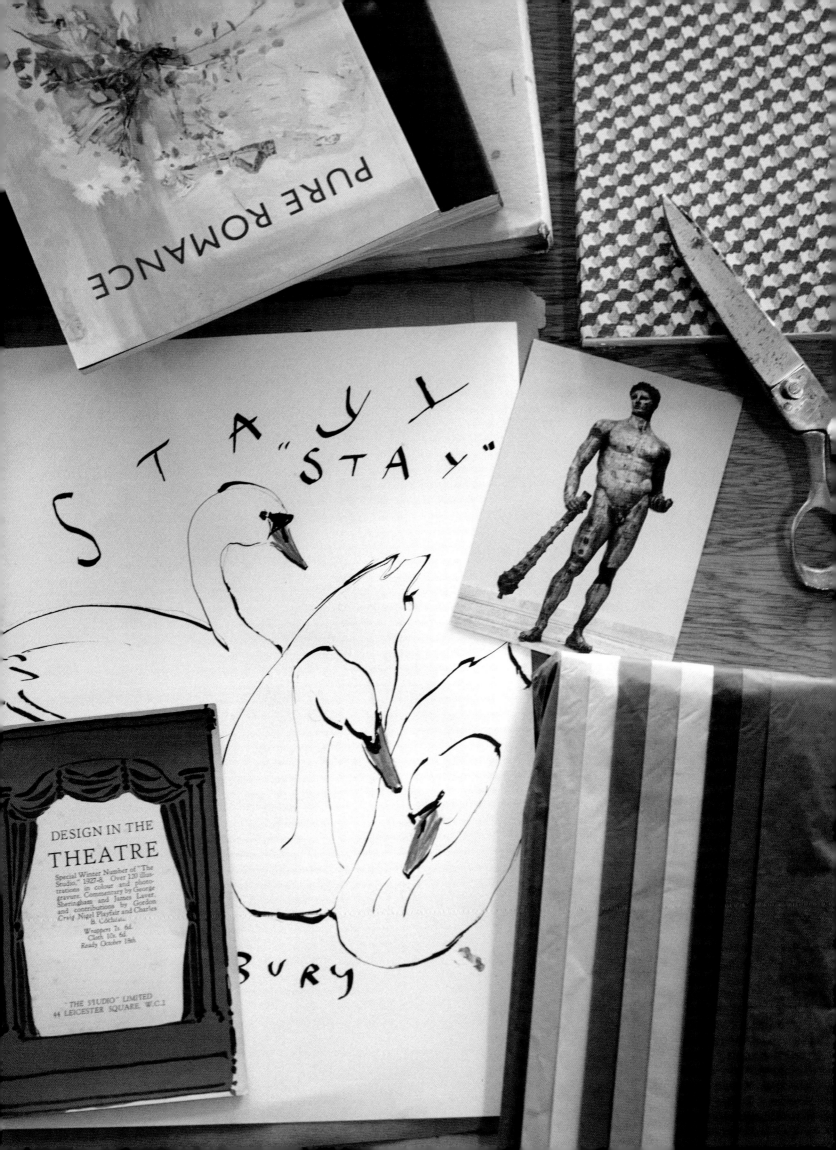

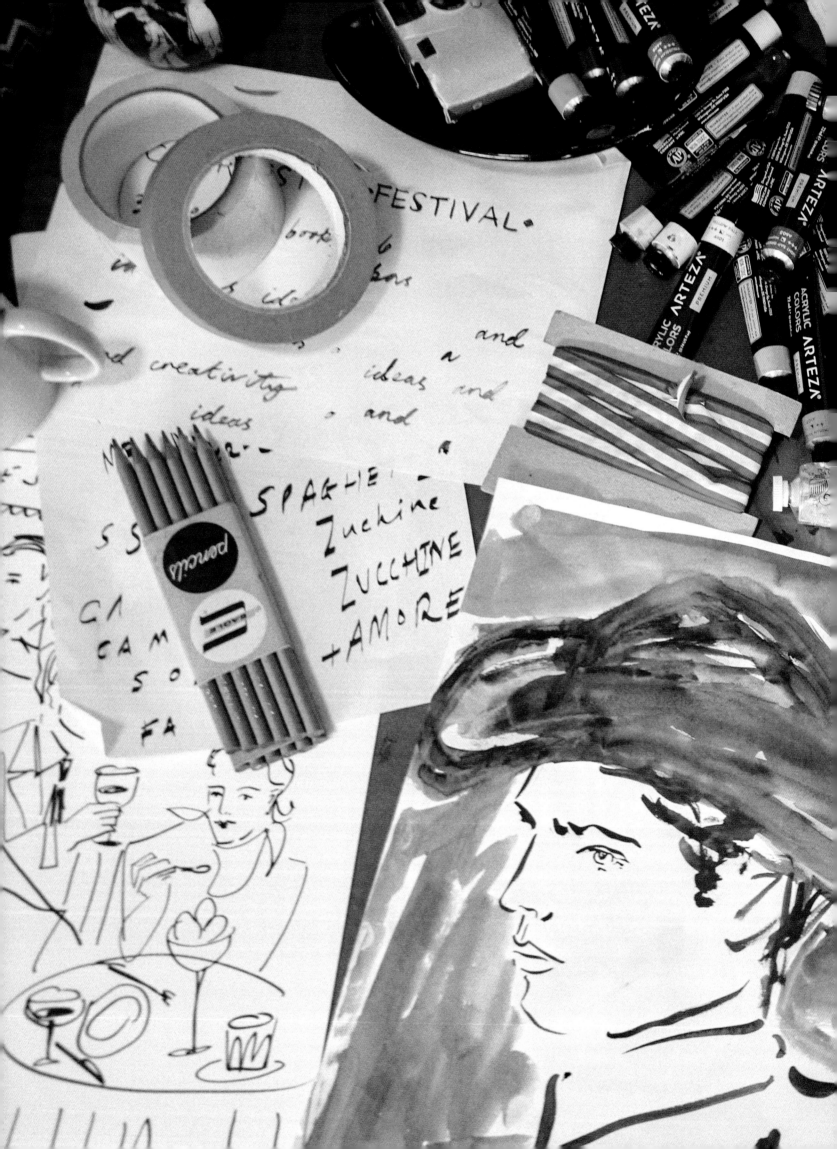

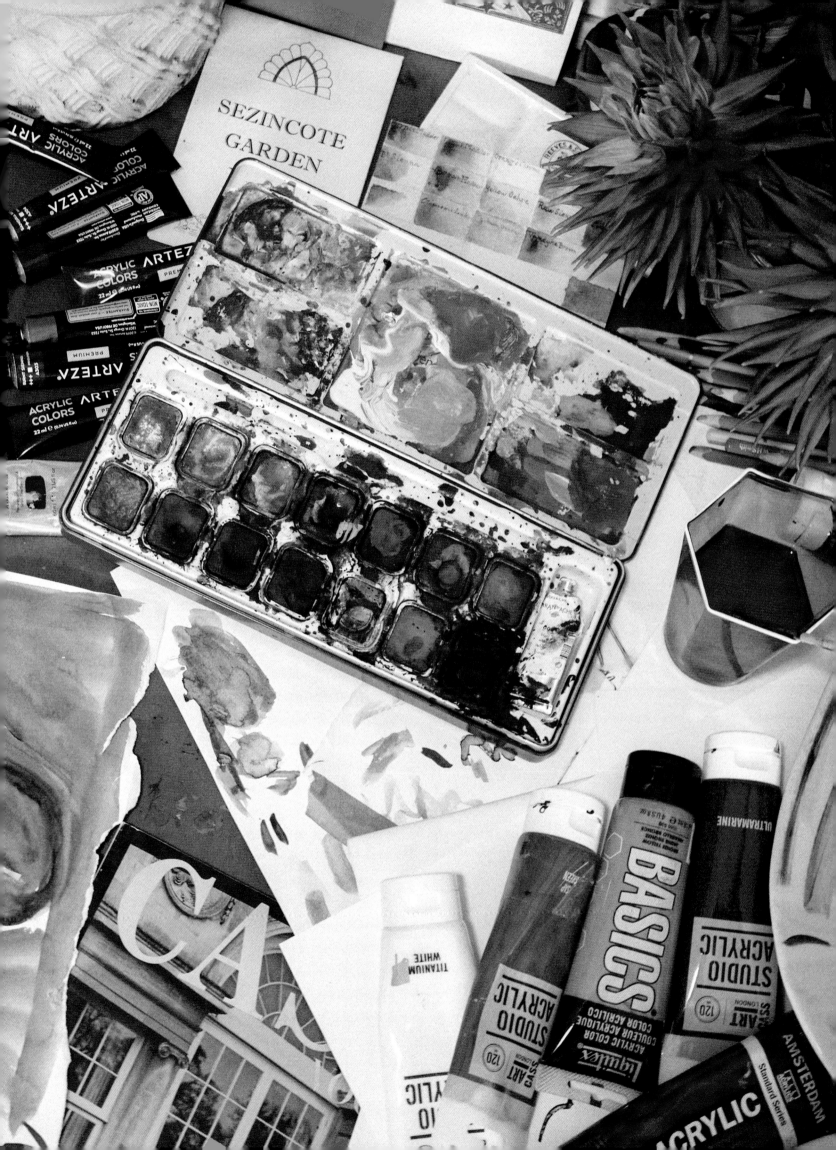

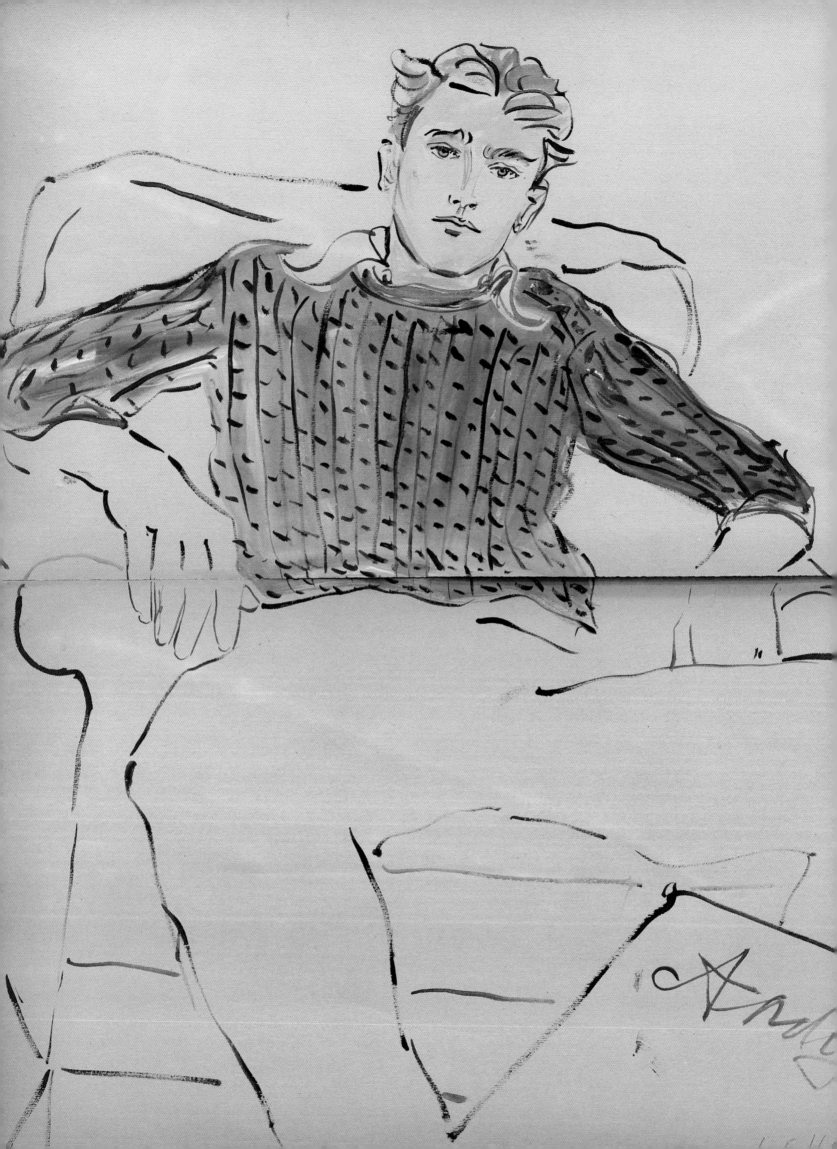

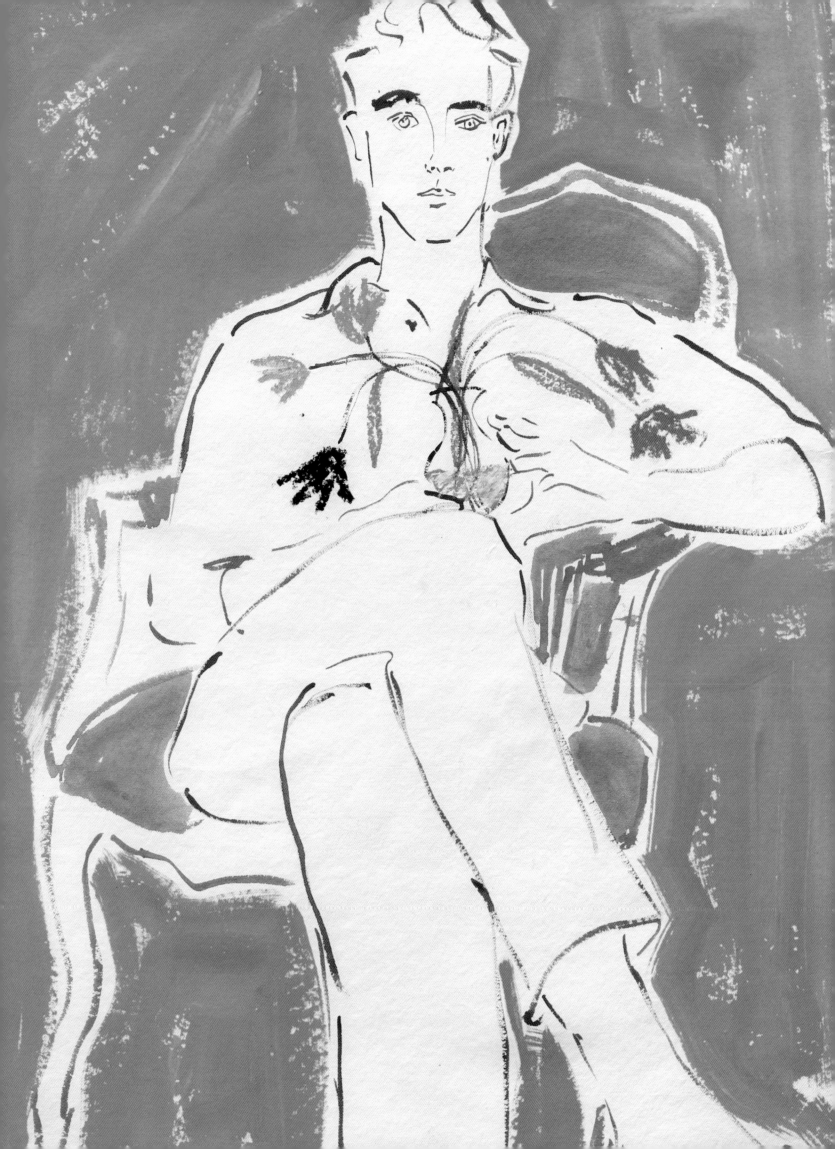

Josette B

HROOM 2021 L.E.H.

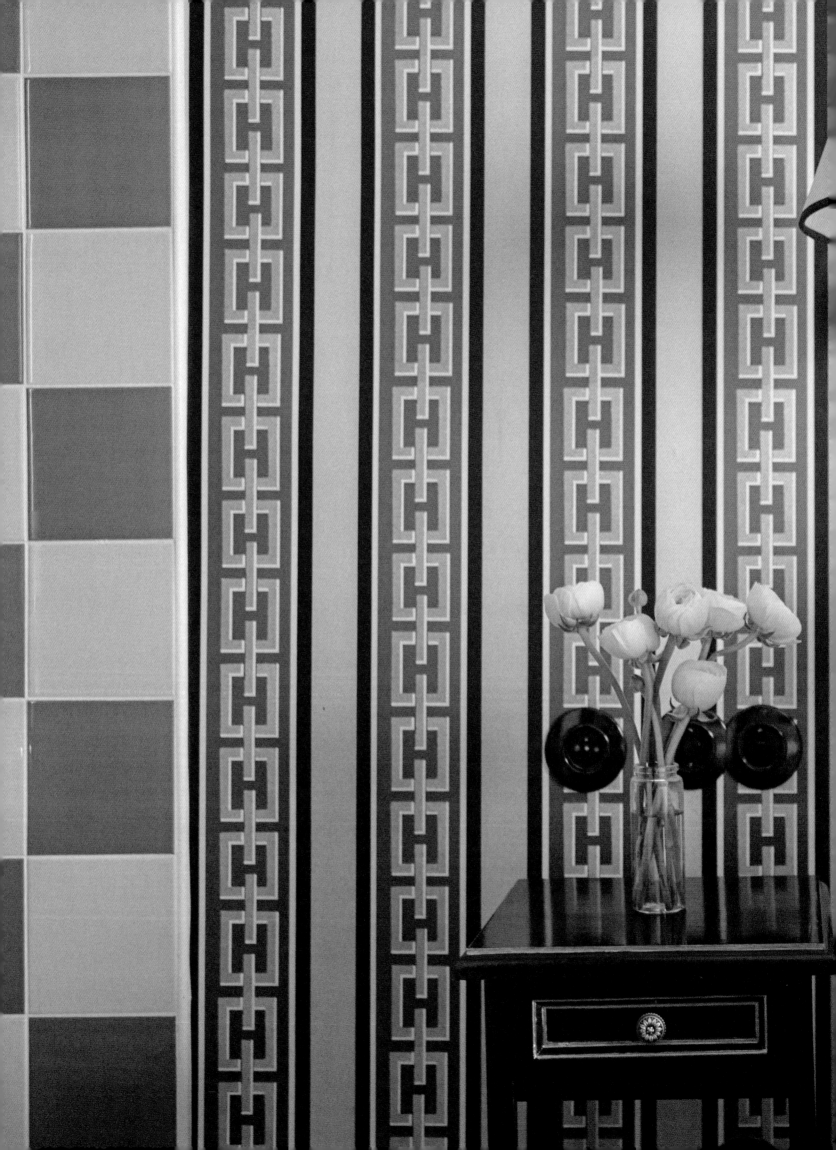

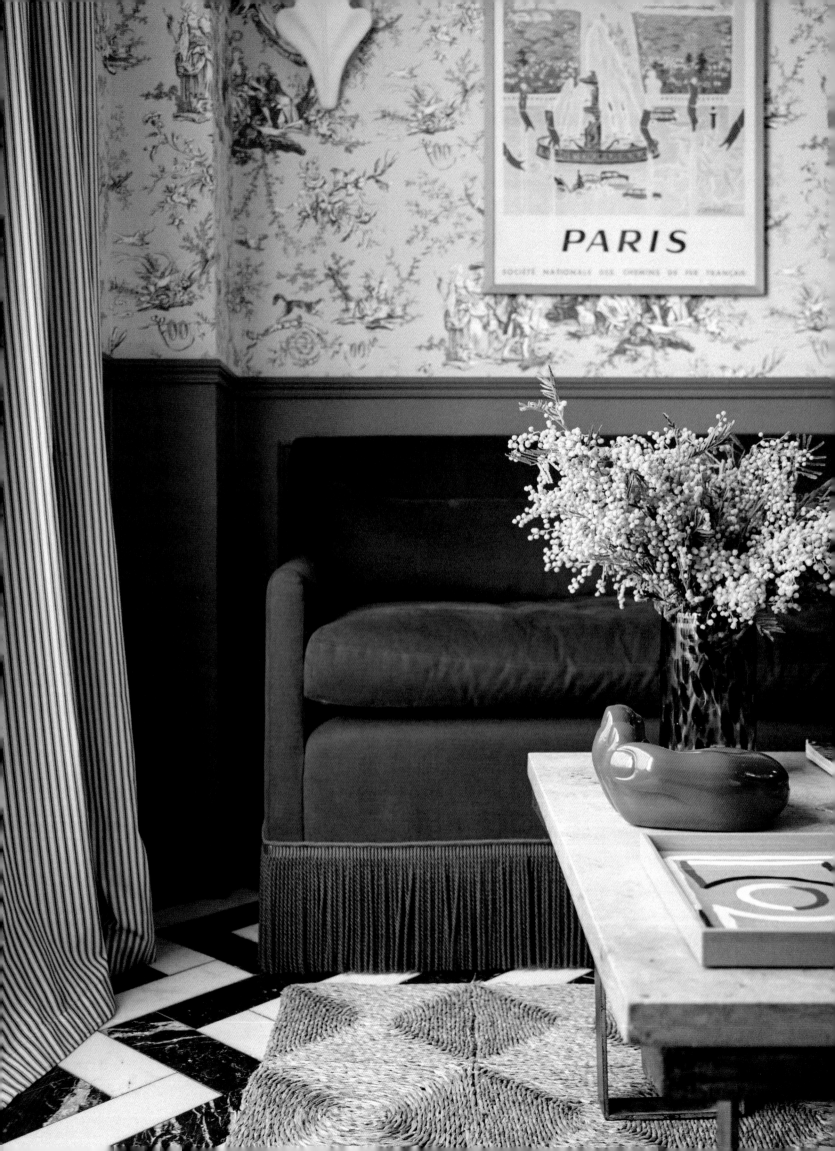

245

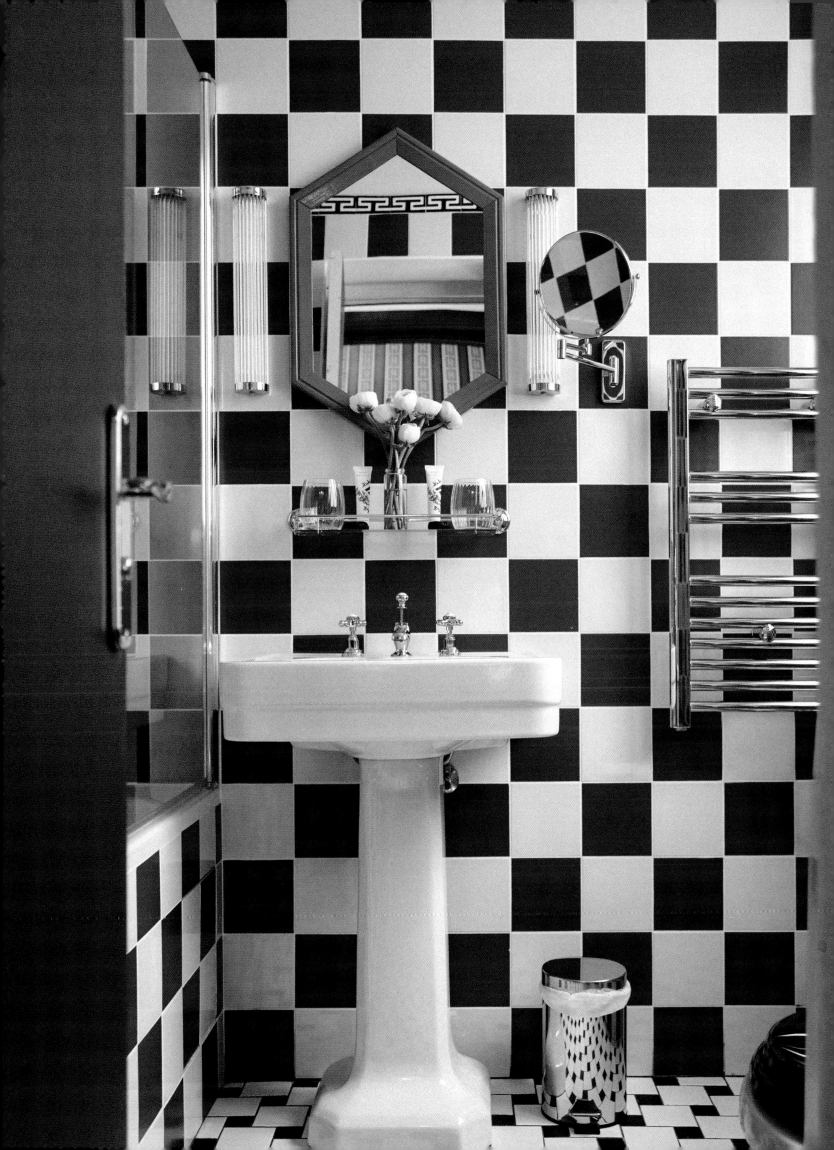

AND
* SQUARE POUFS

* COCKTAIL CHAIRS : pistach

* CLUB CHAIRS : printed / wove

* BANQUETTES / SOFAS : mustar

* HEXAGONAL POUFS : striped

* TABLECLOTHS :
 white + pink fringe

* BRASS floor
 + table lamps
 + side tables

← pleated
silk

painted
parchment

Josette

green + emerald fringe
fabric TBC (Rubelli?)
velvet
printed fabric TBC

peach
glass

Dining Room L.E.H.

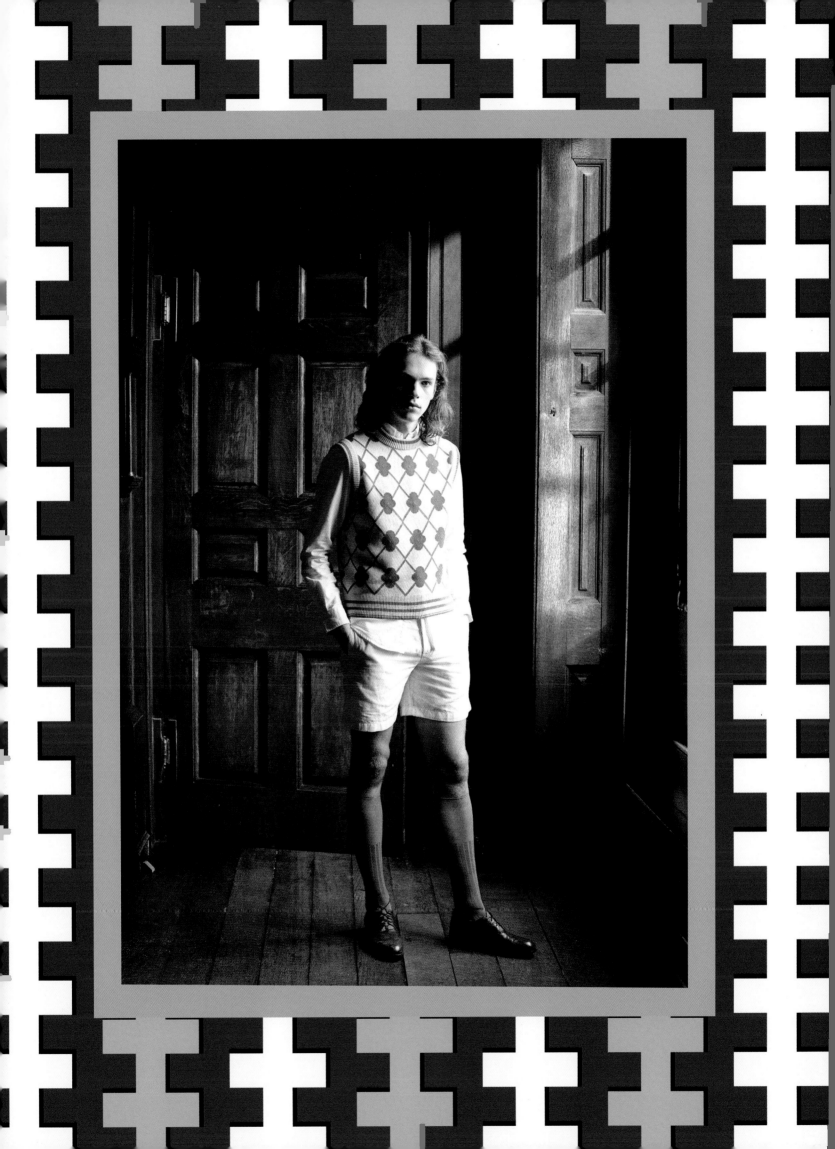

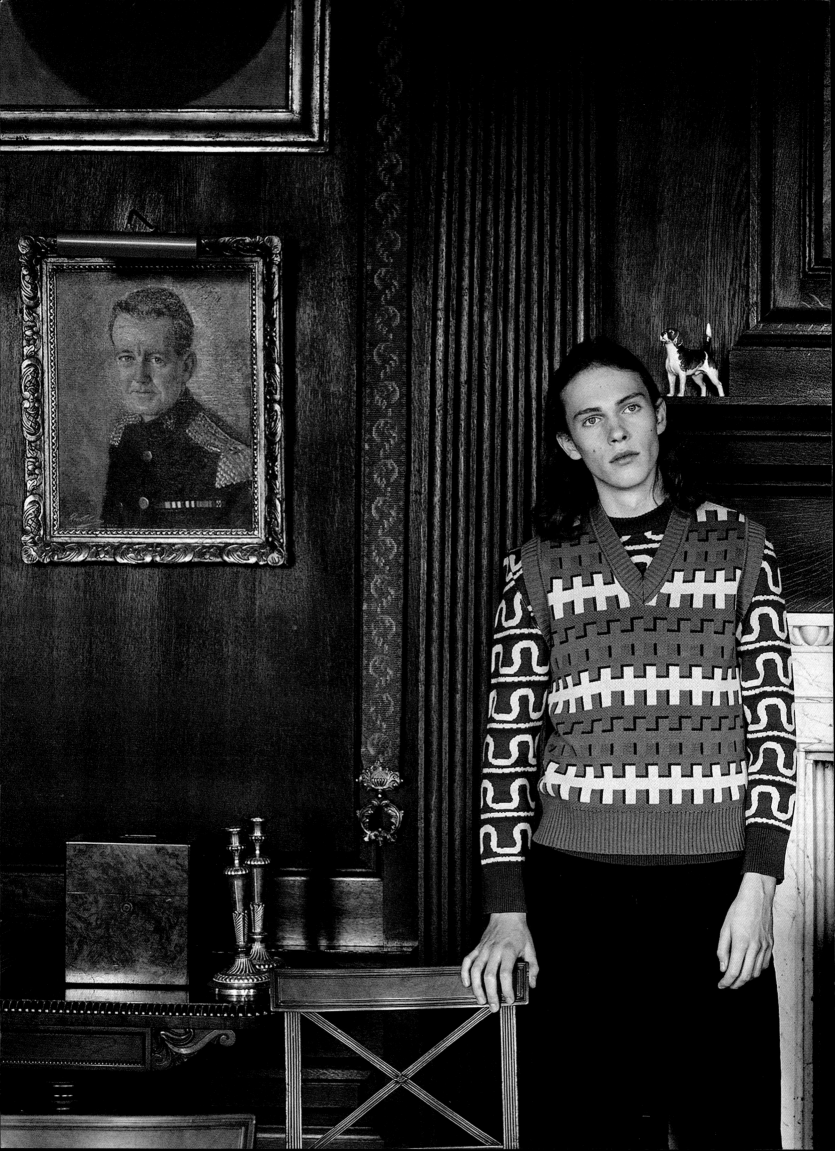

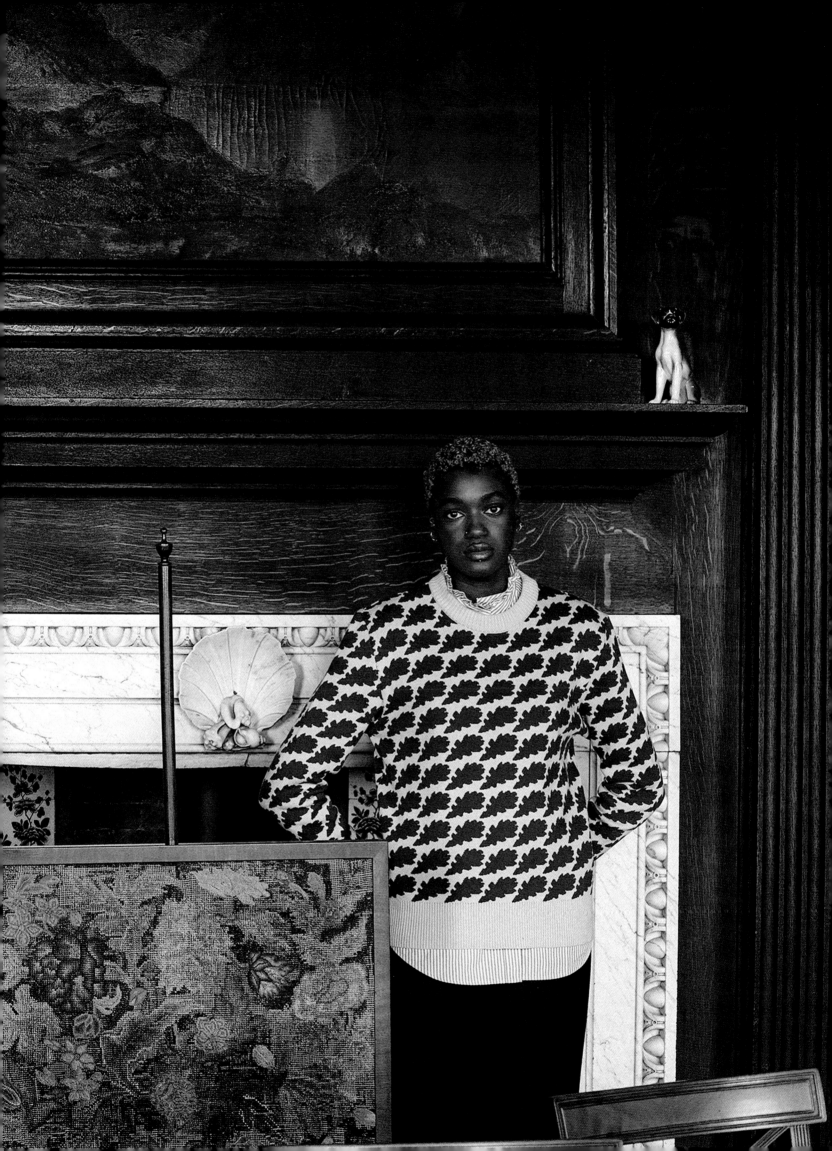

ACKNOWLEDGEMENTS

I have several people to thank for helping me in the making of *A Kind of Magic* ...

First and foremost, Beatrice Vincenzini and David Shannon at Vendome, for sparking up the conversation and enabling me to publish this book. Thanks also to Kit Garis for his help and support.

Thank you to Billal Taright, my close friend and collaborator. We have worked on many a project, but none as complex and as fun as this book. I particularly loved our days shooting in the country, marvelling at the beauty of the fields and flowers. Billal is a true artist, with a totally unique and wondrous way of looking at and capturing things.

Thanks to Roger Barnard, our designer and art director, who brought to this book a plethora of brilliant design ideas, and who came to almost every shoot, always knowing how best to make a tricky shot work.

A heartfelt thank you to my dear friend and neighbour Nicky Haslam, who very kindly provided the foreword for this book. Duncan and I feel very lucky to have Nicky living down the road from our cottage. Us becoming friends over the last few years has been one of the best things about our new life in the country.

Thank you to the brands and companies I collaborate with for agreeing to the presentation of our projects in *A Kind of Magic*.

Thanks, as ever, to my family, for having only ever supported and encouraged me. Growing up, the homes of my parents, grandparents, aunts and uncles were incredibly happy places for me to zip between.

I would also like to thank my boss from 2013 to 2015, Ben Pentreath, who took a chance on me when I didn't know a pelmet from a portico. I look back at my time with Ben (and Lucy and Bridie) very fondly indeed. Ben brought me into a colourful world of interiors that was, before then, almost completely unknown to me, and I will forever be grateful.

Last of all, I would like to thank Duncan Campbell, my husband, who very kindly (and helpfully) agreed to let me make a book featuring our personal spaces. The homes we have made we have created together, and sharing them with Duncan brings me buckets of joy on a daily basis. Choosing and making furniture and bits and bobs to decorate our rooms (and express ourselves), cooking and gardening and simply living in these spaces together: I am filled with happiness. Here's to many more years of us making homes and gardens ...

First published in 2022 by The Vendome Press.
Vendome is a registered trademark of The Vendome Press, LLC
www.vendomepress.com

VENDOME PRESS US
PO Box 566,
Palm Beach,
Florida, FL 33480

VENDOME PRESS UK
Worlds End Studios,
132–134 Lots Road,
London, SW10 0RJ

PUBLISHERS
Beatrice Vincenzini, Mark Magowan & Francesco Venturi

TEXT & ILLUSTRATIONS
Copyright © 2022 Luke Edward Hall

PHOTOGRAPHY
Copyright © 2022 Billal Taright

ADDITIONAL IMAGES
The Gothic Pavilion, Painswick, ca 1748, Thomas Robins (1716–1770) watercolour and pencil on paper © Victoria & Albert Museum, London: pp32–3; *Sezincote* Edward Paine (1912–1997): p35; *Sezincote* Thomas Daniell (1749–1840), © Paul Highnam/Country Life Archive: pp36–7; *Rollright Stones* Joan Blaeu (1596–1673), Atlas Maior, 1662–5, Vol 5, Biblioteca Nacional de España: pp116–17; Detail of *Interior* (1929) by Duncan Grant (1885–1978) © Ashmolean Museum, University of Oxford: pp134–5.

Distributed in North America by Abrams Books
Distributed in the UK, and rest of the world, by Thames & Hudson
ISBN: 978-0-86565-410-5

EDITOR Tessa Monina
PRODUCTION DIRECTOR Jim Spivey
CREATIVE DIRECTOR Roger Barnard

Library of Congress Cataloging-in-Publication Data available upon request.
Printed and bound in China by 1010 Printing International Limited.

FIRST PRINTING